Published by Graphis

Publisher & Creative Director: **B. Martin Pedersen**

Publisher Assistant/Designer: **Claire Yuan Zhuang**

Chief Visionary Officer: **Patti Judd**

Design Director: **Heera Kim**

Senior Designer: **Hiewon Sohn**

Associate Editor: **Colleen Boyd**

Account/Production: **Bianca Barnes**

All creative professions, such as Designers, Art Directors, Photographers, and Illustrators, will be capitalized to honor their respective fields.
ISBN: 978-1-934632-4...

This book is dedicated to my parents,
Klara B. Larsen and Berndt Olav Pedersen,
who managed to bring me and my younger
siblings, Gloria and Frithjof,
to the United States of America after the war.
This country became a gift to us all.

Also, to my wife,
Arna Tomsen Skaarva Pedersen
(Feb. 8th, 1941 – Aug. 29th, 2020),
and our three sons, Ford Erik,
Bjorn Christian,
and Christopher Alexander.

B. MARTIN PEDERSEN PORTRAIT

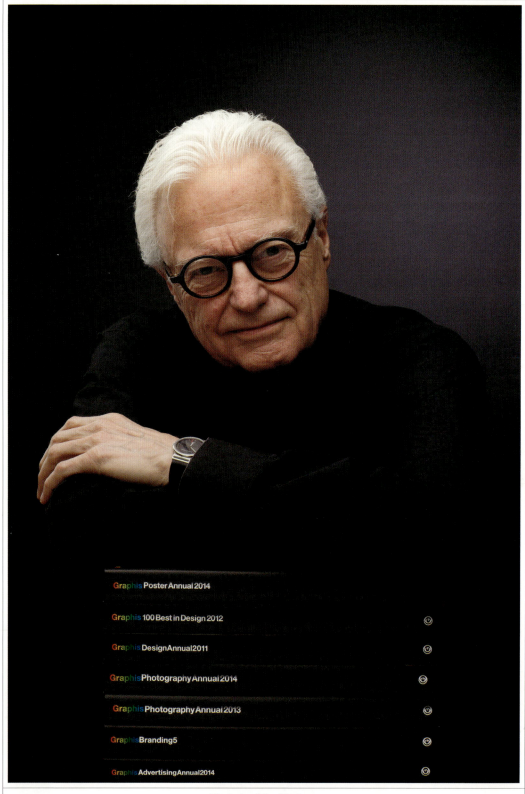

Photo by John Madere

CAREER & LIFE HIGHLIGHTS

B. Martin Pedersen

Publisher and Creative Director of *Graphis* since 1985.

DESIGN

1978:
Won the Columbia University National Magazine Award for the best designed magazine of the year with *Nautical Quarterly*.

1983:
Honored by SPD (The Society of Publication Designers) with the first Herb Lubalin Award for excellence in Editorial Design.

1987:
Elected into AGI (Alliance Graphique International). Herb Lubalin proposed me.

1997:
Inducted into the Art Directors Hall of Fame.

2003:
Received the AIGA Gold Medal for lifetime achievement in Design.

2006:
Appointed Design Advisor for the United States Post Office Citizen Stamp Committee by Postmaster General Jack Potter.

BOATING

1962:
Received my 100 ton USCG captain's license for sail and powered vessels.

1972:
Sailed *Saga*, a Bill Tripp-designed 31 foot sloop, round trip to Bermuda with celestial navigation. This was before GPS.

1997:
Christopher, my 16-year-old son, and his best friend Sebastian took me and my best friend Neil Billings round trip on *Concinnity*, my Hinckley Bermuda 40 yawl, to Bermuda.

1998:
Accepted into the NYYC (New York Yacht Club), having been sponsored by Dan Nerney.

FLYING

1969:
Qualified for single-engine pilot certification.

1989:
Qualified for single-engine instrument rating.

2007:
Earned my twin-engine pilot certification at European Aviation in Naples, Florida, on a Diamond DA42 Twin Star.

CONTENTS

Fine Art .. 9	Muppets: Opening Night 92	Five Logos .. 134
Calendar Series .. 12	Bell Labs .. 96	Logo for Syracuse University 135
Geigy Pharmaceutical Company 18	Dow Jones Annual Reports 97	Hopper Papers New Logo 136
Vanishing American 20	U&LC Magazine .. 100	Energy Medicine Magazine 140
Promotion Mailer 22	Business Week Magazine 106	New York Yacht Club Brochure 141
Personal Christmas Card 23	TDC Awards Book 107	Sonnenblick-Goldman Brochure 142
The American Way 24	Hopper Papers .. 108	Tools for Living .. 144
Promotion Folder 37	United Industrial Syndicate 112	SCM's Xerographic Toner 146
Passages Magazine 38	IBM Japan ... 116	Archtop Guitar Book 149
Environment Information Access 41	TDC Promotion Poster 118	Howard Schatz Ads 163
The Color Connection 44	Biggest Name in Design Poster 119	Ads For Tesla ... 166
VW Type 3 ... 46	SPD Annual .. 120	United Nations of America 171
GPS Paper Selection Collection 47	Graphis Photo Exhibition Brochure 121	The Greatest Generations! 172
Volkswagen Bus: The Gear Box 52	Childcraft .. 122	Poster for Coexistence 173
New York Times Book Review 54	Encore Magazine 123	A Selection of Graphis Books 175
School of Visual Arts Posters 55	To the Third Power 124	Magazine Covers: Walter Herdeg 230
AIGA 120-Page Awards Book 58	Design Congress Poster 125	Magazines Covers: B. Martin Pedersen 252
Sports Car Magazine 59	Japan 2011 Tsunami Poster 126	Graphis Website .. 319
Pastimes Magazine 66	Norwegian Celebration Posters 127	Graphis Certificates 322
Progress Brochure 72	Poster Honoring Fritz Gottschalk 130	Commentary .. 326
Jonson Pedersen Hinrichs & Shakery 74	FAO Schwatz Toy Designs 131	Index ... 333
Citicorp Brochure 76	Iran Protest Poster 132	BMP Biography, Photos, & Testimonials
Nautical Quarterly 78	Lisa Thorsen with Hurt Black Doll 133	... 335

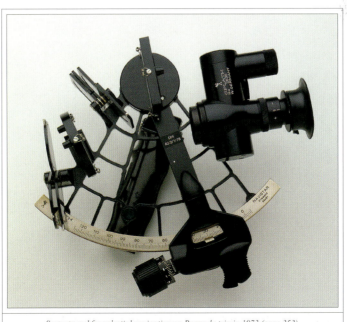

Sextant used for celestial navigation on Bermuda trip in 1973 (page 353).

Paintings

PERSONAL: GHANDI 9

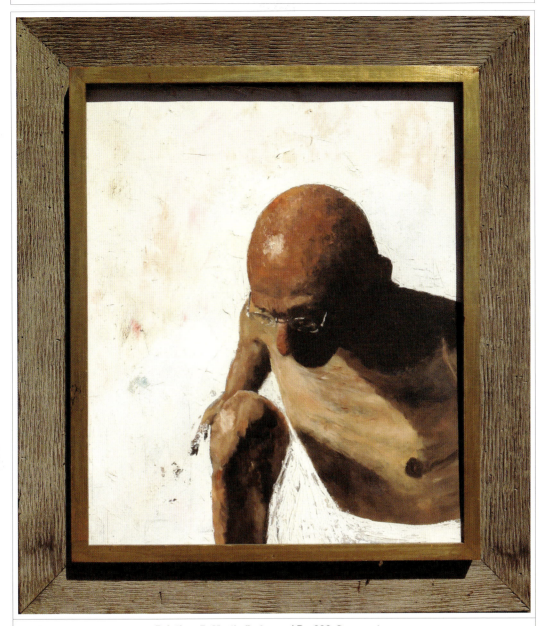

Painting: B. Martin Pedersen | **Pg. 326:** Commentary

10 PERSONAL: JAMAICAN FRUIT LADY

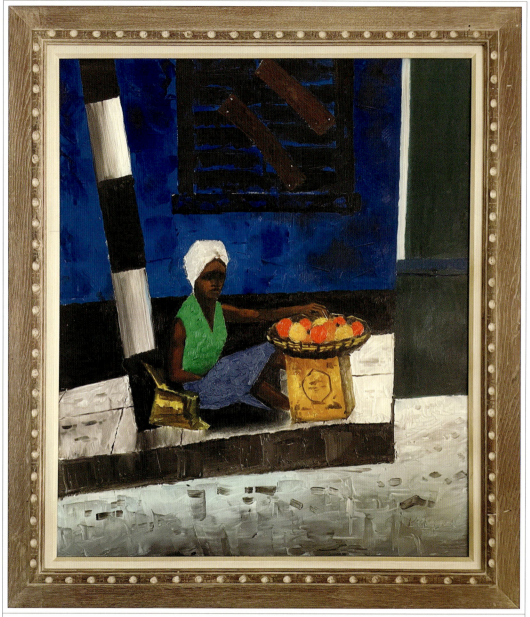

Painting: B. Martin Pedersen | **Pg. 326:** Commentary

PERSONAL: MAASAI WARRIOR 11

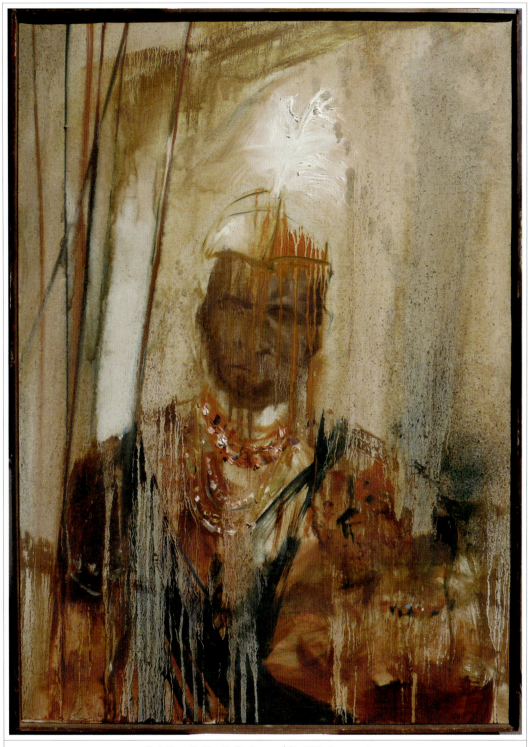

Painting: B. Martin Pedersen | Pg. 326: Commentary

12 CLIENT: S.D. SCOTT PRINTING COMPANY

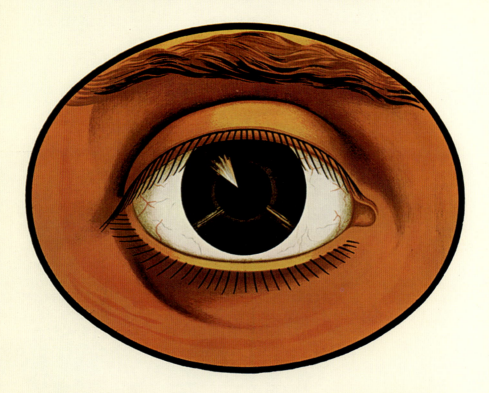

Title: Ides of March | Design: B. Martin Pedersen | Pg. 326: Commentary

CLIENT: **S.D. SCOTT PRINTING COMPANY**

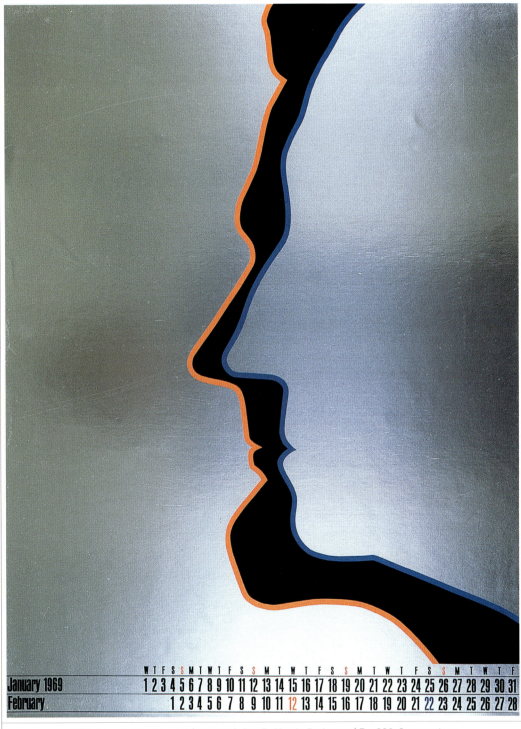

Title: Lincoln/Washington | **Design & Art:** B. Martin Pedersen | **Pg. 326:** Commentary

14 CLIENT: S.D. SCOTT PRINTING COMPANY

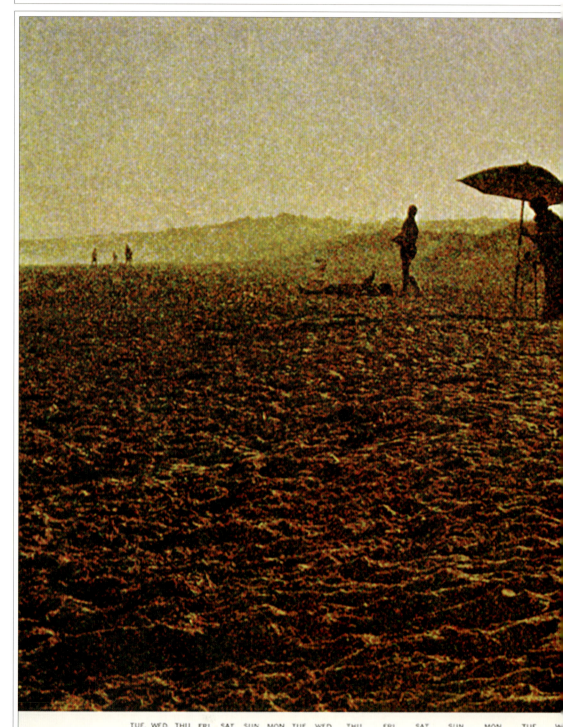

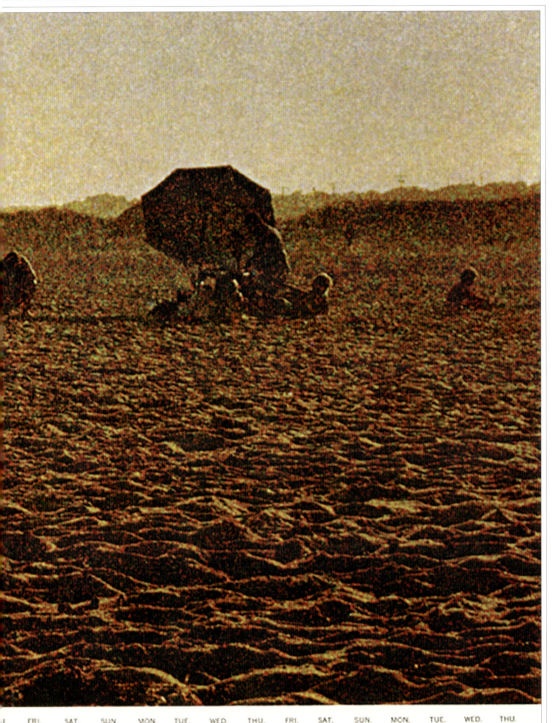

Title: Summer Beach Montauk | **Design & Photo:** B. Martin Pedersen | **Pg. 326:** Commentary

16 CLIENT: S.D. SCOTT PRINTING COMPANY

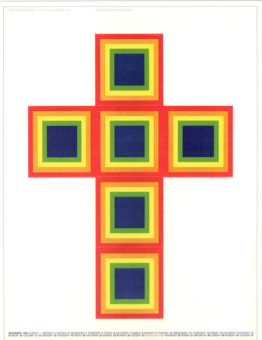
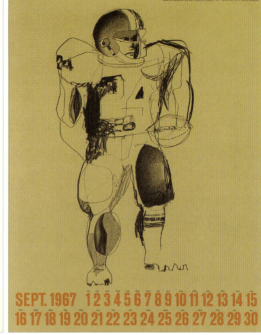
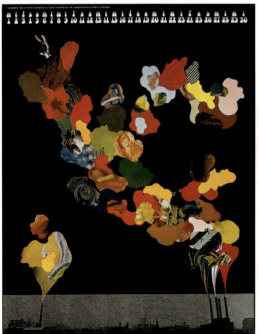
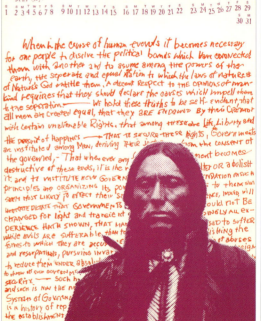

Titles: #1 Xmas Box, #2 Football Player, #3 Beautiful Pollution, #4 Native Americans' Declaration of Independence
Design & Art: B. Martin Pedersen | **Pg. 326:** Commentary

CLIENT: S.D. SCOTT PRINTING COMPANY

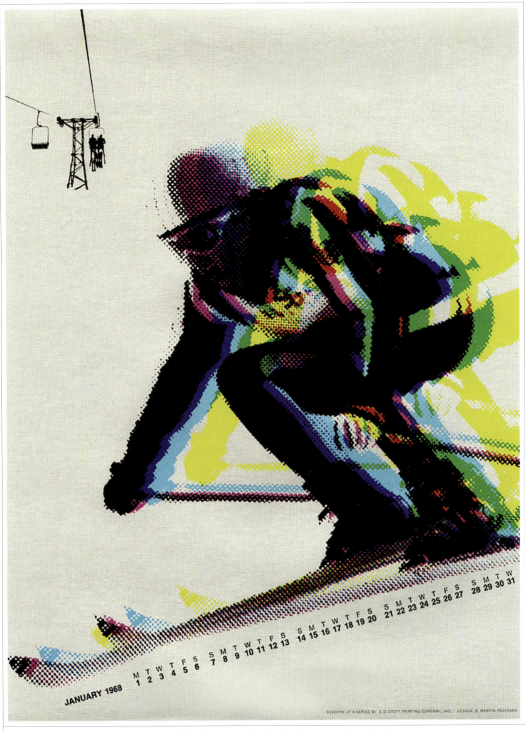

Title: Downhill Skier | **Design & Art:** B. Martin Pedersen | **Pg. 326:** Commentary

18 CLIENT: GEIGY PHARMACEUTICAL COMPANY

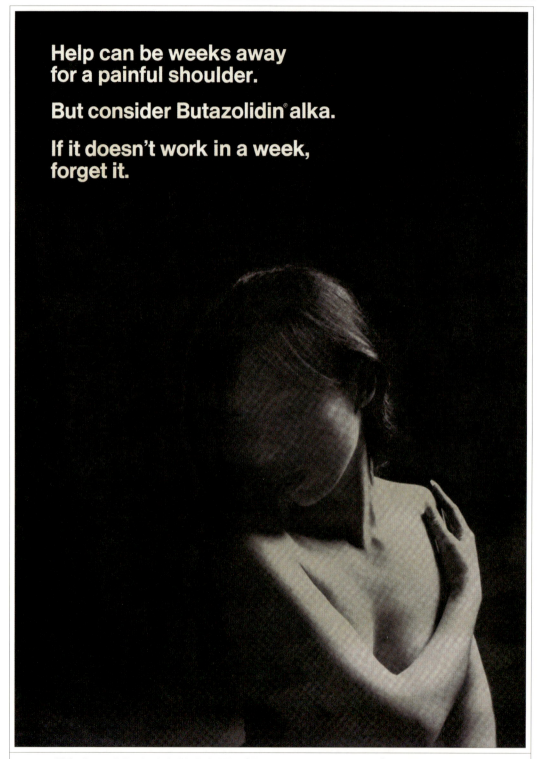

Title: Butazolidin, An Arthritic Pain Killer | **Design:** B. Martin Pedersen | **Pg. 326:** Commentary

CLIENT: GEIGY PHARMACEUTICAL COMPANY

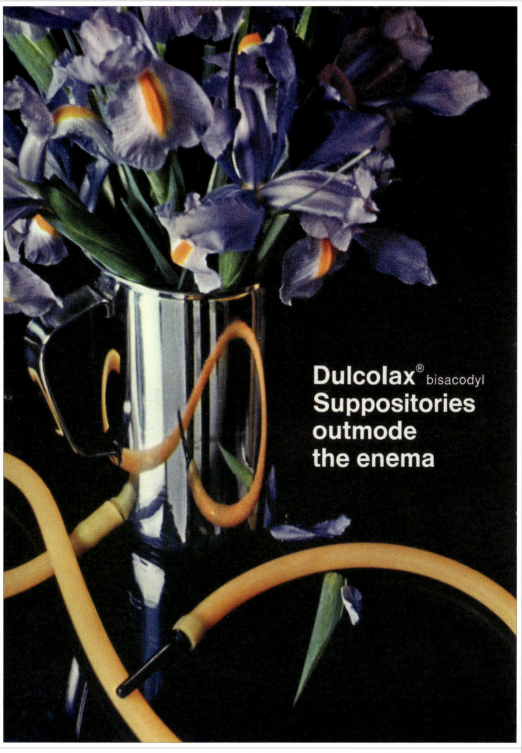

Title: Dulcolax, To Help Loosen Stool | **Design:** B. Martin Pedersen | **Pg. 326:** Commentary

20 PERSONAL: VANISHING AMERICAN

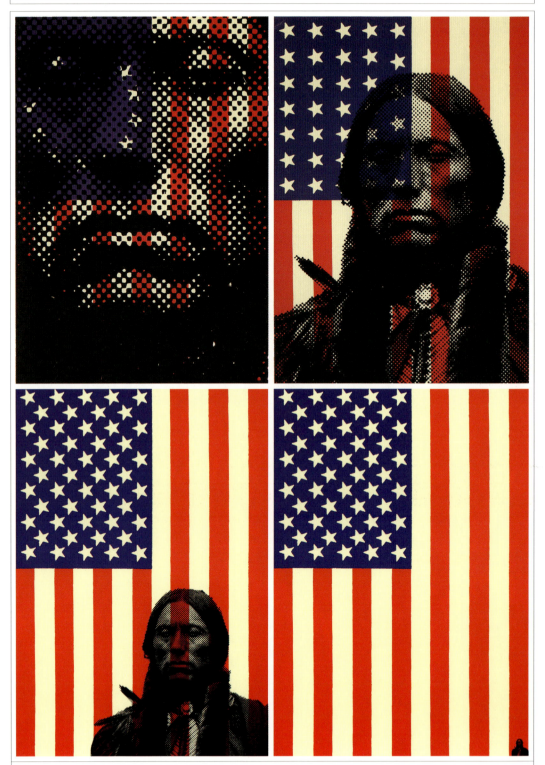

Design: B. Martin Pedersen | **Medium:** Silkscreen | **Pg. 326:** Commentary

PERSONAL: **VANISHING AMERICAN** 21

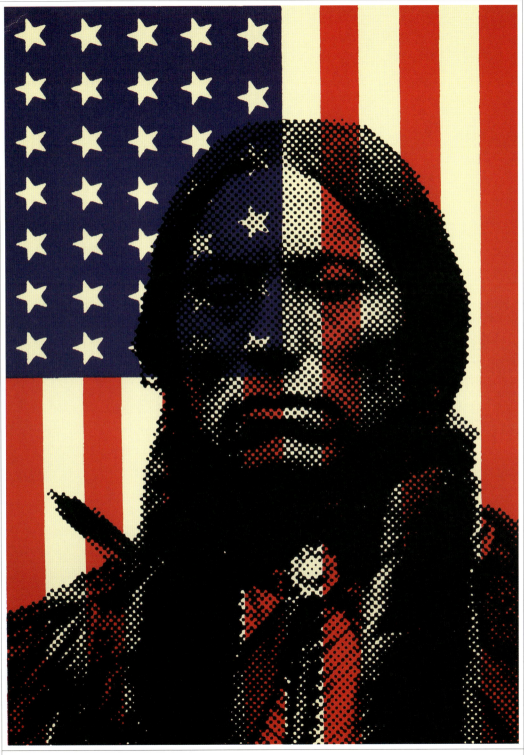

Design: B. Martin Pedersen | **Medium:** Silkscreen | **Pg. 326:** Commentary

22 CLIENT: STANLEY ROSENTHAL

CLICK!

Stanley Rosenthall click, click, would like to click, show you click, some of his click, Photograph's.
He click, click, can be reached click, at 10 West 14 Street, click, click, by calling 243-4840. Click.

Design: B. Martin Pedersen | Pg. 326: Commentary

PERSONAL: CHRISTMAS CARD 23

Design: B. Martin Pedersen | **Pg. 326:** Commentary

24 CLIENT: AMERICAN AIRLINES

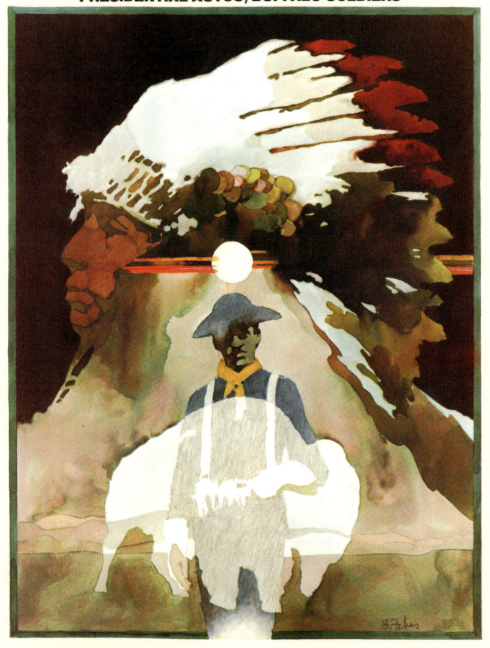

Design: B. Martin Pedersen | Painting: Bart Forbes | Pg. 326: Commentary

CLIENT: AMERICAN AIRLINES 25

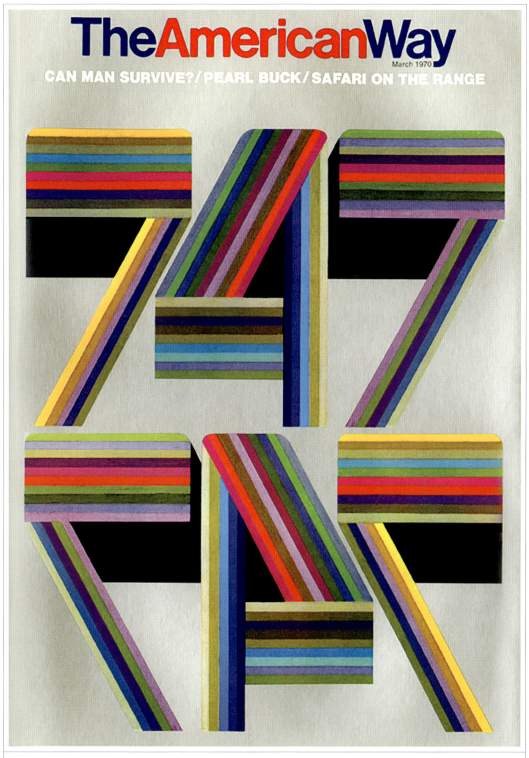

Design: B. Martin Pedersen | **Illustration:** Giuseppe Lucchi | **Pg. 326:** Commentary

26 CLIENT: AMERICAN AIRLINES

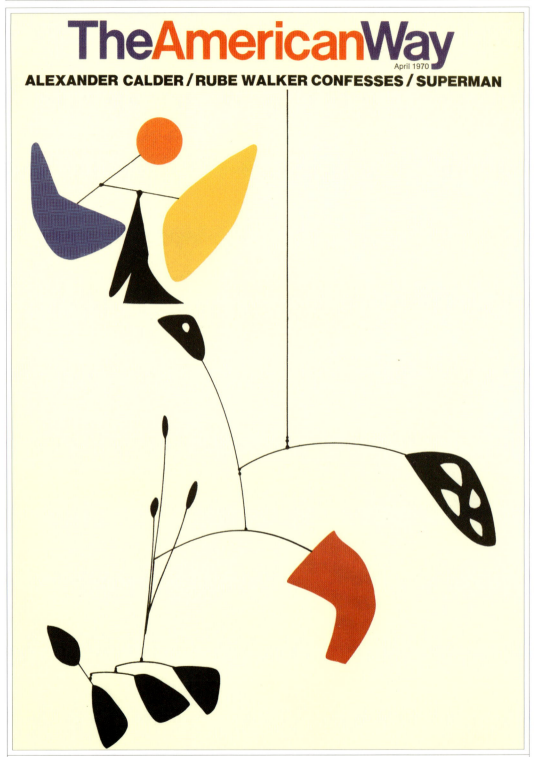

Design: B. Martin Pedersen | **Sculpture:** Alexander Calder | **Pg. 326:** Commentary

CLIENT: AMERICAN AIRLINES

TheAmericanWay
March-April 1969

On our way to a cashless Society/Conglomerates: 2+2=5/The night they turned on Carnegie Hall

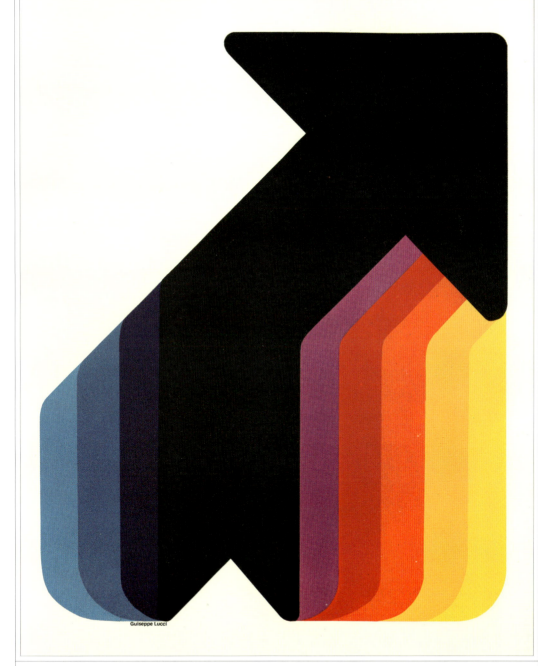

Guiseppe Lucci

Design: B. Martin Pedersen | **Illustration:** Giuseppe Lucchi | **Pg. 326:** Commentary

28 CLIENT: AMERICAN AIRLINES

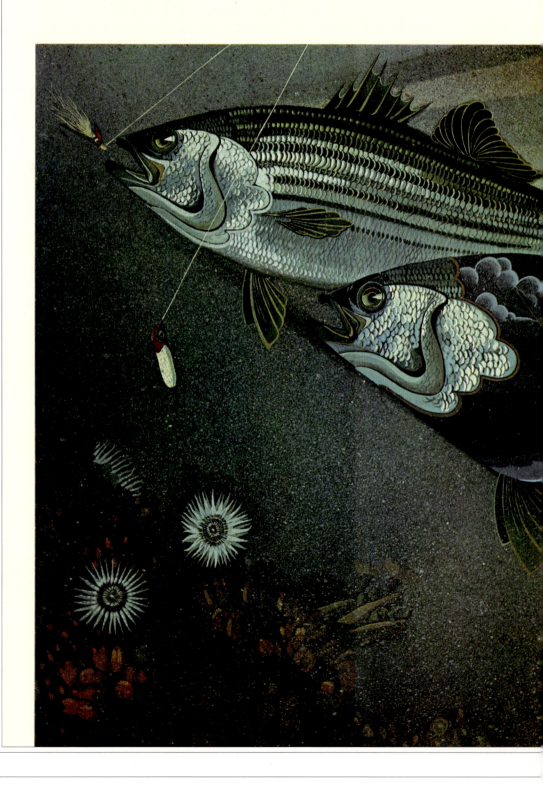

Condensed from The Catch and The Feast
BY JOIE AND BILL McGRAIL
(Copyright, 1969) by Joie Harrison McGrail and William P. McGrail, Jr.)

BASS BY NIGHT

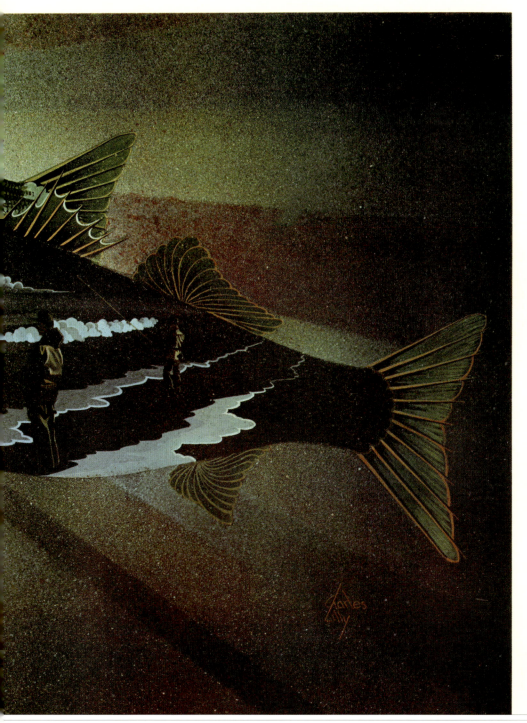

Design: B. Martin Pedersen | **Illustration:** Charles Lilly | **Pg. 326:** Commentary

30 CLIENT: AMERICAN AIRLINES

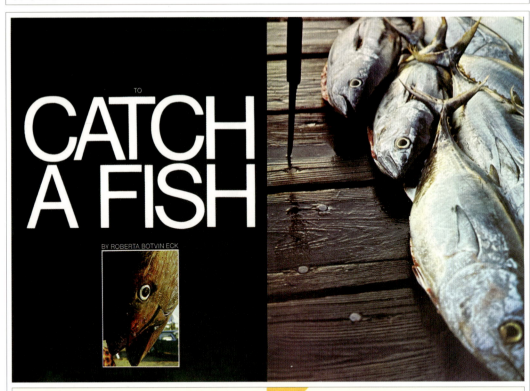

TO CATCH A FISH

BY ROBERTA BOTVIN ECK

for 30,000 tons of frozen watermelon. P.S. What are you doing about our silver mine in Nevada? I hear it's tarnishing."

Blade is now a milkman in Denver, and he is said to be recovering very nicely. But he may have to quit his job. The dairy he works for is considering diversifying its business by adding egg nog.

The more diversified a company gets, the more difficult it becomes to maintain a distinctive corporate image. For instance, a few years ago Peerless Pigskin Corp. had no identity problem. Its slogan, "Pigskins Are Our Proudest Product," was known around the world. But then, in rapid succession, Peerless went into pickles, plastics and pontoon bridges. The slogan became dated, and Wall Street rumors had it that investors were shying away from Peerless because they simply weren't sure what the company was any longer.

Parker Peerless, founder and chairman, took the problem to the company's advertising agency, Chitblains & Fever: "Look," he said, "if you want to keep our account, you've got to come up with a new image for us. Pigskins, pickles, plastics and pontoon bridges are not so complicated,

so get with it. And let's have something catchy, right?"

The agency put its top creative man on the job. After two months of mind-bending exertion, he came up with a winning combination of words. Staggering into the office of the agency head, he was about to deliver his gem when the Peerless account man came bursting in. "Hold it," the account executive screamed. "Peerless has just gone into pajamas!"

Back at his desk, the creative had barely begun to try fitting pajamas into the picture when the creative director popped into his office. "By the way," he said casually, "Peerless just signed to acquire Proudfot Paints. Try to slip a mention of paints into what you're doing, won't you? That's a good lad."

And every time that the agency would come up with a new corporate image, Peerless would go into a new line: perambulators, percolators, poultry, polyethylene. Finally, the creative man ran off to join the Green Berets, Chitblains & Fever lost the account, and Peerless never managed a good public image. But it really didn't matter. Shortly thereafter, Peerless was acquired by Posito's Pizza,

and it became Posito's problem.

Conglomerates do not hesitate to cross cultural, ethnic and geographic lines. One of the problems that can arise out of this is a language gap. When Go Go Corp., a fast-growing Yankee company, acquired Boll Weevil Mills, a slow-growing but profitable operation, it appeared to be a good deal for everyone concerned. Boll Weevil was knee-deep in crack salesmen at its headquarters, just a sparerib's throw from Fatback, Ark., and Go Go needed skilled sales help badly.

So it was that Beauregard Bixbee, top salesman for Boll Weevil, was summarily transferred to the New York office of Go Go, promoted, given a lavish raise and turned loose on the Eastern market. Alas, the move was a disaster.

Though suave to a fault, Bixbee was an adherent of the "You-get-more-sales-with-honey-than-vinegar" school. He would drift lazily up to the receptionist and intone softly, "Pard'n me, honey, but mah goodness if you all haven't got the purtiest little ol' blue eyes in the ever-lovin' world, cross mah palpitatin' heart. You all think your fine old boss could spare a poor country boy a few minutes of his time?"

Design & Top Photo: B. Martin Pedersen | **Bottom Illustration:** Giuseppe Lucchi | **Pg. 326:** Commentary

CLIENT: **AMERICAN AIRLINES** 31

THE 7-FOOTER WHO WASN'T

by Jerry Coleman

There's a sports Hall of Fame in Oklahoma City for athletes who have broken new ground in their world, and not long ago Bob (Foothills) Kurland was inducted. You may find it hard to place Kurland right off, but in large measure he made basketball the game it is today. He was its first great 7-footer, no small accomplishment for a youngster who actually reached only 6 feet, 10½ inches.

His old coach at Oklahoma A & M, Hank Iba, a Hall of Famer himself, spoke for Kurland at the Hall of Fame ceremony. "Gentlemen," the 65-year-old Iba said, "Bob Kurland was more than a great basketball player. He was a trail blazer. He was an overgrown boy at a time when coaches shied away from overgrown boys. We considered them too awkward. Well sir, Bob Kurland changed things. He opened the door for all the big boys we have today."

Kurland was stringy and self-conscious when he left St. Louis in 1942 for A & M's Stillwater campus. He was 17 years old, and an inch and a half short of 7 feet. He had no idea that he would stop growing right there. The sports publicists called him a 7-footer the same time they pinned the "Foothills" nickname on him, but it was all pure puffery aimed at drawing attention to the youngster.

"I remember," Hank Iba said, "when I brought Kurland to New York's Madison Square Garden as a freshman. It was a war year, and the rules allowed us to play freshmen. Anyway, the other coaches looked at Kurland and they said, 'Henry, you'll never make a basketball player out of him. He's too tall.'

Kurland had found himself a room in the field house when he arrived at the Aggie campus. It was convenient and it saved him $10 a month. Hank Iba had another present for him, a skipping rope. "Use this," Iba told him, "It will get those springs working in your legs."

Kurland skipped rope before and after every workout. He learned to leap high enough so that his elbows cleared the basket rim, 10 feet up. Iba made a goal tender out of him. He knocked out as many baskets as he scored in his sophomore year, and the National Collegiate Athletic Association was so aghast at this new wrinkle in the game that it legislated against goal tending.

"Let me tell you how much that hurt Kurland," Iba said. "In each of the next two years we won the NCAA title, the first time in history any school did that, with all those new rules against Kurland. And he was All-America."

In 1945, his junior year, Kurland's team went on from the NCAA to play DePaul, the National Invitational Tournament winner, in a charity game for the American Red Cross. DePaul was led by another giant, the great George Mikan. The game was at the Garden in New York. Both men were in foul trouble, but Mikan got whistled off the court first and Kurland's Aggies won.

To go pro or not to go? That was the big decision facing Kurland after graduation. Professional basketball was just taking shape. The Basketball Association of America had been launched, and George Mikan signed with a team called the Chicago entry. Kurland was flirting with a team called the St. Louis Bombers. "I suppose they'd have given me anywhere from $15,000 to $18,000 a year," he recalled. "At least, they promised that much. But I wasn't sure they would stay solvent."

So Kurland joined the Phillips Petroleum Company to play industrial basketball with its Phillips 66 Oilers. A straight-A student in college, he earned the salary of a graduate engineer and the exposure of a top athlete. His career with the Phillips team, in fact, won him a couple of Olympic Gold Medals.

Today, Kurland is 42 years old and president of Phillips Films, Inc., Cincinnati, a wholly-owned subsidiary of the oil company. He and his wife have four children. The eldest, Alex, is going on 16, and he's preparing to play for his high school basketball team. As young as he is, Alex already reaches 6 feet 6½ inches. He just might turn out to become the family's first *true* 7-footer.

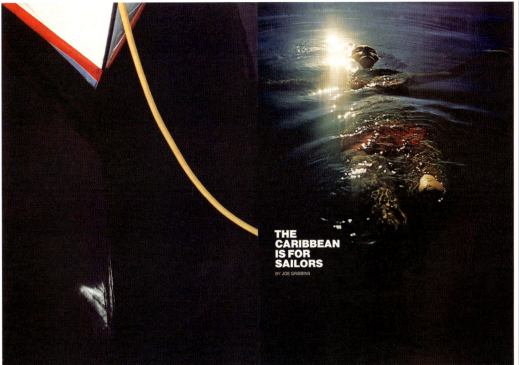

THE CARIBBEAN IS FOR SAILORS
BY JOE GRIBBINS

Design: B. Martin Pedersen | **Top Art:** Santo Pezzutti | **Bottom Photo:** Frank Rohr | **Pg. 326:** Commentary

32 CLIENT: **AMERICAN AIRLINES**

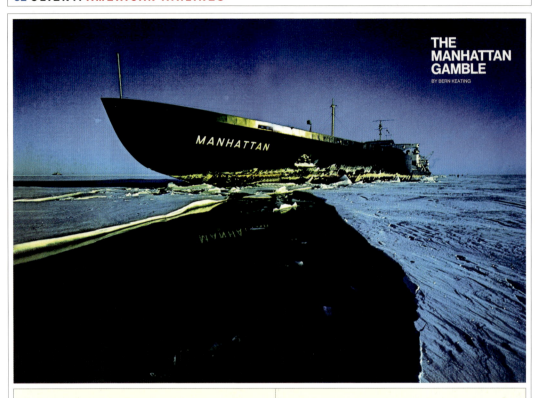

THE MANHATTAN GAMBLE
BY BERN KEATING

New York Magazine: Alive and Well
by Richard Blodgett

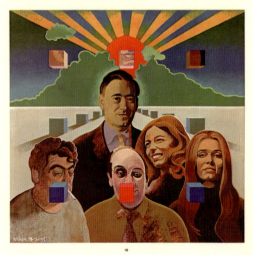

Design: B. Martin Pedersen | **Top Photo:** Dan Guravitz | **Bottom Illustration:** Wilson McLean
Pg. 326: Commentary

CLIENT: **AMERICAN AIRLINES**

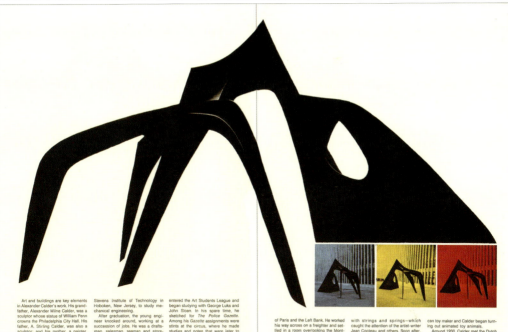

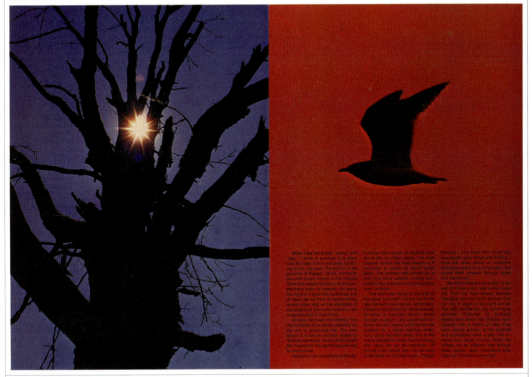

Design: B. Martin Pedersen | **Top Sculpture:** Alexander Calder | **Bottom Photos:** Frank Moscati
Pg. 326: Commentary

34 CLIENT: AMERICAN AIRLINES

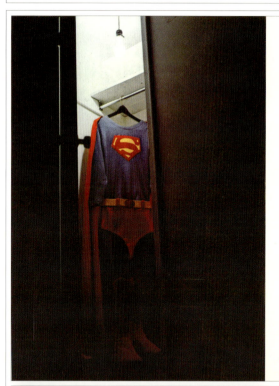

MEET MORT WEISINGER: THE MAN BEHIND

BY PAMELA ROTHON

Any day of the week, you can see Superman flashing across your television tube socking it to some villain in his indefatigable dedication to Truth, Justice and the American way. Fans write him one thousand letters daily. In the schoolboy swapping market, one copy of *Superman* fetches five copies of most other comic books.

Something like 100,000,000 copies of *Superman* sell each year around the world. They appear in twelve languages from Arabic to Swedish. A phenomenal success since his birth in 1938, Superman today is the property of National Periodical Publications, a subsidiary of Kinney National Service, Inc. As a property, Superman is worth around $80,000,000, though a precise value is difficult to come by because it includes the worth of a myriad of other products derived from the original comic book character.

The man behind Superman, his mentor, plotter and boss for the past thirty years, is Mort Weisinger, editor of the *Superman* comic book. You find Mort behind a tasteful mahogany desk in his New York office. A large, balding man with a double chin, Mort smokes big cigars and looks like a tough fight promoter, the type to terrify mild-mannered Clark Kent, reporter for the Metropolis *Daily Planet* and Superman's alter ego. Mort talks rapidly, bangs his desk with his fist, drops cigar ashes on his deep blue office carpet, and generally manages to create the impression that he can be a tyrant if provoked. But the facade can and does dissolve, and a kindly man who loves children and stray dogs emerges.

Yet Mort doesn't fit my preconceived image of Superman's boss. I suppose I expected a seven-foot weight-lifter wearing a fat tie with *VROOSH!* screaming across it in Day-Glow. And the office seems unexpectedly bland: no kryptonite decor, no Lois Lane ashtray, no ray gun, not a trace of Superman.

Superman's boss lights a fresh cigar and says, "Let's start at the beginning. Superman was created by two undersized Cleveland youngsters who spent a miserable childhood being beaten by neighborhood toughs. They were Jerry Siegel and Joe Shuster, both sons of poor parents. They found escape in the world of the dime novel, vicariously living the exploits of unbeatable heroes. They dreamed up their own superhero, a combination of Samson, Hercules and Atlas, with the morals of Galahad, whose mission in life was to smash the bullies of this world.

"Jerry was the writer, Joe the artist. Six years and many rejection slips later, they made their first sale, for $130, to *Action Comics*. Superman became an instant hit. In 1940, I was put in charge of *Superman* magazine, and I've been running it ever since." Joe and Jerry dropped out of the picture years ago when their contract expired.

Mort exhales a large cloud of smoke and impatiently chops at it with his hand. "My job is to keep Superman popular," he says. "If he dies, I'd be out of a job. But everyone knows Superman is indestructible. Not even a lousy plot can kill him." Mort continues: "I think of practically all the plots, but I only write in an emergency. I've invented several characters, including Supergirl and Krypto, the superdog. I'm terribly involved in Superman's life. Apart from being editor of *Superman*, I'm also in charge of public relations for National Periodical Publications. I was story editor for Superman's TV series, too."

Most of the thousand letters Superman receives daily are answered with a form reply, of course. But Mort says a few of the questions asked are awkward, even embarrassing, and require a personal answer. "Lois Lane was dying and needed a blood transfusion from Superman," he recalls. "So one bright kid wanted to know how a needle could pierce Superman's skin.

I copped out. I told him Superman had pierced his own skin with his super-sharp nails, then gave the blood transfusion. On another occasion, there was a glut of mail after a mermaid was shown eating birthday cake under water. Hundreds of kids wanted to know how you could eat cake under water. I racked my brains and finally told them she was eating sponge cake."

Mort shrugs. "You really have to keep on your toes. The kids hero-worship Superman, so we have to be very careful what we print. We bend over backwards to avoid anything unsuitable. We don't use profanity, we never show a bad cop, and we don't encourage violence. We use weird and wonderful adventure stories. We never show a picture of something like picking a pocket or hitting someone on the head that a child could emulate. Our characters walk up walls with suction cups—what kid could do that?"

Superman, Mort says, is religious, but does not attend a church or synagogue. Mort believes Superman is popular because "He stands for might, right and the people. People need heroes in this troubled world, and there aren't enough. The fact that Superman is indestructible is reassurance that good does triumph over evil."

Some readers (and Mort, too, but more of that later) have been deeply affected by Superman. "Every night when Art Buchwald goes home," Mort says, "he pretends he's Superman, then solves all the problems in our mixed-up society." Buchwald recently was photographed for a magazine article in full, four-color Superman regalia. Mort wags his head in amusement. "Yes, Art says it's one of his greatest pleasures, pretending to be Superman.

"When I go home, I go upstairs to my study and write. I've written over four hundred major articles, and I've just completed my second book. Have you read *1001 Valuable Things You*

The first thing that strikes many a stranger in Philadelphia is the sound of music, heavy on brass and drums. Up the street comes a parade, complete with marching bands, floats, automobiles bedecked with crepe, and dignitaries in smiles. If the visitor is like most, he stops to watch awhile, whether the marchers be the South Philadelphia strutters or the African Cultural and Historical Society.

Design: **B. Martin Pedersen** | Top Photos: **Frank Moscati** | Bottom Photos: **Joel Meyerowitz** | Pg. **326:** Commentary

CLIENT: AMERICAN AIRLINES 35

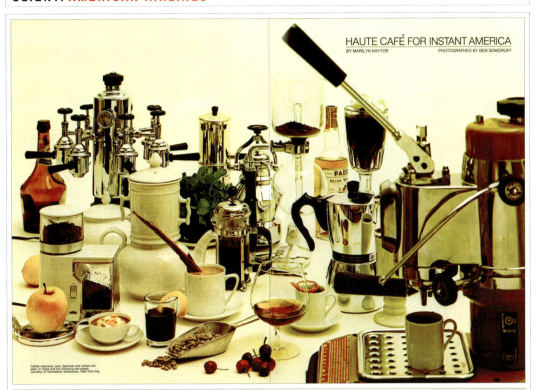

HAUTE CAFÉ FOR INSTANT AMERICA
BY MARILYN KAYTOR PHOTOGRAPHED BY BEN SOMOROFF

Coffee machines, pots, samovar and coffee mill, seen on these and the following two pages, courtesy of Hammacher Schlemmer, New York City.

INSIDE THE RANGERS' PENALTY BOX
BY CURT SCHLEIER

Picture the scene: the Rangers are playing the Red Wings at Madison Square Garden, very early in the season. The home team is in second place, a point in back of Montreal. Meanwhile, Detroit is a point behind New York, and hasn't lost a road game —yet. There are 17,250 fans screaming; referee John Ashley's at center ice with the puck, and you can smell the excitement in the air.

The little rubber disk falls. Swing go the sticks, shhhh go the skates, tick-tock goes the clock thirty-nine times and stops. Stops?

There was this red and white uniform near the wood and glass partition. Little Billy Fairbairn, the right wing of the Rangers, maybe rookie-of-the-year Billy Fairbairn, well it seems that Billy Fairbairn is not partial to red and white uniforms this evening. He pushes the red and white uniform into the partition rather forcefully, nearly shattering it—not to mention the person in the red and white uniform.

Blow goes the whistle. You boarded, says John Ashley. Me?, asks Billy Fairbairn. Open the door, goes Ed Aubell, the man in charge of the penalty box. Close the door, goes Ed Aubell. It's going to be a busy night, says Ed Aubell.

Tick-tock goes the clock, again. Billy sits intently watching the action. Ed sits intently watching the new tote board clock, the way he's been watching penalty clocks for the last nineteen years, for the Rovers for ten, the last nine for the Rangers at Madison Square Garden. After the second hand ticks 105 times, Ed pulls himself up.

"Fifteen, Billy," he says to Billy Aubell counts the last five seconds like the man at Cape Kennedy. Only he doesn't say "ignition." Like show biz, it's "you're on."

Billy leaps to the ice before Ed can open the door. That couldn't have happened at the old Garden, Aubell, who misses the old Garden, says frequently. There was only one penalty box for both teams in the O.G., not two segregated facilities as in the N.G. And there was glass protecting the O.G. penalty box, not like in the N.G.

"Sometimes two guys'd be fighting on the ice," Aubell recalls from the good old O.G. days, "and they'd be so steamed at each other that the fight would go on in the penalty box with me in the middle when the sticks went flying. I was never hurt, though. There was definitely more excitement in the old Garden as far as the penalty box goes.

"I remember one time when Henry Richard got involved in one of the penalty box fights. His brother, the Rocket, was still playing in those days.

Design: B. Martin Pedersen | **Top Photo:** Ben Somoroff | **Bottom Art:** Jerry Cosgrove | **Pg. 326:** Commentary

36 CLIENT: AMERICAN AIRLINES

CLASSIC SWINDLES

by Edward J. Mowery

The modern swindler is an amateurish bumbler compared with the geniuses who plied the trade a generation and more ago. Charles Ponzi, Philip Musica (Dr. F. Donald Coster), David Lamar, Harold Berney, Tony Romano and Cassie Chadwick had no peers. They, and others, no longer operate, doubtless to the relief of today's United States district attorneys and other officials charged with enforcing laws against financial fraud.

Ponzi was one of the greatest. His career began in 1919 in a ramshackle office on School Street in Boston's Italian section. At thirty-seven, the dapper Ponzi, a native of Parma in Italy, was a five-foot, six-inch bundle of insolence who had ruined his father-in-law's fruit business and who was desperately seeking a financial backer for a new trade publication. Opening his mail one day, Ponzi found a letter from Italy containing, instead of return postage in United States stamps, an international reply coupon issued by the Universal Postal Union.

Ponzi knew that the price of such coupons, redeemable in postage stamps, was based on official gold values of currencies used by member countries of the UPU, a treaty organization. Ponzi also knew that the actual free-market value of inflated currencies was much less than their official gold value. Why not, he asked, use inflated currencies to buy international reply coupons, then redeem the coupons for stamps of nations with sounder currencies? The stamps of the latter then could be sold for cash.

A hypothetical illustration: Country A's peso, by official rates of exchange, is equal to one of Country B's dollars. On the free exchange market, however, Country A's peso has deteriorated to the point where it requires two pesos to purchase one dollar. Theoretically, it would be possible to buy two pesos with a dollar and use the pesos to buy $2 worth of international reply coupons, since the value of the coupons was based on official exchange rates. The $2 worth of coupons presumably could be traded in for $2 of stamps, which could be sold.

Enormous practical difficulties would have confronted anyone trying to earn a substantial amount of money with such a scheme, but this did not deter Ponzi from publicizing the idea. In seven short months, he took in nearly $15 million from 40,000 small investors who were promised "50% profit in 50 days."

Some of these investors, the early ones, profited just as Ponzi promised. The money poured in at an ever-increasing rate. Ponzi hired a secretary and assistants. When his School Street office overflowed, he opened a branch in Pi Alley. His take rose to $10,000 in April, $440,000 in May. At the peak of the operation, he took in $7,200,000 in a single day. Ponzi had one hundred agents to take the money, scores of subagents, forty offices outside Boston. It took twenty policemen to keep the crowds in line. In return for the cash they gave him, Ponzi gave his clients simple promissory notes.

What Ponzi was doing, very simply, was paying off the early investors as promised with funds supplied by the latecomers. Ponzi himself admitted at the time: "It won't last forever. No good thing does."

On July 26, 1920, Ponzi was forced to close shop. Though he claimed to have $5 million in cash to meet his obligations, the closing was a signal for state and Federal investigators to move in. They found that the stamp swindler had a police record. They discovered massive embezzlements by Ponzi's employees of the money deposited by clients. When the scheme was finally exposed, the Federal Government charged Ponzi on eighty-six counts of fraud. Stock in the Hanover Trust Company, of which he had bought a substantial interest, tumbled. And there were only six international reply coupons—the paper upon which the entire operation supposedly was based—in Ponzi's possession.

Ponzi went to jail and, while there, received two votes for Massachusetts

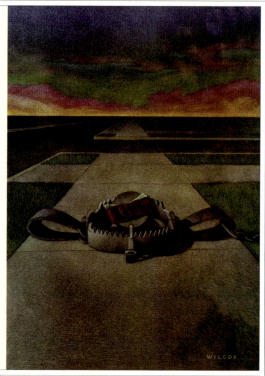

THE AMERICAN FASHION REVOLUTION
BY AMY-LYS

In 1776, America swiftly cut the family ties with Mother Britain. But somehow, when it came to the world of fashion, we were bound to Paris by a stronger cord. Like Portnoy's mother, French couturiers dictated to our emotions, not to reason. With a massive inferiority complex, American women believed that only a Frenchman, born and bred on wine and design, had that mystical sense called style. ☐ Now the transatlantic tables have turned. Absolutely American looks are conquering the world. Our rough, tough jeans are strolling down St. Germain, the Via Veneto, and around Trafalgar Square. Apache vests, bandanas, deer moccasins, and snappered shirts have all ridden out of the Wild West. The easy, breezy casualness of shirts, skirts, and scarves has replaced that "good little dress." Americana cross-the-prairies-in-covered-wagon calicos and patchwork quilting have wiggled their way into the Paris collections. And the biggest smash-bash of all: the star-spangled looks from hippies and "Hair." Flower children, on their little trips, handed out more than daffodils. They gave away pure, undiluted fashion. To name names: love beads, belts, chains, scarves, floppy hats, fringe, shawls, long skirts, long hair. ☐ *Freedom for Men:* The monochromes women are putting on are exactly what men are running from. Away from the monotony of day-in, year-out sameness in color, line and design. Bright and daring leisurewear broke the first barrier—and men had more leisure to wear and enjoy the new ideas. This one step started men thinking. In addition to the white shirt, men turned to deep, dark handsome colors—to blues, browns, yellows, lavenders. Shirts, slacks, rainwear, among others were liberated by wonder fibers for easy care and a fresh-forever look. And everything took shape. Shirts, suits, sweaters, sport coats—all nipped at the waist, slim, figure flattering. ☐ Men's fashion today is in a longer, wider, broader stage, says the Men's Fashion Association. Ties fly wide, wider. Suit lapels go the same route. Jacket lengths add inches. And hats too, with wide, wide brims and higher crowns. Raincoats sneak to a midi length, as does the formal topcoat. Sweaters are below the waist. Walking suits with three-quarter length jackets will look great for Sunday strolls or a fine day at the races. The look is long, lean, youthful American. ☐ There's only a fine line between fun and overdone, show and show-off. And men's fashions have managed to walk the line. Plastic love beads never made it, but scarves with flair and color did. Turtlenecks for formal

Design: B. Martin Pedersen | **Top Art:** David Wilcox | **Bottom Photo:** Hiro | **Pg. 326:** Commentary

CLIENT: AMERICAN AIRLINES 37

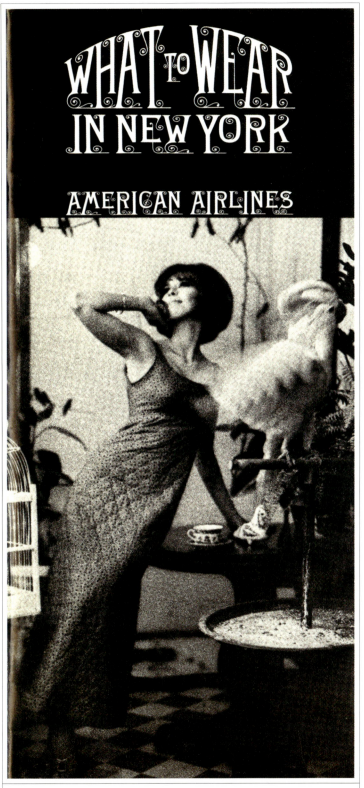

Design: B. Martin Pedersen | **Photo:** Stock
Pg. 326: Commentary

38 CLIENT: NORTHWEST ORIENT AIRLINES MAGAZINE

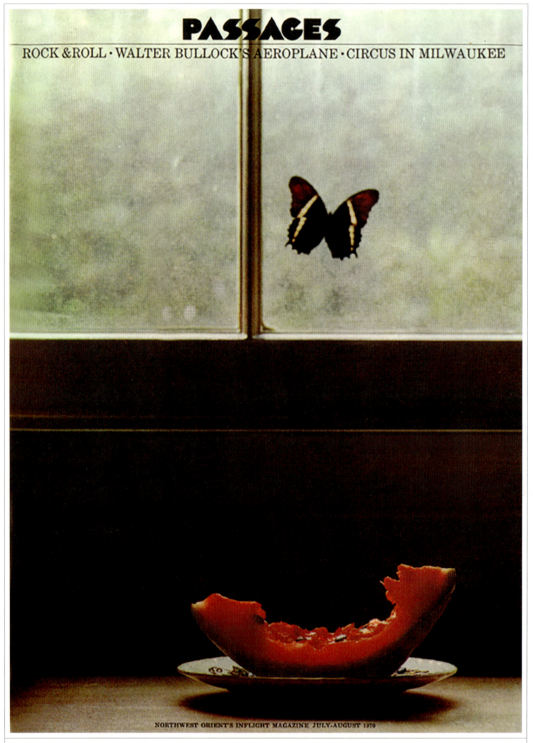

Design: B. Martin Pedersen | **Photo:** Shig Ikeda | **Pg. 326:** Commentary

CLIENT: NORTHWEST ORIENT AIRLINES MAGAZINE

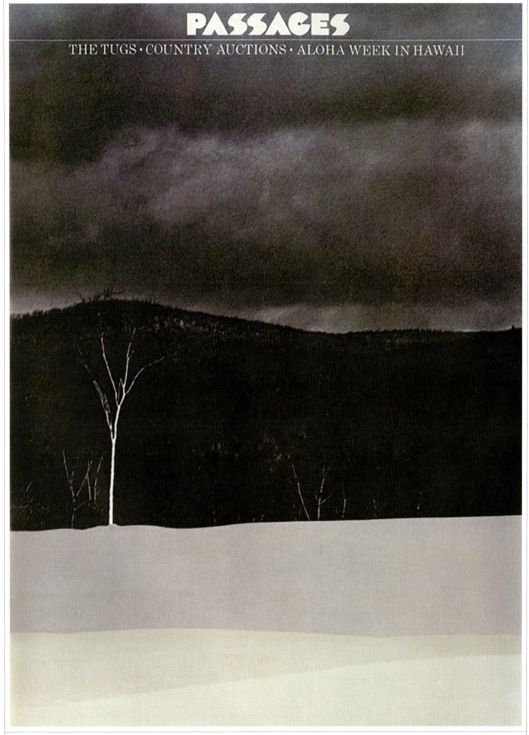

Design: B. Martin Pedersen | **Photo:** Jay Maisel | **Pg. 326:** Commentary

40 CLIENT: NORTHWEST ORIENT AIRLINES MAGAZINE

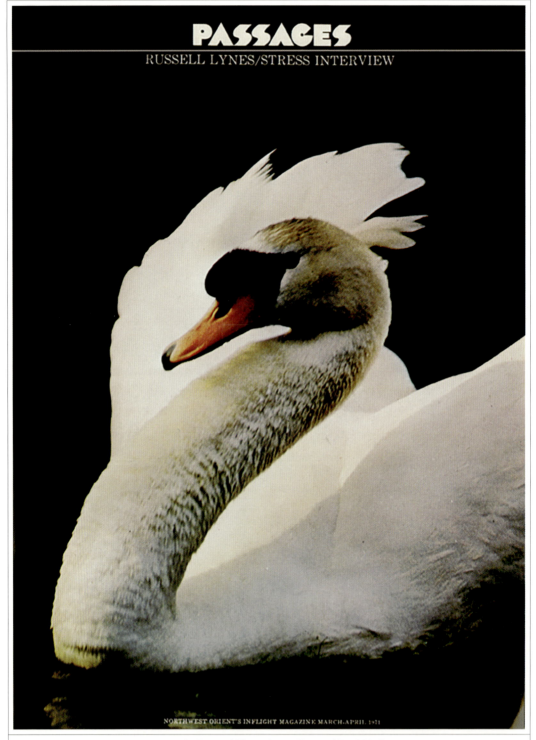

Design: B. Martin Pedersen | Photo: Steve Meyers | Pg. 326: Commentary

Design & Art: Dan McLain, B. Martin Pedersen | **Pg. 326:** Commentary

environment
information
ACCESS

DEC. 15, 1973

CLIENT: ENVIRONMENT INFORMATION ACCESS 43

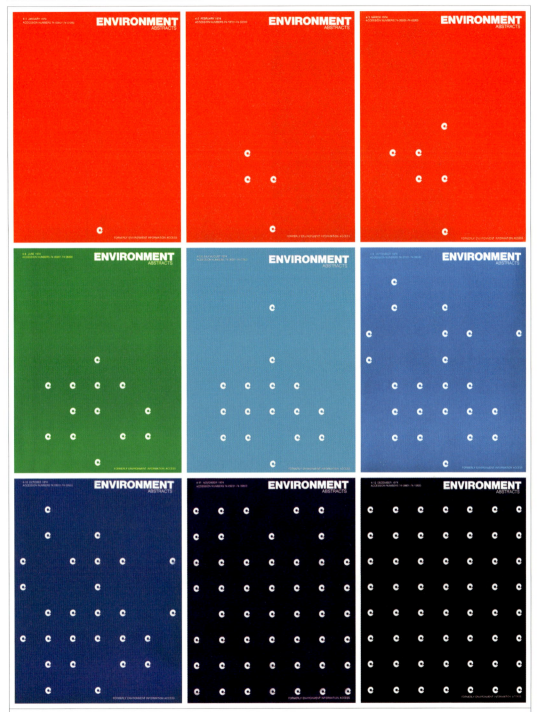

Design & Art: Dan McLain, B. Martin Pedersen | **Pg. 326:** Commentary

44 CLIENT: WEST POINT PEPPERELL

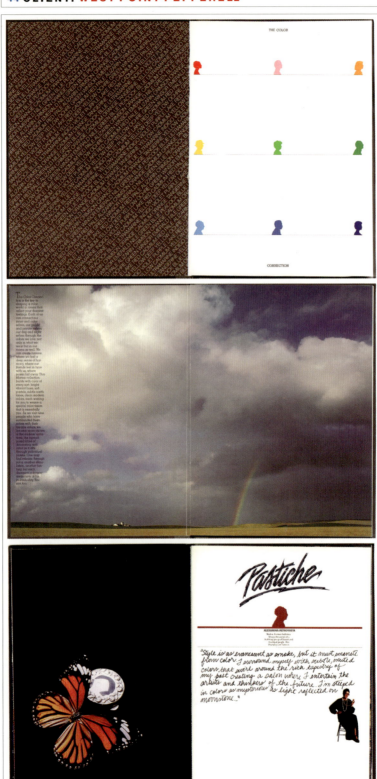

Design: B. Martin Pedersen | Photos: Armen Kachaturian | Pg. 327: Commentary

CLIENT: **WEST POINT PEPPERELL** 45

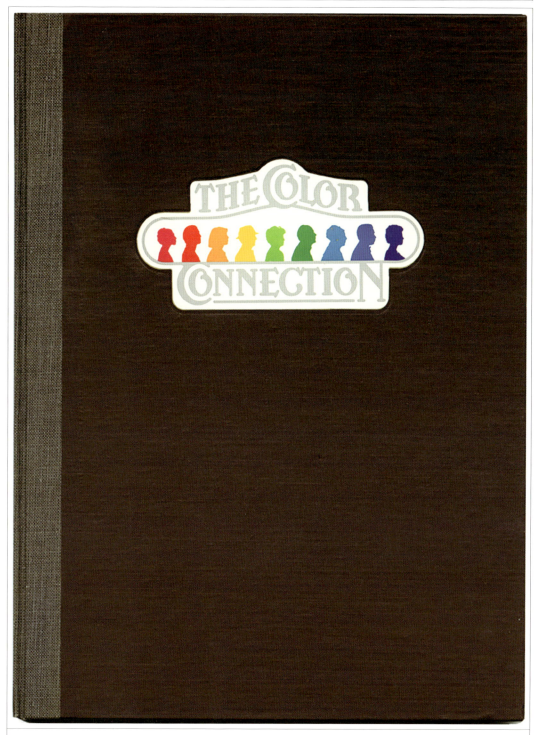

Design: B. Martin Pedersen | **Pg. 327:** Commentary

46 CLIENT: VOLKSWAGON OF AMERICA

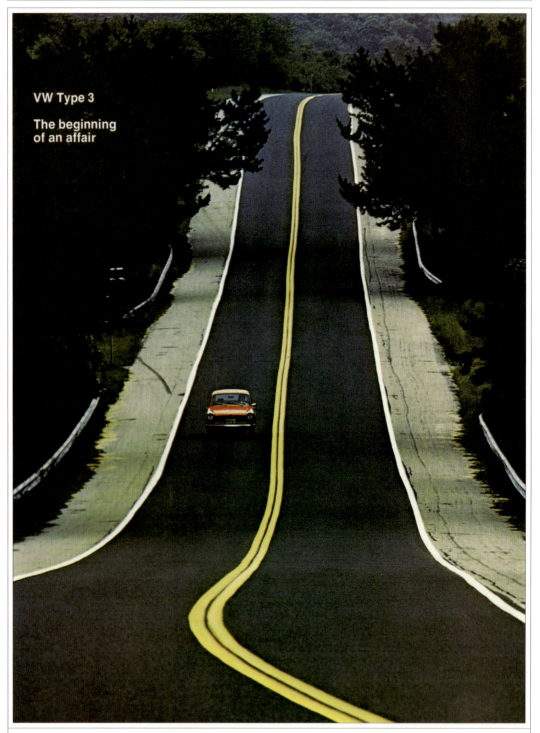

Design: B. Martin Pedersen | Photo: Pete Turner | Pg. 327: Commentary

PERSONAL: GPS PAPER SPECIFIER 47

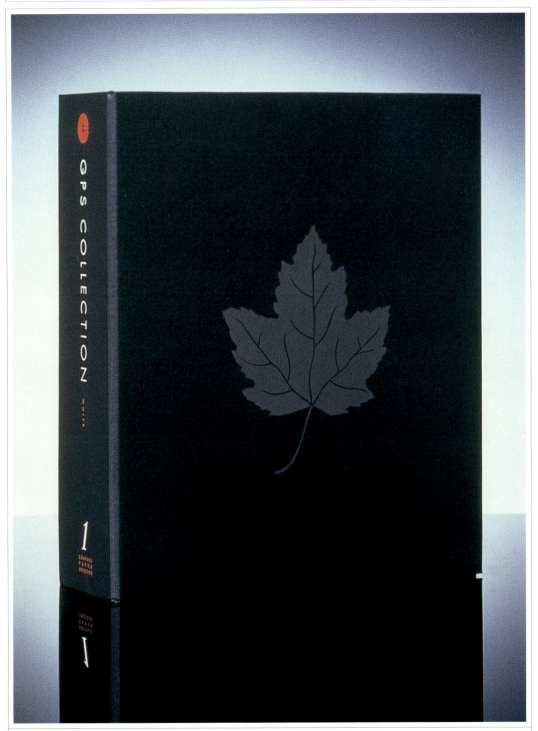

Design: B. Martin Pedersen | **Illustration:** Tracy Savin | **Pg. 327:** Commentary

48 PERSONAL: GPS PAPER SPECIFIER

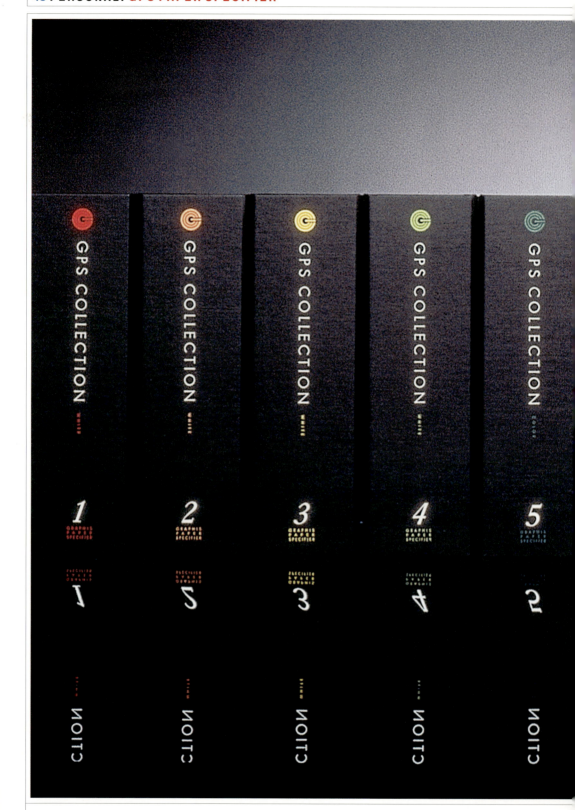

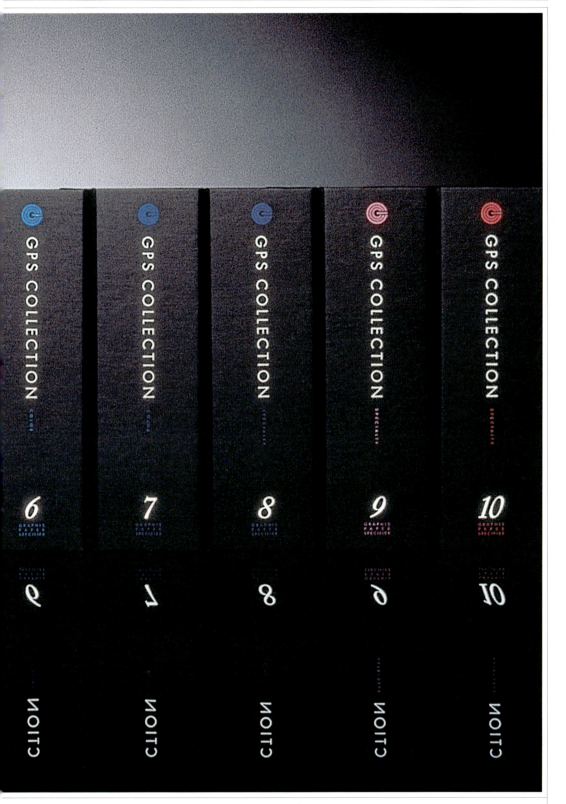

Design: B. Martin Pedersen | **Pg. 327:** Commentary

50 PERSONAL: GPS PAPER SPECIFIER

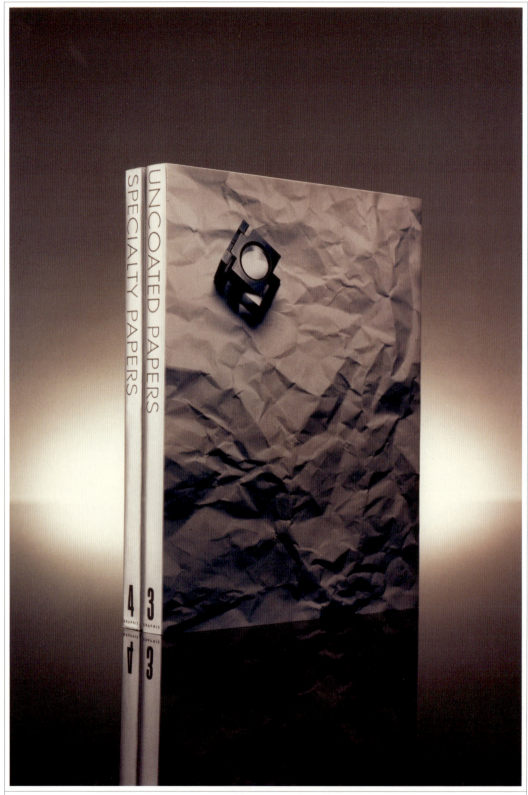

Design: B. Martin Pedersen | **Photo:** Phil Marco | **Pg. 327:** Commentary

PERSONAL: GPS PAPER SPECIFIER 51

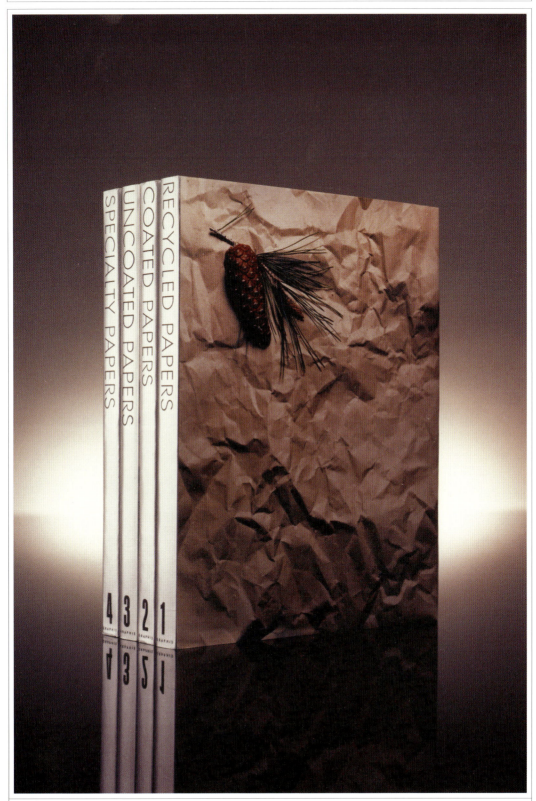

Design: B. Martin Pedersen | **Photo:** Phil Marco | **Pg. 327:** Commentary

52 CLIENT: VOLKSWAGON OF AMERICA

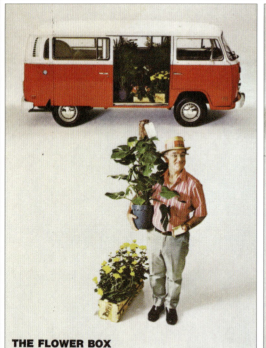

THE FLOWER BOX

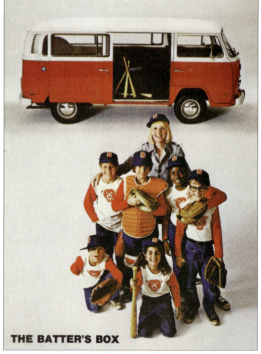

THE BATTER'S BOX

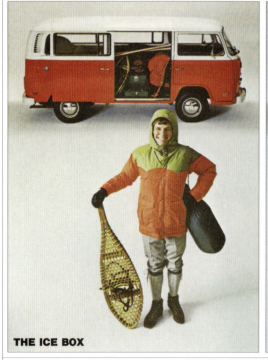

THE ICE BOX

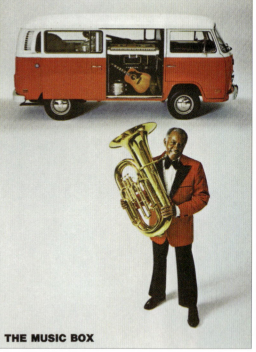

THE MUSIC BOX

Design: B. Martin Pedersen | **Photos:** Frank Moscati | **Pg. 327:** Commentary

CLIENT: VOLKSWAGON OF AMERICA 53

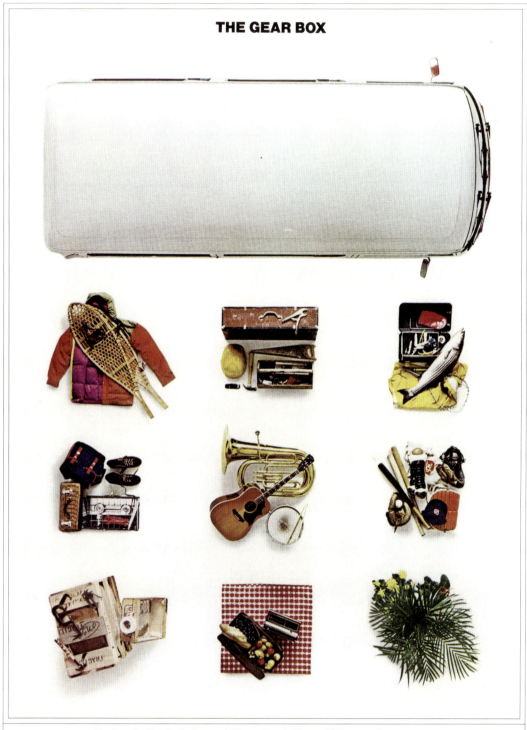

Design: B. Martin Pedersen | **Photo:** Frank Moscati | **Pg. 327:** Commentary

The New York Times Book Review

NOVEMBER 11, 1973 SECTION 7

Two by Lincoln Kirstein

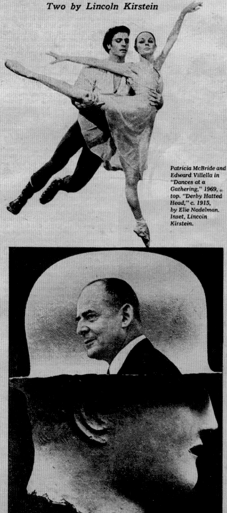

Patricia McBride and Edward Villella in "Dances at a Gathering," 1969, top. "Derby Hatted Head," c. 1915, by Elie Nadelman. Inset, Lincoln Kirstein.

The New York City Ballet

Text by Lincoln Kirstein. Photographs by Martha Swope and George Platt Lynes. 261 pp. New York: Alfred A. Knopf. $25.

By CLIVE BARNES

America is a land with singularly few well-established theatrical institutions. It grew up as a land with puritans rather than princes. Not only were there no court theaters, those precursors of present-day national theaters all over continental Europe, but the country's early puritan ethics, inherited from the dissident English, positively frowned on theatrical folly. Interestingly, England, suffering from that same lingering puritanism and from the indifference of princes, also failed to institutionalize and stabilize its theater.

Museums and art galleries, orchestras and even operas were of course respectable in America. After all, paintings and sculpture were possessions and music was either boring or at least had the grace to keep its distance from life. The theater was different. It could be supported as a popular, even somewhat wicked diversion, but the concept of a resident theater supported by patronage went against the grain. It is against this background that we must consider the achievement of Lincoln Kirstein and George Balanchine who, over the past 40 years, have founded, nurtured and developed the New York City Ballet, which today effortlessly takes its place among the great ballet companies and, for that matter, theatrical institutions of the world.

What is it that makes a man build a theater company rather than a business corporation, elect to lose a fortune rather than make or sustain one? Lincoln Kirstein was born in Boston, first-generation wealthy. The family owned a department store, and the world opened out to the Harvard-educated Kirstein as an attractive prospect for a gentleman stroller. He was one of the new Americans, post-Henry James, who invaded Europe in the twenties and thirties and even stormed Bloomsbury with a nervous diffidence.

Kirstein—who had already picked
Continued on Page 3

Clive Barnes is the dance and drama critic of The Times.

© 1973, The New York Times Co. All rights reserved.

Elie Nadelman

By Lincoln Kirstein. Illustrated. 360 pp. New York: The Eakins Press. $35 to Jan. 31, then $50.

By HILTON KRAMER

Lincoln Kirstein is well-known to the world at large as the founding director of the New York City Ballet, and he is also known to several smaller, overlapping specialized publics for his writings on dance, photography, painting, and sculpture, and for his book of poems, "Rhymes of a Pfc," which W. H. Auden characterized as "the most convincing, moving and impressive book" about World War II he had read. An early novel is known to an even tinier public, and those with unforgiving memories will recall that in his youth Mr. Kirstein also founded and edited The Hound and Horn, one of the best literary journals ever published in this country, which he sadly permitted to go out of business.

The sculpture of Elie Nadelman, though not as familiar as it should be, is nonetheless known to those who visit the permanent collection of the Museum of Modern Art, attend performances at the New York State Theater (where, thanks to Mr. Kirstein and the architect, Philip Johnson, two monumental Nadelman sculptures preside over the spacious promenade), or keep up with the dizzying gyrations of the auction market in which a version of Nadelman's "The Tango" recently brought a record-breaking price.

Yet despite the celebrity of both author and subject, it is no exaggeration to say that Mr. Kirstein's extraordinary new book on Nadelman is the work of an unknown author about the art of an unknown sculptor. For never before has Mr. Kirstein brought the full weight of his learning, his sensibility and his passion to bear on a first-rate art-historical subject, and never before have the scope and grandeur of Nadelman's artistic achievement been so fully and eloquently illuminated. With this book
—Continued on Page 2

Hilton Kramer, art news editor of The Times, is the author of "The Age of the Avant-Garde: An Art Chronicle of 1956-1972," to be published next month.

CLIENT: SCHOOL OF VISUAL ARTS

VISUAL ARTS GALLERY ANNOUNCES ITS FORTHCOMING EXHIBITION

THE MALE NUDE

JOHN BUTTON · PHILIP PEARLSTEIN · ALICE NEEL · LOWELL NESBITT · GEORGE SCHNEEMAN · SYLVIA SLEIGH · MARJORIE STRIDER

Guest Director for this exhibition is John Perreault.

Gallery Hours: Monday through Thursday: 10:00 AM to 5:00 PM and 6:00 PM to 9:00 PM. Friday: 10:00 AM to 4:00 PM. Closed Saturday and Sunday and February 19.

Dates: February 14 through March 12, 1973.

Preview: Wednesday, February 14, 1973, 5:30 to 7:30 PM.

VISUAL ARTS GALLERY / 209 EAST 23 STREET, NEW YORK, NEW YORK

DESIGN BY B. MARTIN PEDERSEN

Design & Art: B. Martin Pedersen | **Pg. 327:** Commentary

56 CLIENT: SCHOOL OF VISUAL ARTS

9:00 PM. Friday; 10:00 AM to 4:00 PM. Closed Saturdays and Sundays

American-Type Sculpture: Part 1

ssaw March 20 April 13 Guest Director Phyllis Tuchman

Design & Art: B. Martin Pedersen | **Pg. 327:** Commentary

58 CLIENT: AMERICAN INSTITUTE OF GRAPHIC ARTS (AIGA)

Design & Photo: B. Martin Pedersen | **Pg. 327:** Commentary

$.75

SPORTS CAR

MARCH 1973

u.s. formula f: a look back, a look ahead
BRITISH FORMULA FORD
GOING RACING GET STARTED RIGHT
PLAYBOY SWINGIN' SAFARI

3 30

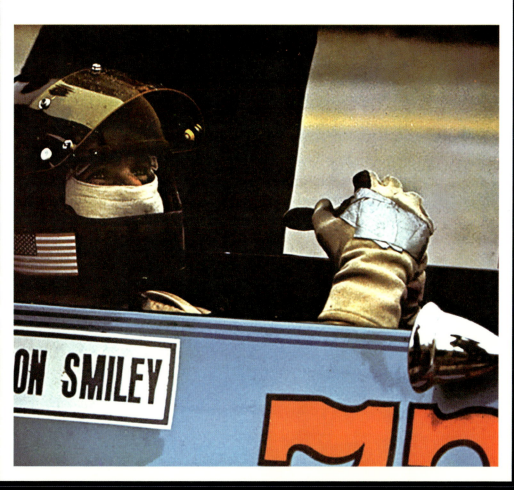

60 CLIENT: SPORTS CAR CLUB OF AMERICA

$.75

SPORTS CAR

MARCH 1972

No 3 Vol 30

my life with porsche

A LOOK AT THE CAN-AM SERIES
RACING IS BOTH A BUSINESS AND A SPORT
TWO-FIVE CHALLENGE
"VEGAS 72"

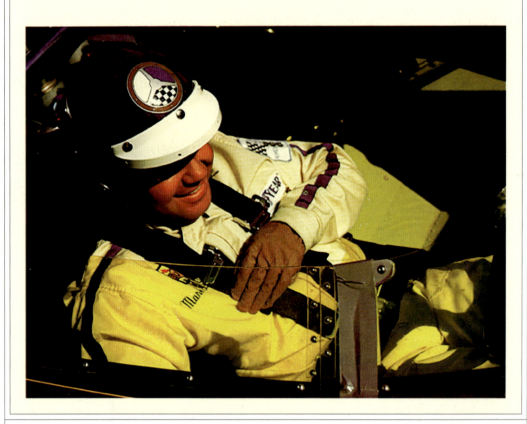

Design & Photo: B. Martin Pedersen | In the Photo: Mark Donahue | Pg. 327: Commentary

At the Races:
Bridgehampton, New York
1972–1973

62 CLIENT: SPORTS CAR CLUB OF AMERICA

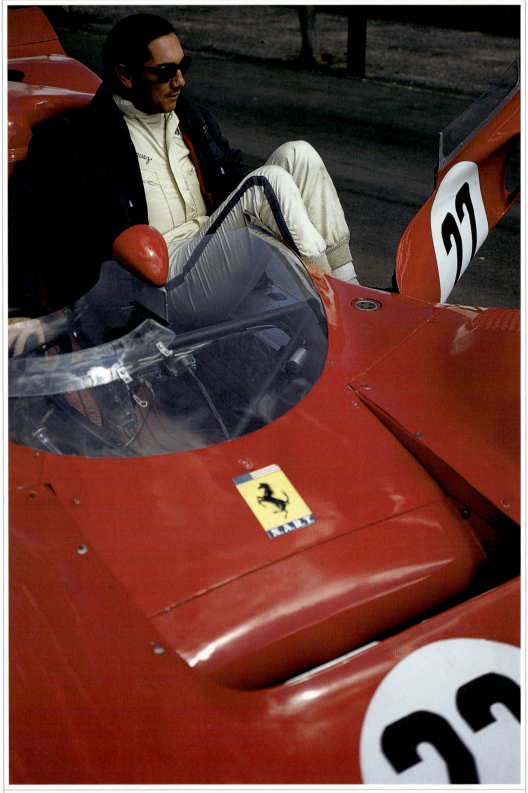

Photo: B. Martin Pedersen | In the Photo: Pedro Rodríguez | Pg. 327: Commentary

CLIENT: SPORTS CAR CLUB OF AMERICA 63

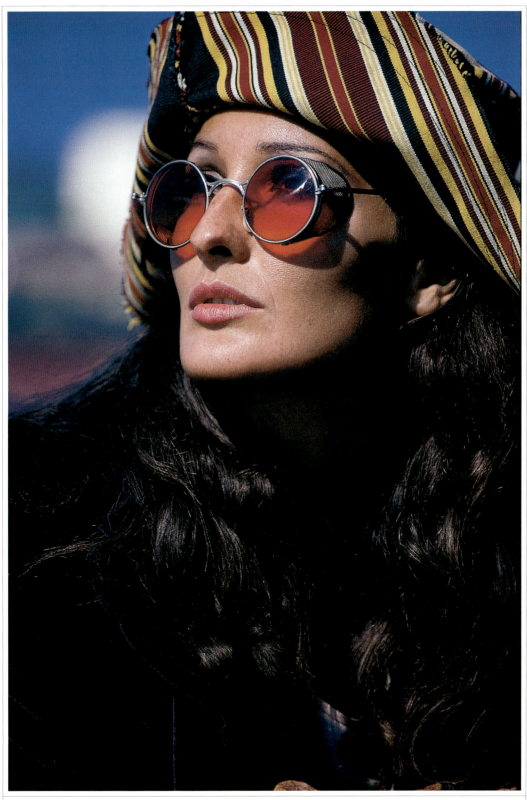

Photo: B. Martin Pedersen/Race Spectator | **Pg. 327:** Commentary

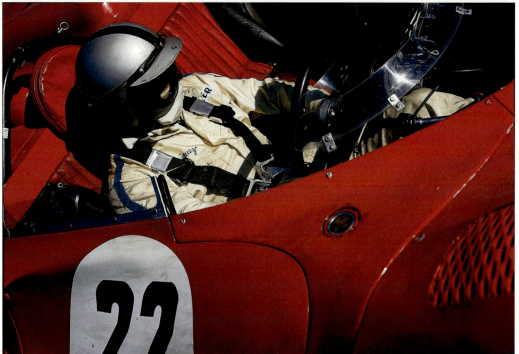

Photos: B. Martin Pedersen | Bottom Photo: Pedro Rodríguez | Pg. 327: Commentary

CLIENT: SPORTS CAR CLUB OF AMERICA 65

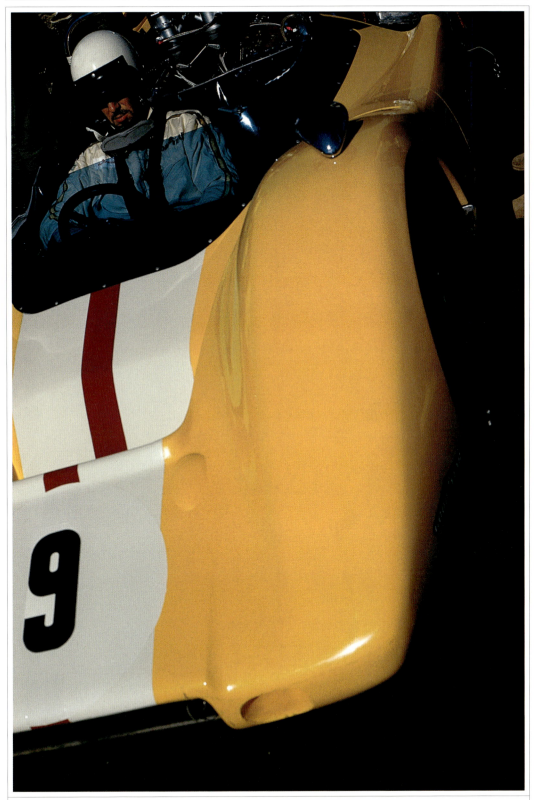

Photo: B. Martin Pedersen | **Pg. 327:** Commentary

66 CLIENT: EASTERN AIRLINES

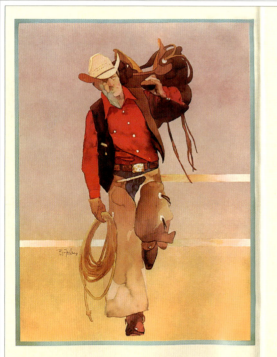

RODEO
Contest and Spectacle
BY WILLIAM DECKER

The first recorded formal rodeo was held on the main street of Pecos, Texas, in 1883 when the merchants there invited nearby cowboys to come to town and help celebrate the Fourth of July by holding a contest. Today there are more rodeos, with more prize money offered, in Texas than any other state of the Union, and they are held the year around. I saw my first rodeo in Texas a good many years ago and since then I've competed in them, judged them, announced them, written about them, and tried to explain them to people. As a sport and a spectacle rodeo is hard to beat, but it helps if you know what to watch for. Here is what the main events look like to the contestants and the judges.

SADDLE BRONC RIDING
This event tests the skill that a working cowboy requires in breaking range-bred horses which run loose until they are fully grown and are ready to be put to work. Unlike horses that are raised in paddocks and pens and handled by men from birth, the range-bred horse is the next thing to wild and the first few saddlings are often explosive. (In the rodeo arena the horse is given all of the advantages.) The rider can only use one rein. He may not touch any part of the horse or equipment with his free hand and he cannot change hands on the rein.

You may see a cowboy stay on for the entire ride (either eight or ten seconds depending on the size of the arena) but hear the announcer say that he did not receive any points from the judges. This means that he was disqualified because he either had a foot come out of a stirrup, or did not "start" the horse properly. The rules are quite specific regarding the latter. On the first jump out of the chutes the rider has to keep his feet up in front of the horse's shoulders so he is not hanging on with his spurs. The bronc has to be free to get clear of the chutes and get

> Today there are more rodeos, with more prize money offered, in Texas than any other state of the Union.

into action before the cowboy can begin to get into rhythm with him. Once the horse is out of the chute, watch how the rider tries to set up his timing. As the horse dives forward the rider leans back so when the horse's front feet hit the ground the rider's feet are in front to receive the shock of the landing. As the horse gathers his legs under for another leap the rider swings his feet back, sometimes all the way to the cantle of the saddle, and then swings them forward as the horse starts upward.

Rhythm and timing are everything in a saddle bronc ride. If you look closely, you will see that some horses wait until their front feet touch the ground and then kick straight up with their hind legs. This sends a jolt under the saddle which follows the jar of the landing. Some horses spin and others twist their bodies while they are airborne, some come to earth with all four feet together directly under their bodies and others land spraddle-legged. You can't hope to hold yourself on by strength. If you try by taking a short grip on the rein the bronc can easily tuck his head down and pull you right out of the saddle. The secret lies in catching the horse's rhythm and getting in step with him. The two judges watch closely for

> The young men who travel the circuit today are athletes who usually specialize in certain events.

mistakes and for style. They score the horse on how hard he bucked and the rider on how well he rode. The cowboy's score is the total of the two, and that is why the contestants always hope to draw the best buckers. No matter how well you ride an easy horse it is hard to win on him. Behind the chutes you will hear one cowboy who has drawn a horse he has never ridden before ask another who knows the horse what he can expect. The answer will sound something like this:

"He's a sly old thing. Likes to try to wipe you off on the gate coming out, but he hates iron so if you hang that outside spur in his shoulder he'll turn away from it. He doesn't use much ground. Tries to get the job done right there in front of the chutes and he's got more action than a hay baler. If you stay with him the first couple of jumps watch for him to suck back and drop a shoulder and go to spinning. Likes to go clockwise. I got him good with my right spur one time and missed him with my left just about the time he ducked out from under me."

BAREBACK BRONC RIDING
This event doesn't have a place in the working cowboy's routine. It was invented for him. Here the rider has to depend upon strength as well as balance because he doesn't have a saddle or rein to depend on, only a surcingle with a handle to hang on to. Since the horse's head is entirely free bareback broncs tend to gyrate more frantically than the saddle broncs and they are usually smaller, more agile horses. The same rules apply and the same scoring system is used as in the saddle bronc event. If you watch, you will be able sometimes to catch the rider kicking his feet higher than his head as he leans back to balance better. The more actively he spurs the higher his score will be. For this event they used to say you needed a grip tighter than a Pullman window, but nowadays the cowboys

Continued on page 19

7

Pastimes March/April 1974

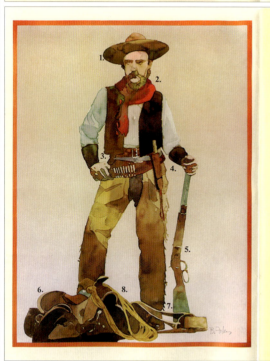

1. Texas Hat The hat was one of the most important parts of cowboy dress, and it was prized for its beauty as well as its usefulness. A typical old-time hat was made of soft, smooth felt, usually dove gray in color. Its crown stood seven inches high. If a cowboy needed to fan a campfire or carry water, he would probably use his trusted hat; at night he might use it for a pillow. The Texas cowboy would rarely take his hat off. But if he wanted to be friendly to a new acquaintance he might sweep it off his head for a brief instant, thereby taking his right hand away from the vicinity of his gun. This showed that the cowboy's intentions were good.

2. Bandana The bandana, originally manufactured exclusively for Southern Black women, was adapted by the cowboy, and in time it became almost his symbol. This handkerchief was folded diagonally to bring the two widely separated corners together, and tied in a square knot around the cowboy's neck. The triangular part that hung loose in the front could be pulled up over the nose and mouth like a mask, affording protection from dust while the cowboy rode behind a herd of cattle. Old-time cowboys never wore white bandanas as they reflected light and could be seen at great distances; red was the standard color.

3. Buckskin Vest Cowboys always wore vests. This was justified by the storage room they provided (what a handy place to keep cigarettes while riding on horseback). Often a little round "bull" sign could be seen dangling from a vest pocket; this was a symbol of fraternity amongst the cowhands. For dances and celebrations cowboys had an extra vest, an ornate masterpiece of dyed wool with plenty of color. But the standard everyday vest was of buckskin—the soft, tough, yellowish leather made from the skin of a deer.

4. Work Knife Knife fighting was looked down upon by cowboys. It was considered "a greaser's way of fighting." A knife fight might end in an hour with both partners sustaining serious injuries; the gun was a much quicker, cleaner way to settle an argument. The cowboy discarded his knife after Indian troubles were over, and rarely carried one unless hunting.

5. Carbine A gun with a barrel much shorter than that of a standard rifle is known as a carbine. The cowboy used it while on horseback; its small size made it easier to fire while riding. He carried it in a quiver-shaped, open-mouthed leather sheath (scabbard).

6. Saddle The cowboy's saddle was his workbench. A seat of leather with a high horn and cantle (back of seat), it was secured to a horse's back to support a rider. Saddles were heavy, perhaps forty pounds; anything lighter would be torn to pieces while the cowboy roped steers and horses. Fashioned after the Arabian-style saddle ridden by Spanish conquerors of the old West, the cowboy saddle was further developed by the cow trade, and today it is like no other saddle in the world.

7. Boots Cowboy boots were always ornate, yet extremely practical. The high, undercut heels kept the cowboy's feet from slipping through the stirrups if he was thrown while riding his horse. Because boot tops were high the cowboy never had to worry about injury from thorns, brush, or snake bite. Fancy stitching helped stiffen the leather. Cowboys were rather vain characters, and they usually wore their boots a size too small for comfort. Small feet were important for a cowboy's image.

8. Lariat A lariat was a cowboy's rope. As a hunter is helpless without his gun, so too was a cowboy without his lariat. In the old days it was used to lasso wild as well as domestic animals. An excellent cowboy in those days was known as "una buena reata," Mexican for "a good rope." This signified the importance of the lariat.

9

Pastimes March/April 1974

Design: B. Martin Pedersen, Louise Fili | **Art:** Bart Forbes | **Pg. 327:** Commentary

CLIENT: EASTERN AIRLINES

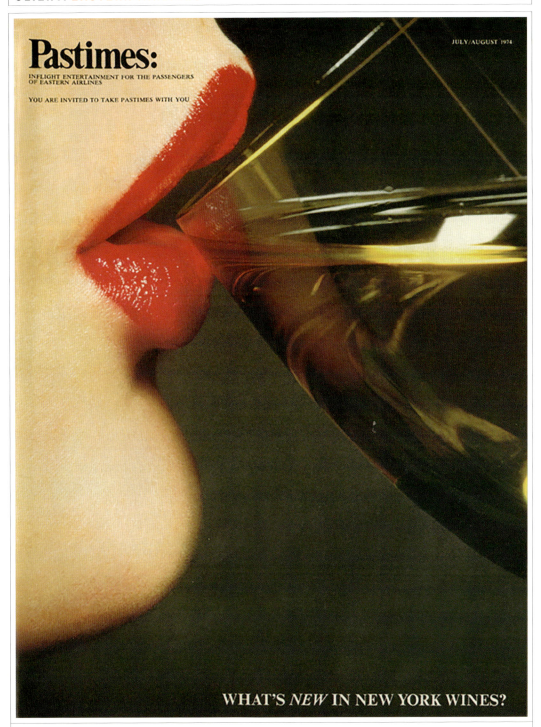

Design: B. Martin Pedersen, Louise Fili | Photo: Pat Field | Pg. 327: Commentary

68 CLIENT: **EASTERN AIRLINES**

Design: B. Martin Pedersen, Louise Fili | Photo: Stock | Pg. 327: Commentary

CLIENT: EASTERN AIRLINES 69

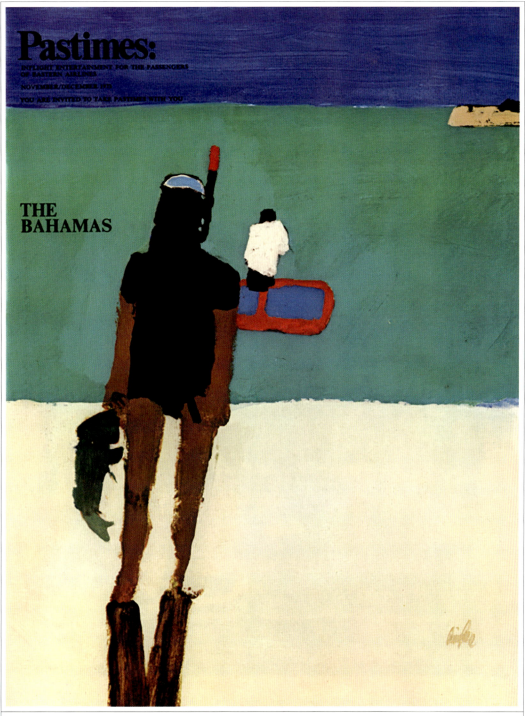

Design: B. Martin Pedersen, Louise Fili | **Art:** Robert M. Cunningham | **Pg. 327:** Commentary

70 CLIENT: **EASTERN AIRLINES**

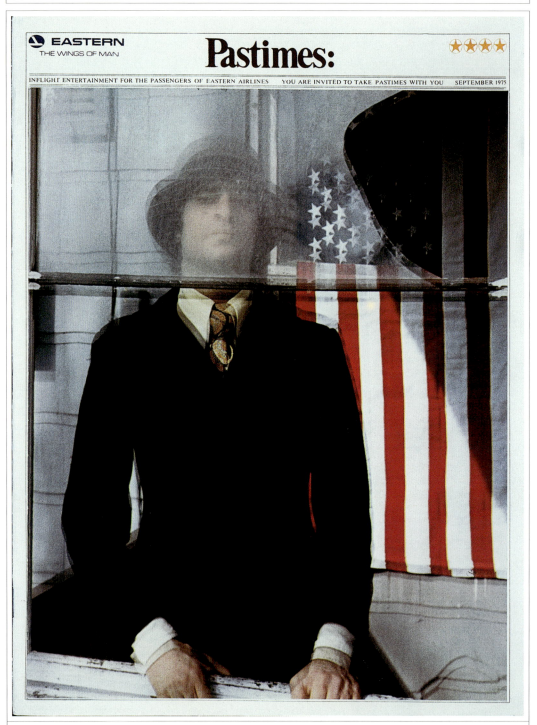

Design: B. Martin Pedersen, Louise Fili | **Photo:** Unknown | **Pg. 327:** Commentary

CLIENT: EASTERN AIRLINES 71

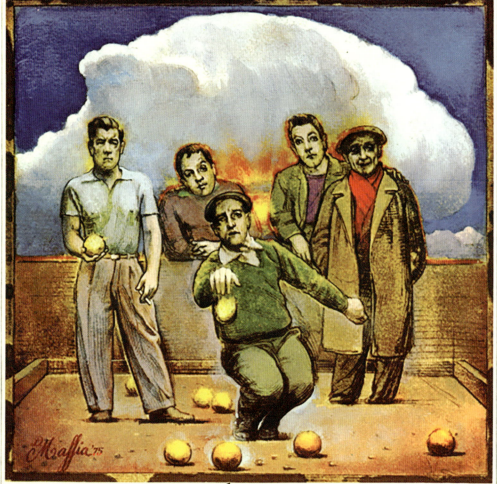

Design: B. Martin Pedersen, Louise Fili | Art: Daniel Maffia | Pg. 327: Commentary

72 CLIENT: COMBUSTION ENGINEERING, INC.

[C-E NATCO]
The Engineer as a Problem Solver

"This job is rush! We need to get on production quick. From here on out, every day we wait will cost our Offshore Group considerable money in lost oil and gas sales from our Block 330 Field," stated James Kates, district manager for the Pennzoil Company, whose area of responsibility included a number of tracts in the Gulf of Mexico.

The Block 330 Field was leased by a number of companies known as the POGO (Pennzoil Offshore Gas Operations) Group. Pennzoil is the designated "operator" and the other companies include Mobil, Exxon, Mesa and Texas Producing.

Kates had made the rush phone call to Robert W. Coggins, vice president of engineering, C-E Natco, a division of the Process Equipment Group. Founded in 1925, Natco specializes in designing equipment and systems that process crude oil and natural gas at the wellhead, removing contaminants such as sand, corrosive fluids and salt water, and segregating petroleum fluids so that the crude oil and raw natural gas are in stable, saleable form. Natco's world is one of highly specialized processes such as vapor dehydration, pressure-stage stabilization, high pressure fluids separation, oil desalting, acid gas stripping, and electrostatic emulsion breaking and disengagement.

A typical engineer in the oil industry has a degree in mechanical or petroleum engineering, or geology. Coggins is an electrical engineer, with a B.S. from the University of Illinois, having joined Natco in 1949, shortly after graduation. "My electrical engineering degree is anything but offbeat," says Coggins. "It has given me a significant advantage, in that I have a better understanding of the electrical requirements of a system, as well as the instrumentation and automation. This is particularly helpful in designing systems that must run unattended for periods of time such as in the Gulf of Mexico and other offshore areas."

Eugene Island Block 330 was leased by the POGO Group back in 1970. By March 1972, when Kates put through his rush call, three drilling platforms had been erected. Oil and gas had been discovered. Plans called for Pennzoil eventually to complete 90 or more wells from the three drilling platforms.

It proved to be a highly complex field with eight different products being produced, including high and low pressure oil and associated gas, gas well gas, and condensate flash gas. According to Coggins, "This is roughly like juggling apples and oranges, as well as pears and plums—keeping track of all things simultaneously and in varying amounts. Several different fluids would be flowing from the ground under different pressures and at different rates. Moreover, the quantities and pressures would change

"Production process plans and equipment would have to take into account the field as it was now, and how it was likely to be in 10, 20, and 30 years."

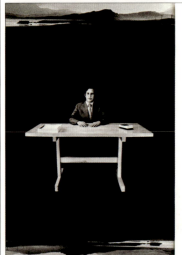

[POWER SYSTEMS GROUP, FOSSIL POWER SYSTEMS]
The Engineer as Administrator

Some job changes, more than anything are tests of a man's versatility. For example, Bill Clayton's promotion last March presented him with one of the most fundamental challenges an engineer can face—the move from the laboratory into an administrative "line" job. Previously, Clayton had been director of product development for C-E Fossil Power Systems, with the responsibility for development of new products. His new position as director of project management and field services calls for him to coordinate all the different groups within engineering to fulfill a contract. Clayton is the main interface between the client and engineering.

Indicative of the complexities of his new level of responsibility is the mail that he now receives. On a typical day recently it included the following:

An analysis of competitive bidding on a contract
A one-page summary of a problem that had developed on another contract
His weekly report on his managers
A summary of a shipment problem
A status report on drum plate coming from a major supplier
A paper on how to prevent boilers from freezing ("It can be a problem, believe it or not.")
Finally, a suggested outline for the keynote address he was to deliver the next week to 15 new service engineers just starting their two-week training program.

That last item gave Bill pause for about five minutes' worth of nostalgia. For it was just 20 years ago that he himself was a trainee service engineer with C-E. It was his first job after Army service.

"They're about the same today as we were then—young, single, and willing to live anyplace for a while," he says. "Naturally, after a couple of years they get married and the turnover is high. I wonder what I should tell them."

Despite his two decades with C-E, William H. Clayton, Jr. doesn't look much older than the trainees. There is no gray in his close haircut and few lines in his face. He looks so much the youthful American engineer that it's surprising to learn his background is quite cosmopolitan.

In his early years, he moved back and forth from South America to the United States, as his father would serve three years abroad, then three years at the W. R. Grace home office in New

The move from the laboratory into an administrative "line" job is one of the most fundamental challenges an engineer can face.

Engineering—a Profession in Transition

For years, pundits have been predicting that engineers would assume a greater role in running the economy. The influence of engineers has indeed been growing, but lately, the pace has accelerated—with important implications. Historically, engineers are involved in the design and manufacture of the millions of products and processes that make up our society. But now, as companies are becoming more complex and technologically oriented, engineers are being called on to manage the entire enterprise as well. One result is that more engineers are seeking graduate degrees in business administration. In 1969, only about 2% of all engineers in the United States held M.B.A.'s. This year, Harvard University stated that 22% of its M.B.A. candidates held bachelor's degrees in engineering. In fact, engineering appears to be the "single largest undergraduate major indicated."

The Graduate Division of the Wharton School at the University of Pennsylvania noted that 20% of its current class have "engineering or physical science backgrounds."

George Dinas, associate director of placement services at the New York University Graduate School of Business Administration, observes that many major corporations prefer a technical undergraduate degree for their M.B.A. recruits and will "pay premium for it as well." He explained that, "one of the key ingredients of an engineer is his appreciation of technological and manufacturing processes," which, when combined with skills in business administration, provides an "excellent groundwork for executive talent" and increases the individual's value to the company since the modern executive needs a broader scope of competence than ever before. The Wytmar Company of Chicago, which keeps tabs on all executive appointments in the country, indicated that 13% of all chief executive officers in the United States have a technical background.

A graduate degree in business can open the way to the executive suite, but, even without an M.B.A., the majority of engineers today exercise some kind of managerial responsibility.

Charts A and B (see page 9) indicate the extent to which engineers assume managerial duties throughout their careers. The young engineer performs largely technical duties, but as the age level increases, managerial duties expand rapidly and "the percentage of engineers in general management increases steadily from 2% at the start to 17% at retirement age. By the time engineers are 40, two-thirds or more will have taken on managerial or supervisory duties of an increasingly responsible nature." The Engineers Joint Council, therefore, believes that, "the gradual transition from technical to managerial responsibilities is something that more engineers should recognize as a normal pattern

More and more engineers are seeking graduate degrees in business administration.

Design & Photos: B. Martin Pedersen | Pg. 327: Commentary

CLIENT: COMBUSTION ENGINEERING, INC.

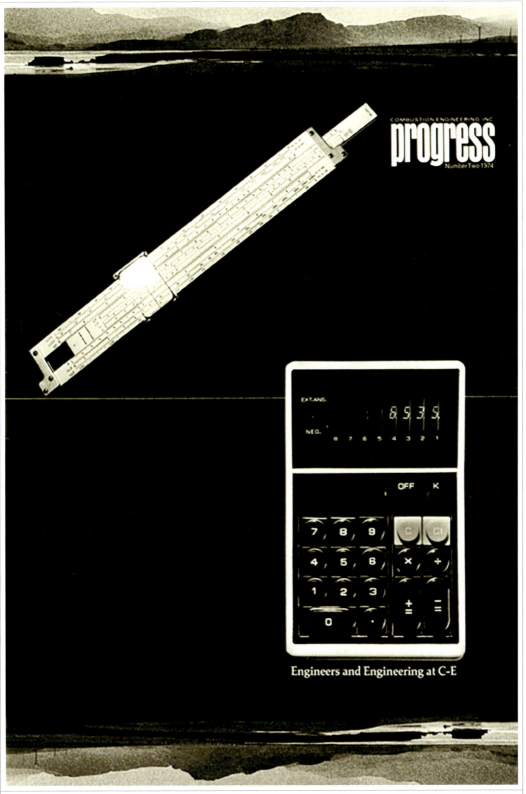

Design & Photo: B. Martin Pedersen | **Pg. 327:** Commentary

74 CLIENT: JONSON PEDERSEN HINRICHS & SHAKERY INC.

Top: Vance Jonson, B. Martin Pedersen | **Bottom:** Linda & Kit Hinrichs | **Photo:** Frank Moscati
Pg. 327: Commentary

CLIENT: JONSON PEDERSEN HINRICHS & SHAKERY INC.

Jonson Pedersen Hinrichs & Shakery Inc.
141 LEXINGTON AVE., NEW YORK, NEW YORK 10016. TELEPHONE 212·889-9611

NewYork&San Francisco

Design: B. Martin Pedersen | Pg. 327: Commentary

76 CLIENT: CITICORP

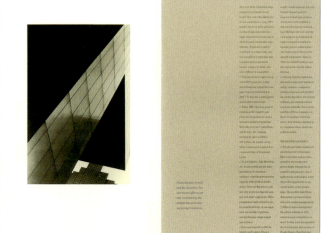

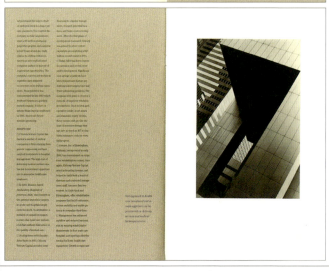

Design: Adrian Pulfer, B. Martin Pedersen | **Photos:** April Johnson
Pg. 328: Commentary

CLIENT: CITICORP 77

Design: Adrian Pulfer, B. Martin Pedersen | Photo: April Johnson | Pg. 328: Commentary

78 CLIENT: **NAUTICAL QUARTERLY MAGAZINE**

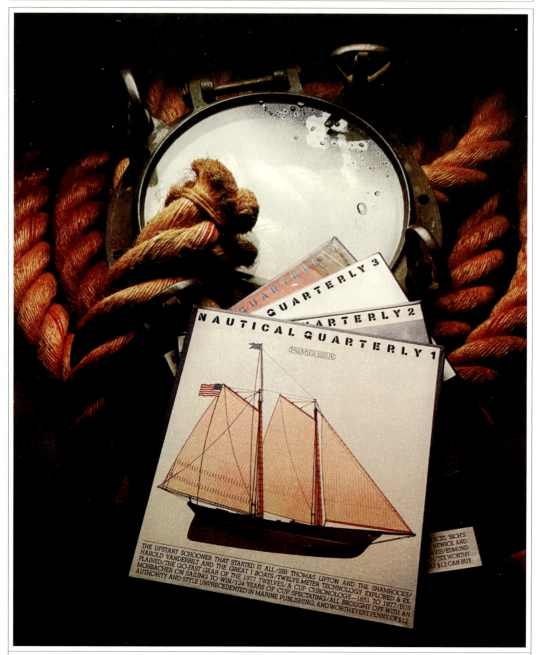

Design: B. Martin Pedersen | **Assistant Art Director:** Randell Pearson | **Photo:** Phil Marco | **Pg. 328:** Commentary

IT WAS AN ARISTOCRATIC BOAT BOOK IN A BLUE BLAZER, MINUS THE BRASS BUTTONS. **Kenny Wooton,** *Yachting Magazine, December 2012*

CLIENT: **NAUTICAL QUARTERLY MAGAZINE** 79

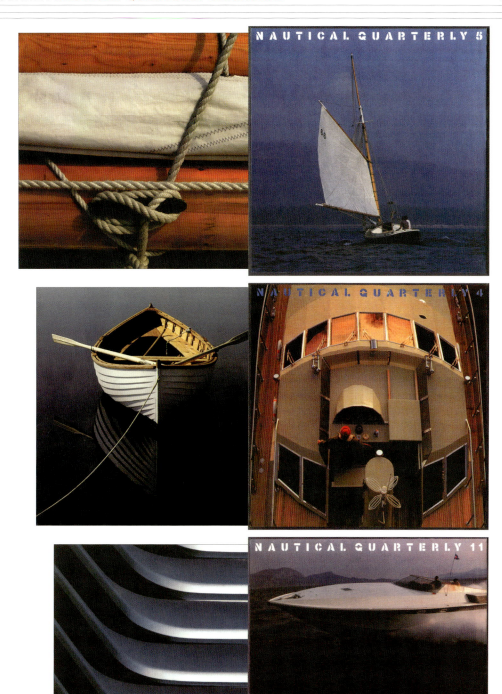

Design: B. Martin Pedersen | **Assistant Art Director:** Randell Pearson | **Photos:** Allan Weitz | **Pg. 328:** Commentary

80 CLIENT: NAUTICAL QUARTERLY MAGAZINE

Cruising is getting back to basics, even if you do it in a very elaborate boat. It's you and the weather and the water. The weather and the water take the edge off your city nerves and put an edge on your appetite. When that happens, it's appropriate to get back to basics in cruising cuisine by serving up some of the sea's free lunch. The three essays on the following pages investigate the possibilities of fresh seafood on most of the U.S. coastline. These possibilities are as old as the Indians, and the information presented here by three dedicated epicures of the coast may not be news to you. Consider it a reminder that some of the finest, freshest food you'll ever enjoy is under and around your boat this summer. It's free lunch, and it's free in every sense of the word.

FREE LUNCH

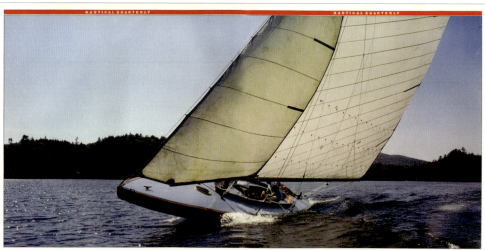

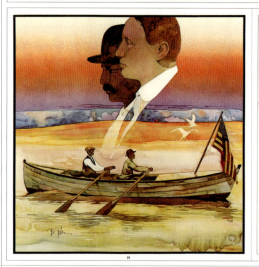

Back in the 1890s, a New York newspaper called the Police Gazette had a substantial readership and an editor-in-chief named Richard K. Fox. Successful in society as well as in business, Fox was fond of athletics and a man of romantic disposition with enough wisdom and energy to bring his conflicting natures constructively together in his work. He was a shrewd, creative editor, and he produced a lively and well rounded paper that attracted readers with illustrations of bosomy ladies aboard Columbia high-wheeler bicycles in addition to a sports paper's interest in the Welterweight prospects of Mysterious Billy Smith. ☐ Fox—who loved the sea and spent the better part of each summer in then-chic Long Branch, New Jersey—came up with the idea of offering a $10,000 Police Gazette prize to the first person or persons to row across the Atlantic without help from sail or mechanical power. ☐ Fox may not have considered the feat possible when he offered the prize. He certainly didn't know that it would be claimed by two of his Jersey shore neighbors.

TWO MEN, FOUR OARS, 3,390 MILES

BY DIANA JONES

Design: B. Martin Pedersen | **Assistant Art Director:** Randell Pearson | **Top Photo:** Phil Marco
Middle Photo: Allan Weitz | **Botton Art:** Bart Forbes | **Pg. 328:** Commentary

CLIENT: NAUTICAL QUARTERLY MAGAZINE

Design: B. Martin Pedersen | **Assistant Art Director:** Randell Pearson | **Photo:** Allan Weitz | **Pg. 328:** Commentary

82 CLIENT: NAUTICAL QUARTERLY MAGAZINE

Design: B. Martin Pedersen | **Assistant Art Director:** Randell Pearson | **Photo:** Ted Spiegel | **Pg. 328:** Commentary

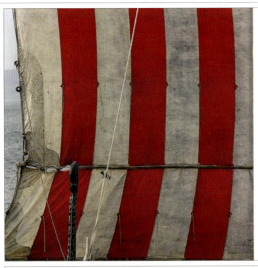

VIKING SHIPS

BY JOSEPH GRIBBINS

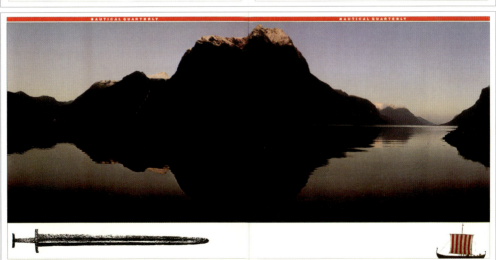

Design: B. Martin Pedersen | **Assistant Art Director:** Randell Pearson | **Photos:** Ted Spiegel
Pg. 328: Commentary

84 CLIENT: NAUTICAL QUARTERLY MAGAZINE

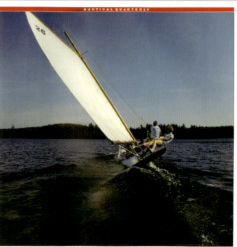
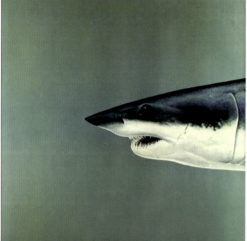

One would assume that the subject of sharks has been virtually exhausted, and that we now know as much as we need to know about these animals. We all know, for example, that sharks are "swimming noses," with an incredibly well-developed sense of smell which permits them to detect a single molecule of blood in the water from great distances; they then home in unerringly on the bleeding victim — whether fish or wounded swimmer — and attack with grisly efficiency. Everyone also knows that sharks have razor-sharp teeth and that they circle their intended victims, dorsal fin knifing through the water, before they attack. Sharks are also totally unpredictable, and they will attack a swimmer one day and ignore a potential meal the next. We also know that there are many species of sharks that are man-eaters, cruising menacingly offshore, just waiting to make a meal of an unwary swimmer. Furthermore, everyone is aware that all sharks need to keep moving to stay alive; that they never stop growing; that they are usually large and voracious creatures, so perfectly attuned and adapted to their environment that they have not changed in 300 million years. All of the foregoing assumptions are incorrect. ▲▲▲▲▲

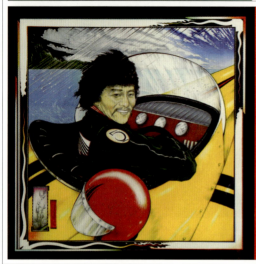

Design: B. Martin Pedersen | **Assistant Art Director:** Randell Pearson | **Top Photo:** Allan Weitz
Middle Art: Richard Ellis | **Bottom Art:** David Palladini | **Pg. 328:** Commentary

CLIENT: NAUTICAL QUARTERLY MAGAZINE 85

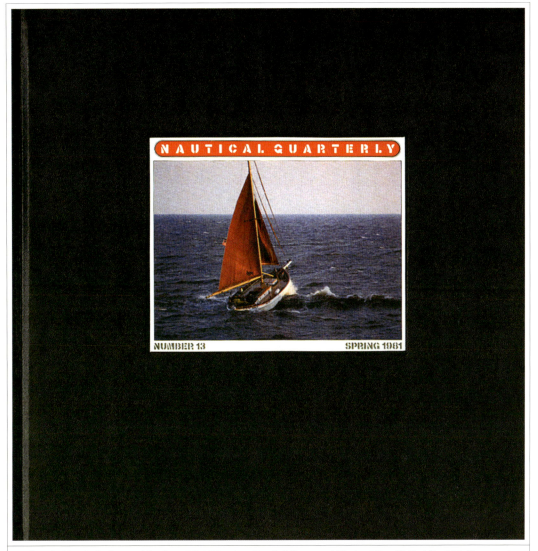

Design: B. Martin Pedersen | **Assistant Art Director:** Randell Pearson | **Photo:** Allan Weitz | **Pg. 328:** Commentary

86 CLIENT: NAUTICAL QUARTERLY MAGAZINE

Design: B. Martin Pedersen | Assistant Art Director: Randell Pearson | Photos: Alfred Parraga
Pg. 328: Commentary

CLIENT: NAUTICAL QUARTERLY MAGAZINE

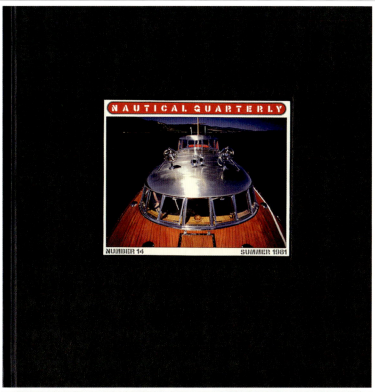

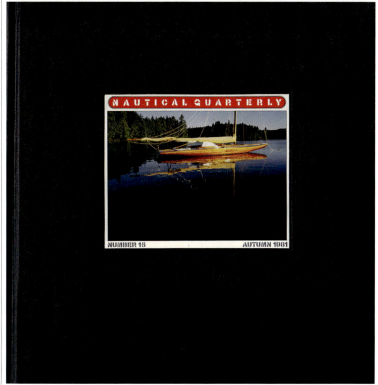

Design: B. Martin Pedersen | **Assistant Art Director:** Randell Pearson
Photos: Allan Weitz | **Pg. 328:** Commentary

88 CLIENT: NAUTICAL QUARTERLY MAGAZINE

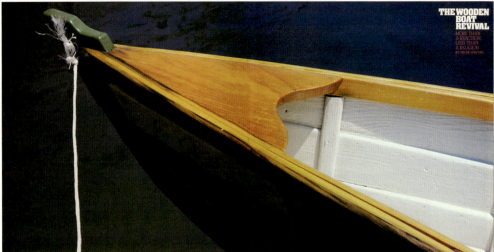

THE WOODEN BOAT REVIVAL
—MORE THAN A REACTION, LESS THAN A RELIGION
BY PETER SPECTRE

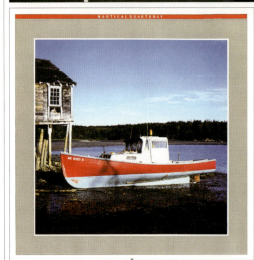
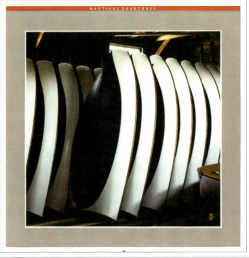

Design B. Martin Pedersen | **Assistant Art Director:** Randell Pearson | **Photos:** Allan Weitz
Pg. 328: Commentary

CLIENT: NAUTICAL QUARTERLY MAGAZINE 89

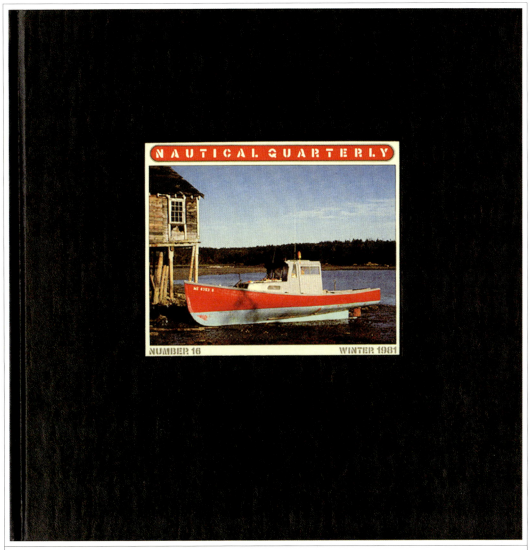

Design: B. Martin Pedersen | **Assistant Art Director:** Randell Pearson | **Photo:** Allan Weitz | **Pg. 328:** Commentary

THIS BELOVED MAGAZINE'S LITERARY LIFE WAS TOO SHORT, BUT ITS IMPACT IS STILL FELT TODAY. **Kenny Wooton,** *Yachting Magazine, December 2012*

90 CLIENT: NAUTICAL QUARTERLY MAGAZINE

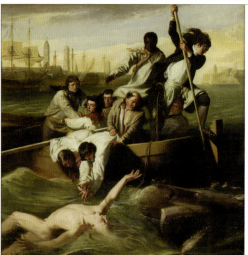

SHARKS
BY RICHARD ELLIS

WHAT WE KNOW, WHAT WE DON'T KNOW, WHAT WE ONLY THINK WE KNOW...

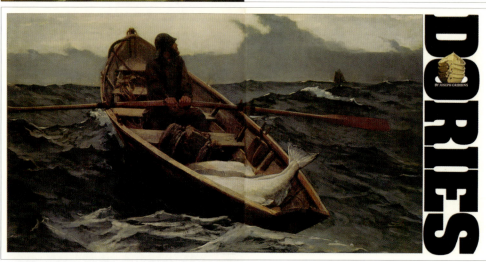

DORIES
BY JOSEPH GRIBBINS

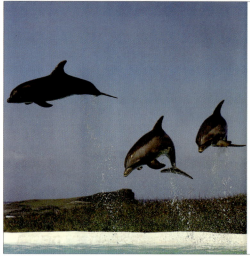

DOLPHINS
BY RICHARD ELLIS

Design: B. Martin Pedersen | **Assistant Art Director:** Randell Pearson | **Top Art:** John Singleton Copley
Middle Art: Winslow Homer | **Bottom Photo:** Unknown | **Pg. 328:** Commentary

CLIENT: NAUTICAL QUARTERLY PROMOTION POSTER

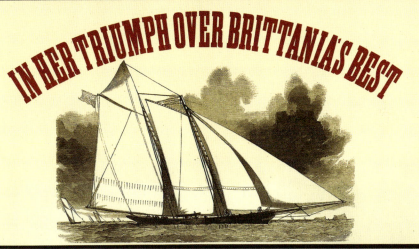

Design: B. Martin Pedersen | Pg. 328: Commentary

92 CLIENT: MUPPETS (JIM HENSON & ROBERTA JIMENEZ)

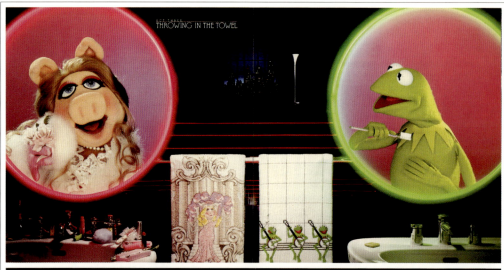
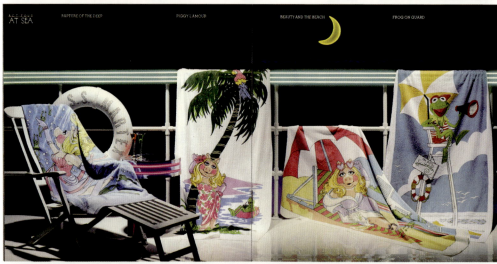

Design: B. Martin Pedersen | Photos: Armen Kachaturian | Pg. 328: Commentary

CLIENT: MUPPETS (JIM HENSON & ROBERTA JIMENEZ)

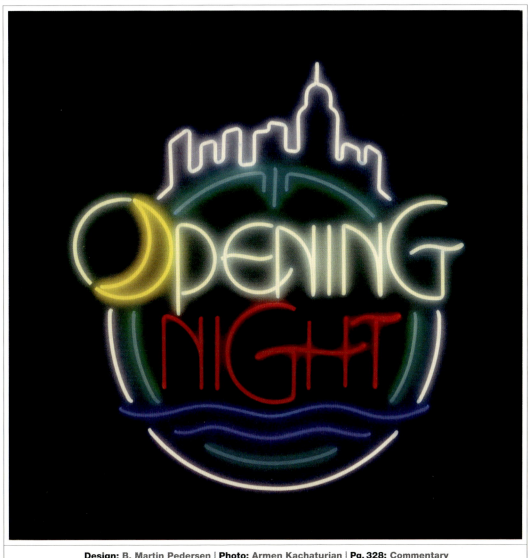

Design: B. Martin Pedersen | **Photo:** Armen Kachaturian | **Pg. 328:** Commentary

MISS PIGGY: IMPOSSIBLE TO WORK WITH. HOWEVER, KERMIT WAS A GENTLEMAN.

B. Martin Pedersen, *Designer*

94 CLIENT: MUPPETS (JIM HENSON & ROBERTA JIMENEZ)

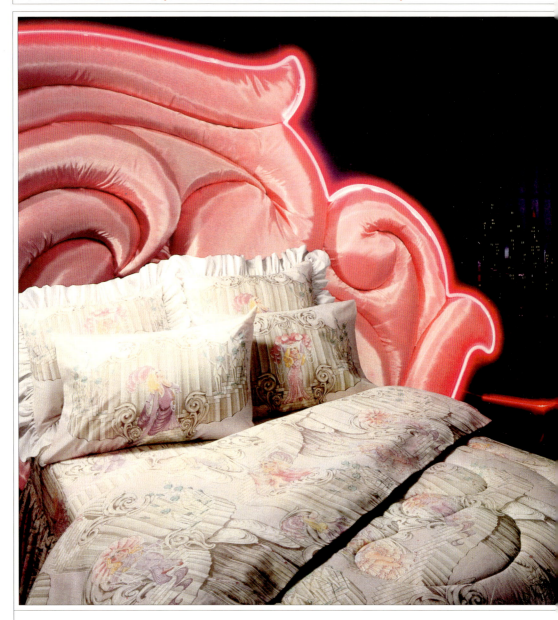

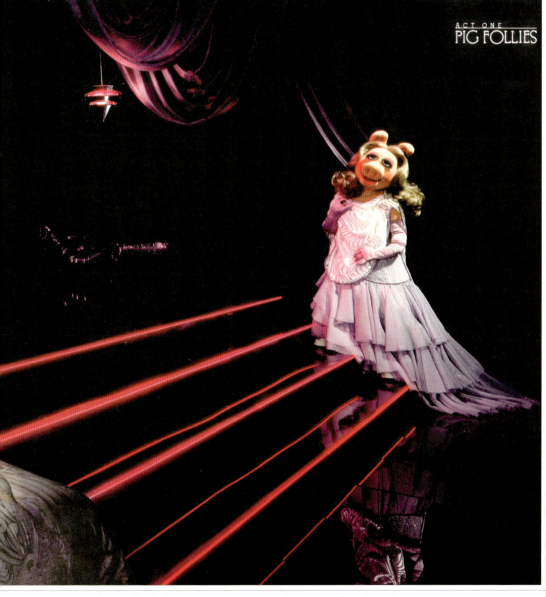

Design: B. Martin Pedersen | **Photo:** Armen Kachaturian | **Pg. 328:** Commentary

96 CLIENT: BELL LABS

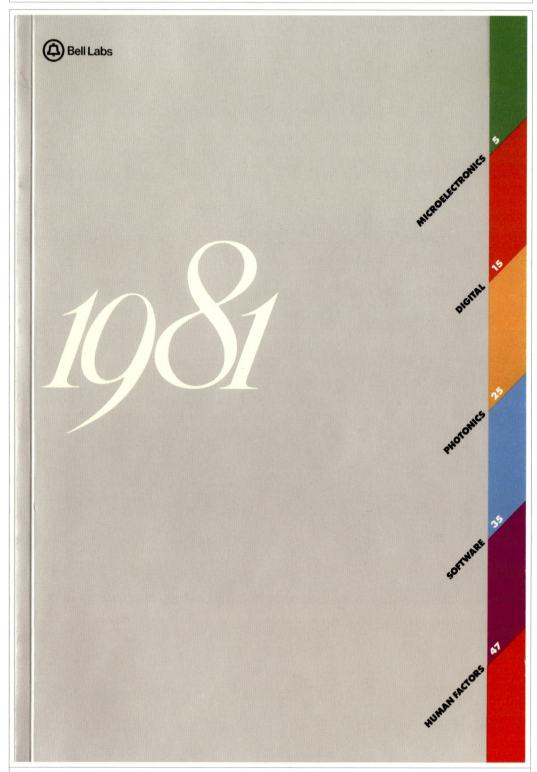

Design: B. Martin Pedersen | **Pg. 328:** Commentary

CLIENT: **DOW JONES & COMPANY** 97

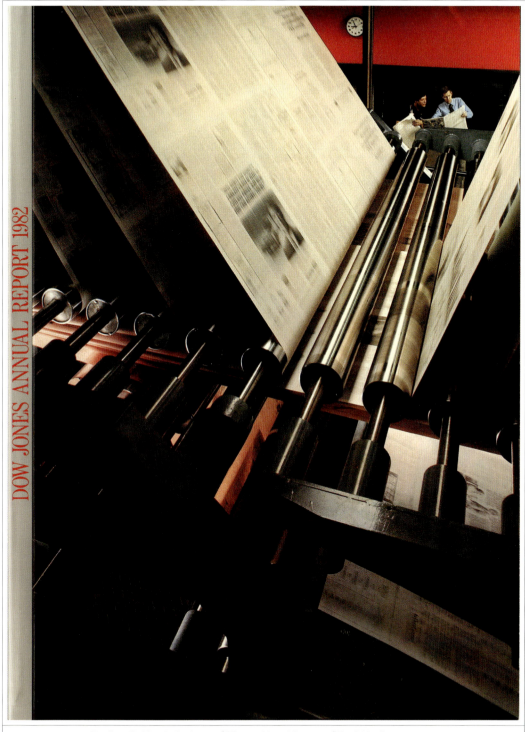

DOW JONES ANNUAL REPORT 1982

Design: B. Martin Pedersen | **Photo:** Cheryl Rossum | **Pg. 328:** Commentary

PRESIDENT/CEO WARREN PHILLIPS WAS JUST GREAT TO WORK WITH. **B. Martin Pedersen,** *Designer*

98 CLIENT: DOW JONES & COMPANY

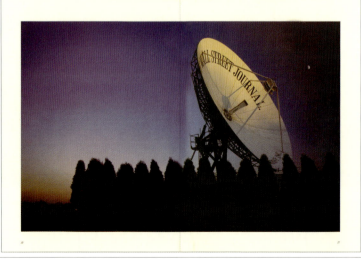

Design: B. Martin Pedersen | **Photos:** Cheryl Rossum | **Pg. 328:** Commentary

CLIENT: DOW JONES & COMPANY

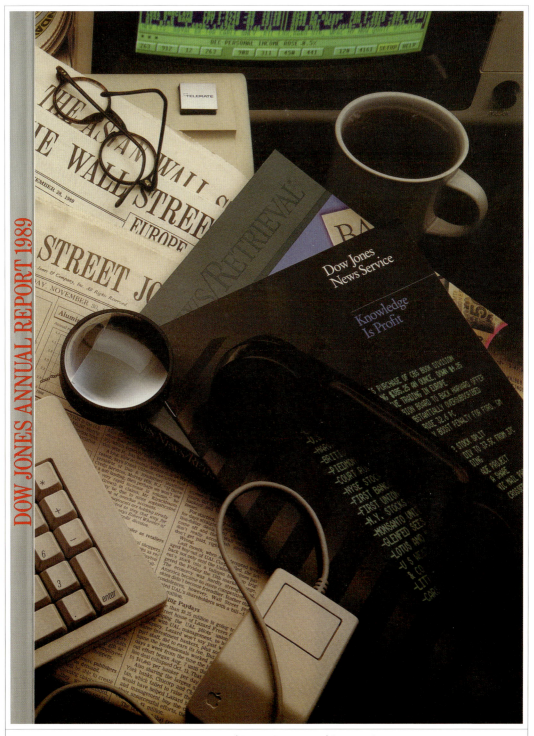

Design: B. Martin Pedersen | **Photo:** Phil Marco | **Pg. 328:** Commentary

100 CLIENT: INT'L. TYPEFACE CORP. (AARON BURNS & HERB LUBALIN)

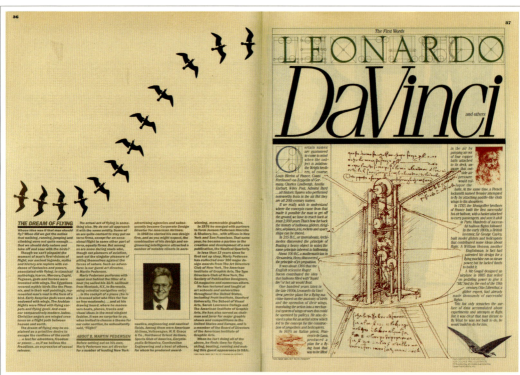

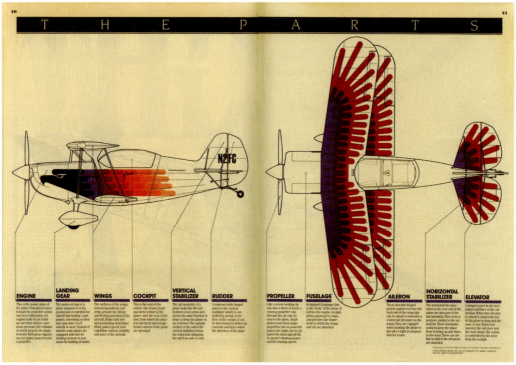

Design: B. Martin Pedersen | Art: Unknown | Pg. 329: Commentary

THE WR[

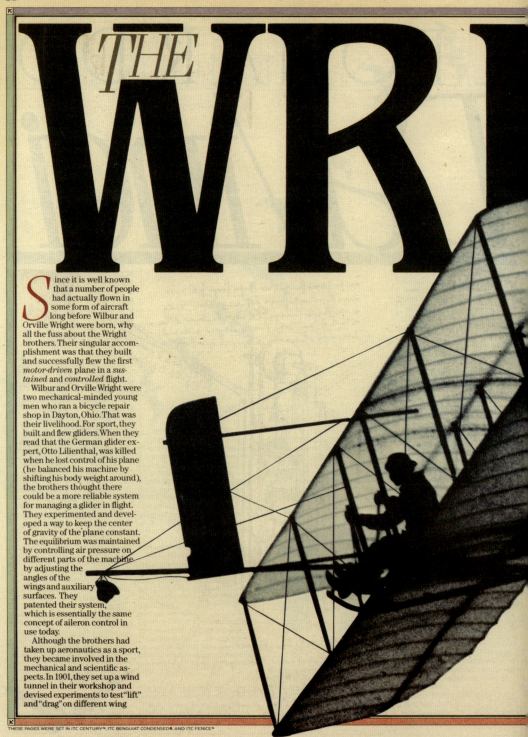

Since it is well known that a number of people had actually flown in some form of aircraft long before Wilbur and Orville Wright were born, why all the fuss about the Wright brothers. Their singular accomplishment was that they built and successfully flew the first *motor-driven* plane in a *sustained* and *controlled* flight.

Wilbur and Orville Wright were two mechanical-minded young men who ran a bicycle repair shop in Dayton, Ohio. That was their livelihood. For sport, they built and flew gliders. When they read that the German glider expert, Otto Lilienthal, was killed when he lost control of his plane (he balanced his machine by shifting his body weight around), the brothers thought there could be a more reliable system for managing a glider in flight. They experimented and developed a way to keep the center of gravity of the plane constant. The equilibrium was maintained by controlling air pressure on different parts of the machine by adjusting the angles of the wings and auxiliary surfaces. They patented their system, which is essentially the same concept of aileron control in use today.

Although the brothers had taken up aeronautics as a sport, they became involved in the mechanical and scientific aspects. In 1901, they set up a wind tunnel in their workshop and devised experiments to test "lift" and "drag" on different wing

THESE PAGES WERE SET IN ITC CENTURY™, ITC BENGUIAT CONDENSED®, AND ITC FENICE™

GHT STUFF

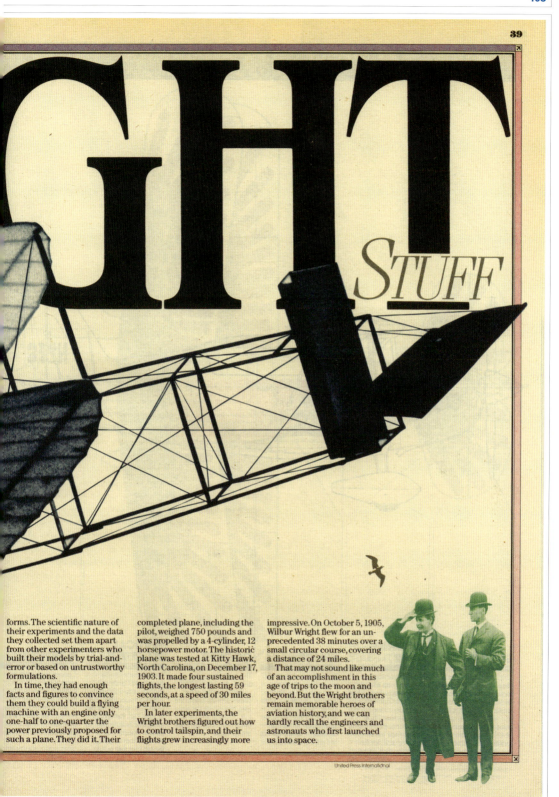

forms. The scientific nature of their experiments and the data they collected set them apart from other experimenters who built their models by trial-and-error or based on untrustworthy formulations.

In time, they had enough facts and figures to convince them they could build a flying machine with an engine only one-half to one-quarter the power previously proposed for such a plane. They did it. Their completed plane, including the pilot, weighed 750 pounds and was propelled by a 4-cylinder, 12 horsepower motor. The historic plane was tested at Kitty Hawk, North Carolina, on December 17, 1903. It made four sustained flights, the longest lasting 59 seconds, at a speed of 30 miles per hour.

In later experiments, the Wright brothers figured out how to control tailspin, and their flights grew increasingly more impressive. On October 5, 1905, Wilbur Wright flew for an unprecedented 38 minutes over a small circular course, covering a distance of 24 miles.

That may not sound like much of an accomplishment in this age of trips to the moon and beyond. But the Wright brothers remain memorable heroes of aviation history, and we can hardly recall the engineers and astronauts who first launched us into space.

United Press International

Design: B. Martin Pedersen | **Art:** Unknown | **Pg. 329:** Commentary

20 MEET SPACE EXPLORER IGAR

Mostly we think of graphic designers as just earthbound creatures, permanently trapped in 2-dimensional space. Now we'll have to alter that concept. Here is the work of Takenobu Igarashi, Japanese designer, whose posters, logos, corporate identity graphics and writings have made him a trendsetter in his native Japan, and internationally, as well.

But, as you can see from his designs, there is no confining him to the printed page. He started this 3-dimensional alphabet with drawings of simple, minimal letterforms, then proceeded to enlarge and extrapolate each character into a complex, multi-leveled, multi-faceted piece of sculpture.

"I want to make letters on a mammoth scale," explains Igarashi, "so people can climb on top of the sculpture, or inside it, and experience the space and volume fully." For that reason, he refers to his alphabet forms not just as sculpture to be looked at, but as architectural environments.

An entire Igarashi alphabet was exhibited recently at the Reinhold-Brown

Gallery in New York City. The letters were fabricated in brushed aluminum, but he has also worked with brass, chrome, wood, cast concrete, plastic and marble. Though these pieces were small in scale (approximately 5½ inches tall) some of his giant letters are 12 feet high and 20 feet wide, and are intended for public or corporate environments, indoors or out.

According to Igarashi, the alphabet is an appealing design project, because "It is a universally understood sign system." However, with or without the recognizable symbolism, letterforms make unexpectedly beautiful abstract designs in space.

Igarashi is a graduate of Tama University of Fine Arts in Tokyo, and he received his Master's Degree in Design from the University of California, Los Angeles. He established his own studio, Takenobu Igarashi Design, in Tokyo, in 1970. His posters, logos, corporate graphics and signage are recognized and admired internationally. The Museum of Modern Art in New York City has a permanent collection of his posters, and he has been commissioned to design their 1985 calendar,

as well. He has international clients and has taught and lectured worldwide. Both Graphis and Idea magazines have honored him with special feature articles, and he is the recipient of numerous awards. His most recent contribution to the field of graphic design is his own book, Igarashi Space Graphics, which encompasses three major areas: Architectural Graphics, Communication Graphics and Pure Graphics. It is an intelligent and highly intelligible work with illuminating insights into how he thinks and how he works. Available from Reinhold-Brown Gallery, 26 East 78th Street, New York, NY 10021. Marion Muller

A. The H photographed on the beach makes a grand portal to the sea. In ABS resin with lacquer coating. Actual size: 300 x 300 x 100 mm.

B. B in Indian sandstone is reminiscent of ancient Egyptian temple thrones. Actual size: 220 x 300 x 170 mm.

C. A in gleaming solid aluminum. Actual size: 380 x 310 x 180 mm.

D. Reaching toward the heavens, an inspirational X, in lacquered brass. Actual size: 300 x 240 x 460 mm.

PHOTOS: HIDEKI ADACHI

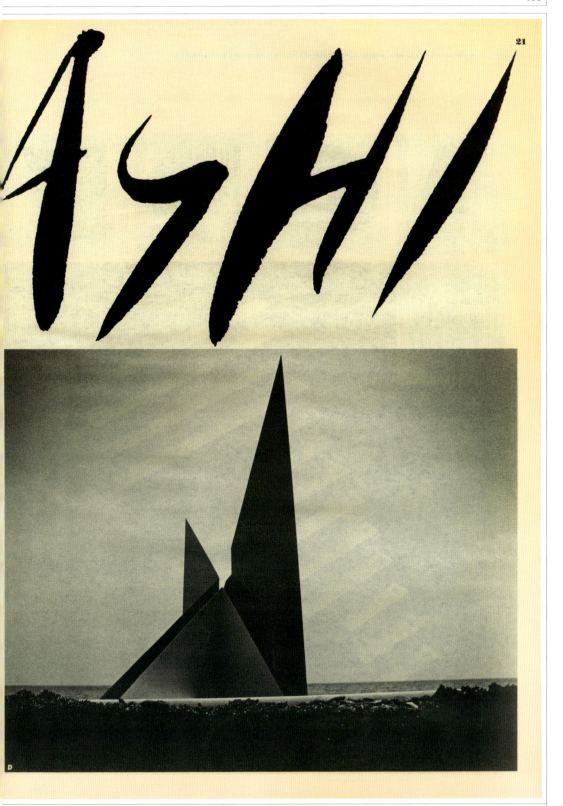

Design: B. Martin Pedersen | **Sculptures:** Takenobu Igarashi | **Pg. 329:** Commentary

106 **CLIENT: BUSINESS WEEK MAGAZINE**

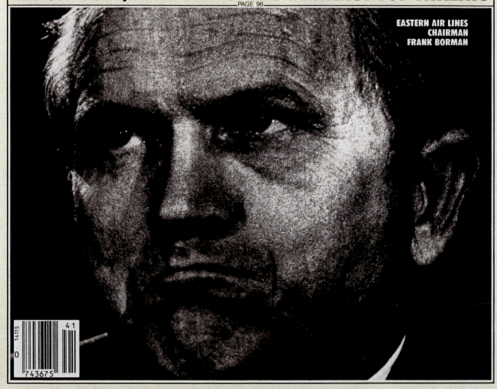

Design: B. Martin Pedersen | Photo: Business Week | Pg. 329: Commentary

CLIENT: TYPE DIRECTORS CLUB (TDC) 107

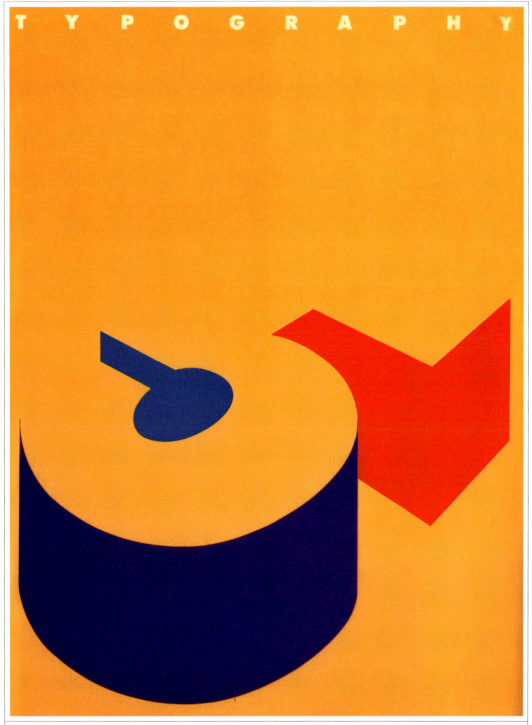

Design & Art: B. Martin Pedersen, Adrian Pulfer, Randell Pearson | **Pg. 329:** Commentary

108 CLIENT: HOPPER PAPER COMPANY

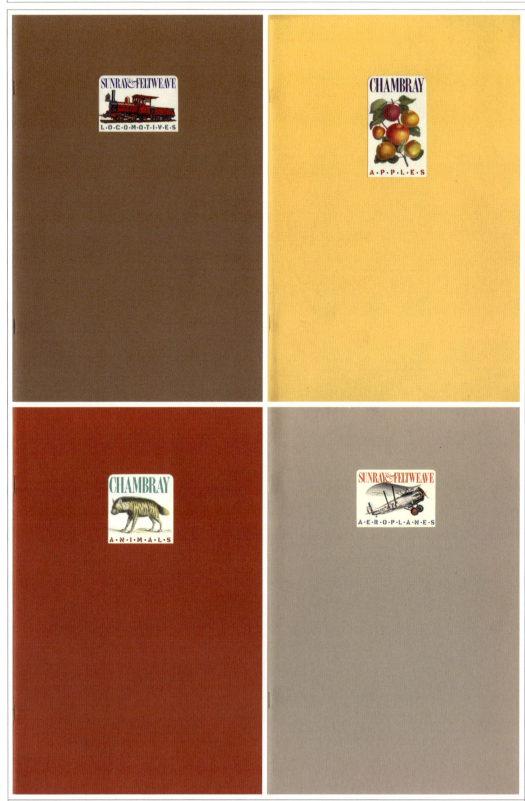

Design: B. Martin Pedersen, Adrian Pulfer | **Art:** Stock | **Pg. 329:** Commentary

CLIENT: HOPPER PAPER COMPANY

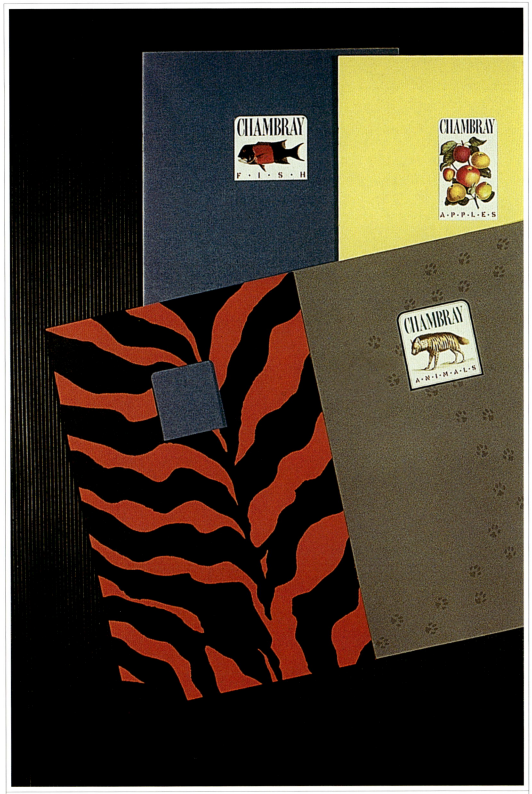

Design: B. Martin Pedersen, Adrian Pulfer | **Art:** Stock | **Pg. 329:** Commentary

110 CLIENT: HOPPER PAPER COMPANY

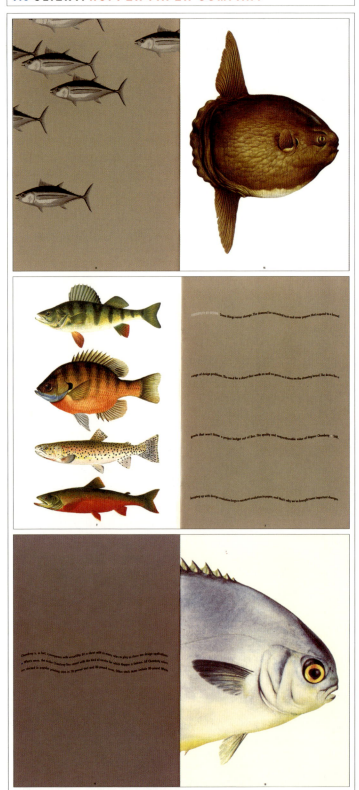

Design: B. Martin Pedersen, Adrian Pulfer | Art: Stock
Pg. 329: Commentary

CLIENT: HOPPER PAPER COMPANY 111

Design: B. Martin Pedersen, Adrian Pulfer | **Art:** Stock | **Pg. 329:** Commentary

112 CLIENT: UNITED INDUSTRIAL SYNDICATE

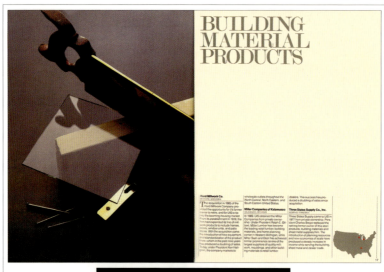

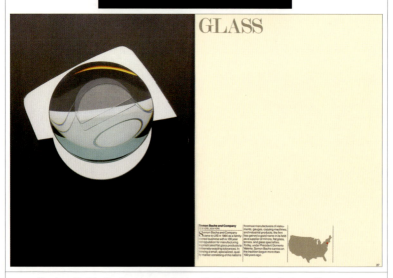

Design: B. Martin Pedersen, Adrian Pulfer | Photos: Andrew Unangst
Pg. 329: Commentary

CLIENT: UNITED INDUSTRIAL SYNDICATE 113

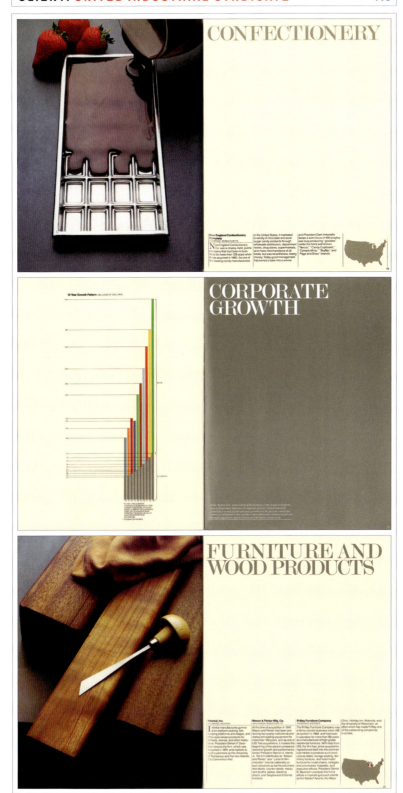

Design: B. Martin Pedersen, Adrian Pulfer | **Photos:** Andrew Unangst
Pg. 329: Commentary

114 CLIENT: UNITED INDUSTRIAL SYNDICATE

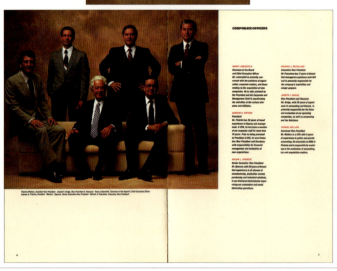

Design: B. Martin Pedersen, Adrian Pulfer | **Photos:** Cheryl Rossum
Pg. 329: Commentary

CLIENT: UNITED INDUSTRIAL SYNDICATE 115

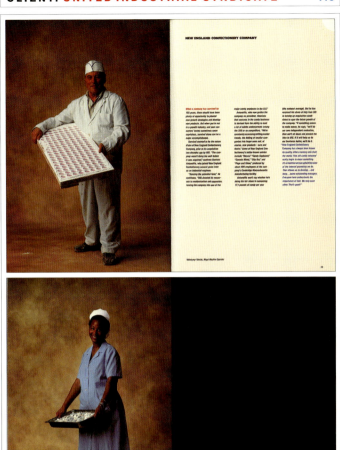
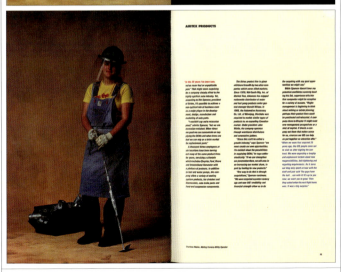

Design: B. Martin Pedersen, Adrian Pulfer | **Photos:** Cheryl Rossum
Pg. 329: Commentary

116 CLIENT: IBM JAPAN

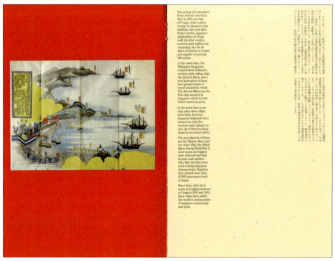

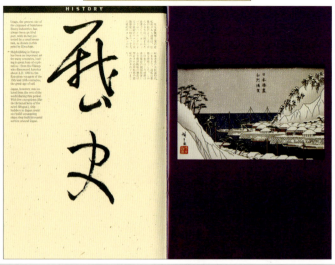

Design: B. Martin Pedersen | Calligraphy: Kiyo Shibata
Pg. 329: Commentary

CLIENT: IBM JAPAN 117

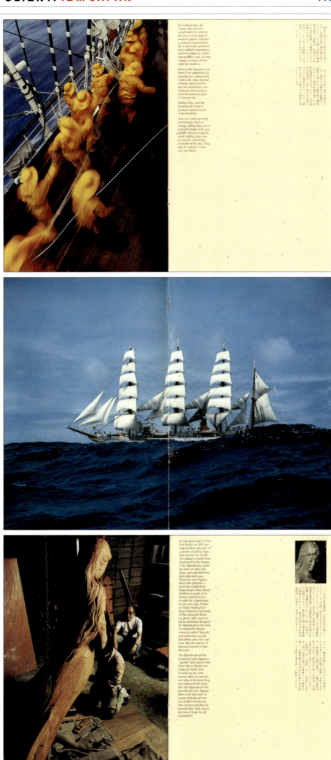

Design: B. Martin Pedersen | **Photos:** Shinji Sakata
Pg. 329: Commentary

118 CLIENT: TYPE DIRECTORS CLUB (TDC)

WE INVITE

107 — ITC BODONI SEVENTY-TWO™

YOU TO JOIN THE

65 — ITC BODONI SEVENTY-TWO

TYPE DIRECTORS CLUB

45 — ITC BODONI SEVENTY-TWO

INTERNATIONAL MEMBERSHIP.

35 — ITC BODONI SEVENTY-TWO

The TDC is an international association of individuals with a passion for "the love of letters," their forms, effects, their history and future. ❧ We explore all aspects of typography through presentations and discussions that range from the

22 — ITC BODONI SEVENTY-TWO ,

aesthetics of type design to the impact of computer technology, along with TDC publications of current news of typographic interest. ❧ Members will receive our annual, *Typography,* as well as our newsletter, *TDC LetterSpace.* ❧ In addition, the TDC holds a prestigious international

17 — ITC BODONI TWELVE

annual competition. As a Type Directors Club member, if your work is selected for the annual competition, your hanging fees will be reduced. ❧ For additional information contact Ms. Carol Wahler, Executive Director, 60 East 42nd Street, Suite 721, New York, New York 10165. Telephone (212) 983-6042 or Fax (212) 983-6043.

14 — ITC BODONI TWELVE

Design: B. Martin Pedersen | Pg. 330: Commentary

CLIENT: JONSON PIRTLE PEDERSEN ALCORN METZDORF & HESS 119

ANNOUNCING THE BIGGEST NAME IN DESIGN.

Jonson Pirtle Pedersen Alcorn Metzdorf & Hess
45 CHARACTERS

Chermayeff & Geismar Associates
31 CHARACTERS

Anspach Grossman Portugal Inc.
29 CHARACTERS

Pentagram Design Ltd.
20 CHARACTERS

Vignelli Associates
19 CHARACTERS

JONSON PIRTLE PEDERSEN ALCORN METZDORF & HESS, 141 LEXINGTON AVENUE, NEW YORK, NEW YORK 10016 (212) 889-9611

Design: Richard Hess | **Pg. 330:** Commentary

120 **CLIENT: MADISON SQUARE PRESS**

Design: B. Martin Pedersen | **Photo:** Richard Levy | **Pg. 330:** Commentary

CLIENT: **GRAPHIS** 121

Design: B. Martin Pedersen | **Photo:** David Tu | **Pg. 330:** Commentary

122 CLIENT: CHILDCRAFT (WILFRED DEMISCH)

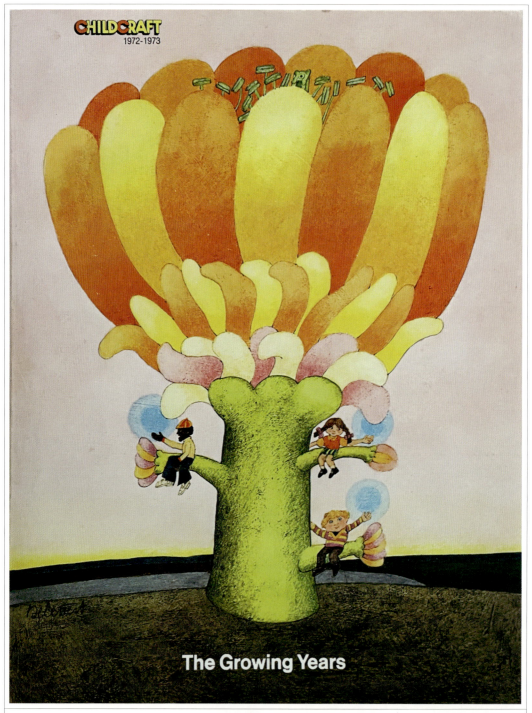

Design: B. Martin Pedersen | **Art:** Étienne Delessert | **Pg. 330:** Commentary

CLIENT: **ENCORE MAGAZINE (IDA LEWIS & NIKKI GIOVANNI)** 123

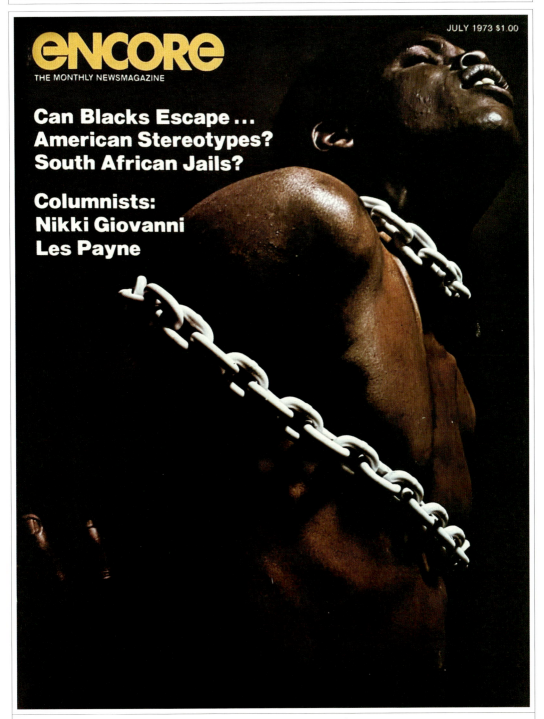

Design: B. Martin Pedersen | **Photo:** Mike McDonnell | **Pg. 330:** Commentary

124 CLIENT: **BILL KOCH, AMERICA'S CUP WINNER**

TO THE THIRD POWER

AMERICA³ · THE INSIDE STORY OF BILL KOCH'S WINNING STRATEGIES FOR THE AMERICAS CUP · BY PAUL LARSEN · PHOTOGRAPHS BY DANIEL FORSTER

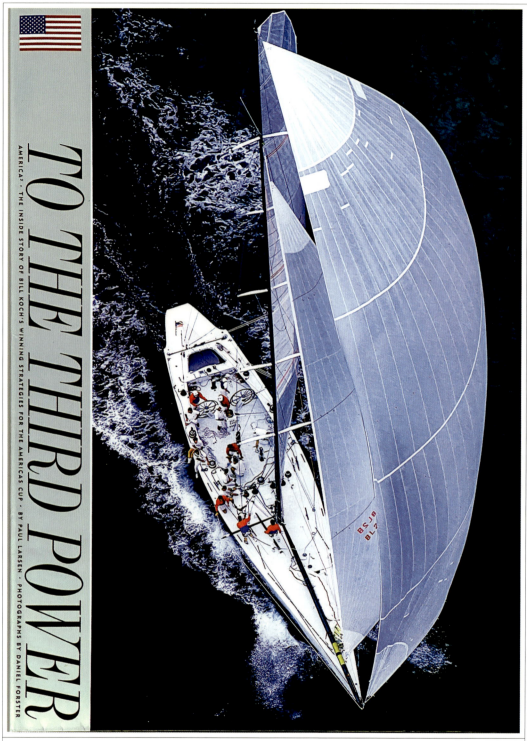

Design: B. Martin Pedersen | Photo: Daniel Forster | Writer: Paul Larsen | Pg. 330: Commentary

CLIENT: PANAMERICANA 96 GRAPHIC DESIGN CONGRESS

(SAO PAULO, BRASIL 4 A 8 DE MARÇO 1996)

PANAME
RICANA 96
GRAPHIC
DESIGN
CONGRESSO
PANAMERICANO
DE DESIGN GRÁFICO
PARTICIPAÇÃO: AGI/USA
ESCOLA PANAMERICANA DE ARTE

Design: B. Martin Pedersen | **Pg. 330:** Commentary

126 PERSONAL: JAPAN 2011 TSUNAMI

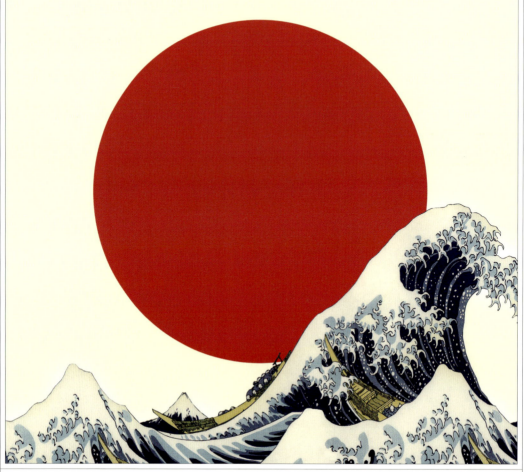

起死回生

WAKE FROM DEATH AND RETURN TO LIFE

Design: B. Martin Pedersen | **Painter:** Katsushika Hokusai | **Pg. 330:** Commentary

PERSONAL: NORWEGIAN SEA HERITAGE

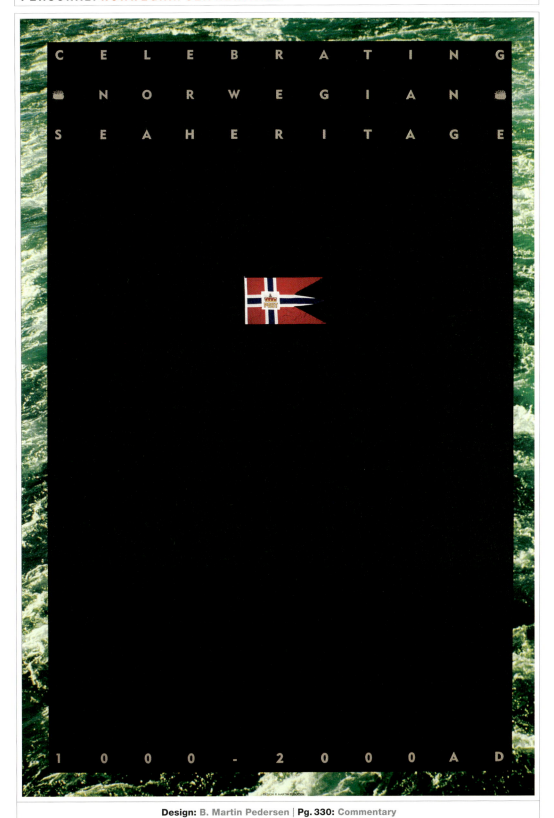

Design: B. Martin Pedersen | **Pg. 330:** Commentary

128 PERSONAL: NORWEGIAN EXPLORATION

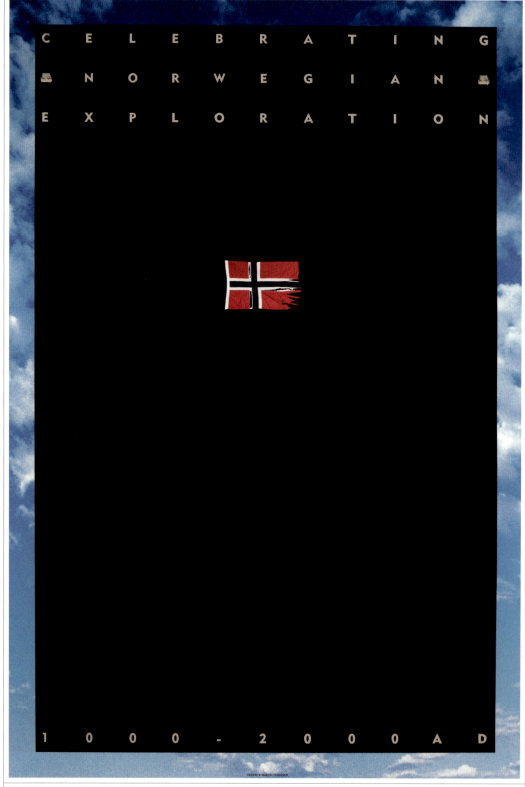

Design: B. Martin Pedersen | **Pg. 330:** Commentary

PERSONAL: NORWEGIAN IMMIGRATION 129

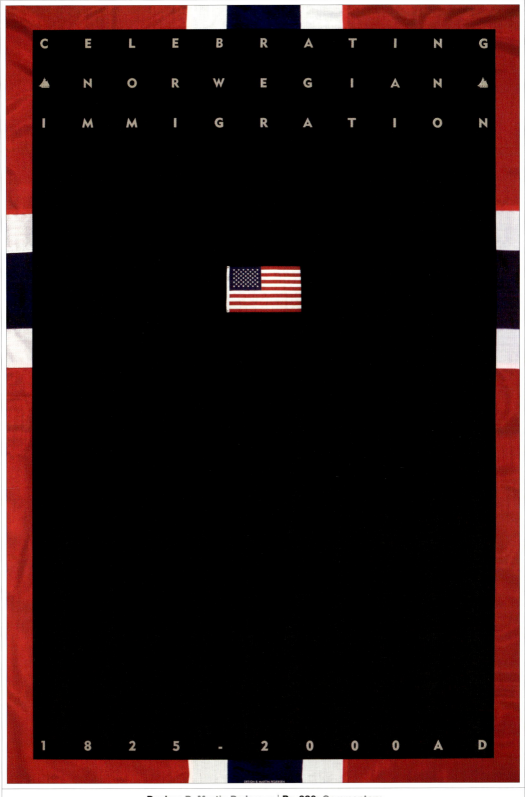

Design: B. Martin Pedersen | **Pg. 330:** Commentary

130 CLIENT: FRITZ GOTTSCHALK, FAMED SWISS DESIGNER

FRITZ GOTT SCHA LK

Grattis på födelsedagen!
Bonne Anniversaire!
Alles Gute zum Geburtstag!
Happy Birthday!
Gratulerer med dagen!
Buon Compleanno!

Design: B. Martin Pedersen, YonJoo Choi | **Pg. 330:** Commentary

CLIENT: **FAO SCHWARZ (WILFRED DEMISCH)** 131

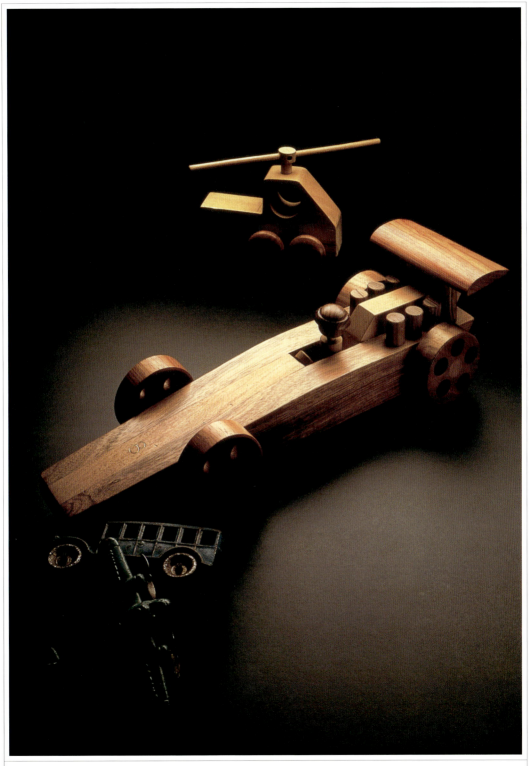

Toy Design: B. Martin Pedersen | **Photo:** Phil Marco | **Pg. 330:** Commentary

132 PERSONAL: **PROTEST AGAINST MAHSA AMINI KILLING**

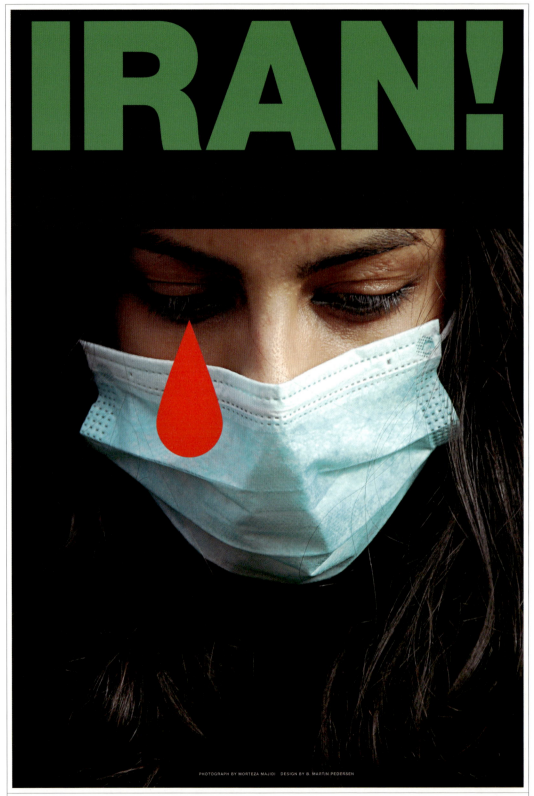

Design: B. Martin Pedersen | **Photo:** Morteza Majidi | **Pg. 330:** Commentary

PERSONAL: LISA WITH HURT DOLL 133

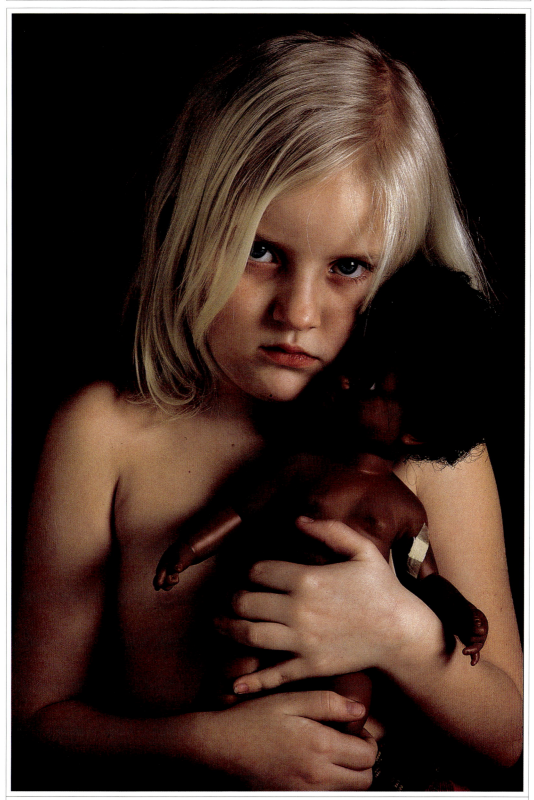

Design: B. Martin Pedersen | **Photo:** Armen Kachaturian | **Pg. 330:** Commentary

CLIENT: BRAHMS RESTAURANT IN BROOKLYN

Design: B. Martin Pedersen | **Pg. 330:** Commentary

CLIENT: TYPE DIRECTORS CLUB (TDC)

Art Director: B. Martin Pedersen | **Typographer:** Gerard Huerta | **Pg. 330:** Commentary

CLIENT: NY HAIRDRESSER

Design: B. Martin Pedersen | **Pg. 330:** Commentary

CLIENT: F&C NAVAL ARCHITECT

Design: B. Martin Pedersen | **Pg. 330:** Commentary

CLIENT: EVAN & LEWIS CHEESE STORE

Design: B. Martin Pedersen | **Pg. 330:** Commentary

CLIENT: SYRACUSE UNIVERSITY 135

Design: B. Martin Pedersen | **Pg. 330:** Commentary

136 CLIENT: HOPPER PAPER COMPANY

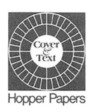

Original Logo & Development of New Logo | **Design:** B. Martin Pedersen, Adrian Pulfer | **Pg. 330:** Commentary

CLIENT: HOPPER PAPER COMPANY 137

Design: B. Martin Pedersen, Adrian Pulfer | **Pg. 330:** Commentary

138 CLIENT: HOPPER PAPER COMPANY (With New Logo)

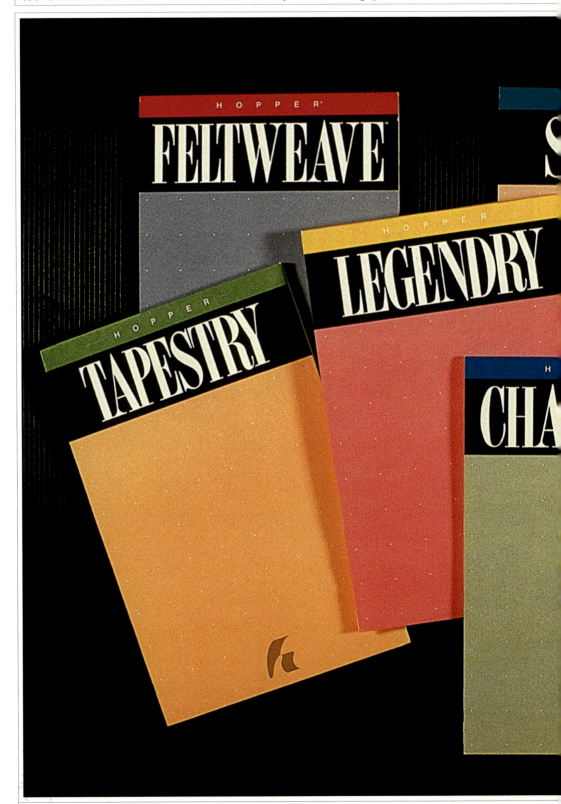

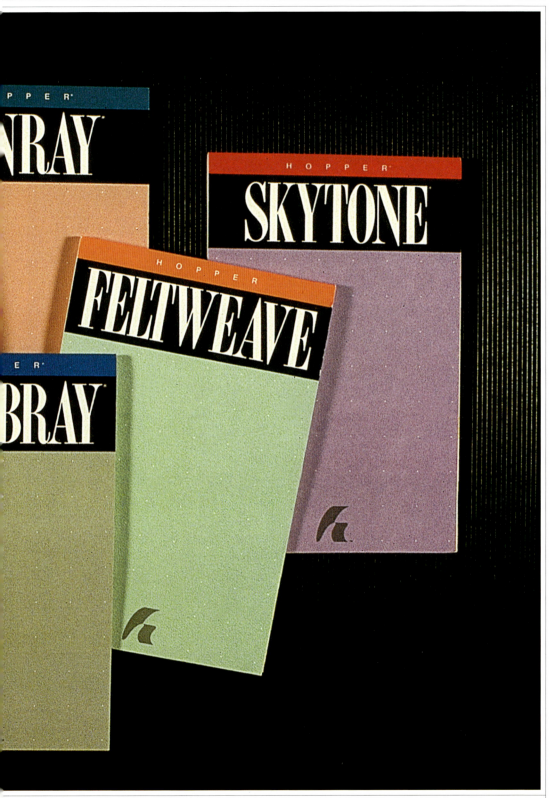

Design: B. Martin Pedersen, Adrian Pulfer | **Pg. 330:** Commentary

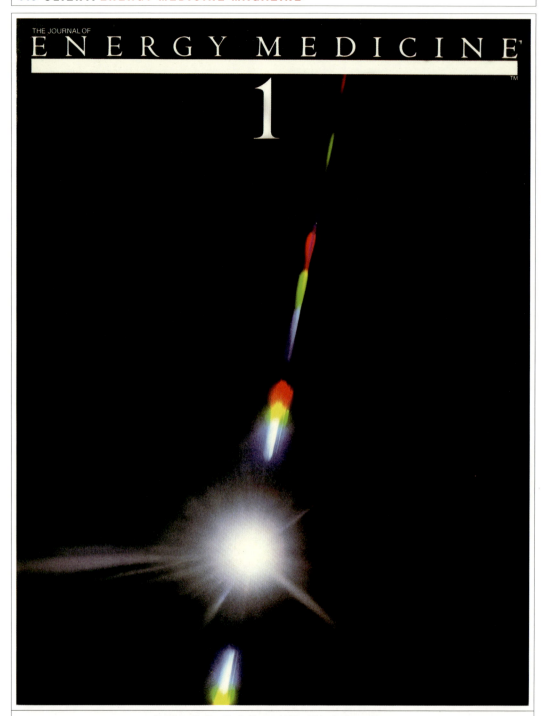

Design: B. Martin Pedersen | Pg. 331: Commentary

142 CLIENT: SONNENBLICK-GOLDMAN

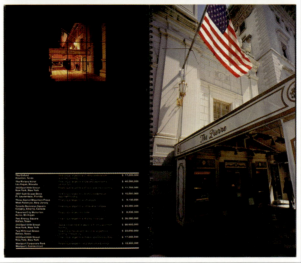

Design: B. Martin Pedersen | **Photos:** Cheryl Rossum
Pg. 331: Commentary

144 CLIENT: TOOLS FOR LIVING

Design: B. Martin Pedersen, Adrian Pulfer | Pg. 331: Commentary

CLIENT: **TOOLS FOR LIVING** 145

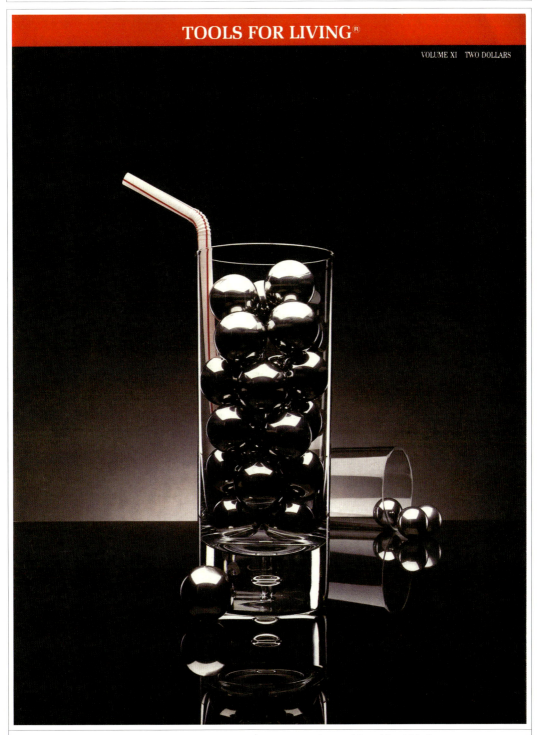

Design: B. Martin Pedersen, Adrian Pulfer | **Photo:** Supplied by Client | **Pg. 331:** Commentary

146 **CLIENT: SCM SYSTEMS**

Design: B. Martin Pedersen | **Pg. 331:** Commentary

CLIENT: RUDY'S MUSIC STORE SOHO 149

Design: B. Martin Pedersen, YonJoo Choi | **Photo:** Vincent J. Ricardel | **Pg. 331:** Commentary

150 **CLIENT: RUDY'S MUSIC STORE SOHO**

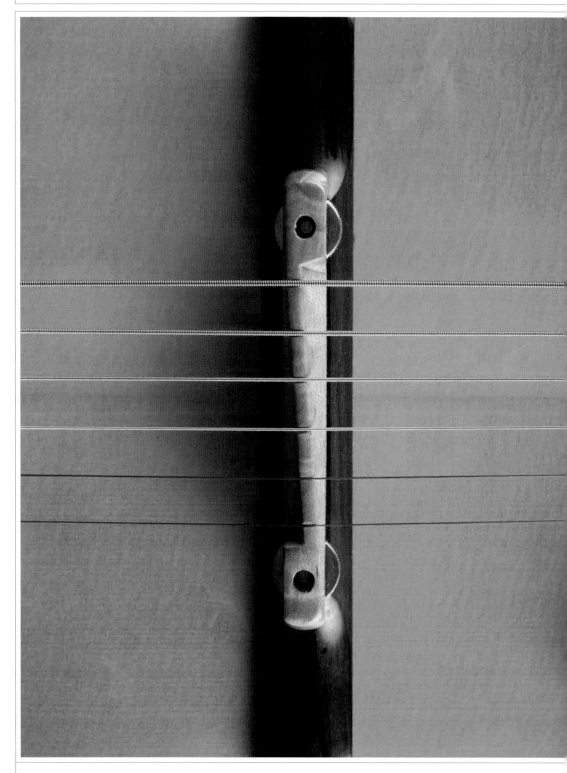

Table of CONTENTS

006
AUTHOR'S NOTE:
RUDY PENSA

011
FOREWORD:
MARK KNOPFLER | PAT MARTINO

017
CREMONA TO NEW YORK
RUDY PENSA

036
D'ANGELICO

154
D'AQUISTO

270
MONTELEONE

374
MONTELEONE'S FOUR SEASONS

412
NOTES

Design: B. Martin Pedersen, YonJoo Choi | **Photo:** Vincent J. Ricardel | **Pg. 331:** Commentary

152 CLIENT: RUDY'S MUSIC STORE SOHO

The ART *of*
D'ANGELICO

CHAPTER
2

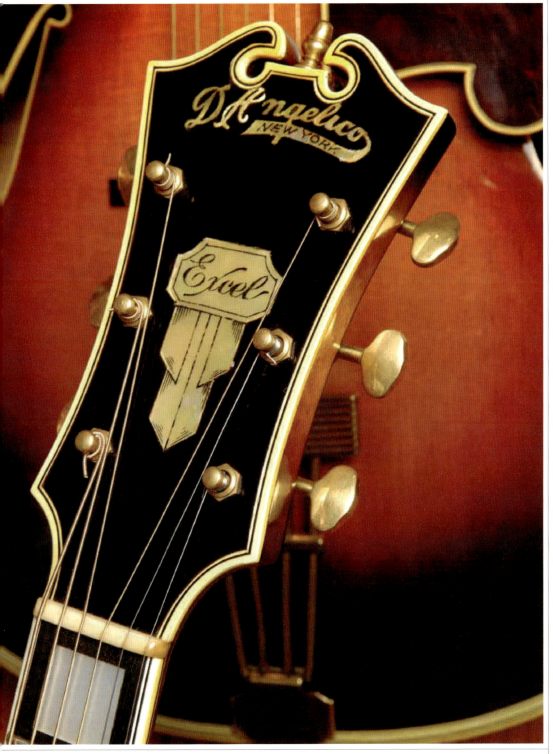

Design: B. Martin Pedersen, YonJoo Choi | **Photo:** Vincent J. Ricardel | **Pg. 331:** Commentary

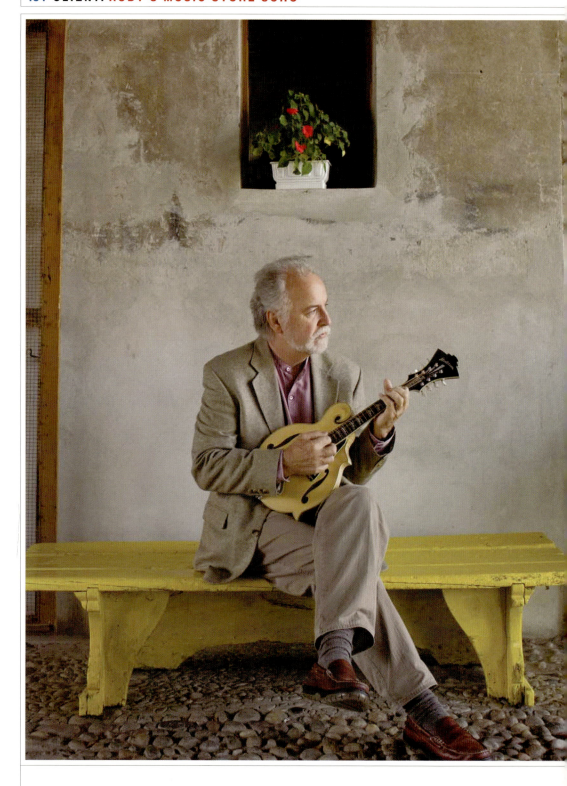

The ART of MONTELEONE

CHAPTER 4

Design: B. Martin Pedersen, YonJoo Choi | **Photo:** Vincent J. Ricardel | **Pg. 331:** Commentary

156 **CLIENT: RUDY'S MUSIC STORE SOHO**

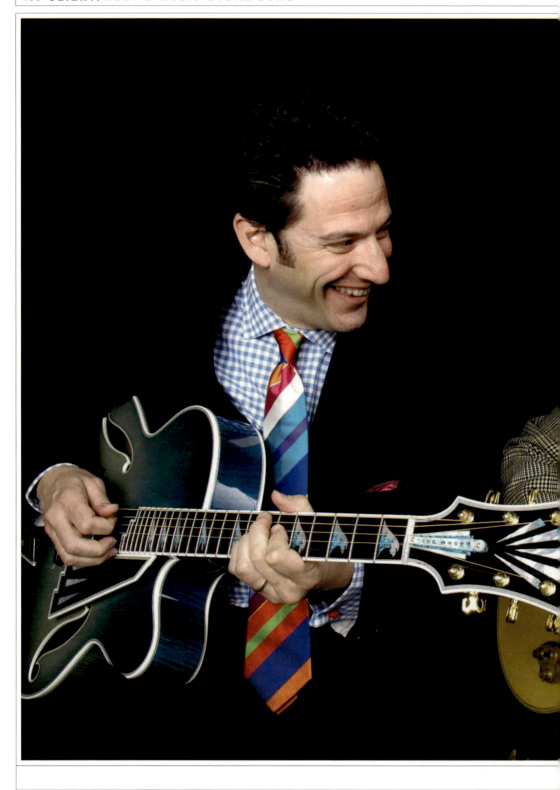

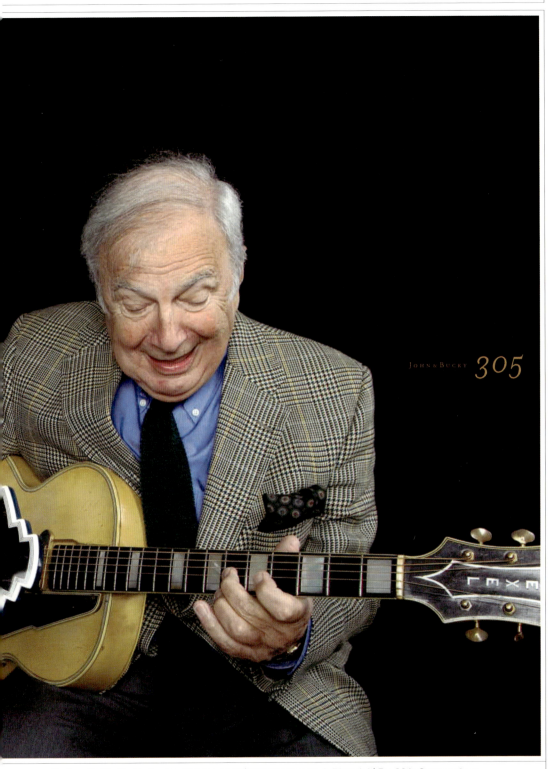

JOHN & BUCKY 305

Design: B. Martin Pedersen, YonJoo Choi | **Photo:** Vincent J. Ricardel | **Pg. 331:** Commentary

158 CLIENT: RUDY'S MUSIC STORE SOHO

Monteleone's FOUR SEASONS

CHAPTER 5

Design: B. Martin Pedersen, YonJoo Choi | **Photo:** Vincent J. Ricardel | **Pg. 331:** Commentary

160 CLIENT: RUDY'S MUSIC STORE SOHO

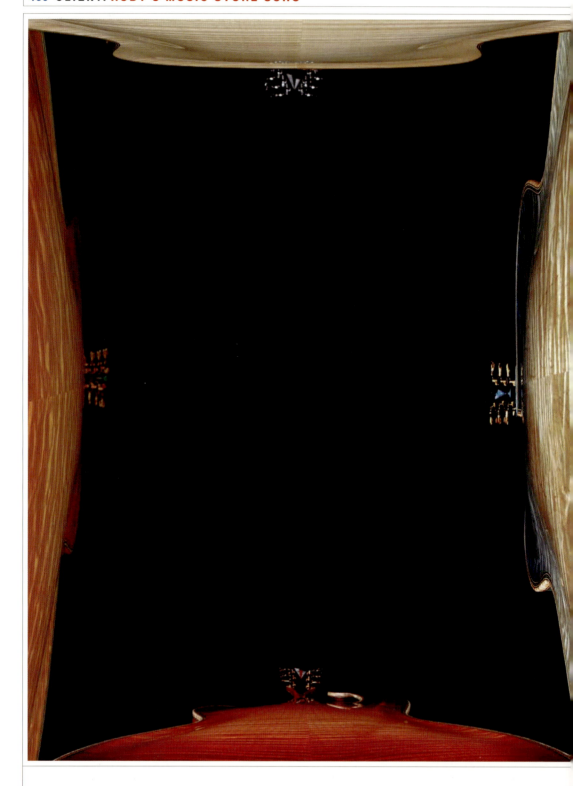

Design: B. Martin Pedersen, YonJoo Choi | Photos: Vincent J. Ricardel | Pg. 331: Commentary

Advertising

CLIENT: **HOWARD SCHATZ PHOTOGRAPHY** 163

Design: B. Martin Pedersen | Photo: Howard Schatz | Pg. 331: Commentary

164 **CLIENT:** **HOWARD SCHATZ PHOTOGRAPHY**

FINE ART

SCHATZ!

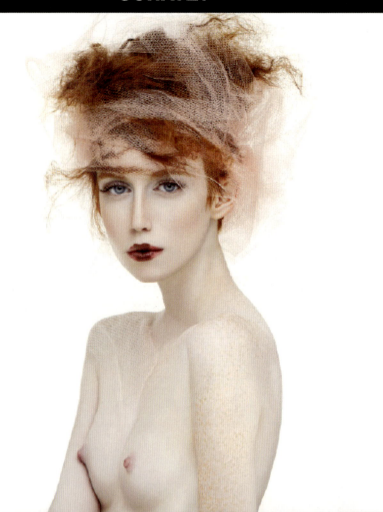

LAWRENCE FINE ART, 37 NEWTOWN LANE, EAST HAMPTON, NY | (516) 547-8965

Design: B. Martin Pedersen | **Photo:** Howard Schatz | **Pg. 331:** Commentary

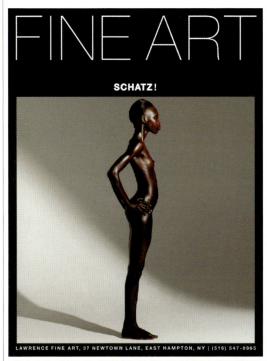
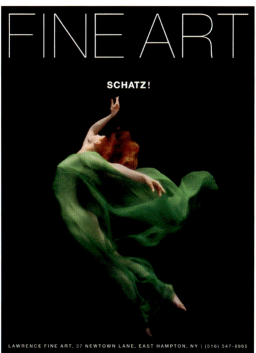
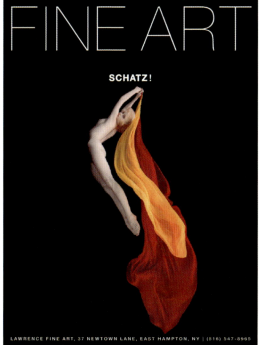
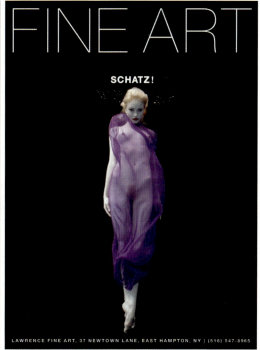

Design: B. Martin Pedersen | **Photos:** Howard Schatz | **Pg. 331:** Commentary

166 CLIENT: TESLA

2008 TESLA ROADSTER

It's green!

It does 0-60 mph in 3.7 seconds!

No gas, no oil, and it's beautiful!

Design: B. Martin Pedersen | **Photo:** Tesla | **Pg. 331:** Commentary

168 CLIENT: TESLA

2017 TESLA MODEL 3

Still green!

Now does 0-60 mph in only 1.9 seconds!

No gas, no oil, and *still* beautiful!

TESLA

Design: B. Martin Pedersen, YonJoo Choi | **Photo:** Tesla | **Pg. 331:** Commentary

Posters

PERSONAL: **UNITED NATIONS OF AMERICA** 171

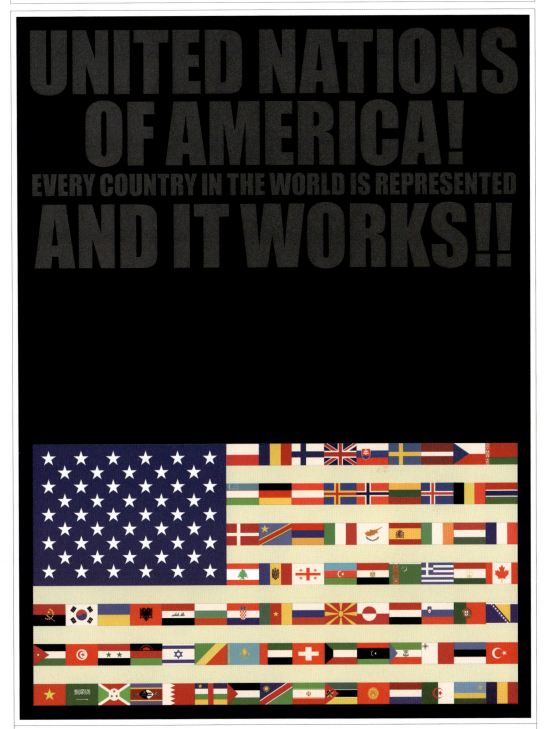

Design: B. Martin Pedersen | Pg. 331: Commentary

172 **PERSONAL: SOLDIER CORPSES**

SOLDIER CORPSES!

Lucian King Truscott Jr. was instrumental in winning many important battles during WW II, but his most impressive qualities were on display on May 31, 1945, when he delivered a speech at an American cemetery in Nettuno, Italy. Unfortunately, there is no transcript of Truscott's declamation. However, Bill Mauldin listened to his words as a 23-year-old infantry sergeant. Mauldin, who later won two Pulitzer Prizes as an editorial cartoonist, described Truscott's remarks. Here is his account: At the start of his speech, Truscott turned away. And with his back to the audience he addressed himself to the corpses he had commanded. It was the most moving gesture I ever saw. It came from a hard-boiled old man who was incapable of planned dramatics. The general's remarks were brief and extemporaneous. He apologized to the dead men for their presence here. He said everybody tells leaders it is not their fault that men get killed in war, but that every leader knows in his heart this is not altogether true. He said he hoped he would be forgiven for any mistakes that he may have made, but he realized that this would be asking a hell of a lot under the circumstances. He also said he would not speak about the glorious dead because he didn't see much glory in getting killed in your late teens or early 20s. He promised that if in the future he ran into anybody, especially old men, who thought death in battle was glorious, he would straighten them out. He said he thought it was the least he could do. He then walked quietly away.

Design: B. Martin Pedersen | **Photo:** Harris & Ewing Photo Studio | **Pg. 331:** Commentary

PERSONAL: COEXISTANCE POSTER 173

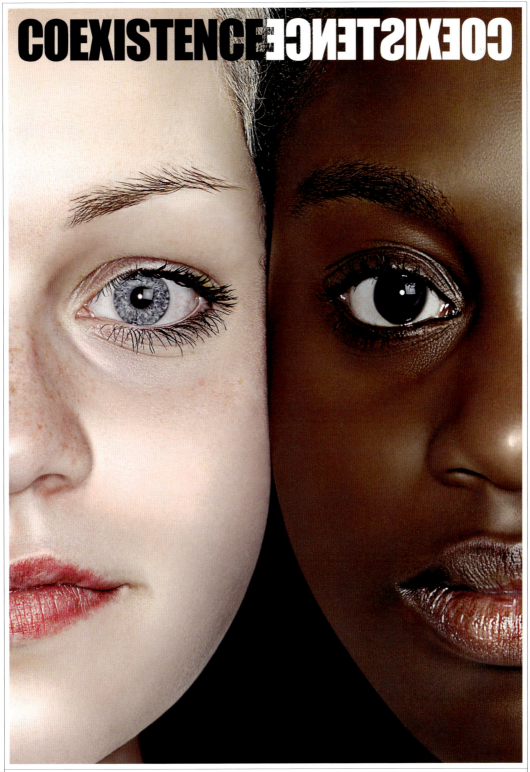

Design: B. Martin Pedersen | **Photo:** Gandee Vasan | **Pg. 331:** Commentary

Graphis Books

GRAPHIS: ANNUAL REPORT BOOKS 175

Design: B. Martin Pedersen | **Cover Photo:** Phil Marco | **Pg. 331:** Commentary

176 GRAPHIS: BROCHURES 2

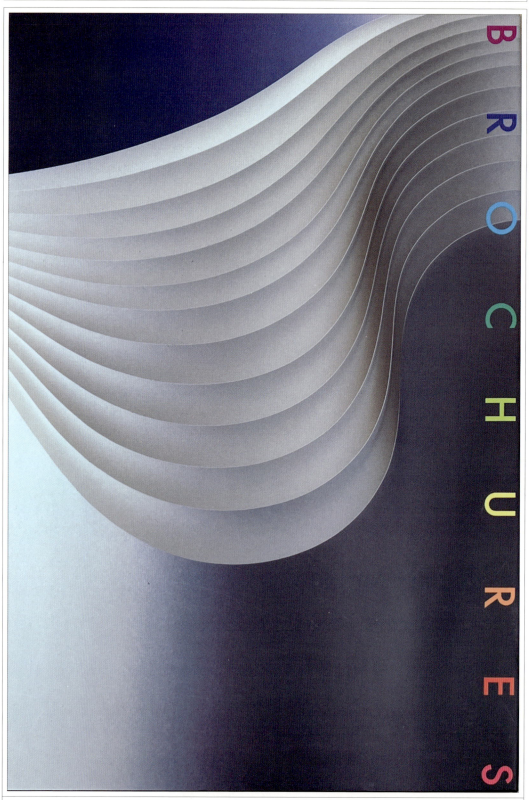

Design: B. Martin Pedersen, Gregory Michael Cerrato | **Pg. 331:** Commentary

GRAPHIS: POSTER ANNUAL 2010 177

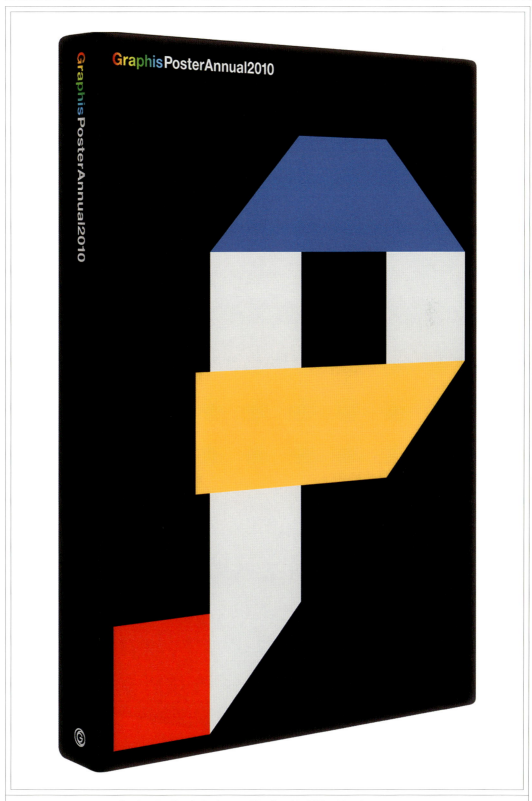

Design: B. Martin Pedersen, YonJoo Choi | **Pg. 331:** Commentary

178 GRAPHIS: POSTER ANNUAL 2023

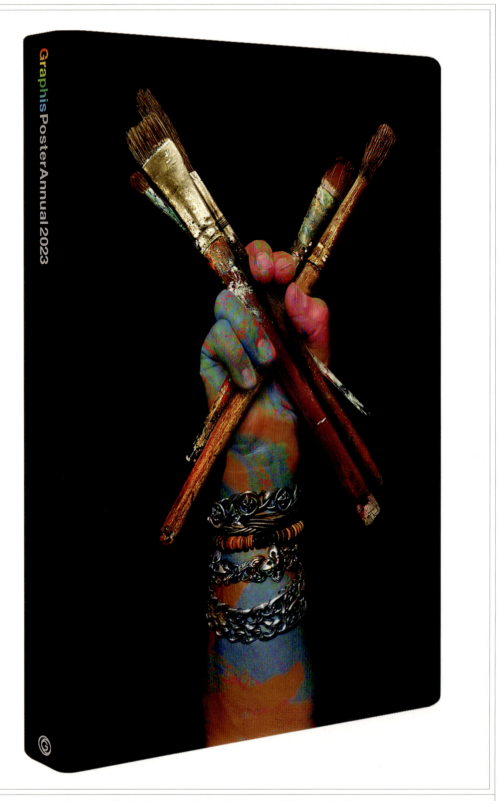

Design: B. Martin Pedersen | **Cover Photo:** Ron Taft | **Pg. 331:** Commentary

GRAPHIS: SOCIAL & POLTITICAL PROTEST POSTERS 179

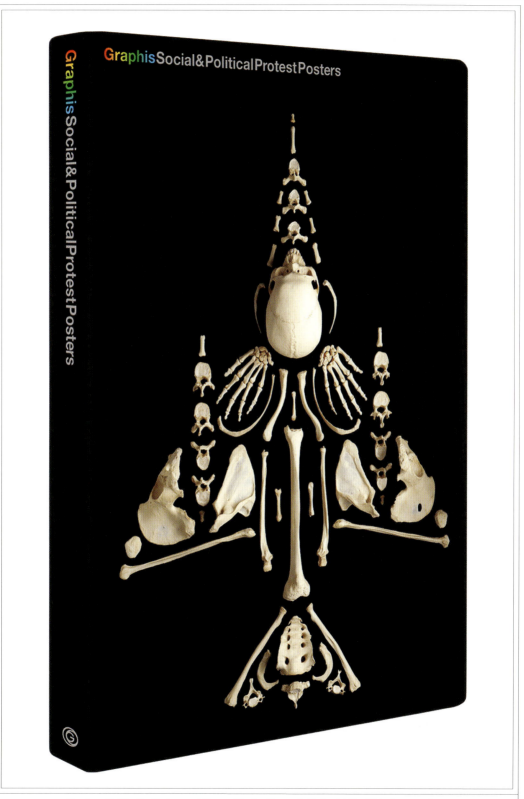

Design: B. Martin Pedersen | **Cover Photo:** François Robert | **Pg. 331:** Commentary

180 GRAPHIS: PROTEST POSTERS 2

Design: B. Martin Pedersen | **Cover Photo:** François Robert | **Pg. 331:** Commentary

Design: B. Martin Pedersen, YonJoo Choi | **Pg. 331:** Commentary

Design: B. Martin Pedersen | **Cover Photo:** Carmit Makler Haller | **Pg. 331:** Commentary

GRAPHIS: PHOTOGRAPHY ANNUAL 1998

Design: B. Martin Pedersen | **Cover Photo:** Walter Fogel | **Pg. 331:** Commentary

184 GRAPHIS: PHOTOGRAPHY ANNUAL 2009

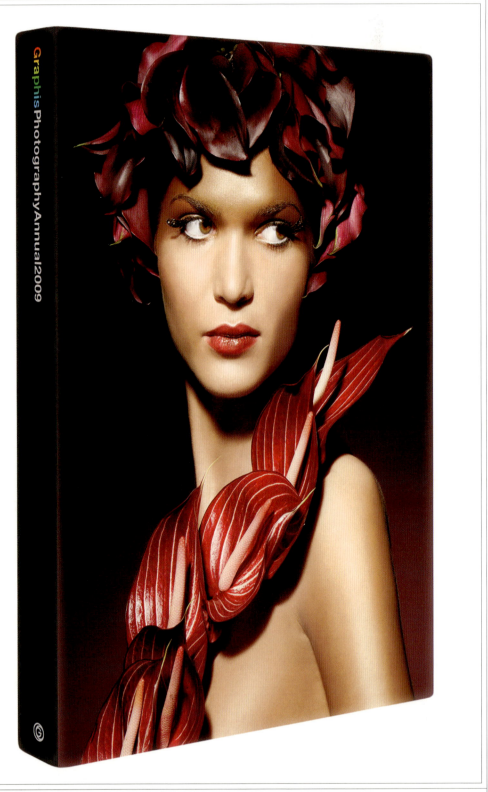

Design: B. Martin Pedersen, YonJoo Choi | **Cover Photo:** Kevin Michael Reed | **Pg. 331:** Commentary

GRAPHIS: PHOTOGRAPHY ANNUAL 2010 185

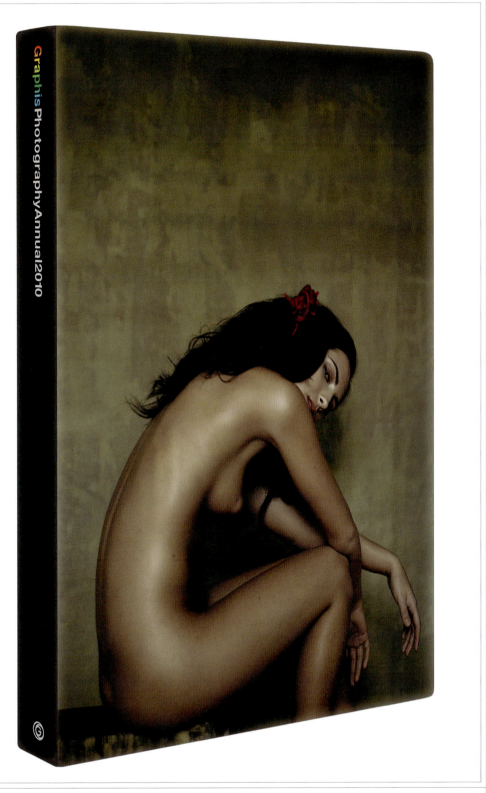

Design: B. Martin Pedersen, YonJoo Choi | **Cover Photo:** Erik Almås | **Pg. 331:** Commentary

186 GRAPHIS: PHOTOGRAPHY ANNUAL 2011

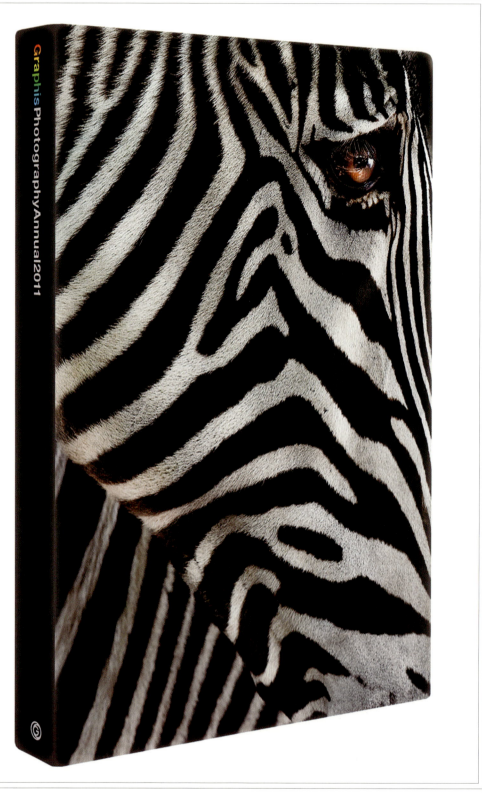

Design: B. Martin Pedersen, YonJoo Choi | **Cover Photo:** Barry Shepherd | **Pg. 331:** Commentary

GRAPHIS: **PHOTOGRAPHY ANNUAL 2012** 187

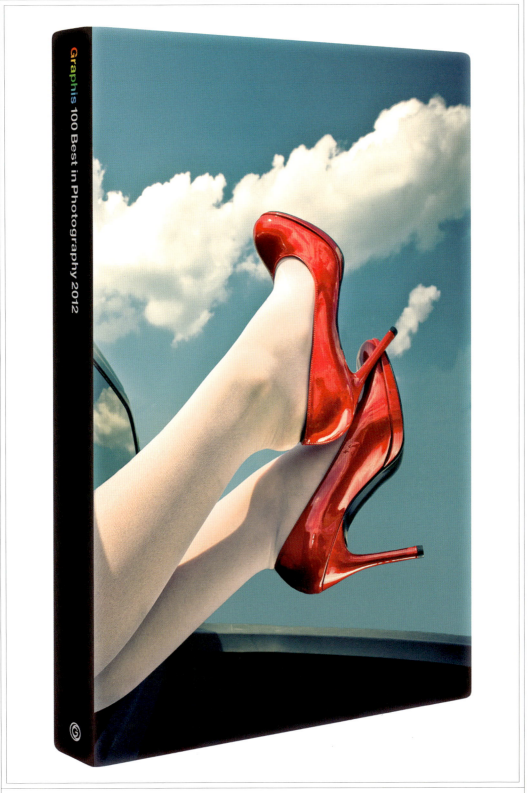

Design: B. Martin Pedersen | **Cover Photo:** Todd Burandt | **Pg. 331:** Commentary

Design: B. Martin Pedersen | **Cover Photo:** Laurie Frankel | **Pg. 331:** Commentary

GRAPHIS: PHOTOGRAPHY ANNUAL 2015

189

Design: B. Martin Pedersen | **Cover Photo:** Colin Faulkner | **Pg. 331:** Commentary

190 GRAPHIS: PHOTOGRAPHY ANNUAL 2016

Design: B. Martin Pedersen | Cover Photo: Christopher Griffith | Pg. 331: Commentary

GRAPHIS: PHOTOGRAPHY ANNUAL 2017

Design: B. Martin Pedersen | **Cover Photo:** Robert Tardio | **Pg. 331:** Commentary

192 **GRAPHIS: PHOTOGRAPHY ANNUAL 2018**

Design: B. Martin Pedersen | **Cover Photo:** Tim Flach | **Pg. 331:** Commentary

GRAPHIS: PHOTOGRAPHY ANNUAL 2019

193

Design: B. Martin Pedersen | **Cover Photo:** Parish Kohanim | **Pg. 331:** Commentary

194 GRAPHIS: **PHOTOGRAPHY ANNUAL 2020**

Design: B. Martin Pedersen | **Cover Photo:** Todd Wright | **Pg. 331:** Commentary

GRAPHIS: PHOTOGRAPHY ANNUAL 2021 195

Design: B. Martin Pedersen | **Cover Photo:** Ashley Camper, Colin Douglas Gray | **Pg. 331:** Commentary

196 GRAPHIS: PHOTOGRAPHY ANNUAL 2022

Design: B. Martin Pedersen | **Cover Photo:** Howard Schatz | **Pg. 331:** Commentary

GRAPHIS: PHOTOGRAPHY ANNUAL 2023

Design: B. Martin Pedersen | **Cover Photo:** RJ Muna | **Pg. 331:** Commentary

198 GRAPHIS: NUDES 3

Design: B. Martin Pedersen | **Cover Photo:** Herb Ritts | **Pg. 331:** Commentary

GRAPHIS: NUDES 4

Design: B. Martin Pedersen | **Cover Photo:** Parish Kohanim | **Pg. 331:** Commentary

200 GRAPHIS: ADVERTISING ANNUAL 2006

Design: B. Martin Pedersen & Luis Diaz | **Cover Photo:** ComGroup | **Pg. 331:** Commentary

Design: B. Martin Pedersen | **Cover Photo:** Ron Taft | **Pg. 331:** Commentary

202 GRAPHIS: NEW TALENT DESIGN ANNUAL 2004

Design: B. Martin Pedersen | Cover Photo: Danny Noval, Angela Finney
Instructor: Ron Seichrist | Pg. 331: Commentary

GRAPHIS: NEW TALENT ANNUAL 2007/2008 203

Design: B. Martin Pedersen | Cover Photos: Laura Kottlowski, Emily Guman, Melinda Reidenbach
Instructor: Lanny Sommese | Pg. 331: Commentary

204 GRAPHIS: NEW TALENT ANNUAL 2010

Design: B. Martin Pedersen, YonJoo Choi | **Cover Photo:** Jason Giles | **Instructor:** Lanny Sommese
Pg. 331: Commentary

GRAPHIS: NEW TALENT ANNUAL 2023 205

Design: B. Martin Pedersen | **Cover Illustration:** Jiyun Choi | **Instructor:** Paul Rogers | **Pg. 331:** Commentary

206 GRAPHIS: PACKAGING DESIGN 9

Design: B. Martin Pedersen | **Cover Art:** B. Martin Pedersen, Jennah Synnestvedt | **Pg. 331:** Commentary

GRAPHIS: PACKAGING DESIGN 10

207

Design: B. Martin Pedersen | **Cover Photo:** PepsiCo Design & Innovation | **Pg. 331:** Commentary

208 GRAPHIS: CORPORATE IDENTITY 2

Design: B. Martin Pedersen | **Cover Photo:** Sussman/Prejza & Co., Inc. | **Pg. 331:** Commentary

GRAPHIS: CORPORATE IDENTITY 3 209

Design: B. Martin Pedersen | **Pg. 331:** Commentary

210 GRAPHIS: LOGO DESIGN 5

Design: B. Martin Pedersen | **Logo:** John Fisk | **Pg. 331:** Commentary

GRAPHIS: LOGO DESIGN 7 211

Design: B. Martin Pedersen | **Logo:** Eduardo del Fraile | **Pg. 331:** Commentary

212 GRAPHIS: LETTERHEAD 7

Design: B. Martin Pedersen, Eno Park | **Name Card:** Mine | **Pg. 331:** Commentary

CLIENT: LOGO/LETTERHEAD 9 213

> "I asked Paul if he would come up with a few options, and he said, "No. I will solve your problem for you and you will pay me. You don't have to use my solution. If you want options go talk to other people.""
>
> Steve Jobs (1955–2011) Former co-founder & CEO, Apple Inc., on working with Paul Rand.

Design: B. Martin Pedersen | NEXT Logo: Paul Rand for Steve Jobs | Pg. 331: Commentary

214 GRAPHIS: PRODUCTS BY DESIGN

Design: B. Martin Pedersen, Randell Pearson, Greg Simpson | **Chair Design:** Marc D'Estout
Pg. 331: Commentary

GRAPHIS: PROMOTION DESIGN 2 215

Design: B. Martin Pedersen | Cover Art: Niklaus Troxler | Pg. 331: Commentary

216 GRAPHIS: TYPOGRAPHY 1

Design: B. Martin Pedersen | **Cover Art:** Tadanori Hakura | **Pg. 331:** Commentary

GRAPHIS: ANIMAL 217

Design: B. Martin Pedersen | **Cover Photo:** James Balog | **Pg. 331:** Commentary

218 GRAPHIS: ANIMAL

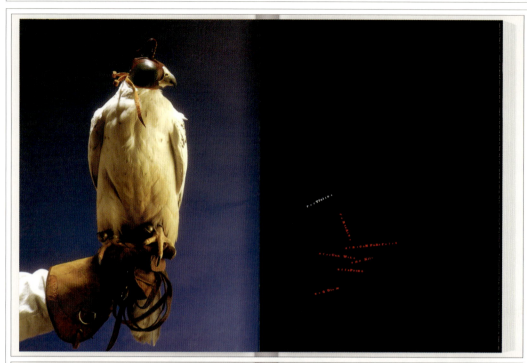

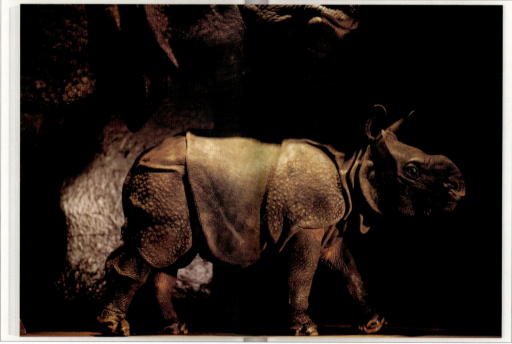

Design: B. Martin Pedersen | **Photos:** James Balog | **Pg. 331:** Commentary

GRAPHIS: ANIMAL

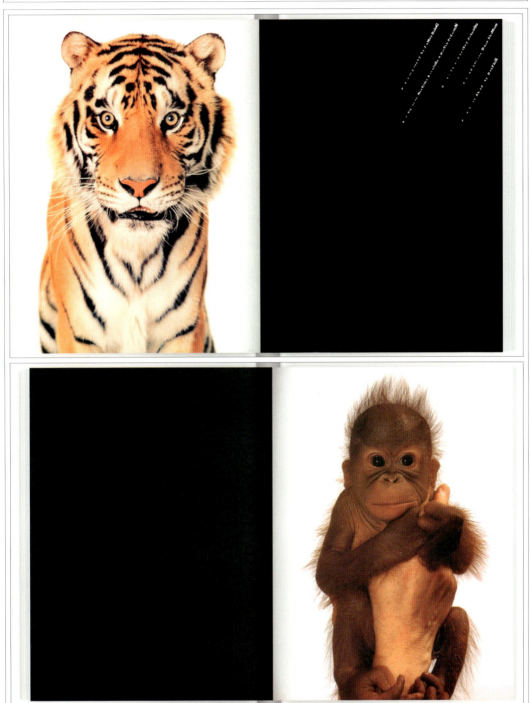

Design: B. Martin Pedersen | **Photos:** James Balog | **Pg. 331:** Commentary

220 GRAPHIS: TINTYPES

Design: B. Martin Pedersen | **Cover Photo:** Jayne Hines Bidaut | **Pg. 331:** Commentary

GRAPHIS: INFORMATION ARCHITECTS (RICHARD SAUL WURMAN) 221

Design: B. Martin Pedersen | Pg. 331: Commentary

222 GRAPHIS: MASTERS OF THE 20TH CENTURY

Design: Mervyn Kurlansky | **Pg. 331:** Commentary

GRAPHIS: JAPANESE MASTERS　　　223

Design: B. Martin Pedersen, Lauren Slutsky | **Cover Type:** Ikko Tanaka | **Pg. 331:** Commentary

224 GRAPHIS: ALLY & GARGANO

Design: Amil Gargano | **Pg. 331:** Commentary

GRAPHIS: TAKENOBU IGARASHI 225

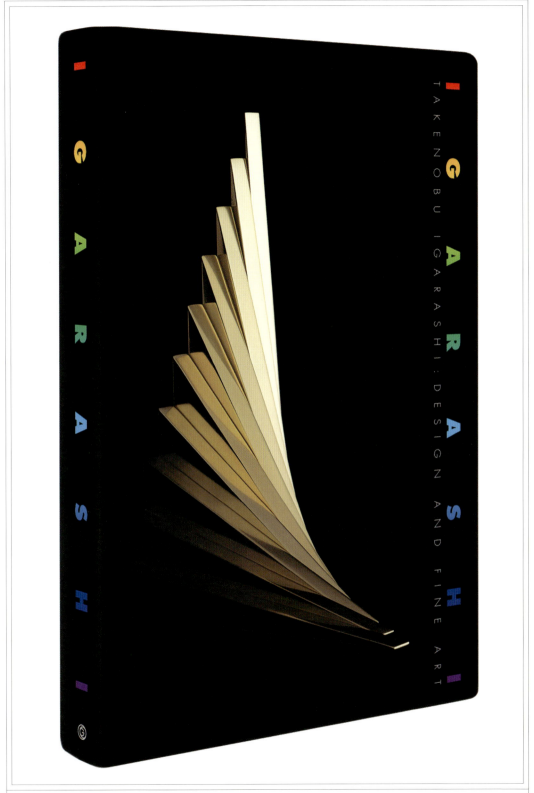

Design: B. Martin Pedersen, Heera Kim | **Cover Sculpture:** Takenobu Igarashi | **Pg. 332:** Commentary

226 GRAPHIS: JOSON

Design: B. Martin Pedersen | **Cover Photo:** JoSon | **Pg. 331:** Commentary

GRAPHIS: NARRATIVE DESIGN 227

Design: Kit Hinrichs | Pg. 331: Commentary

228 GRAPHIS: WILDE YEARS

SVA NYC

HONORING THE LEGACY OF THE

WILDE

YEARS - SCHOOL OF VISUAL ARTS

1706 GRAPHIS NEW TALENT SVA WINNERS FROM 2010 TO 2020
88 PLATINUM, 987 GOLD, AND 631 SILVER AWARDS WINNERS!

WILDE YEARS

Graphis

Design: B. Martin Pedersen, Richard Wilde, Hiewon Sohn | **Pg. 331:** Commentary

Graphis Magazine Covers 1944–1985: Walter Herdeg

230 GRAPHIS: MAGAZINE NO. 1/2

Design: Walter Herdeg | Cover Art: Max Hunziker | Pg. 332: Commentary

GRAPHIS: MAGAZINE NO. 5/6

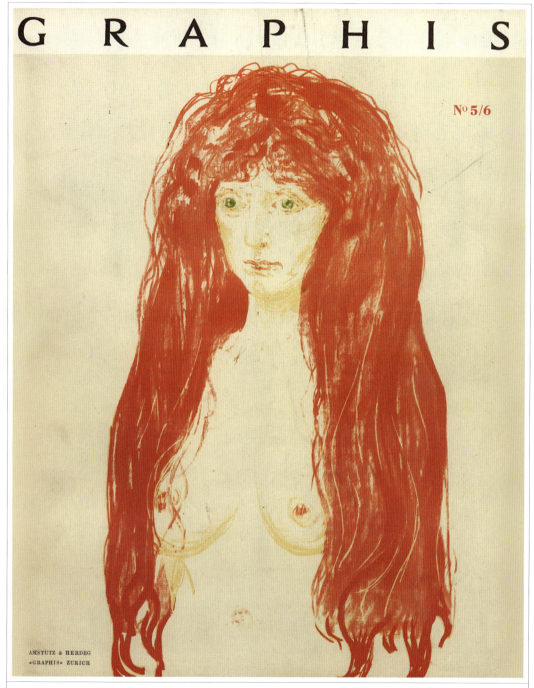

Design: Walter Herdeg | **Cover Art:** Edvard Munch | **Pg. 332:** Commentary

232 GRAPHIS: MAGAZINE NO. 112

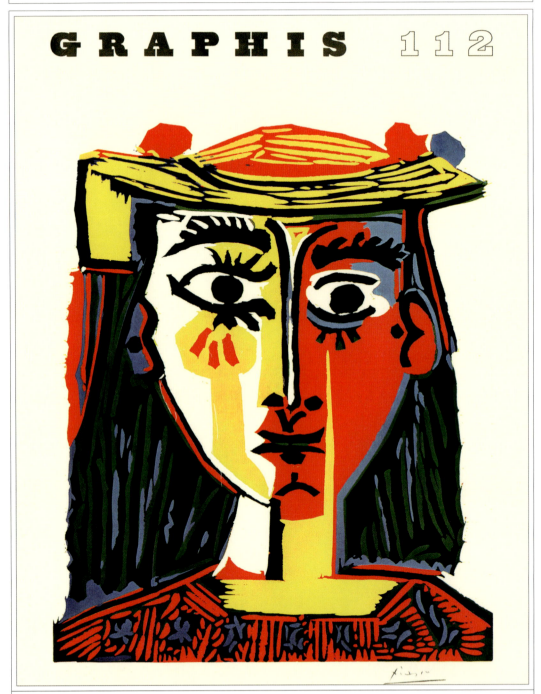

Design: Walter Herdeg | **Cover Art:** Pablo Picasso | **Pg. 332:** Commentary

GRAPHIS: MAGAZINE NO. 119

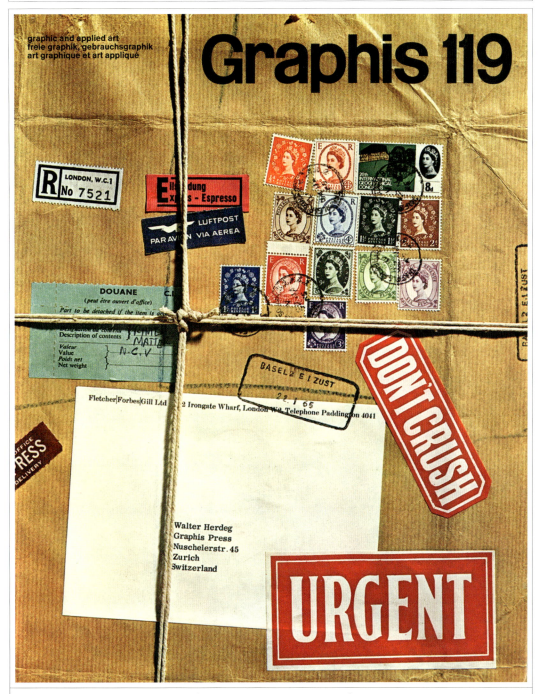

Design: Walter Herdeg | **Cover Art:** Fletcher/Forbes/Gill | **Pg. 332:** Commentary

234 GRAPHIS: MAGAZINE NO. 120

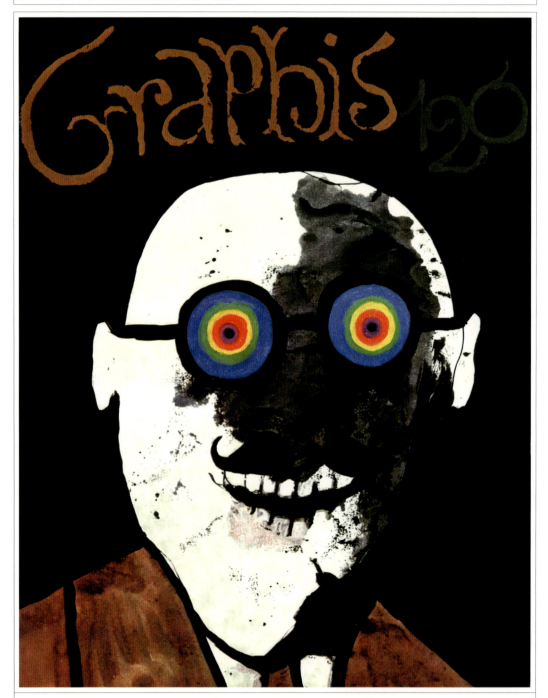

Design: Walter Herdeg | **Cover Art:** Tomi Ungerer | **Pg. 332:** Commentary

GRAPHIS: MAGAZINE NO. 122

graphis 122

Design: Walter Herdeg | **Cover Art:** Victor Vasarely | **Pg. 332:** Commentary

236 GRAPHIS: MAGAZINE NO. 123

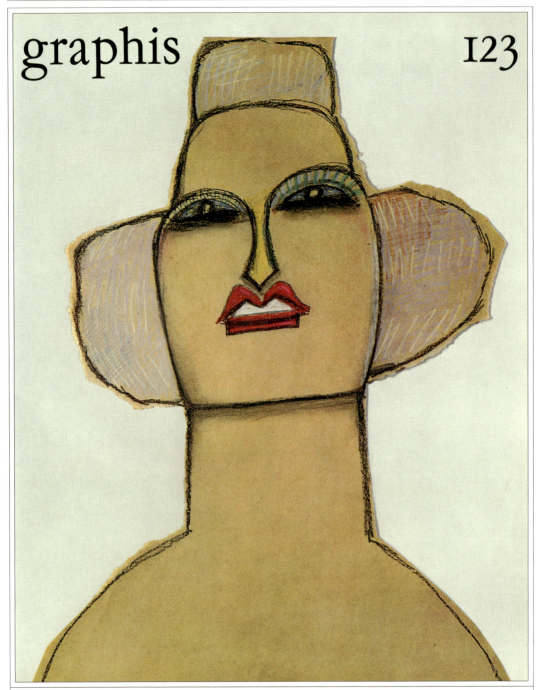

Design: Walter Herdeg | **Cover Art:** Saul Steinberg | **Pg. 332:** Commentary

GRAPHIS: MAGAZINE NO. 133 237

Design: Walter Herdeg | **Cover Art:** Milton Glaser | **Pg. 332:** Commentary

238 GRAPHIS: MAGAZINE NO. 135

Design: Walter Herdeg | Cover Art: Peter Max | Pg. 332: Commentary

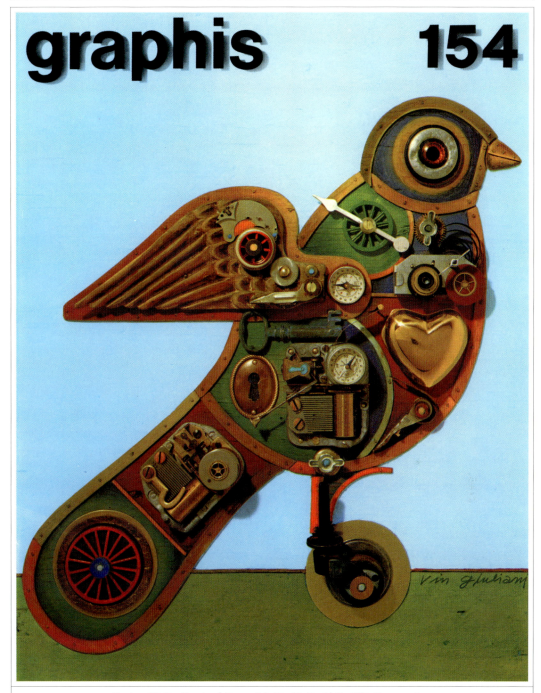

Design: Walter Herdeg | **Cover Art:** Vin Giuliani | **Pg. 332:** Commentary

240 GRAPHIS: MAGAZINE NO. 158

Design: Walter Herdeg | **Cover Art:** Mervyn Kurlansky | **Pg. 332:** Commentary

GRAPHIS: MAGAZINE NO. 173

Design: Walter Herdeg | **Cover Art:** Jean Mazenod | **Pg. 332:** Commentary

242 GRAPHIS: MAGAZINE NO. 175

Design: Walter Herdeg | **Cover Art:** Seymour Chwast | **Pg. 332:** Commentary

Design: Walter Herdeg | **Cover Art:** Richard Hess | **Pg. 332:** Commentary

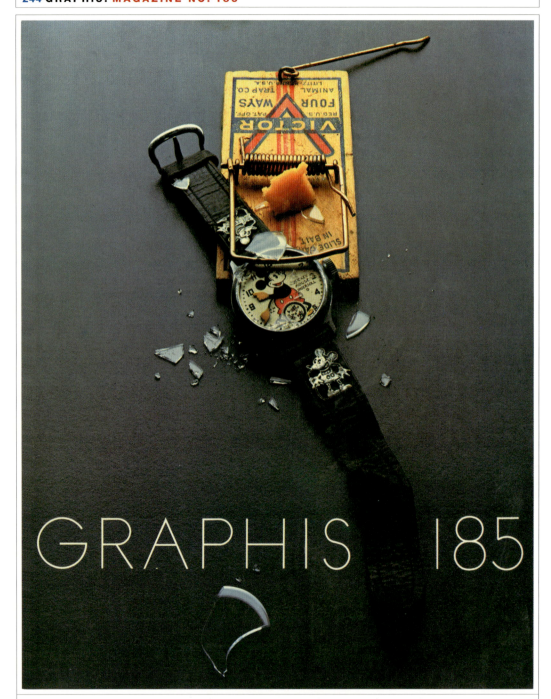

Design: Walter Herdeg | **Cover Photo:** Phil Marco | **Pg. 332:** Commentary

GRAPHIS: MAGAZINE NO. 191

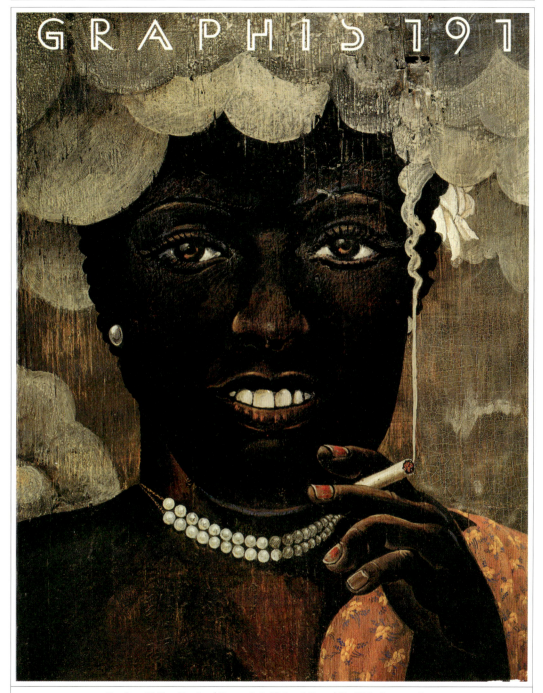

Design: Walter Herdeg | **Cover Art:** Richard Hess | **Pg. 332:** Commentary

246 GRAPHIS: MAGAZINE NO. 192

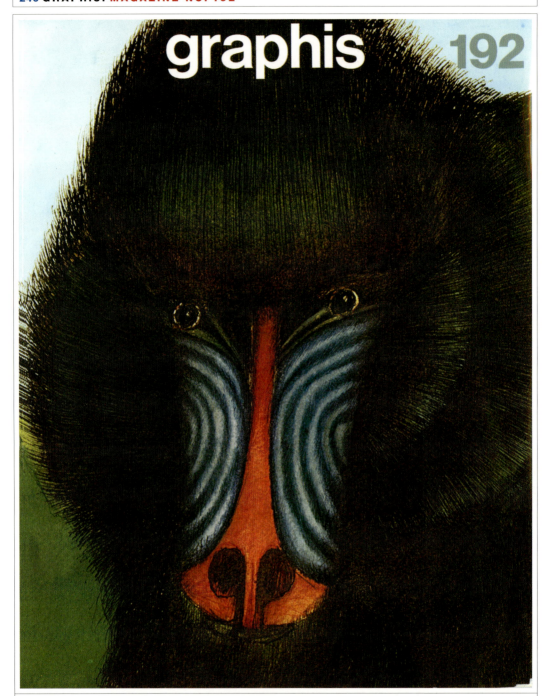

Design: Walter Herdeg | **Cover Art:** Alain Le Foll | **Pg. 332:** Commentary

GRAPHIS: MAGAZINE NO. 208 247

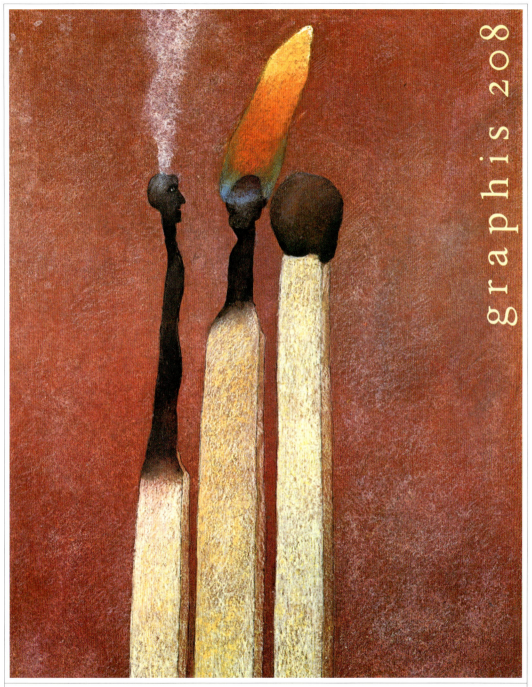

Design: Walter Herdeg | **Cover Art:** Étienne Delessert | **Pg. 332:** Commentary

248 GRAPHIS: MAGAZINE NO. 215

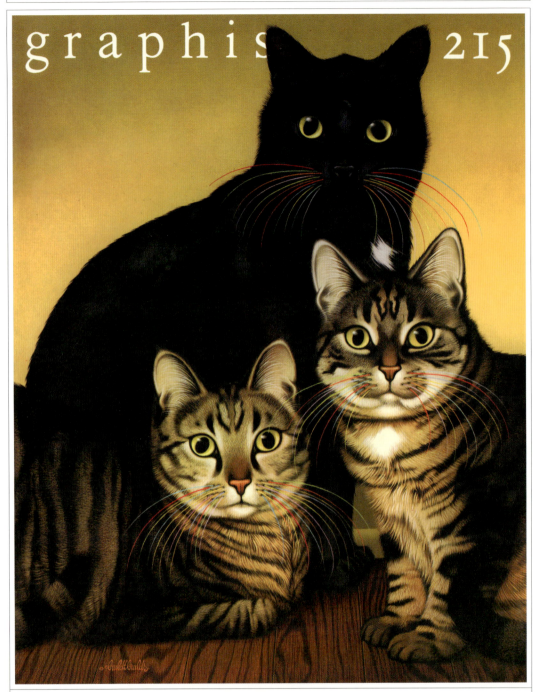

Design: Walter Herdeg | **Cover Art:** Braldt Bralds | **Pg. 332:** Commentary

GRAPHIS: MAGAZINE NO. 222

249

Design: Walter Herdeg | **Cover Art:** Mendell & Oberer | **Pg. 332:** Commentary

250 **GRAPHIS: MAGAZINE NO. 248**

Design: Walter Herdeg | **Cover Art:** Skip Liepke | **Pg. 332:** Commentary

Graphis
Magazine Covers 1985–2024: B. Martin Pedersen

252 GRAPHIS: MAGAZINE NO. 254

Design: B. Martin Pedersen | **Cover Photo:** Takenobu Igarashi, Mitsumasa Fujitsuka | **Pg. 332:** Commentary

GRAPHIS: MAGAZINE NO. 256 253

Design: B. Martin Pedersen | **Cover Art:** Ben Verkaaik | **Pg. 332:** Commentary

254 GRAPHIS: MAGAZINE NO. 275

Design: B. Martin Pedersen | **Cover Photo:** Ann Rhoney | **Pg. 332:** Commentary

GRAPHIS: MAGAZINE NO. 281

Design: B. Martin Pedersen | **Cover Art:** John Mattos | **Pg. 332:** Commentary

256 GRAPHIS: MAGAZINE NO. 288

Design: B. Martin Pedersen | **Cover Photo:** Reven T.C. Wurman | **Pg. 332:** Commentary

GRAPHIS: MAGAZINE NO. 304

257

Design: B. Martin Pedersen | **Cover Photo:** Penny Wolin | **Pg. 332:** Commentary

258 GRAPHIS: MAGAZINE NO. 311

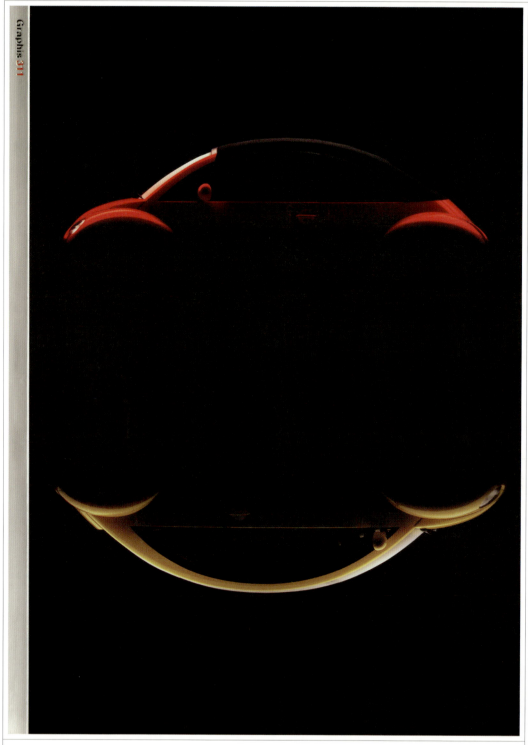

Design: B. Martin Pedersen | **Editor:** Martin C. Pedersen | **Cover Photo:** From Volkswagen | **Pg. 332:** Commentary

GRAPHIS: MAGAZINE NO. 322 259

Graphis322

Jennifer Sterling
Olgoj Chorchoj
Scholz & Friends
Howard Schatz
David Lancashire
Vietnam Art
Bruce McCall

Design & Cover: B. Martin Pedersen | **Pg. 332:** Commentary

260 GRAPHIS: MAGAZINE NO. 323

Graphis323

Stasys
Louise Fili
Paolo Roversi
Dale Chihuly
Jennifer Tipton
Mullen

Design & Cover: B. Martin Pedersen | **Pg. 332:** Commentary

GRAPHIS: MAGAZINE NO. 326, 328, 329, 330

261

Design & Cover: B. Martin Pedersen | **Pg. 332:** Commentary

262 GRAPHIS: MAGAZINE NO. 340

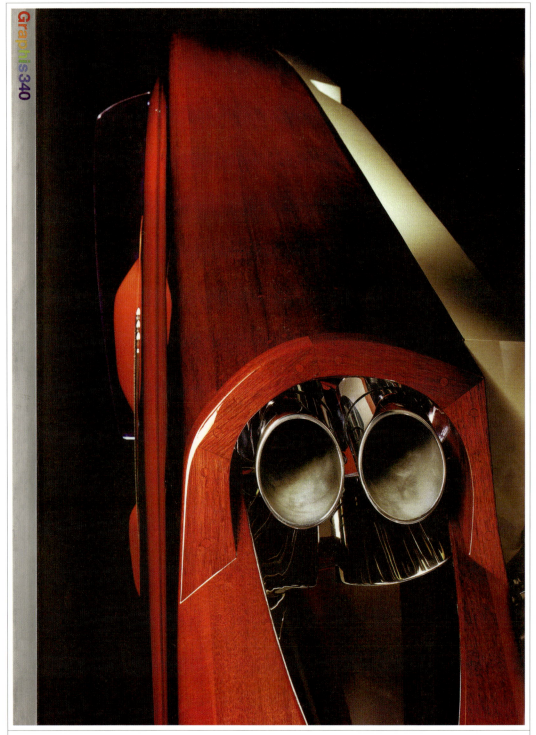

Design: B. Martin Pedersen | **Cover Photo:** Jorge Alvarez | **Pg. 332:** Commentary

GRAPHIS: MAGAZINE NO. 336

263

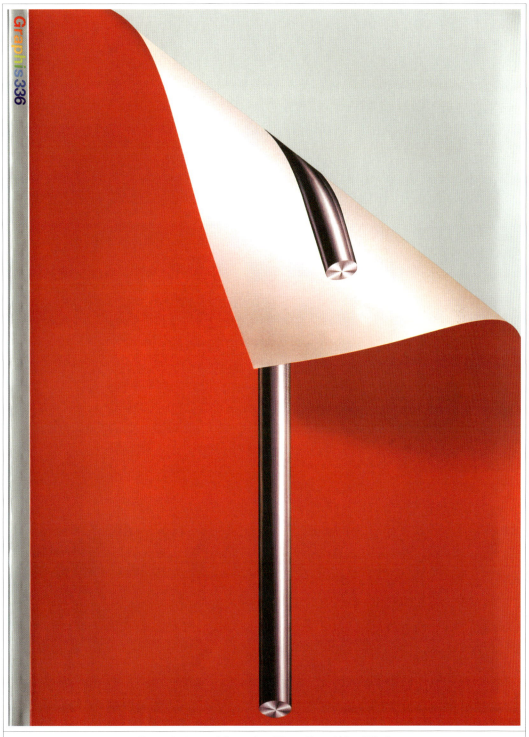

Design: B. Martin Pedersen | **Cover Art:** Mitsuo Katsui | **Pg. 332:** Commentary

264 GRAPHIS: MAGAZINE NO. 344

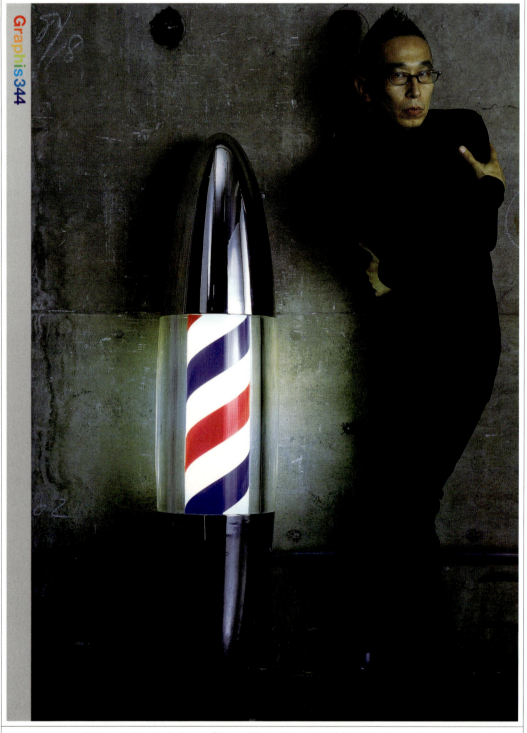

Design: B. Martin Pedersen | **Cover Photo:** Taku Satoh | **Pg. 332:** Commentary

GRAPHIS: MAGAZINE NO. 351

265

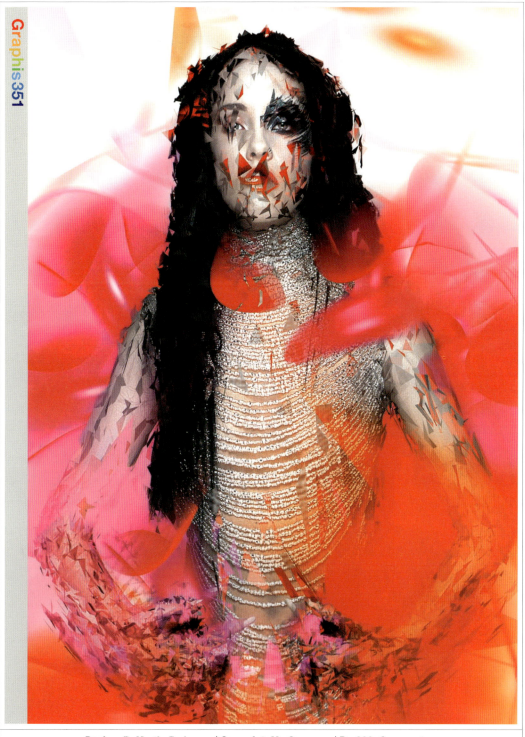

Design: B. Martin Pedersen | **Cover Art:** Me Company | **Pg. 332:** Commentary

Graphis Journals

GRAPHIS: JOURNAL DESIGN EXPLORATION 267

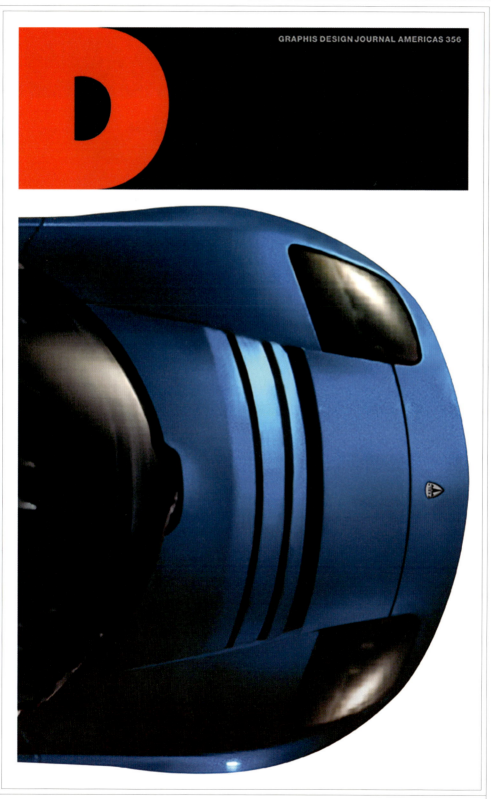

Design: B. Martin Pedersen, YonJoo Choi | **Cover Photo:** Tesla | **Pg. 332:** Commentary

268 GRAPHIS: JOURNAL DESIGN EXPLORATION, DES/ADV/PHO/ID+A

Design: B. Martin Pedersen, YonJoo Choi | **Cover Photos:** #1 Tesla, #2 Goodby, Silverstein & Partners, #3 Henry Leutwyler, #4 Harley-Davidson | **Pg. 332:** Commentary

GRAPHIS: JOURNAL DESIGN EXPLORATION, ID+A 269

Design: B. Martin Pedersen, YonJoo Choi | **Vase Design:** Unknown | **Pg. 332:** Commentary

270 GRAPHIS: JOURNAL NO. 356

Design: B. Martin Pedersen | **Cover Art:** Rachel Ake | **Instructor:** Carin Goldberg | **Pg. 332:** Commentary

GRAPHIS: JOURNAL NO. 357

Design: B. Martin Pedersen | Cover Art: Peter Kraemer | Pg. 332: Commentary

Terry Heffernan: Not So Still Life

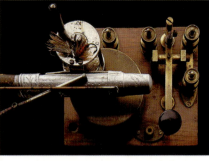

TERRY HEFFERNAN IS ONE OF THE BEST PHOTOGRAPHERS IN THE WORLD—HIS WORK SPEAKS FOR ITSELF. WHAT SEPARATES HIM FROM OTHERS IS HIS ABILITY TO MAKE EVERY DESIGNER'S OR ART DIRECTOR'S WORK BETTER THAN IT WAS ORIGINALLY ENVISIONED.

TERRY SIMPLY LOVES MAKING IMAGES, WHETHER IT'S ON ASSIGNMENT FOR AN AD AGENCY OR ROAMING THE BASEMENT OF AN OBSCURE MUSEUM.

I HAVE LEARNED MUCH FROM HIM. WE SHARE A WAY OF SEEING, WHICH SEEKS TO REDUCE THINGS TO THEIR CLEANEST, SIMPLEST, AND MOST GRAPHIC REPRESENTATIONS. AT LEAST I TRY FOR THIS; TERRY IS A MASTER OF IT.

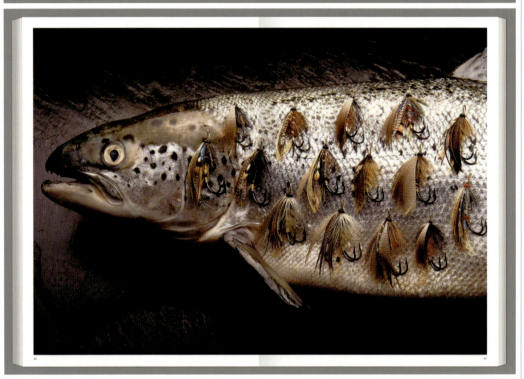

Design: B. Martin Pedersen | **Photos:** Terry Heffernan | **Pg. 332:** Commentary

GRAPHIS: JOURNAL NO. 357

Design: B. Martin Pedersen | **Top Art:** Mitsuo Katsui | **Bottom Art:** Woody Pirtle | **Pg. 332:** Commentary

274 GRAPHIS: JOURNAL NO. 358

Design: B. Martin Pedersen | **Cover Art:** Hoon-Dong Chung | **Pg. 332:** Commentary

GRAPHIS: JOURNAL NO. 359

GRAPHIC DESIGN | ADVERTISING | PHOTOGRAPHY | ART/ILLUSTRATION | PRODUCTS | ARCHITECTURE | EDUCATION

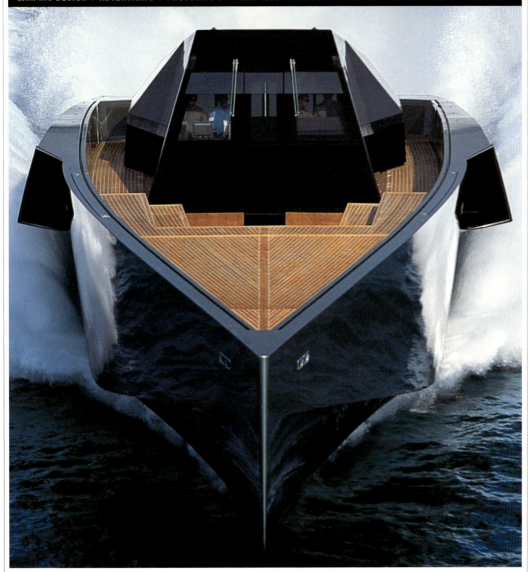

Design: B. Martin Pedersen | **Cover Photo:** Gilles Martin-Raget | **Pg. 332:** Commentary

276 GRAPHIS: JOURNAL NO. 358

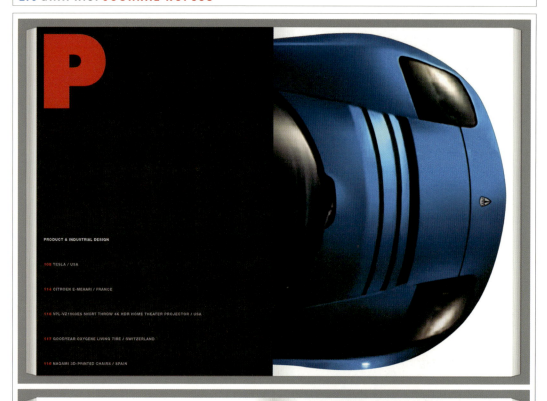

PRODUCT & INDUSTRIAL DESIGN

108 TESLA / USA

114 CITROEN E-MEHARI / FRANCE

116 VPL-VZ1000ES SHORT THROW 4K HDR HOME THEATER PROJECTOR / USA

117 GOODYEAR OXYGEN LIVING TIRE / SWITZERLAND

118 NAGAMI 3D-PRINTED CHAIRS / SPAIN

Toshiaki & Hisa Ide's IF Studio: Storytelling in Branding

EVERY SO OFTEN, A DESIGN TEAM EMERGES THAT RAISES THE BAR FOR EVERYONE. SUCH IS THE CASE WITH IF STUDIO. THEIR THINKING, CREATIVE OUTPUT, AND TIMELESS WORK REPRESENT THE BEST OF WHAT DESIGN "CAN BE" AND "SHOULD BE."
Dana Arnett, CEO, VSA Partners

THE NAME OF THEIR STUDIO, IF, SAYS EVERYTHING THERE IS TO KNOW. THEY ARE A CREATIVE TEAM THAT IS ALWAYS WONDERING WHAT IF, OR WHERE TO, OR WHAT NEW DIRECTIONS TO TAKE IN EVERYTHING THEY DO.
Kit Hinrichs, Principal, Studio Hinrich

THE WORK OF IF STUDIO IS A LOVE AFFAIR. THEIR COMMUNICATION, BASED ON THE SUBLIME COMBINATION OF GRAPHIC DESIGN AND PHOTOGRAPHY, IS ALWAYS CARRIED OUT WITH A SENSE OF CREATIVITY, INNOVATION, AESTHETIC RIGOR, AND PASSION, PROVOKING AN EMOTIONAL EXPERIENCE OF RARE BEAUTY.
João Machado, Founder, João Machado

TOSHIAKI AND HISA IDE COMBINE EXQUISITE ART DIRECTION WITH FLAWLESS TYPOGRAPHY THAT RESULT IN IMAGES THAT ACHIEVE BEAUTY, WHICH IS THE BEST THING I CAN SAY ABOUT A DESIGNER.
Stefan Sagmeister, Founder, Sagmeister & Walsh

Design: B. Martin Pedersen | **Top Photo:** Tesla | **Bottom Design:** IF Studio
Pg. 332: Commentary

GRAPHIS: **JOURNAL NO. 359** 277

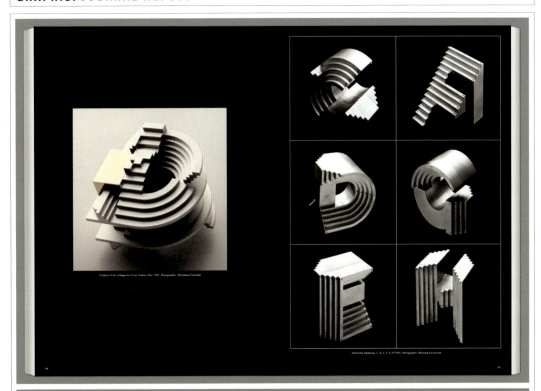

Design: B. Martin Pedersen | **Top Sculptures:** Takenobu Igarashi | **Bottom Ad:** Giulia Giancola
Instructor: Kevin O'Neill | **Pg. 332:** Commentary

278 GRAPHIS: JOURNAL NO. 360

Design: B. Martin Pedersen | **Cover Photo:** Howard Schatz | **Pg. 332:** Commentary

Design: B. Martin Pedersen | **Cover Photo:** Caroline Knopf | **Pg. 332:** Commentary

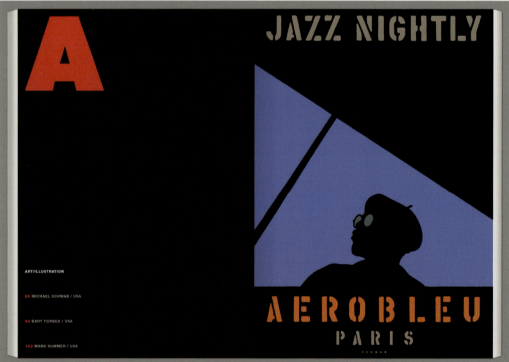

Design: B. Martin Pedersen | **Top Photos:** Howard Schatz | **Bottom Design:** Michael Schwab
Pg. 332: Commentary

GRAPHIS: JOURNAL NO. 361

281

Introduction by Allan Weitz, Photographer

Creativity is not the rarest of attributes, nor are technical skills, or an eye for design for that matter. But when you channel these attributes through a single individual—specifically a creative, technically-minded individual with a good eye and a camera, you get something special in return. - Parish Kohanim possesses each of these attributes and he channels his trifecta of gifts into producing commercial and fine art photographs that are as fresh and captivating today as when he first hit the scene over 30 years ago. - I remember first seeing his work early on, and being a nit-picker when it comes to color and composition, I began keeping an eye out for his work when flipping through magazines and trade journals. Spotting Kohanim's photographs isn't a challenge—his sense of composition, color, and texture meld fluidly, regardless of his subject matter. - In a world in which we are literally bombarded by visual imagery wherever we look, it pleases me to know I can still spot - and appreciate - a Parish Kohanim photograph when I see one.

STOP SPENDING SO MUCH TIME ON YOUR DEVICES.
NOTICE THE BEAUTY ALL AROUND YOU.
Parish Kohanim, Photographer

Introduction by Robert Appleton, Designer, Professor, & AGI Member

I've known Peter and Janet since the early 1980s when Peter ran the design firm and Janet made art. The quality of Peter's typography, his concepts and his image making as an illustrator, painter, collagist and embroiderer, are each enough to signify the title of "master." The additional presence of modesty and humor complete the signs of a great communicator. Add to this his skill of creating unique works imbued with an uncanny folk quality and you have that very unusual individual: a complete Designer, a business-person and an Artist residing in one body. Janet's fearlessness in dealing with complex emotions have made her art challenging from the beginning. Her mastery of form expresses beauty and depth. When she developed a passion for modernist typography, she also mastered that. Then came the retail store. Her business and civic intelligence have real standing in the town where their entire family (including two talented sons: Jesse, a sculptor, and Justin, a writer and musician) has lived for many years. Peter and Janet Cummings Good are a design paradigm - a kind of arts and crafts movement of their own, which demonstrates a new (and old) way forward in American design.

**Design: B. Martin Pedersen | Top Photos: Parish Kohanim | Bottom Designs: Cummings & Good
Pg. 332: Commentary**

282 GRAPHIS: JOURNAL NO. 362

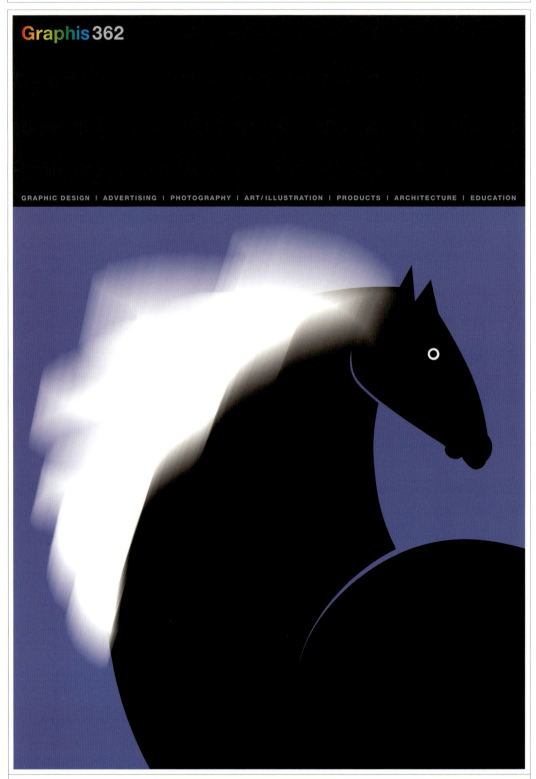

Design: B. Martin Pedersen | Cover Art: João Machado | Pg. 332: Commentary

GRAPHIS: JOURNAL NO. 363

283

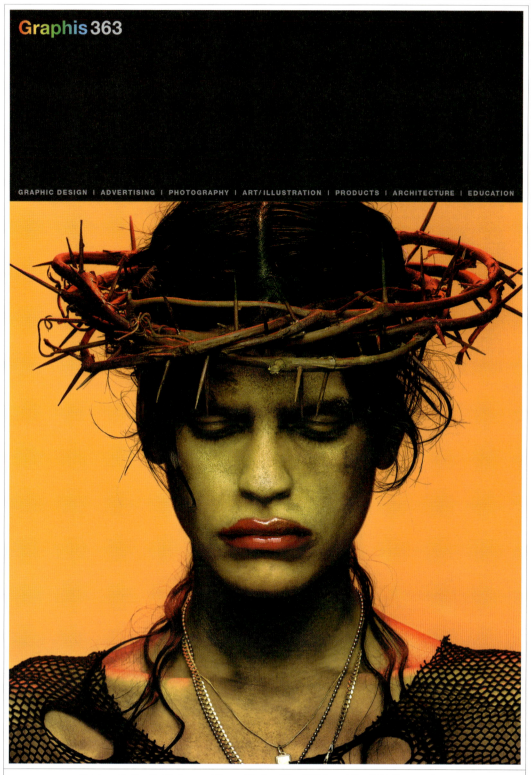

Design: B. Martin Pedersen | **Cover Photo:** Albert Watson | **Pg. 332:** Commentary

284 GRAPHIS: JOURNAL NO. 362

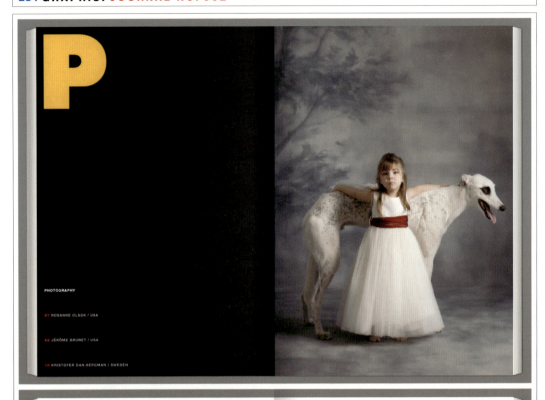

PHOTOGRAPHY

57 ROSANNE OLSON / USA

69 JÉRÔME BRUNET / USA

78 KRISTOFER DAN-BERGMAN / SWEDEN

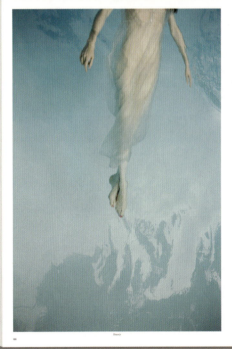

Introduction by Howard Schatz Photographer

If one looks, i.e. really studies the photographic works of Rosanne Olson, one begins to discover that there are layers of visual magic that become revealed that are not immediately noted at the initial examination. There is more to see with each looking and more to feel. It is quite a rich experience to study her work as it is consistently charming, initially. It then blossoms to enchanting, alluring, and even magically sublime. ■ Each area of her impressive range of endeavors embraces a distinctive vision that includes inventive thinking, tender caring, and compassion. ■ I so much enjoyed carefully looking at her work; and in many cases having seen before, relooking. One gets the idea that behind these wonderfully imaginative images is a beautifully lovely human being—the photographs revealing the photographer.

ROSANNE POSSESSES A RARE COMBINATION OF ARTISTIC SENSIBILITY, COMPASSIONATE HEART, AND MASTERY OF HER MEDIUM. SHE CREATES AN IMPRESSIVE RANGE OF LOVELY, EVOCATIVE IMAGES THAT TRULY RESONATE WITH PEOPLE.

Gregory Heisler, *Portrait Photographer*

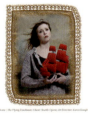

Design: B. Martin Pedersen | Photos: Rosanne Olson | Pg. 332: Commentary

Design: B. Martin Pedersen | **Top Photo:** Albert Watson | **Bottom Art:** Audi | **Pg. 332:** Commentary

286 GRAPHIS: JOURNAL NO. 364

Design: B. Martin Pedersen | **Cover Art:** Milton Glaser | **Pg. 332:** Commentary

Milton Glaser has inspired many young designers and illustrators in his career. He too was inspired by a painter from the past, Claude Monet. When I found this out, I asked Milton if he would write a letter to Monet as if he were alive today. On the following page, you can read his handwritten letter. From one legendary icon to another.

Dear Monet,
Over the last year I have been working on a series of drawings based more or less on your life. I say more or less because some of the events I have depicted are based on actual photographs of you, your garden, and your contemporaries. Other scenes are completely made up. There is a sense that all history is a series of opportunistic lies, in the air right now, that makes it quite possible for me to invent your life to suit my own needs. Curiously I've never felt drawn to your work because I related it to my own. Actually I embarked on the series because I felt it might move me in a direction that was unfamiliar. The attempt to transform solid intractable paint into mutable light has never been a concern of mine. I realize that as much as anything, the way you looked, portly, solid, earthy, bearded, with a cigarette dangling from your lips, and a wide brimmed hat on your head make you enormously drawable. I also recall the pleasure of a visit to your home and garden at Giverny some years ago. The scope of your ambition in creating an earthly paradise was what impressed me most.

The restored gardens, the lily pond, the wisteria that covered the Japanese bridge all exceeded my expectations, but it was your yellow dining room and blue tiled kitchen that delighted me most. Years later I designed a restaurant for the Barbizon Hotel called Monet's dining room, based on your remarkable interiors. Sadly the project was never implemented. Perhaps, on the other hand it is better for some ideas to remain unexploited. It is the harmony and totality of your life and vision I find most compelling. The yellow dining room with its japanese prints, painted chairs and specially designed yellow plates create an atmosphere as pleasurable and life enhancing as any of your paintings.
I suspect that you were not an easy man to be with. No one with your immense will and appetite could be. As for me, holding you in my mind and entering your luminous world this past year, has been a source of profound pleasure. Thank you for all that.
Milton Glaser

CLAUDE, THE HARMONY AND TOTALITY OF YOUR LIFE AND VISION I HAVE FOUND MOST COMPELLING.

HOLDING YOU IN MY MIND AND ENTERING YOUR LUMINOUS WORLD THIS PAST YEAR, HAS BEEN A SOURCE OF PROFOUND PLEASURE.
THANK YOU FOR ALL THAT. Milton Glaser, *Designer*

Design: B. Martin Pedersen | Art & Text: Milton Glaser | Pg. 332: Commentary

GRAPHIS: JOURNAL NO. 365

289

Introduction by Robert Rodriguez *Illustrator, Graphis Master*

Several years ago, at ArtCenter College of Design, I remember Braldt telling students he wasn't a better artist than anyone else, he just worked harder. I knew at the time it was exactly what they needed to hear, even though it wasn't completely accurate. The fact is, Braldt is better than anyone else. His paintings could easily fall into just being about technique, but they never do. There is an emotional calmness that always makes them more than that. His work is so personal, though the influence of the early Dutch masters is evident, it's filtered through Braldt's personality, with all his sensitivity and humor. I saw a recent painting of his from across the room and I immediately knew the artist. The colors and atmosphere read from 15 feet away, even before I got close enough to see the perfection in the brushwork.

I PERSISTENTLY PURSUED MY PATH
BY MY OWN MEANS, TEACHING MYSELF
HOW TO DRAW AND PAINT.

Braldt Bralds,

Introduction by Adam Voorhes *Photographer at The Voorhes*

I idolized Mark Laita when I was a student and sent him letters begging to work for him. They included photos of toilet brushes in toilets and brooms with dustpans. His studio manager did have me come into his Culver City studio for a couple of days, but it was just two weeks before I moved to New York. Laita's work has been an inspiration and a high water mark for Robin and I to look up to from the beginning of our career. From the simplicity of light raking over soft folds of fabric, to complex conceptual composites, Laita paved the way from classic to contemporary still life photography. His work can be simultaneously timeless and timely, and endlessly inspiring.

PHOTOGRAPHER MARK LAITA HAS A CAREER
THAT SPANS OVER 20 YEARS, WITH HIS CLEAN,
GRAPHIC IMAGERY USED BY CLIENTS SUCH
AS APPLE AND BMW.

Jessica Stewart,

Design: B. Martin Pedersen | **Top Art:** Braldt Bralds | **Bottom Photos:** Mark Laita | **Pg. 332:** Commentary

Design: B. Martin Pedersen | **Cover Art:** Mark Hess | **Pg. 332:** Commentary

292 GRAPHIS: JOURNAL NO. 366

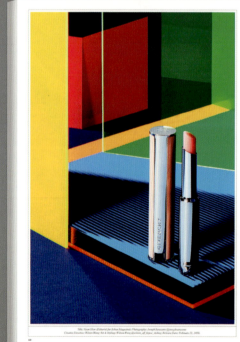

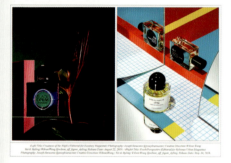

> THERE ARE A LOT OF DAYS THAT IT JUST FEELS LIKE A JOB, AND THERE ARE DAYS THAT I CAN'T IMAGINE MY LIFE WITHOUT IT. I LOVE CREATING IMAGES.
> —Joseph Saraceno, *Photographer*

Design: B. Martin Pedersen | **Top Art:** Mark Hess | **Bottom Photos:** Joseph Saraceno | **Pg. 332:** Commentary

ADVERTISING

JOHN FAIRLEY, CURIOUS PRODUCTIONS / UK

Introduction by Toshiaki & Hisa Ide, *Founder Partner Exec. Creative Director, & Design Director, IF Studio*

We have worked together with Athena for 7 years now. She is a great talent in the creative field. Design today is all about collaboration and, unlike the 90's or early 2000's, you can't rely on craftsmanship only. One needs to be flexible and collaborative. The overall look and feel is critical. We collaborate and work together to make something great. • Athena brings in charisma and positive energy once she steps into the room. We may not always agree, but the creative collaboration is easy—a conversation explored from many perspectives. Influenced by her work in theater, film, and photojournalism, Athena's photography stands out in that she dives into storytelling and expresses the theatricality of a moment in a single frame. • Her work goes deeper than the 2-dimensional photographic print. She facilitates and expresses the entire design process at IF Studio as the Associate Creative Director. She develops the design concept, understands the product, and incorporates the marketing and advertising goals while balancing the budget and communicating with the creative and client teams— which is quite unique. Her strength is this multifaceted approach while still expressing a sense of relationship and an emotional connection to design.

IF YOU FIND YOURSELF SAYING "BUT" OR "IF" OR "I'M TRYING", NO MORE EXCUSES! GET CREATIVE!

Athena Azevedo, *Photographer & Associate Creative Director, IF Studio*

Design: B. Martin Pedersen | Top Photo: Dan Humphreys | Bottom Photos: Athena Azevedo | Pg. 332: Commentary

Design: B. Martin Pedersen | **Plane Design & Cover Photo:** Finn Nygaard | **Pg. 332:** Commentary

P

PHOTOGRAPHY

LENNETTE NEWELL / USA

ARMAND TAMBOLY / GERMANY

Introduction by Susan Baraz *Director of Photography, AtEdge*

In my life's work, I've been very fortunate to be involved in judging, heading events, and reviewing thousands upon thousands of photographers' images. Many have melded together, and names are rarely etched in my mind. It's mostly been on to the next one. All that halted when it came to Lennette Newell. Her name and her work was unforgettable from the moment I viewed it so many years ago. "Who is this person?" I remembered saying to myself. These images were beyond anything I could claim a reference to, and to my delight took me to new photo realms: animals, people as animals, whole, bizarre, mysterious worlds created, using a familiar base as the starting point. It was an immediate, visceral reaction, and to this day that feeling remains unchanged. Newell's work never fails to excite. Lennette is constantly striving to conceive, construct, and compose works that convey something truly unique in photography. The results are always, to me, breathtaking. Great photography has a universal appeal. It's a passport to an adventure without boundaries. It elicits an experience that's capable of transforming us. Handled through the eyes of a brilliant photographer, it transports to an unknown, never before seen world. Lennette Newell captures that each time she embarks on a new project. She encapsulates the always elusive mystery of wondrous photography.

WITH MORE EXPERIENCE, YOU WORK SMARTER, AND WITH THAT COMES THE ABILITY TO RECOGNIZE WHEN A MOMENT IN TIME CAPTURE IS TRULY EXTRAORDINARY. **Lennette Newell,** *Photographer*

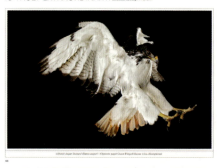

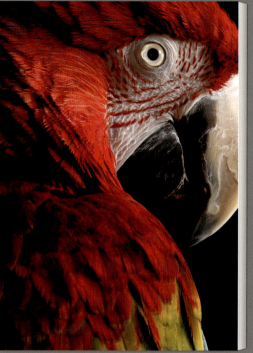

Design: B. Martin Pedersen | Photos: Lennette Newell | Pg. 332: Commentary

FBC Design: Fit for Film

DOING SHOOTS FOR NETWORK TV IS NEVER EASY, BUT FBC ALWAYS HAS A SOLID GAME PLAN AND LEAVES ENOUGH ROOM TO FIND UNEXPECTED PIECES OF MAGIC. THEY TAKE THE RAW IMAGERY AND COME BACK WITH SOMETHING EXCELLENT.
Mathieu Young, *Photographer*

WORKING FOR OVER A DECADE WITH FX AND FOX TV, I'VE WORKED ON SOME AMAZING PROJECTS. THEY'VE GIVEN ME THE CHANCE TO PUSH BOUNDARIES AND EXPAND THEIR IDEAS. I AM BLESSED TO WORK WITH CREATIVES LIKE THIS.
Frank Ockenfels, *Photographer*

I'VE WORKED WITH THE TEAM AT FBC FOR OVER A DECADE ON NUMEROUS SHOOTS. THE ENTIRE TEAM HAS ALWAYS BEEN GREAT AND PAUL SPECIFICALLY HAS BEEN AN AMAZING COLLABORATOR EVERY TIME WE HAVE WORKED TOGETHER.
Justin Stephens, *Photographer*

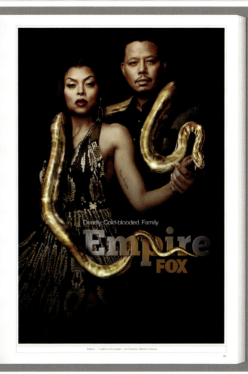

P

PRODUCT & INDUSTRIAL DESIGN

114 DIAMOND AIRCRAFT DA42-VI / AUSTRIA

116 MELT MIRRORS BY BOWER STUDIOS / USA

117 BLACK HOLE BY FUTUREDGE DESIGN STUDIO / IRAN

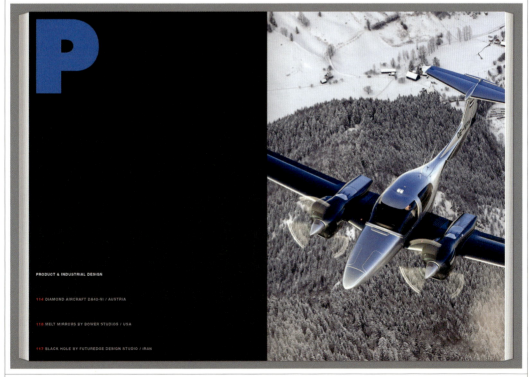

Design: B. Martin Pedersen | Top Design: FBC Design | Bottom Photo: Diamond Aircraft | Pg. 332: Commentary

298 GRAPHIS: JOURNAL NO. 370

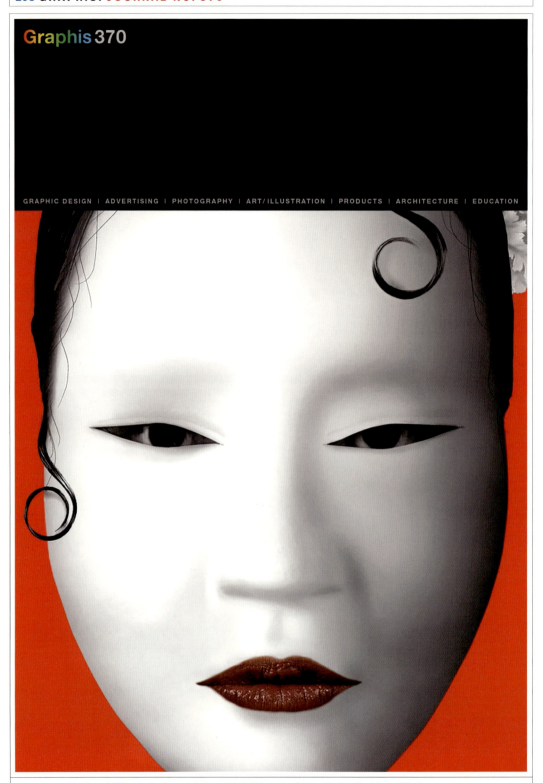

Design: B. Martin Pedersen | Cover Art: Eduardo del Fraile Studio | Pg. 332: Commentary

GRAPHIS: JOURNAL NO. 371

Graphis 371

GRAPHIC DESIGN | ADVERTISING | PHOTOGRAPHY | ART/ILLUSTRATION | PRODUCTS | ARCHITECTURE | EDUCATION

Design: B. Martin Pedersen | Cover Art: Thomas Blackshear | Pg. 332: Commentary

300 GRAPHIS: JOURNAL NO. 370

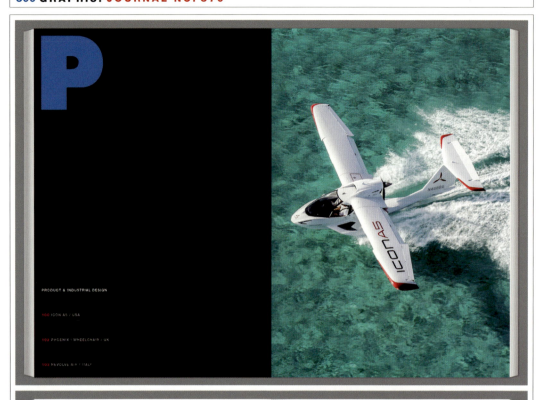

PRODUCT & INDUSTRIAL DESIGN

100 ICON A5 / USA

102 PHOENIX I WHEELCHAIR / UK

103 REVOLVE AIR / ITALY

Michael Schoenfeld: Finding the Beauty in Everyone

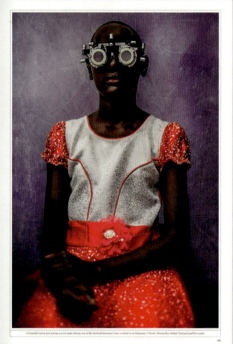

LOCATION, STUDIO PORTRAIT, STILL-LIFE, EDITORIAL — MICHAEL HAS TACKLED THEM ALL. I CAN'T THINK OF ANYONE MORE SKILLED AT POST-PRODUCTION DIGITAL WORK. HE'S CONSISTENTLY EXPLORING NEW TECHNIQUES AND STYLISTIC IDEAS.
Scott Eggers, *Founder & Graphic Designer, Eggers Design*

HAVING WORKED WITH MICHAEL FOR NEARLY THIRTY YEARS, I'VE WATCHED HIM WORK ON HUNDREDS OF PROJECTS. HE APPROACHES EVERY ASSIGNMENT WITH THE SAME ENERGY AND PASSION, REGARDLESS OF THE SIZE OR SCOPE.

HE SEES EVERY PHOTO AS AN OPPORTUNITY TO TELL A STORY. HE DOESN'T GET DISTRACTED BY TRENDS OR GET LOCKED INTO A PARTICULAR STYLE. HE CRAFTS AND PUSHES IMAGES THAT RESONATE WITH HIS AUDIENCE.
Richard Oliver, *Chief Creative Officer & Partner, Pedimy*

I'VE WORKED WITH SEVERAL GIFTED CREATIVES; VERY FEW ARE LIKE HIM. AGENCIES OFTEN HIRE OUTSIDE TALENT, AND IN DOING SO, WE EXPOSE OURSELVES TO VARIABLES WE CAN'T CONTROL.

WORKING WITH HIM RELIEVES THIS VULNERABILITY. GENUINE CREATIVITY, HONEST PROFESSIONALISM, AND A REAL "KNOCK IT OUT OF THE PARK" MENTALITY SEEM TO BE HIS GO-TO.
Ben Cranes, *Creative Director, Good Barker Boston*

Design: B. Martin Pedersen | **Top Photo:** Icon Aircraft | **Bottom Photo:** Michael Schoenfeld | **Pg. 332:** Commentary

GRAPHIS: JOURNAL NO. 371

Introduction by Alain Le Quernec *Graphic Designer, ALQ*

Too often we associate the work of a graphic designer with a particular emblematic work. This is reductive, and sometimes a bad habit, because it obscures the interest in and the diversity of the designer's other work. Yet, that is exactly what I end up doing with Boris Ljubicic, whose name recalls the memory of the strong feeling I got when I discovered, for the first time, the poster for the Mediterranean Games. I remember how much I was struck by its strength, its simplicity, and its obviousness. It's the rare case of an image that makes you think, "How is it possible that nobody did it before?" and makes any attempt to be inspired by it look like plagiarism. That is why the name Boris Ljubicic is, for me, definitely associated with this image. It is purely sentimental.

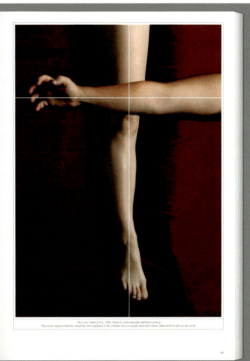

HIS MAJOR CONTRIBUTION TO CROATIAN DESIGN WAS THE IDENTITY CREATION FOR THE MEDITERRANEAN SPORT GAMES IN SPLIT. WITH THAT PROJECT, LJUBICIC SET THE STANDARDS FOR CORPORATE IDENTITY CREATION IN CROATIA.
Goroslav Keller,

Introduction by Maryvonne Leshe *Managing Partner, Trailside Galleries*

Every artist is always working towards creating something new, original, and emotionally satisfying, a feat easier said than done. Upon viewing Thomas Blackshear's art for the first time, the work immediately struck me as being uniquely original, creative, and powerful. It was clear this was an artist who looked at Western art through a completely different lens and who possessed a very innovative perspective. We had the opportunity to meet at a museum event several years ago, and I invited him to join my gallery. In the years since, it has been wonderful to watch the continued growth of his creative process and to witness the well-deserved awards and accolades. I find Thomas to be an extremely talented, intelligent, humble, and gracious man, and someone that I am lucky to call a friend.

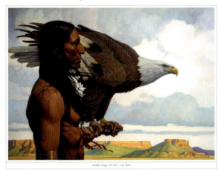

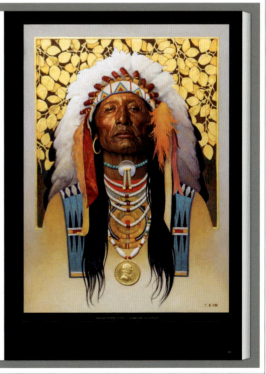

ILLUSTRATION IS LIKE PUTTING A PUZZLE TOGETHER, TRYING TO SHOW DIFFERENT WAYS OF TELLING A STORY VISUALLY.
Thomas Blackshear,

Design: B. Martin Pedersen | **Top Designs:** Boris Ljubicic | **Bottom Art:** Thomas Blackshear | **Pg. 332:** Commentary

Graphis 372

GRAPHIC DESIGN | ADVERTISING | PHOTOGRAPHY | ART/ILLUSTRATION | PRODUCTS | ARCHITECTURE | EDUCATION

Design: B. Martin Pedersen | **Cover Photo:** Tim Flach | **Pg. 332:** Commentary

GRAPHIS: JOURNAL NO. 373

Design: B. Martin Pedersen | **Cover Photo:** Giulia Giancola | **Instructor:** Kevin O'Neill | **Pg. 332:** Commentary

Robert Tardio: Spectacular Still Lives

ROBERT HAS THE AMAZING ABILITY TO CREATE CONTEMPORARY IMAGES THAT BECOME TIMELESS. HE HAS A TRUE UNDERSTANDING OF COMPOSITION, AND IS A MASTER OF USING NEGATIVE SPACE.
Craig Cutler, Photographer, Craig Cutler Studios

HIS BRILLIANT CREATIVE MIND, COUPLED WITH HIS HUMBLE, EGOLESS SOUL, MAKES HIM THE RAREST OF RARE TALENT. HE HAS AN INHERENT ABILITY TO FIND THE EXTRAORDINARY IN THE ORDINARY.
Abbe Novack, Senior Producer, Buzz

TO SPEND A DAY WITH ROBERT, WORKING TOGETHER TO CREATE AMAZING IMAGES IS, QUITE FRANKLY, THE BEST PART OF MY JOB.
Mike Hoffman, Associate Creative Director, Buzz

HE IS ONE OF THOSE RARE CREATIVE TYPES WHO MAKE EVERYTHING LOOK EFFORTLESS, WHEN IN AN INDUSTRY THAT IS FAST-PACED AND EVER-EVOLVING, THEIR ATTENTION TO DETAIL IS ANYTHING BUT.

HE NEVER FAILS TO TREAT EACH CLIENT WITH KINDNESS AND EXPERTISE, HE SEAMLESSLY FITS HIMSELF INTO THE GROUP TO BRING THE PROJECT TO LIFE, AND HIS SENSE OF HUMOR DOESN'T HURT.
Lauren Festino, Head of Creative, APR

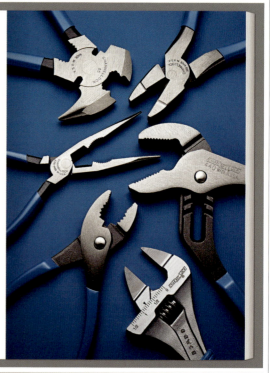

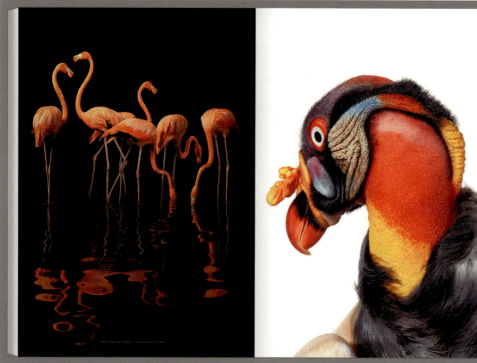

Design: B. Martin Pedersen | **Top Photo:** Robert Tardio | **Bottom Photos:** Tim Flach | **Pg. 332:** Commentary

GRAPHIS: JOURNAL NO. 373

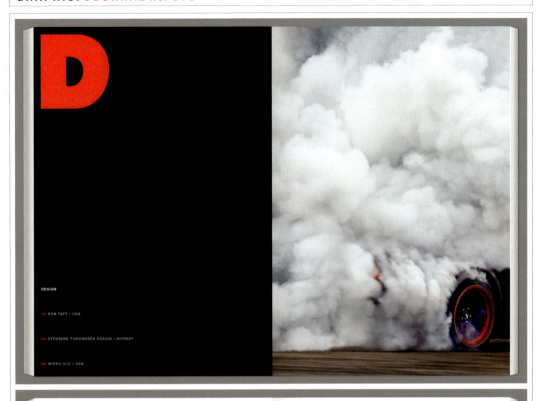

DESIGN

10 RON TAFT / USA

24 STRØMME THRONDSEN DESIGN / NORWAY

26 MIRKO ILIC / USA

Kah Poon: The Success of Loving What You Do

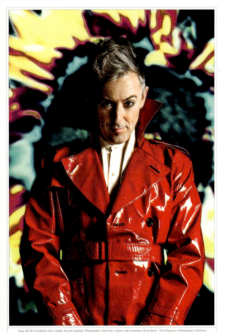

HE BRINGS ENERGY AND A UNQUENCHABLE PASSION TO EVERY PHOTOSHOOT. WITH AN IMPECCABLE EYE AND REFINED AESTHETIC, HE PRODUCES EXCEPTIONAL BEAUTY. ALWAYS HUMBLE, ALWAYS A JOY TO WORK WITH.
Adrian Peller,

THE EPITOME OF PROFESSIONALISM, POON'S WORK FOR OUR FINE ART GALLERY IN NEW YORK HAS BEEN MASTERFUL, TASTEFUL, INDISPENSABLE, AND PEERLESS.
Glen Nelson,

HE IS A MASTER PHOTOGRAPHER — LONG HONING HIS CRAFT AND DEVELOPING A PARTICULAR AND UNIQUE POINT OF VIEW. WHETHER IT'S AN IMAGE OF A CELEBRITY, A FASHION EDITORIAL, OR A DANCER, HIS PHOTOS ARE IMMEDIATELY RECOGNIZABLE.
Joshua Williams,

Design: B. Martin Pedersen | **Top Photo:** Ron Taft | **Bottom Photo:** Kah Poon | **Pg. 332:** Commentary

Design: B. Martin Pedersen | Cover Photo: Nicholas Duers | Pg. 332: Commentary

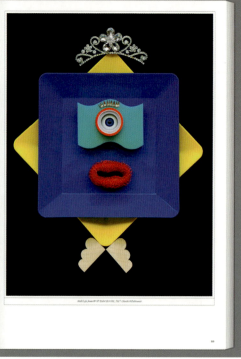

Design: B. Martin Pedersen | **Top Design:** Studio Eduardo Aires | **Bottom Photos:** Torkil Gudnason
Pg. 332: Commentary

GRAPHIS: JOURNAL NO. 375

Design: B. Martin Pedersen | **Top Art:** Peter Kraemer | **Bottom Art:** Richard Hess (Left), Mark Hess (Right)
Pg. 332: Commentary

Graphis 376

GRAPHIC DESIGN | ADVERTISING | PHOTOGRAPHY | ART/ILLUSTRATION | PRODUCTS | ARCHITECTURE | EDUCATION

Design: B. Martin Pedersen | **Cover Photo:** Carmit Makler Haller | **Pg. 332:** Commentary

GRAPHIS: JOURNAL NO. 377 311

Design: B. Martin Pedersen | **Cover Photo:** PepsiCo Design & Innovation | **Pg. 332:** Commentary

312 GRAPHIS: JOURNAL NO. 376

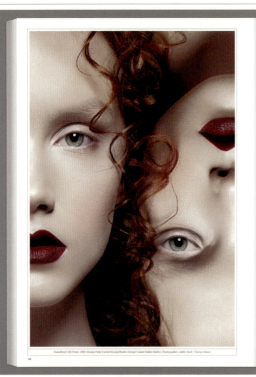
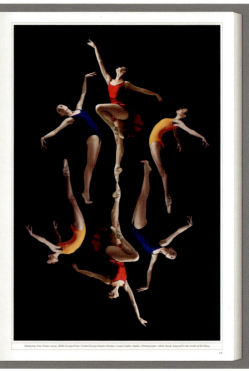
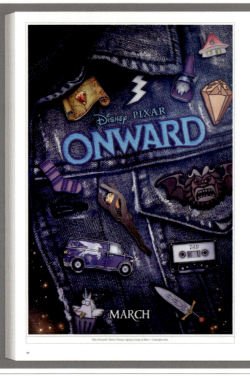
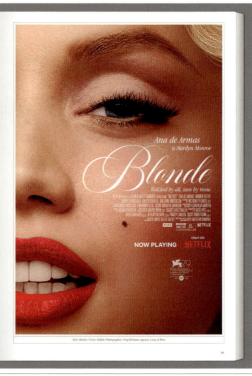

Design: B. Martin Pedersen | **Top Designs:** Carmit Makler Haller | **Bottom Designs:** Leroy & Rose
Pg. 332: Commentary

GRAPHIS: JOURNAL NO. 377

Richard Wilde, School of Visual Arts:
A Problem-Solving Education, Part II

THE PURE JOY RICHARD TOOK IN CULTIVATING AND CELEBRATING HIS STUDENTS' WORK AND ACCOMPLISHMENTS WAS BOUNDLESS AND INFECTIOUS, AND IS WHAT MADE GOOD STUDENTS (AND GOOD TEACHERS) GREAT.
Peter Ahlberg,

20 YEARS AGO, RICHARD BROUGHT ME BACK TO TEACHING, HE INSPIRED ME TO ADD VALUE TO THE ADVERTISING AND DESIGN DEPARTMENT BY BEING MYSELF AND ONLY TEACHING THINGS I WAS PASSIONATE ABOUT.

HE MADE IT POSSIBLE FOR ME AND MY COLLEAGUES TO CARVE OUT OUR OWN SPACES IN THE CURRICULUM THAT WE COULD OWN, EXPERIMENT WITH, AND BUILD.
Richard Mehl,

RICHARD WILDE AMAZINGLY HIRED ME TO TEACH IN THE 1970S AND GAVE ME THE FREEDOM TO LET MY STUDENTS BE REBELS, TO EXPRESS THEMSELVES FREELY AND FEARLESSLY IN UNSANCTIONED WAYS, AND TO CHALLENGE CONVENTIONAL THINKING.
Joey Skaggs,

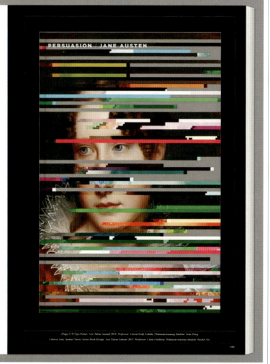

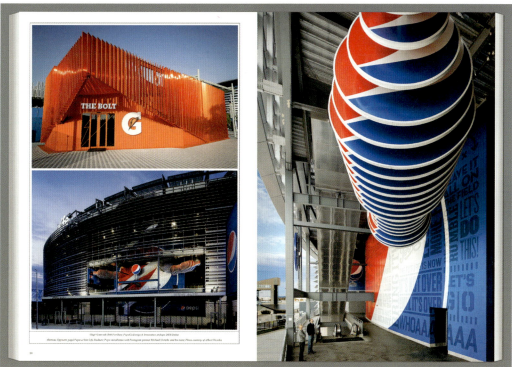

Design: B. Martin Pedersen | **Top Design:** Rachel Ake | **Top Instructor:** Carin Goldberg
Bottom Designs: PepsiCo Design & Innovation | **Pg. 332:** Commentary

Design: B. Martin Pedersen | **Cover Photo:** Takahiro Igarashi | **Pg. 332:** Commentary

Design: B. Martin Pedersen | **Cover Design:** Armando Milani | **Pg. 332:** Commentary

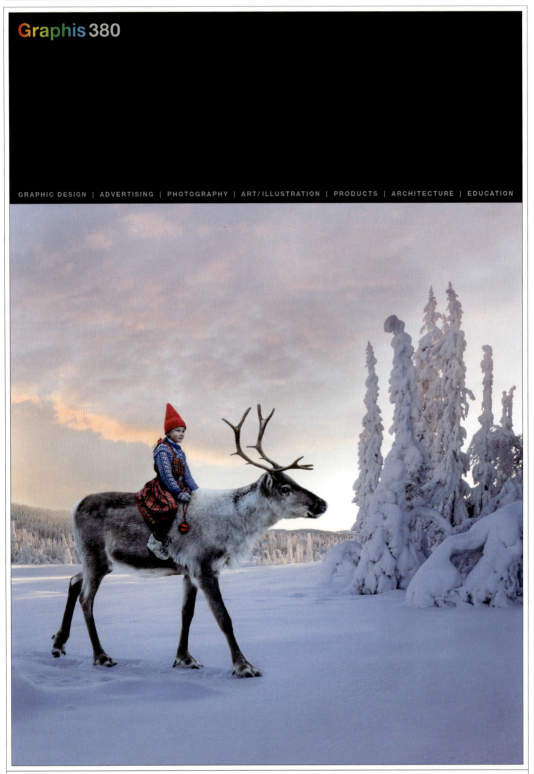

Design: B. Martin Pedersen | **Cover Photo:** Per Breiehagen | **Pg. 332:** Commentary

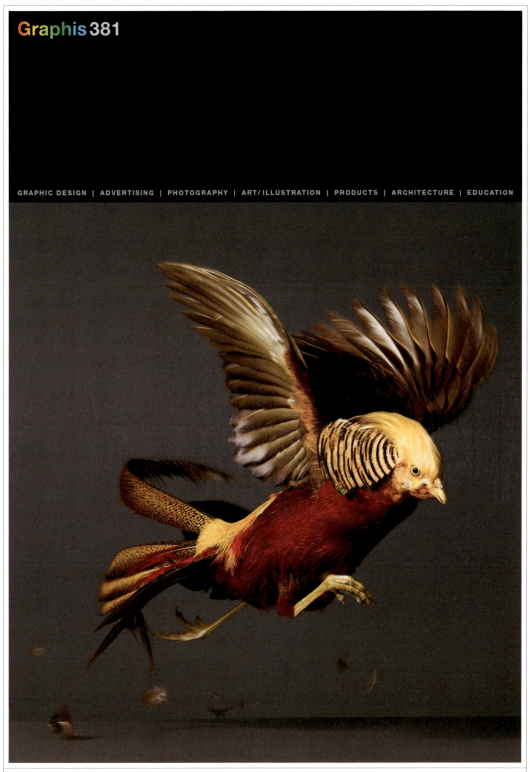

Graphis Website

GRAPHIS: WEBSITE

Design: Graphis Design Team | **Pg. 332:** Commentary

320 GRAPHIS: WEBSITE

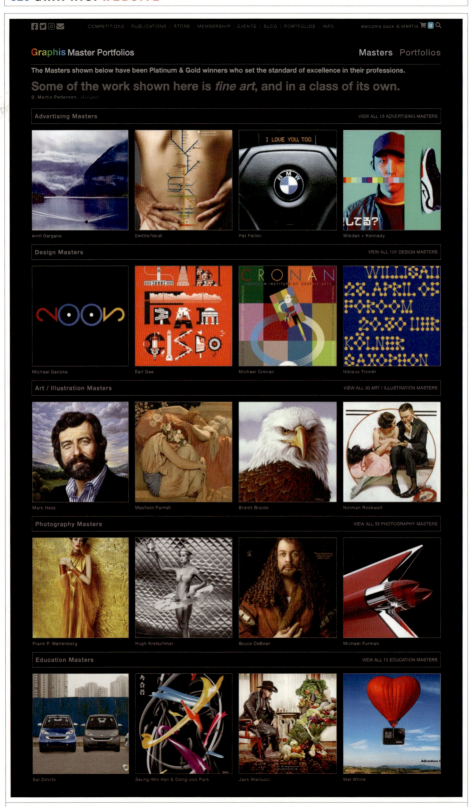

Design: Graphis Design Team | **Pg. 332:** Commentary

GRAPHIS: WEBSITE

321

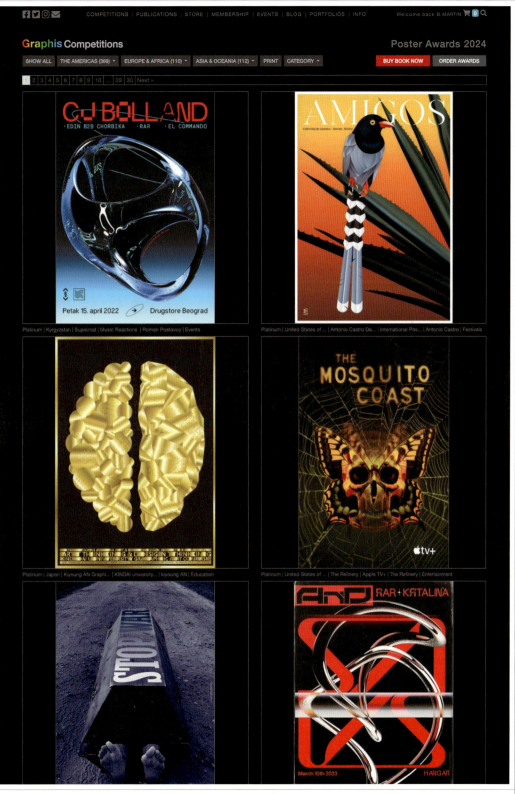

Design: Graphis Design Team | **Pg. 332:** Commentary

322 GRAPHIS: PLATINUM AWARD CERTIFICATE (OLD)

GRAPHIS ANNU

PRESENTED TO JAMES
 DESIGN

Design: B. Martin Pedersen | **Sculpture:** Takenobu Igarashi | **Pg. 332:** Commentary

324 GRAPHIS: AWARD CERTIFICATES

Design: Graphis Design Team | **Pg. 332:** Commentary

GRAPHIS: AWARD CERTIFICATES 325

Design: Graphis Design Team | **Pg. 332:** Commentary

326 COMMENTARY

9-11 FINE ART (1962)
After being released from active duty in the U.S. Naval Reserve following the Berlin Crisis, I had a budget to afford three months to paint to see if it was something I might consider pursuing in my future. I rented a small second-floor studio apartment at 774 9th Avenue* and bought a cheap plastic table with two chairs. In addition, I had a sleeping bag and an air mattress.

*It still exists there today in 2024.

My biggest expense was oil paints. I bought them at the Sam Flax art store on 59th Street, along with a roll of canvas. I stretched and stapled the canvas onto wooden frames myself and purchased the cheapest easel.

For inspiration, I had a book on the life of Michelangelo by Irving Stone called *The Agony and the Ecstasy*. I was amazed that he and all the masters from Italy, Spain, and Holland underwent years of apprenticeships until they could master the human body. If you could do that, you could draw anything.

After three months of painting, I threw out most of my work and kept only what I felt was worthwhile.

I realized that surviving as a fine artist was impractical, so I started looking for a job in a design firm. I got a position in Rapeci's Inc., a small schlock (Jewish for low quality) design firm with a few pharmaceutical accounts in New Jersey. It was all I could qualify for with my present portfolio. While there, I worked on improving it.

1964–1965
With a new portfolio, I landed a job at Chenault & Associates at 605 3rd Avenue, a Design and Advertising sweatshop. The CEO, Stacey Mathis, was a hard-driving executive of Greek heritage. Their biggest client was TWA Airlines, which occupied several floors in the same building. I worked on various accounts, including TWA, while continuing to improve my portfolio.

It was expected that the entire creative team, including writers, put in 10 to 11-hour days. Mathis was quick to fire anyone who didn't meet his high expectations.

1966–1968
After Chenault, I got a job at American Airlines at 633 3rd Avenue as a Corporate Design Director with Sandra Ericson, a Designer who also worked there. Our boss was Juan Homs, the Communications Director, and getting quality design work to pass with him was not possible. He later went on vacation for a few weeks, and I got a rush job to design a brochure (page 37). When he came back and saw what I had done, he went ballistic. The brochure, however, became a hit with all the travel agents and won several awards for me.

12-17 S.D. SCOTT PRINTING COMPANY: CALENDAR SERIES
While working at American Airlines, I printed numerous brochures with S.D. Scott Printing Company. Bob Sloan, the head salesman of the company, asked if I could show him more of my work.

After viewing my portfolio at the time, he then asked if I would consider doing a promotion campaign for him that would be mailed monthly to Designers with the hope they would consider printing with S.D. Scott. He said that, for economics, it needed to be a single four-color piece that should be visually attractive to the creative professionals. He couldn't afford to pay me, but my return was that he would print it at no expense, which would be a dual promotion for both myself and his printing company. I took a few weeks and created an idea for a monthly calendar series with unusual visual ideas for each month and showed them to him. He liked what I had originated, and we got started.

It was my first exposure to the creative community when they were mailed in 1967.

18, 19 GEIGY PHARMACEUTICAL COMPANY
After American Airlines, I got a job at GEIGY, whose Swiss design staff won numerous awards at the AIGA and the New York Art Directors Club. My requirements were that I had to be a Packaging Designer as well as an Advertising Art Director.

GEIGY brought modernism early to the U.S. with all the work executed in Helvetica. John DeCesare and I were the only Americans there; the rest were Swiss, and they were all great Designers.

20, 21 VANISHING AMERICAN
This is a series of silkscreens of Comanche Warrior Chief Quanah Parker. They appeared on the cover of *The American Way* magazine. They were seen by ARROW, a Native American legal group, who then called and asked if they could use them for their promotions. I sent them free copies and gave them the ownership.

22 PROMOTION MAILER
Designed for Photographer Stanley Rosenthal.

23 PERSONAL CHRISTMAS CARD
I started Pedersen Design Inc. in our apartment on 79th Street and Riverside Drive in 1969. My wife, Arna, had found the place. I had been away for a few years from American Airlines when Juan Homs, whom I had worked with, found that I was now independently in business, and he called me. He asked if I would start a magazine with him. I said, "I have never designed a magazine before, and I am reluctant, especially since I couldn't get quality work approved by you."

He apologized for the difficulties he had put me through and said he realized that I had talent, which would be required from me for the magazine. He said he was also hiring a great writer from *The Wall Street Journal* named Donald Moffitt as the editor and would like me to consider taking this seriously.

I met with Mr. Moffitt and found that he had written a number of award-winning articles for the *Journal*. For one of these articles, he had teamed up with Hunter S. Thompson and had written about Hells Angels. When the series of these articles was published, it put Sonny Barger and the Hells Angels on the map.

We talked further. I liked Don and decided to take it on. This was the first airline magazine out there. After a few of our issues were in print, they became a success, and we won many awards with it.

24-36 AMERICAN AIRLINES MAGAZINES (1969–1971)

37 AMERICAN AIRLINES BROCHURE
Promotion folder for travel agents.

38-40 NORTHWEST ORIENT AIRLINES: PASSAGES MAGAZINE

41-43 ENVIRONMENT INFORMATION ACCESS: JIM KOLLEGER
This was a budget job, and I brought on a talented young Designer named Dan McLain. He was quiet, somewhat of a recluse, and deeply passionate about the environment. I gave him creative freedom on the project, and not only did he produce exceptional work, but he also spent his weekends camping in the woods.

COMMENTARY

44, 45 WEST POINT PEPPERELL: THE COLOR CONNECTION
I had great freedom on this job with the client under
Carole Lewis and her boss, Bob Chorlton, and hired
a great Photographer, Armen Kachaturian, and Alex
Eames, who was a talented stylist. The book/brochure
won several awards.

46 VOLKSWAGEN OF AMERICA: VW TYPE 3
I had the privilege of working with Photographer Pete
Turner, and our client at VW was Howard Mihls.
We all decided to shoot in Montauk, and as expected,
Pete delivered outstanding shots.
My VW Type 3 won a number of awards.

47-51 GPS PAPER SELECTION COLLECTION
I developed an idea for a more efficient way of getting
all the varieties of paper together in 10 volumes from
all the paper companies.
At the time, all the other Designers producing annual
reports and I received multiple book samples of paper
from each paper company as they hoped their paper
would be selected for the annual reports we designed.
After we made our selections at the end of the year,
most of these paper samples were thrown away.
The new volumes that I suggested would be filled with
paper samples of a size that would fit ring-bound books
from each paper mill and placed in the appropriate
volumes of coated, uncoated, and by colors for
accessible selections for the design community and
international printers.
This would reduce a lot of paper waste. Most paper
mills responded positively and started to send their
papers to fill our books. However, Mohawk Paper,
a major paper company, turned it down.
Since they were very large, this project was then killed.
I had paid a printer selected by Bob Salt, the print
salesman I had used, for the production of the volumes.
In the end, after it folded, I had a lot of bills to pay.
There were many disappointed printers and Designers
in the annual report community who would have had
a valuable resource that would have saved paper and
everyone a lot of time.

52, 53 VOLKSWAGEN BUS: THE GEAR BOX
Another job with Howard Mihls from Volkswagen. After
several ideas to present this small bus, the one accepted
was unusual in the automotive industry. It was to sell the
space the bus had with the idea it could transport groups.
I hired Frank Moscati again as the Photographer on this,
and he put together groups of models to pose as particular
types of groups. He also put together still life photos of
objects particular to each group for the brochure. Frank
was brilliant as always.
The brochure was a success with the Volkswagen dealers.

54 NEW YORK TIMES BOOK REVIEW
Louis Silverstein, the head Art Director at *The New York
Times*, asked me for a rush job to design the front page
of *The New York Times Book Review*. Louis was an
award-winning icon at *The New York Times*, and I was
honored that he chose me.

55 SCHOOL OF VISUAL ARTS
Poster for the "Art Exhibition of the Male Nude" at the
School of Visual Arts.

56, 57 SCHOOL OF VISUAL ARTS
Another poster, this time for an exhibition of sculptures
by U.S. artists.

58 AIGA 120 PG. AWARDS BOOK
For the cover, I photographed these various items.
The Rolls-Royce grill represented quality. The drawing
board on which I put a typewriter represented Designers
and Art Directors, and the typewriter with an eye was
for writers. I photo-composed all these images by hand
and used them for the cover. There were no Apple
computers or InDesign at that time.

59, 60 SPORTS CAR CLUB OF AMERICA
I was asked to start a new magazine with David Ash
for this club on a very tight budget for the client.
The races took place around the country, and to keep
costs down, I waited until the event came to the
Bridgehampton race track, which was close to where
I lived in Montauk. I had a Nikon prepared, and to save
more money, I told the publisher that I thought I could
photograph the two-day event as well.

62-65 AT THE RACES: BMP PHOTOGRAPHS
On the day of the races, I arrived at dawn and started
to shoot the individual car drivers as they came into
the pits after driving the track to test their cars before
the race. I did my best not to get in the way. It was
an exciting day and went very fast for me.
After the races, David Ash gave me the text for the stories
in the magazine. I then returned and put the magazine
together. The drivers were legends like Dan Nerney, the
Rodríguez brothers, and Swede Savage*.
*Swede Savage later died in the Indianapolis Speedway Race at age 26.
The Rodriguez brothers also died racing.*

66-71 EASTERN AIRLINES: PASTIMES MAGAZINE
Another airline magazine with Thomas Humber
as Editor and Louise Fili as Designer, with a budget
to work with great Illustrators and Photographers
(like *American Airlines*).
They were all responsible and brilliant in their crafts,
and we won awards at design competitions.

72, 73 COMBUSTION ENGINEERING: PROGRESS BROCHURE
I photographed objects and people and then assembled
them for the cover image.

**74, 75 JONSON PEDERSEN HINRICHS & SHAKERY
(1975–1985)**
The photo of Vance Jonson, Kit and Linda Hinrichs,
and me was taken when we first formed the partnership.
Neil Shakery joined us about a year later.
Earlier, Kit had approached me several times about
a partnership. I didn't think it would work, so I had
to turn him down. Kit wanted to move back to San
Francisco, where he grew up, and proposed that I take
over his accounts while paying him a percentage of
the profits to support him on the West Coast. I told him
that he had a very special design style that his clients
came to him for, and I wasn't going to be able to do that.
He had also left his former partner, Anthony Russell.
I asked him why he had not had him do this. He told me
that Tony had refused it.
On one occasion at my Lexington Avenue office, Vance
Jonson had visited me, and we were about to go to
lunch. Kit arrived unexpectedly at my office as we were
about to leave. We invited him to join us at a small
Japanese restaurant a block away.
As we sat down, Kit said he still wanted something
to happen. He related his desire for a partnership, and
I stated my reservations to Vance.
Vance listened until he understood our circumstances,

328 COMMENTARY

and he agreed with me. He was a great Designer and a savvy businessman. After some time, he came up with a brilliant solution. He said that we should be separate and not into each other's pockets financially, and he felt that Pedersen Design should own the partnership in New York while Kit would own it in California.

He then asked if he could also be part of this and could own it in Connecticut. We all agreed. He also felt we each had equity in our reputations, and he then tossed a coin (which may have been double-headed) for the succession of the names. He won first, me second, and that was how we first got named Jonson Pedersen & Hinrichs Inc.

This was a far superior partnership to Pentagram at the time. We won numerous awards together in the shows. About a month later, Kit got to bid amongst a few other design firms for the Royal Viking Cruise Line that sailed from the West Coast to Hawaii and back. He called Vance and me and asked if we could join him in meeting the client. It was agreed that Vance should make our introduction with his 6'5 height and pleasant voice. The day came when Vance presented us, and afterward, we both flew back to the East Coast. A few days later, Kit got the call that we got the account. The discussion went on to how to share it. Vance and I agreed that it should be Kit's account since the client was there, and he should also keep all the money for doing the job. About a year later, Neil Shakery joined me at my office after leaving Time Life, and some months later, we added him to the title and became Jonson Pedersen Hinrichs & Shakery Inc.

76, 77 CITICORP BROCHURE
Adrian Pulfer, a brilliant Designer from Salt Lake City, joined me in my New York office and designed an elegant brochure for a successful financial firm in New York City with some input from me. The brochure featured quiet simplicity and fine art architectural photographs. It was a winning project.

78-90 NAUTICAL QUARTERLY MAGAZINE (1977–1982)
Because of my love for boats, I thought about starting a new magazine on the subject.
At the time, I was frustrated with *Yachting Magazine*, a well-written publication owned by the Bonnier publishing company in Sweden. However, it was heavy on text and light on what I felt were just OK visuals of the boats. In addition, you had to search through the articles to find the specifications of some of these boats. I spent evenings designing and putting my visual ideas of boat presentations and typographic text on about 10 to 12 illustration boards. I then called the acquisition editor at Time Life, and I was told by his secretary to drop them off in the reception room and expect to be called in a few weeks.
To my surprise, two days later, I was called, and I met with the editor. I sat down, and he had a few of the boards on his desk. He said, "If I wanted Time Life to do this new publication, I would hire you now."
I was stunned. He continued. "However, I will tell you something you have to promise never to repeat. If you were to start the magazine here, you would have to work with a large committee, resulting in something you wouldn't recognize. You would then continuously go to the bathroom to throw up. I advise you to find a person who loves boats to support this publication financially."
A few months later, I got Donald McGraw of McGraw

Hill, brother to James McGraw, the company's vice president at the time. Don owned a 50' Hinckley yawl and was the company's print salesman. He needed something like this to give him some dignity.
In developing the start of what was required, I hired Joe Gribbins, an editor who had worked under Donald Moffitt and me on *The American Way*. I also checked print costs and put a budget together that I would require for the design, production, and printing for a specified time until, hopefully, returns could give a positive cash flow. Don McGraw accepted my asking price. We went to attorneys, and the magazine got its start. The good news was that it became a hit.
After four years, with a few recessions and unexpected bills, I needed another investment. This additional money came again from Don McGraw. A few days later, C.S. Lovelace, a managing director that McGraw had hired, related that my design fees now had to be reduced dramatically. These were the days of mechanicals, which were work and production demanding and required a core staff. I looked over the time and money I needed to continue and found I was already losing money on the project. I completed my last issue, which was #17 for the spring of 1982, and then resigned. After that, they hired a lady Designer for less money.

New Start For Me?
Having heard of what had happened, several Designer friends encouraged me to start a new design magazine. That's a long story that evolved into my purchasing *Graphis* with a huge mortgage, which my wife Arna allowed me to do.
About a year later, I read a book on the life of Howard Hughes, a business genius. He related that on one of his business deals, he had lost a company he had started for the same reasons as mine. His following formula for an investment was if his budget required $1 million, he would ask for $3 million and work as if he had only a half million. Lesson learned.
Losing *Nautical Quarterly* ultimately became a good thing because *Graphis* became my life after that.

91 NAUTICAL QUARTERLY PROMOTION POSTER

92-95 MUPPETS: OPENING NIGHT
I got a call from Roberta Jimenez, who worked with Jim Henson, asking if I would do a brochure promoting Miss Piggy and Kermit. I thanked her but turned it down because I thought this was out of my league. Later on, we met each other, and she felt that she would like to work with me on it, so I accepted the challenge. I then hired Armen Kachaturian to do the Photography. An opening night neon theatre logo and a stage were also developed. The brochure was an unusual success.

96 BELL LABS
I was hired to design a brochure that promotes the different departments of brilliant engineers in that exceptional company. I needed a lot of advice and education to understand enough of it to complete the brochure successfully. Their presence humbled me, and they were pleased with the result.

97-99 DOW JONES & COMPANY: ANNUAL REPORTS
I had the Dow Jones Annual Report as a client for a few years and had the privilege of working with Warren Phillips, the company's CEO. Like many of the previous CEOs, he'd originally been an investigative reporter and

COMMENTARY

was terrific to work with. Each time I came to Dow Jones, I dressed up in a suit and tie like the rest of the management there, which resulted in me getting invited to a number of board meetings that helped me with ideas. I stated that whatever I presented, I wanted them to comment on it for improvements.

On one report, I was told by Warren that he would like the different Dow Jones businesses to be visually represented with paintings from the Whitney Museum. I told him I would do my best.

After a few weeks, I came back with the presentation, and in presenting it to the executives, I related that a few of these paintings were not correctly representative and that we should take a new direction. There was a pause, and Warren asked if I could leave the room with him for a few minutes. He then told me that his daughter was the curator of the Whitney Museum.

My immediate response to him was, "Why didn't you tell me this from the beginning?" He was embarrassed, and I said, "I will make this work."

I also worked with Cheryl Rossum. She is a brilliant Photographer who consistently came through with award-winning photographs.

100-105 INTERNATIONAL TYPEFACE CORP. (ITC)
AARON BURNS & HERB LUBALIN

In 1980, Herb Lubalin, one of my idols for years, whom I was fortunate to have met in my career, was taken ill. He was a design and typographic genius. His Assistant Art Director called me to design a few issues of the magazine. I was sad to have heard of his illness and pleasantly surprised to have been selected.

Aaron Burns, the owner, told me that it would be great to do a boating theme for the first issue. I said, "I have done enough boats. Could I try airplanes, which I also love as a subject?" I got the approval, but I was highly intimidated and feeling insecure about this assignment. When I designed the issue, I used the company's typefaces. When it went to press, Aaron was away. When he returned, he was extremely angry with my design of the issue but never called me to let me know. I found this out later from someone else.

I was pleased with it and submitted it to the Society of Publication Designers. At the awards show that I had been invited to, I found that I had won the gold medal for the issue. Aaron was there that evening and came up to congratulate me with tears in his eyes.

I had been told earlier that he had art-directed Herb on all past issues. Had he been there when I completed the issue, he would not have approved it. I sat with him afterward and told him that if he had left Herb alone to perform his craft, *U&LC* would have been a consistent gold winner for years in all the shows.

106 BUSINESS WEEK MAGAZINE (1982)

Lou Young, *Business Week*'s editor at McGraw Hill, called and asked if I would design a cover that could get better recognition on the newsstand. After we agreed on the price and time needed, I went to the newsstand in Grand Central. The only thing that stood out from all the magazine covers was all the newspapers competing with each other with their headlines. I then returned to my office and worked on several other possible solutions. I reduced the size of the logo, increased the size of the lead story type, and made four to five covers. When I was ready, I called Lou for an appointment. A day later, I came to his office, and he asked me to follow him down a hall into their large conference room.

En route, he told me that, when I presented the work, he would only have an opinion once he lived with the covers for a few days.

As we entered the boardroom, I went to the front and put the five covers on a ledge there. He sat silent for a few minutes and then came out and said, "A bit strong, don't you think?" I said he wasn't going to make a statement otherwise and that the assignment was to compete on the newsstand. He grabbed them, walked me back to his office, and said, "You're right." He then asked if I could join him the next day in presenting the covers to Harold McGraw, the company's president, and his lieutenants. I said that I would.

He then said he would call me after he could arrange it. Two days later, I came, and we presented the covers; Harold said this looked a bit too strong, and his lieutenants all chimed in and agreed.

Lou said, "We have a deadline for tomorrow's next issue. Why don't we give it a try?"

It went to press, and the copies sold off the newsstands. However, as the months and years went by, they went back to how it was before. Lou was not pleased, but we had at least tried.

107 TYPE DIRECTORS CLUB ANNUAL BOOK

I was asked to design a cover for the TDC's fifth annual and came up with a poster art direction of the number five leaning on its side in three dimension.

108-111 HOPPER PAPERS

This paper company came asking if we could come up with a design direction to help display their different color paper grades. Adrian Pulfer was working with me, and we decided to make multiple brochures with their different grades, each visually represented by images of other subjects. The client was pleased with the results.

112-115 UNITED INDUSTRIAL SYNDICATE (UIS)

This company managed several different businesses and asked us to design a promotional sales brochure that adequately represented them with some dignity.

Adrian and I went through several ideas and thought still life fine art photographs could represent their business. We presented the idea with sketches and photos, and they approved the direction. It didn't hurt that we also suggested a group shot of all the executives.

We returned to the office, sought out several still life Photographers, and settled on Andrew Unangst. He did a brilliant job, and they were pleased with the results, especially their group shot.

116, 117 IBM JAPAN

I received an assignment from Rolf Sauer at IBM in Rochester, New York, to design an IBM capabilities brochure to present their latest technology. IBM Japan had just received the honor of restoring and rebuilding Japan's WWII square-rigged sail training vessel used as a de-masted freighter in the last year of the war. She was to be restored in a large shipyard that had built the largest oil tankers afloat. This vessel was minuscule compared to the large tankers but high in honor.

On my long trip to Japan with the client, I received a document explaining Japan's business culture. I felt the 8 ½" x 12" four to eight-page brochure that was already sold was just OK. Given the importance of this job, we needed a better solution that could give respect to the country. I came up with an imitation sailcloth cover with the Japanese Sun. I had the brochure start

330 COMMENTARY

by honoring the proud seamanship history from Japan's past through the present and end by using pictures of the sail training vessel that they were so proud of and which was honored as the main subject of the brochure. The titles of each of the headings in English were to be represented in Japanese by an artist who could execute them with a Japanese brush.

When we arrived at the meeting with the IBM Japanese team, they loved it. A team member's mother did the script headings. When we flew back to New York, I produced the brochure and sent copies to Japan. When the ceremony for the ship's launch took place, the Prime Minister of Japan was present along with a number of other dignitaries.

Although everyone received a copy of the brochure, they all requested more copies after the ceremony. The brochure won many awards, and my client became a hero in his office. Months later, the chief engineer of the sail training vessel's restoration came to New York City and took me and my IBM client for a celebratory dinner at the Rainbow Room restaurant in Radio City.

118 TYPE DIRECTORS CLUB PROMOTION POSTER

119 BIGGEST NAME IN DESIGN POSTER

After I had successfully purchased *Graphis*, I had to resign from JPH&S. Dick Hess then insisted that he, John Alcorn, and Lyle Metzdorf should take over my design clients. I told them that this was not going to work. This was their promotional poster, which was a great idea, but the business didn't work.

120 SOCIETY OF PUBLICATION DESIGNERS ANNUAL

Design of the cover.

121 GRAPHIS PHOTO EXHIBITION BROCHURE

Sponsored by Kodak at a gallery on Park Avenue. The exhibition was a huge success with a huge crowd. The awards were individual Takenobu Igarashi "G" sculptures that Kodak had also paid for. Albert Watson received a Platinum award. When he held the sculpture, he was both gratified and impressed. He came over later to thank me for this and expressed the hope that this would be repeated annually. That was our hope, and our Kodak client was thrilled with the event's success and the compliments he received. Sadly, a few months later, our Kodak client host was transferred, and future exhibits ended. Kodak film was now becoming ancient history with digital cameras becoming more available to the public.

122 CHILDCRAFT: CHILDREN'S TOY CATALOGUE

Étienne Delessert, the famous Swiss children's book Designer and Illustrator, is the cover artist.

123 ENCORE MAGAZINE (IDA LEWIS AND NIKKI GIOVANNI)

Ida Lewis and Nikki Giovanni, a poet, originated this first black news magazine. Ida came to me and asked if I could design and produce it for her. I agreed, and she called me her white angel when the magazine was done. She and Nikki did a great job with the content, but unfortunately, it didn't last very long. It's a shame because they were ahead of their time with this.

124 TO THE THIRD POWER: AMERICA'S CUP BOOK

Bill Koch and the Koch brothers were the wealthiest Americans until Jeff Bezos and Bill Gates. After winning the America's Cup for the NYYC, he came to me to have a book written and produced. He had

chosen Roger Vaughn, whom I knew, to write the book and chose me for the design.

Mr. Koch came to my studio on 141 Lexington Avenue with four massive winch grinders that had sailed on his boat. Each of them had just received a new Rolex watch from Mr. Koch. We all sat down at my glass conference table, and I brought out several books to discuss the size, which was then agreed on. Roger then went to Mr. Koch's home in Massachusetts to discuss the book's editorial approach. He and I had discussed it earlier and thought this and his tactics for winning could be a great management book for the campaign. He had gone to top yacht Designers, sailmakers, crew members, etc., and if any of them did not rise to their expected skill levels, he would fire them. So, when Roger met with Mr. Koch with the suggestion of the potential for a great management book, he turned it down since he felt that he would be criticized for having fired several of these talents. Roger said that this was expected when one wants to win. Mr. Koch kept pouring Roger glasses of expensive wine, and he couldn't win Roger over. In the end, Roger said that if he wanted a noncontroversial fairytale, he wasn't interested in doing it.

Roger was replaced by Paul Larsen, another writer with whom I worked on the book. Though Paul did a commendable job following Mr. Koch's wishes, Roger would have done a sensational job on a management book that could have been a top seller.

125 POSTER FOR THE PANAMERICANA 96 DESIGN CONGRESS

126 POSTER TO REMEMBER THE TRAGEDY OF LIVES LOST IN TYPHOON ROKE THAT STRUCK SENDAI, JAPAN

127-129 THREE POSTERS HONORING NORWEGIAN HERITAGE, EXPLORATION, AND U.S. IMMIGRATION

130 POSTER HONORING FRITZ GOTTSCHALK, A BRILLIANT SWISS DESIGNER

131 FAO SCHWARZ: WOODEN TOY DESIGNS

132 POSTER PROTESTING THE KILLING OF MAHSA AMINI IN IRAN

133 LISA THORSEN WITH A HURT BLACK DOLL

This was before Johnson & Johnson had changed their Band-Aids to match black skin tones.

134 FIVE LOGOS

1. Brahms Restaurant in Brooklyn
2. Type Directors Club
3. NY Hairdresser
4. F&C Naval Architect
5. Evan & Lewis Cheese Store

135 LOGO FOR SYRACUSE UNIVERSITY

I designed this with approval from the school chancellor. A few months later, the athletic director refused it, and another logo was designed to his liking.

136-139 NEW LOGO DEVELOPMENT FOR HOPPER PAPERS

Adrian Pulfer was still working with me when the same lady executive came to us to design a series of their paper promotions (see pages 108-111). We had worked with her before and weren't impressed with their logo. We almost hid it in our previous job. We wanted a new logo and refused the job unless we could convince her that the logo needed improvement.

She wanted to work with us but was afraid of a negative response from upper management. We said, "We'll attempt this, and you'll then show it to the management

COMMENTARY

and hope they'll approve it. Not only that, but we'll give it to you for very little money." She agreed.

We first developed a logo with multiple layers of paper (second from the top). In the cab ride to her office, I told Adrian that the layered paper wasn't working. I took out a piece of paper, folded it into an "H," and then roughly drew it on another piece of paper. Upon arriving, we showed it to the lady executive, and she got it. The next day, we gave her a proper presentation that she could show to her boss. He loved it; she was now safe, and we went back to work on the multiple paper samples.

140 ENERGY MEDICINE: NEW MAGAZINE

141 NEW YORK YACHT CLUB: BROCHURE

142, 143 SONNENBLICK-GOLDMAN: REAL ESTATE BROCHURE

144, 145 TOOLS FOR LIVING SALES CATALOGUES

146-148 SCM'S XEROGRAPHIC TONER: PACKAGING

149-161 ARCHTOP GUITAR BOOK

A guitar store owner* in New York City came to me with Vincent J. Ricardel, a partner in the book with a finished design that the store owner had directed.
I left out the owner's name for obvious reasons.

It was a mess, and he wanted me to fix it.

The good news is that Vincent had great photographs of the guitars and famous guitarists he had taken over several years. The bad news, however, was that the photos had been displayed horribly.

I told the owner, "If you want to work with me, I would love to do a great job on this, but I can't fix what you have here. I will need to start fresh, show you what I would do with a few spreads, and offer them to you before I start the rest of the book. If you approve of the direction, I will proceed with the book, but I will need payments to start and more as I progress." I then received the upfront payment. A few weeks later, I called the guitar store owner, and he came with Vince to see some of the spreads I had designed. They looked at them and approved the direction. I then started the book.

I found the guitar store owner had been to several other design firms that had refused to work with him since he had over-directed the design. This was to be a massive design project with a potentially difficult client.

At the time, I was working with a great young Designer named YonJoo Choi. We both worked for about a month on the job. When we finished, we made a slideshow of all the spreads we could show on the computer.

On the day of the presentation, Vincent and his partner had also invited one of the guitar craftsmen whose guitars were also in the book. His name was John Monteleone, and he lived in the middle of Long Island. He had a small building in the backyard of his house where he crafted his guitars. He was a brilliant luthier. I told Vincent's partner not to comment when everyone arrived as we showed the spread. He agreed. As the lights turned off and the slideshow started, I watched Monteleone. He nodded in silent approval at each slide. When the lights came back on, Monteleone approached me and gave me a big hug of approval.

The book's contents present three luthiers from the U.S. and Italy: John D'Aquisto, James D'Angelico, and John Monteleone. The book sold successfully and presented the accomplished guitarists who made purchases.

In 2011, the Metropolitan Museum had an opening of their showing of these amazingly crafted guitars. The book was accepted and successfully sold in the museum store. There was a huge crowd. As Arna and I entered for the evening, we were at the back of the line. John Monteleone, who had a line of well-wishers greeting him, saw us, temporarily left them for a moment, took us to the beginning of the line, and hugged us both, having now met Arna for the first time. It was such an extraordinary evening.

Famed guitarist Mark Knopfler stated, "There are no other guitar books after this book."

163-165 HOWARD SCHATZ: ADS

Howard Schatz has consistently demonstrated brilliance as a Photographer with his partner Beverly Ornstein. I believe Howard will go down in history as one of the century's greatest Photographers. He has multiple brilliant portfolios on endless subjects and continues to tirelessly reinvent himself. They have major shoots every day during the week.

166-169 ADS FOR TESLA

171 UNITED NATIONS OF AMERICA

As stated, every nation is represented here, and these immigrants built this country. The Americans gained grace from their immigrant forefathers; most couldn't work this hard. This is still happening today with the immigrants who come here and are willing to work, many having more than one job to survive.

172 SOLDIER CORPSES!

173 POSTER FOR COEXISTENCE

175-228 A SELECTION OF GRAPHIS BOOKS

224 ALLY & GARGANO

I received a phone call from a gracious man asking if I was Mr. Pedersen. I said I was. He responded, "You won't know who I am, but I was in Advertising in the 1960s, and I just completed a 500-page book on my agency's work. I'm coming to you first because I would love for you to publish it."

I asked him his name, and he said, "Amil Gargano." My response was, "Amil Gargano of Ally & Gargano?" He said, "Yes. Do you know of me?" I replied, "You are one of my Advertising heroes, and I have worshiped your work. Please send me the book."

When I received it, I was knocked out. I called him back and said I would publish the book. I also asked if it would be possible to get testimonials from one or two of his clients. He then said that Fred Smith of FedEx, a Marine Silver and Bronze Star medalist officer with two tours in Vietnam, had called him and Carl Ally for a celebratory dinner. He had toasted them and related that after one year, Ally & Gargano had put him into a very profitable position with their ad campaign.

I asked if he would consider sending a FedEx express message to Mr. Smith, asking him if he would recall the conversation and permit Ally & Gargano to use the testimonial for the book. Amil did just that the following morning and got approval from Mr. Smith the next day.

I never met Mr. Carl Ally, who was more the business part of the partnership. Both had served in the Vietnam War and survived it. Carl had also been a fighter pilot in WWII as well.

There is a picture of each of them in the book: Carl standing beside his plane with a confident attitude, and Amil in his Army uniform holding a rifle.

332 COMMENTARY

Much of their work in the book is timeless and would be Platinum and Gold winners in *Graphis* today. They got SAS (Scandinavian Airlines) as an account, and Amil traveled to Norway with the Photographer Gordon Parks. They returned with some great shots. They also got Volvo from Sweden. Their ad campaign increased sales aggressively. SAAB then called them and asked if they could also do their campaign. Carl Ally said, "We can't do that; we have the Volvo account, which is your competitor." SAAB said, "We've talked to Volvo; they highly recommended you and are okay with it." So Carl and Amil started another team in their agency and increased the SAAB sales to their satisfaction. I have never heard of any ad agency with two competitive accounts. They received numerous awards, and later, they received a number of Italian accounts as well. Amil Gargano was inducted into the Art Directors Club Hall of Fame in 1984. Carl Ally (Alchetron) retired in 1990 and was inducted into the Advertising Hall of Fame in 1991. He died of a heart attack in his home in Rowayton, Connecticut, on February 17th, 1999, at 74 years old. Amil came from an Italian family, and Carl was half Turkish and half Italian. They were both street-smart, successful Admen. Carl had a temper, and Amil was uncompromising. They must have had many arguments, but they made Advertising history. *Advertising Age* named Ally & Gargano the "Agency of the Year" in 1981.

225 TAKENOBU IGARASHI
Takenobu Igarashi called and asked if I would design a book on all of his work. I was honored and thanked him for this, but I refused since he was too much of an idol. I told him that I would freeze on the job, just like the past talents that Walter Herdeg, one of *Graphis*' founders, had asked to do covers for him. He was insistent, and I spoke to Arna about my hesitation. She knew Takenobu and his wife, Fumiko, as well. We had dinner and discussed it further. She said to take the attitude as if it was my work instead. I called him back and accepted the job, and he sent the work to Heera Kim. We then worked on it together. After the book was nearly finished, the hardest part was figuring out what to do with the cover. We found that one of his sculptures, with an upward-rising shape, represented his art symbolically. Then, we did his name using bold letters that could hold a rainbow. Takenobu Igarashi may go down as one of the greatest Design and Fine Art talents of the last century.

230-250 WALTER HERDEG'S MAGAZINE COVERS (1944–1985)

252-317 B. MARTIN PEDERSEN'S MAGAZINE COVERS (1985–2024)

319-321 GRAPHIS WEBSITE

322-325 GRAPHIS PRINTED AWARD

SINCE 1985, *GRAPHIS* HAS BEEN AN EPIC JOURNEY FOR ME AND, WHILE SHE WAS ALIVE, MY WIFE ARNA.

WE BOTH FELT IT WAS A COMMITMENT AND AN HONOR TO SERVE THIS EXTRAORDINARY INTERNATIONAL CREATIVE COMMUNITY.

THROUGH OUR PLATINUM WINNERS, WE DISCOVER EMERGING TALENTS.

B. Martin Pedersen, *Designer*

INDEX 333

CLIENTS/CLIENT CONTACTS

American Airlines ... 24-37
American Institute of Graphic Arts (AIGA) ... 58
Bell Labs ... 96
Brahms Restaurant in Brooklyn ... 134
Business Week Magazine ... 106
Childcraft (Wilfred Demisch) ... 122
CitiCorp ... 76, 77
Combustion Engineering, Inc. ... 72, 73
Dow Jones & Company ... 97-99
Eastern Airlines ... 66-71
Encore (Ida Lewis & Nikki Giovanni) ... 123
Energy Medicine Magazine ... 140
Environment Information Access ... 41-43
Evan & Lewis Cheese Store ... 134
F&C Naval Architect ... 134
FAO Schwarz (Wilfred Demisch) ... 131
Geigy Pharmaceutical Company ... 18, 19

Gottschalk, Fritz ... 130
Graphis ... 121
Hopper Paper Company ... 108-111, 136-139
Howard Schatz Photography ... 163-165
IBM Japan ... 116, 117
International Typeface Corp. (Aaron Burns & Herb Lubalin) ... 100-105
Jonson Pedersen Hinrichs & Shakery Inc. ... 74, 75
Jonson Pirtle Pedersen Alcorn Metzdorf & Hess ... 119
Koch, Bill (America's Cup Winner) ... 124
Madison Square Press ... 120
Muppets (Jim Henson & Roberta Jimenez) ... 92-95
Nautical Quarterly Magazine ... 78-91
New York Times Book Review ... 54
New York Yacht Club ... 141
Northwest Orient Airlines Magazine ... 38-40

NY Hairdresser ... 134
Panamericana 96 Graphic Design Congress ... 125
Rosenthal, Stanley ... 22
Rudy's Music Store Soho ... 149-161
S.D. Scott Printing Company ... 12-17
School of Visual Arts ... 55-57
SCM Systems ... 146-148
Silverstein, Louis ... 54
Sonnenblick-Goldman ... 142, 143
Sports Car Club of America ... 59, 60, 62-65
Syracuse University ... 135
Tesla ... 166-169
Tools for Living ... 144, 145
Type Directors Club (TDC) ... 107, 118, 134
United Industrial Syndicate ... 112-115
Volkswagon of America ... 46, 52, 53
West Point Pepperell ... 44, 45

AD AGENCIES/DESIGN FIRMS

ComGroup ... 200
Cummings & Good ... 281
Eduardo del Fraile Studio ... 298
FBC Design ... 297
Goodby, Silverstein & Partners ... 268

Leroy & Rose ... 312
Me Company ... 265
Mine ... 212
PepsiCo Design & Innovation ... 207, 311, 313

Studio Eduardo Aires ... 308
Sussman/Prejza & Co., Inc. ... 208

DESIGNERS

Ake, Rachel ... 270, 313
Cerrato, Gregory Michael ... 176
Choi, YonJoo ... 130, 149-161, 168, 169, 177, 181, 184-186, 204, 267-269
Chung, Hoon-Dong ... 274
D'Estout, Marc ... 214
del Fraile, Eduardo ... 211
Fili, Louise ... 66-71
Finney, Angela ... 202
Fisk, John ... 210
Gargano, Amil ... 224
Giancola, Giulia ... 277, 303
Giles, Jason ... 204

Glaser, Milton ... 286, 288
Guman, Emily ... 203
Hakura, Tadanori ... 216
Haller, Carmit Makler ... 182, 310, 312
Herdeg, Walter ... 230-250
Hinrichs, Kit ... 227
IF Studio ... 276
Kim, Heera ... 225
Kottlowski, Laura ... 203
Kraemer, Peter ... 309
Kurlansky, Mervyn ... 222
Ljubicic, Boris ... 301
Milani, Armando ... 315

Noval, Danny ... 202
Nygaard, Finn ... 295
Pearson, Randell ... 78-90, 107, 214
Pulfer, Adrian ... 76, 77, 107-115, 136-139, 144, 145
Rand, Paul ... 213
Reidenbach, Melinda ... 203
Simpson, Greg ... 214
Slutsky, Lauren ... 223
Sohn, Hiewon ... 228
Synnestvedt, Jennah ... 206
Troxler, Niklaus ... 215
Wilde, Richard ... 228

ARTISTS/ILLUSTRATORS/PAINTERS/SCULPTORS

Blackshear, Thomas ... 299, 301
Bralds, Braldt ... 248, 289
Calder, Alexander ... 26, 33
Choi, Jiyun ... 205
Chwast, Seymour ... 242
Copley, John Singleton ... 90
Cosgrove, Jerry ... 35
Cunningham, Robert M. ... 69
Delessert, Étienne ... 122, 247
Ellis, Richard ... 84
Fletcher/Forbes/Gill ... 233
Forbes, Bart ... 24, 66, 80
Giuliani, Vin ... 239

Glaser, Milton ... 237
Hess, Mark ... 290, 292, 306, 309
Hess, Richard ... 119, 243, 245, 309
Hokusai, Katsushika ... 126
Homer, Winslow ... 90
Hunziker, Max ... 230
Igarashi, Takenobu ... 104, 105, 225, 277, 322, 323
Katsui, Mitsuo ... 263, 273
Kraemer, Peter ... 271, 309
Kurlansky, Mervyn ... 240
Le Foll, Alain ... 246
Liepke, Skip ... 250

Lilly, Charles ... 28, 29
Lucchi, Giuseppe ... 25, 27, 30
Machado, João ... 282
Maffia, Daniel ... 71
Mattos, John ... 255
Max, Peter ... 238
Mazenod, Jean ... 241
McLain, Dan ... 41-43
McLean, Wilson ... 32
Mendell & Oberer ... 249
Munch, Edvard ... 231
Palladini, David ... 84
Pezzutti, Santo ... 31

334 INDEX

Picasso, Pablo 232	Schwab, Michael 280	Vasarely, Victor 235
Pirtle, Woody 273	Steinberg, Saul 236	Verkaaik, Ben 253
Savin, Tracy 47	Ungerer, Tomi 234	Wilcox, David 36

PHOTOGRAPHERS

Almås, Erik 185	Johnson, April 76, 77	Robert, François 179, 180
Alvarez, Jorge 262	JoSon 226	Rohr, Frank 31
Azevedo, Athena 291, 293	Kachaturian, Armen 44,	Rossum, Cheryl 97, 98,
Balog, James 217-219 92-95, 133 114, 115, 142, 143
Bidaut, Jayne Hines 220	Knopf, Caroline 279	Sakata, Shinji 117
Breiehagen, Per 316	Kohanim, Parish 193, 199, 281	Samuels, Peter 317
Burandt, Todd 187	Laita, Mark 287, 289	Saraceno, Joseph 292
Camper, Ashley 195	Leutwyler, Henry 268	Satoh, Taku 264
Duers, Nicholas 307	Levy, Richard 120	Schatz, Howard 163-165,
Faulkner, Colin 189	Maisel, Jay 39 196, 278, 280
Field, Pat 67	Majidi, Morteza 132	Schoenfeld, Michael 300
Flach, Tim 192, 302, 304	Marco, Phil 50, 51,	Shepherd, Barry 186
Fogel, Walter 183 78, 80, 99, 131, 175, 244	Somoroff, Ben 35
Forster, Daniel 124	Martin-Raget, Gilles 275	Spiegel, Ted 82, 83
Frankel, Laurie 188	McDonnell, Mike 123	Taft, Ron 177, 201, 305
Fujitsuka, Mitsumasa 252	Meyerowitz, Joel 34	Tardio, Robert 191, 304
Gray, Colin Douglas 195	Meyers, Steve 40	Tu, David 121
Griffith, Christopher 190	Moscati, Frank 33, 34, 52, 53, 74	Turner, Pete 46
Gudnason, Torkil 308	Muna, RJ 197	Unangst, Andrew 112, 113
Guravitz, Dan 32	Newell, Lennette 294, 296	Vasan, Gandee 173
Harris & Ewing Photo Studio 172	Olson, Rosanne 284	Watson, Albert 283, 285
Heffernan, Terry 272	Parraga, Alfred 86	Weitz, Allan 79-81, 84, 85, 87-89
Hiro 36	Poon, Kah 305	Wolin, Penny 257
Humphreys, Dan 293	Reed, Kevin Michael 184	Wright, Todd 194
Igarashi, Takahiro 314	Rhoney, Ann 254	Wurman, Reven T.C. 256
Igarashi, Takenobu 252	Ricardel, Vincent J. 149-161	
Ikeda, Shig 38	Ritts, Herb 198	

CALLIGRAPHERS/TYPOGRAPHERS

Huerta, Gerard 134	Shibata, Kiyo 116	Tanaka, Ikko 223

EDITORS/WRITERS

Larsen, Paul 124	Pedersen, Martin C. 258

INSTRUCTORS

Goldberg, Carin 270, 313	Rogers, Paul 205	Sommese, Lanny 203, 204
O'Neill, Kevin 277, 303	Seichrist, Ron 202	Wilde, Richard 228

B.MARTIN PEDERSEN BIOGRAPHY

HISTORY

1923: My Father's Early Life

My father, Berndt Olav Pedersen, lived at 8610 Owls Head Court, near the ferry with access to Staten Island and Battery Park in New York City. He had emigrated to the United States at the age of 20 from Lista in southern Norway in 1923, had done well for himself, and could, therefore, later afford to live in a graceful neighborhood.

Saturday, September 16, 1933

Berndt Olav Pedersen, 30 years old, married fellow Norwegian Klara B. Larsen, 24 years old, in Bay Ridge, Brooklyn.

Saturday, April 17, 1937

I was born in the Methodist Episcopal Hospital in Bay Ridge, Brooklyn, to Berndt Olav Pedersen and Klara Larsen Pedersen, who named me Bjarne Martin Pedersen.

Wednesday, October 19, 1938

My sister, Gloria Olga, was also born at the Methodist Episcopal Hospital in Bay Ridge, Brooklyn.

1939: To Norway

My parents took us all to Norway on the *SS Stavangerfjord* after the grandparents on both sides urged them to come, wanting to see the grandkids. There were rumors of a war starting, but it was not taken seriously because of WWI. After all, with its staggering loss of life, it was supposed to have been 'the war to end all wars.'

Really?

Tuesday, April 9, 1940: Surprise

Germany launched a blitzkrieg ("Lightning War") by air, sea, and land. The king, his son, and the cabinet fled the Royal Palace in Oslo, pursued by German paratroopers. By the end of May, less than two months later, the Germans had 300,000 troops occupying Norway, a country with a population of three million. This resulted in a ratio of one German to every 10 Norwegians, the highest of any other occupied Allied country.

Friday, June 7, 1940

King Haakon VII finally escaped Norway with his son Olav and cabinet members after two months on the run with German paratroopers in constant pursuit. They eventually boarded the *HMS Cruiser Devonshire* and departed Tromsø for the U.K. with Crown Prince Olav and the cabinet to represent Norway in exile.

August, 1940: Three Escapes

Three small boats departed Lista, outside of Farsund, escaping the German occupation within weeks of each other, unaware of the others' departures. These boats were typical Norwegian wooden (lapstrake) double-ended open boats called sjekte, ranging in size from 17 to 21 feet, with single-piston motors capable of reaching up to six knots in calm water and up to four knots in heavy seas. Sjekte like these were common throughout the country.

The first boat to leave was skippered by 52-year-old submarine captain Edvard Christian Danielsen, who did this alone. This was a remarkable feat of seamanship. Upon arrival, he was arrested, interrogated, and quickly cleared. He then went to London and met with King Haakon, who had arrived a few days earlier. In recognition of his bravery, the king upgraded his rank to admiral and put him in charge of the Royal Norwegian Navy in absentia.

The second boat to leave had four men aboard: Carl Berthelsen, Kåre Langfeldt Jensen, Kåre Kirkvaag, and Jacob Ø. Samuelsen. The third boat had my father's younger brother, Frithjof, 28 years old, as well as two other Norwegian patriots, Odd Kjell Starheim, 24 years old, and Alf Lindeberg, 32 years old*, who also departed Lista. Their boat was 21' long and named *MS Viking*.

All three (photo on page 382) had graduated from Farsund's skipper school, so they named the boat SS or Steam Ship. A steamship is an ocean-going vessel, and a boat is coastal. Since they had prepared the boat for an ocean journey 300 nautical miles away to Aberdeen, Scotland, she was appropriately named.

All three boats* had headed north-northwest for Aberdeen, Scotland, 292 nautical miles away across the North Sea. They had all left at night so as not to be detected by German planes (Luftwaffe). They each reached Aberdeen about four days later. On arrival, boats #2 and #3 were arrested and interrogated until they were found to be Norwegian nationals.

*The three boats found Aberdeen with celestial navigation by taking morning, noon, and afternoon sun sights, which gave them the latitude of Aberdeen. Upon reaching this latitude, they then turned west and arrived at Aberdeen.

Sabotage Training

After being cleared, they all immediately volunteered for the Special Operations Executive (SOE), Winston Churchill's secret three-month intensive sabotage spy training school.*

*Churchill's school for Allied nations people who escaped their countries to learn sabotage training. They would parachute at night back to their countries to cause chaos for the Germans.

Sunday, November 10, 1940

After completing three months of intense SOE training, Frithjof and Alf Lindeberg from Farsund, along with Melangton Rasmussen from Bergen, boarded a Norwegian fishing boat named *URD*, which was to take them back to Norway.

When they returned, they were equipped with radio transmitters to send brief Morse code messages reporting valuable information about the occupying Germans in Norway to England. What they didn't know was that the German Abwehr (secret service) had purchased the boat in Lista, so upon arrival, they were each followed.

CAPTURES

Monday, December 16, 1940

Alf Lindeberg was first captured by the Germans at his father's home in Kristiansand, Norway and imprisoned there.

Wednesday, December 18, 1940

Two days later, the Germans surrounded Frithjof's father's house, my grandfather's house next to us in Kviljo, Lista. They could not find him in the house or the barn there. After they came to our house and after pitchforking the hay in our barn, they found him. He was then arrested and sent to the police station in Farsund.

About a week later, Frithjof and also Alf in Kristiansand were sent to Oslo's Møllergata 19 prison. Josef Terboven was Reichskommissar (imperial commissioner) in Oslo. Siegfried Wolfgang Fehmer, who reported to Terboven, was in charge of the prison. Fehmer was initially charming, though he became sadistic when he didn't get answers.

The prisoners had clearly not been treated well and were most likely tortured separately until their stories eventually matched.

Wednesday, January 1, 1941

Odd Kjell Starheim arrived aboard a British submarine at night near Farsund. The sub surfaced, and he boarded a small inflatable rubber boat with his transmitter and gear. Afterward, the sub descended slowly and floated Odd's boat. He then paddled free for the shore in freezing weather.

He landed outside of Farsund, deflated his boat, and hid it. He then connected with a Norwegian agent codenamed Fie (Sofie Rørvik). She gave him the directions to another agent's home further up a mountain outside of Farsund. Odd arrived there wet and shivering from the cold and was given dry clothes. He fell asleep in a warm bed for the night.

Days after, he was taken to a small cabin above Lista with a clear view of the coastline and reported with brevity to London. He later learned that Alf and Frithjof had been captured by the Germans, which depressed and angered him.

Wednesday, April 23, 1941

The Lista airport was completed, built by Russian and Polish prisoners, along with paid Norwegian laborers. The airport was only a runway length away from our house on the coast.

Since then, we had begun getting bombed by the British.

Wednesday, May 21, 1941

Odd Kjell Starheim, in his hideout in the mountains above Lista, spotted two German warships and gave a brief four-word signal: "Two large enemy warships." A German detected his signal and sent a single radial to his location.

Agent Fie, or Sofie Rørvik, saw the patrols who were following the radial, breaking into homes on the way and sticking pitchforks in barns with hay. She then walked through the patrols and went to Odd's hideout to warn him. On arrival, she told him that he had to immediately destroy what he could in minutes and then leave without any incriminating spyware on him. After leaving the cabin, they walked locked arm in arm, pretending they were lovers, and successfully passed through the patrols.

Sometime later, the Germans came to his hideout, realized he was a Norwegian agent, and sent dragnets out to capture him. After the escape, Odd knew he would be continuously pursued, and fled into the countryside, staying away from towns and the shoreline. The ships that Odd had reported turned out to have been the *Bismarck* and the *Prinz Eugen*, two of Adolf Hitler's prized and dangerous battleships that the British had been after but had lost contact with.

Tuesday, May 27, 1941

Six days after Odd's message, the 51,000-ton *Bismarck*—Germany's flagship battleship —was sunk in 12,000 feet of water. It took Admiral Lutjens and 2,300 German Kriegsmarine sailors with it.

Mid-June

After a grueling 250-mile trek to Sweden, Odd finally arrived there after a month on the run with the Germans chasing him.

Thursday, August 7, 1941

After a few trials, Alf Lindeberg, Frithjof Pedersen, and Melangton Rasmussen were sentenced to death by Admiral Max Bastion for espionage against the Third Reich.

Sunday, August 10, 1941

Three days later, all three were transported from Bergen to the Åckershus Gestapo headquarters in Oslo, arriving late at night.

Monday, August 11, 1941

The following morning, the three were roused from their sleep just before dawn, marched outside, and tied to a post facing a firing squad. They had all refused blindfolds.

Their bodies were removed and tossed into a truck, then buried in unmarked graves. They were the first to be executed at Åckershus. The order had directly come from Hitler, who wanted to set an example for anyone else considering committing espionage against the Third Reich. It didn't work—42 other Norwegian patriots were executed there before the war was over.

In peace, sons bury their fathers,
In war, the fathers bury their sons.

Sunday, March 15, 1942

Bletchley Park in England received a message that Odd Kjell Starheim and Einar Skinnerland had stolen a 620-ton German ship called the *Galtesund* from Flekkefjord and headed for Scotland. Odd and Einar immediately radioed for support, received assistance from the Royal Air Force, and successfully made it to Aberdeen.

Einar Skinnerland was an engineer at the Rjukan Telemark factory in southern Norway, where the Germans produced heavy water for the development of their atomic bomb. The British had tried to destroy the factory with bombers twice, but it was halfway down a fjord that made it impossible to hit. Einar's information on the plant was crucial to the British for future sabotage attempts.

Sunday, February 28, 1943

Almost a year later, Odd, now with 12 Norwegian commandos, hijacked another passenger vessel from the Germans called *SS Tromøsund* and then set a course for Scotland.

338 B.MARTIN PEDERSEN BIOGRAPHY

Monday, March 1, 1943

Days later, the *SS Tromøsund*, en route to Aberdeen, was sunk by the German Luftwaffe, resulting in the loss of all 26 people on board. The bodies of Odd and the ship's captain were washed ashore days later on the Swedish island of Tjørn, near Bohuslän, about 20 miles north of Gothenburg.

Odd's body was transported to Farsund, where he was laid to rest in Lista's Vanse Kirke's graveyard with a small memorial stone made for him. Having seen the stone many years later in the Vanse churchyard, I felt it should have been a much larger monument for him. The British awarded him the DSO, and he also received the Norwegian War Cross.

1944

I started school in Hananger at seven-and-a-half, under my first teacher, Fru (Mrs.) Theissen. Each school day, I would walk roughly three-and-a-half miles from Kviljo to Hananger with some books, school supplies, and lunch that my mom had made.

The Germans had taken over the original schoolhouse, and classes were moved to a small house with only two classrooms for four classes. Due to this lack of space, we went to school every other day and were given ample homework to make up for the lost time.

At school, I met and made three new friends in my class: Arvid and Ernst Nodeland, who lived on a corner farm that I passed on the way to school, and my schoolteacher's son Tor-Magne Theissen. We had an agreement that we would each finish our homework early so we could get together for various adventures on our day off.

During the War

Whenever we heard an air raid siren at school, Fru Theissen would immediately get us out of the classroom and rush us outside into the crawl space under the schoolhouse building. We would first hear the 88mm shore guns firing at the arriving British bombers and fighters, which would then bomb and strafe the German airport about three miles away from us. After about 15 minutes, it would be over, and we would then crawl back out and return to our classroom.

Air Battles

Walking home after class one day, I saw an air battle over the Lista airport. Though the planes were distant, I could still hear the rat-tat-tat of their machine guns, which didn't frighten me because of the distance. Instead, I was excited.

These planes were magical to me; I envied the pilots' freedom and wished I was up there in a plane of my own. Of course, that wasn't very smart since I also realized they were in deadly combat with each other. I was then struck for life with an interest in the magic of planes.

Some Years Later

After graduating from the equivalent of high school at the age of 14, Tor-Magne applied for sail training on the 1927 square-rigged vessel *Sørlandet**, based in Kristiansand. Tor-Magne became qualified and decided to pursue a career as a merchant marine officer , although he could have chosen the Royal Norwegian Navy instead. He went to sea on a Norwegian merchant vessel and became their engineering officer.

A few years later, his ship sank in the English Channel after a collision. He bravely stayed behind in the engine room to save his men before the ship went down. Tor-Magne never made it out.

After the war, Norway received the German sail training vessel *Staatsrad Lehmkuhl*, built in Bremerhaven in 1914, as a repatriation prize. The United States received the German sail training vessel, *Horst Wessel*, one of five launched in 1936 from the Blohm+Voss yard in Hamburg and was renamed the *Eagle* (WIX-327) for the U.S. Coast Guard sailing out of Connecticut. Had I stayed in Norway, I would have likely taken this training.

**Sørlandet was 210' long with a 30' beam displacing 891 tons. It could reach a speed of 14 knots under power and 17 knots under sail. She was one of two Norwegian-built sail training vessels; the other was the Christian Radich, constructed in Sandefjord in 1937.*

Sunday, January 23, 1944

Artist Edvard Munch died in Oslo. Born on December 12, 1863, he was 81 years old.

May 1944

British long-range Bristol Twin-Engine Beaufighters, specially equipped for night fighting and bombing, were escorted by Mustangs of the 65th Squadron led by Squadron Leader Peter Hearne. They took off from Peterhead, Scotland, and flew up to 300 miles at night to targets in Stavanger, Lista, and Kristiansand, Norway.

The night flights were flown low over the water to avoid German radar. There were times when it was so stormy that the squadron commander would increase altitude by a few hundred feet to keep rough sea salt spray from damaging the Mustang's Rolls-Royce engines. This was dicey, high, intense flying for all the pilots. These were the bombings that I experienced in 1944 that frightened me, especially the ones at night.

Monday, June 5, 1944: Operation Overlord (D-Day)

The Battle of Normandy was planned. General Dwight D. Eisenhower was appointed supreme commander, responsible for directing 156,000 allied troops landing on five Normandy beaches. There were also 7,000 ships and LST landing crafts manned by 195,000 naval personnel from each of the allied nations. Each beach had a code name: the British would storm Gold and Sword, the Americans would storm Omaha and Utah, and the Canadians would storm Juno.*

What was little known is that the Germans who defended Normandy were old men and Hitler Youth boys. None of them survived.

I saw only one film on the war whose name I can't remember, where an American soldier who had survived the beach carnage and had scaled a cliff to shoot the Germans realized after several fatal shots that he had killed kids. He stopped and shouted, "We are killing kids—what kind of a f*****g war is this?"

On the first day, 4,114 Allied troops were killed, including 2,501 Americans, and more than 5,000 wounded. As the battle progressed, 73,000 Allied soldiers were killed, with 153,000 wounded and missing.

At School, Another Air Raid Alarm

We scrambled underneath the school again and then heard the British planes firing and dropping bombs a distance away. A German freighter had continuously been attacked off the coast of Lista by British warplanes.

With the ship now afire and realizing that she was also sinking, the German skipper turned her towards land and grounded her on the small island of Rauna* a short distance off the coast of Lista. The ship had been carrying explosives, and when she started to blow, there were several minor explosions that continued until a big blast destroyed the ship, instantly killing everyone aboard. After the skipper had run it aground, there could have been a few sailors who managed to jump into the water to save themselves, but it wasn't likely.

The next day off from school, I left my house for the beach and walked about a quarter mile. Approaching the dunes, I started to walk cautiously. I heard the welcome pounding of the surf and then the seagulls and other birds circling and screeching at my intrusion into their lives. I realized that if any Germans were on the beach, I would be discovered. After passing by the last dunes and sighting the beach, there were, fortunately, no Germans there.

I walked to the surf line on the safe path between the mined area and then turned west to come in line with Rauna, where the ship had exploded the day before. This would be where the majority of the debris would have washed ashore. To my relief, there were no bodies there, though I found pieces of clothing and other reminders that men had been killed. Several more innocent items like kapok life jackets had also washed ashore. I decided to take home two that were in the best shape.

I continued further because I saw a gray-painted pole washed ashore and partially covered by sand. When I lifted the top end, I discovered the stern flagpole of the ship that had broken off at the base from the explosion's impact. The pulley on top of the pole used to raise the flag was still intact but jammed with sand. I then dragged the flagpole by holding it at the top and letting the bottom drag in the sand to where I had left the life jackets.

When I finally came home, I called my father and proudly showed him what I had taken from the beach. Rather than complimenting this effort, he became angry with me, partly for having gone to the beach alone but mostly because I had returned with stolen (not salvaged) German property

and a pole that carried the German flag. My father said he would throw it away because we could get in trouble if the Germans ever searched our house.

I returned for the lifejackets and hid them under the hay in the barn.

This is where Odd, Frithjof, and Alf had started their journey in 1940.

Germans Begging for Food

With the war going badly for the Germans, supplies and food no longer came to them. Two soldiers would come twice a week to our farmhouse with a tin bucket for food. They often gave my mother a list of what they wanted.

We farmed potatoes, beets, string beans, and turnips, and my father also fished. My mother, who hated the Germans, would bring my sister and me with her because we were both skinny. She said she couldn't fill the quota since we all had to be fed. There were no arguments.

Another Day, the Pilot

On one of these occasions, a pilot came with a young Hitler Youth boy. When my mother had just completed filling buckets with food, she noticed that the pilot had been looking at my sister and me and was starting to get emotional. His lips were quivering, and tears were welling up in his eyes.

My mother asked him what was wrong. In response, the pilot opened his wallet, took out a photo, and handed it to my mother. It was a photo of his wife and two kids who resembled Gloria and me. He then took out a letter that he had just received informing him they had all been killed.

Overcome by emotion, my mother grabbed the two of us and held us tightly. Through tears, she told the pilot how sorry she was for what had happened and that this was a terrible war for all of us. That moment will stay with me forever.

Sunday, February 11, 1945

Mom gave birth to a very healthy baby boy. There was no guessing as to what he should be named. It was, of course, Frithjof, after his uncle.

Thursday, April 12, 1945

Franklin D. Roosevelt died that day. The news came to the Norwegians via the Norwegian SOE agents since no one had radios. His death left the entire country in deep despair; FDR was highly revered, and many feared the war would never end without him.

Monday, April 30, 1945

Hitler committed suicide with Eva Braun.

Monday, May 7, 1945

Germany surrendered, and the war was finally over.

We Hear the Great News

Later that day, Dad came to me and asked me to go to the front of the house facing the ocean. Surprisingly, I saw that my father had saved the German flagpole I had carried home; I thought he had destroyed it. He had also dug a hole and planted it in the ground.

As I approached, he handed me a folded Norwegian flag he had saved and asked if I would clip it onto the lanyard. I did, and as it was being raised, the famous Lista wind immediately took it.

When it reached the top, the flag flew freely after having been dormant for five long years. My mom had come out and witnessed this, and we all raised our right arms to our chests in a salute.

Loss of Lives

More than 10,000 Norwegians lost their lives in the war, and over 50,000 were arrested by the Germans during the occupation. At the start of the war, Norway had approximately 1,000 merchant ships transporting supplies and soldiers for the Allies. Of these, 700 were sunk by U-boats, resulting in the loss of 3,700 Norwegian merchant seamen and leaving thousands of Norwegian widows.

The Germans had 863 U-boats on war patrols, and 785 men were lost; only 9% of them survived. The Kriegsmarine sailors and skippers were aware of these odds every time they went to sea.

"Man Has Yet to Conquer War!"
B. Martin Pedersen

Wednesday, June 6, 1945
King Haakon VII returned to Norway for a huge celebration.

1945: The 88mm* Gun Near Our Beach
After the coastal guns were neutralized and abandoned, my friends and I all went to one of the emplacements and decided to make it our clubhouse. When we first arrived, we played with the guns, each taking turns maneuvering the cannon barrel.

Two roughly 10-inch diameter wheels with handles were on one side to point the gun barrel to the targets. One wheel was for the barrel's vertical movements. The other, held with only one hand, was horizontal and turned clockwise or counterclockwise to guide the barrels horizontally towards a target. We managed to place spent shell casings in the barrel, pretending we were shooting down planes.

We met there a number of times until it became boring. Afterwards, we came up with the idea that we could raise our manhood.

These Krupp-made 88mm anti-aircraft guns were the deadliest in the war, and the Allies called them the ack-ack guns, from the German "acht" for "eight."

1945: Make-Believe Raleighs & Raising Our Manhood
We learned that our fathers were enjoying their new English Raleigh cigarettes, and we decided to try some ourselves. So, we all agreed to take the cigarette stubs that our fathers had finished and start to save them. We did this daily until we had enough to make full-size cigarettes.

When we each felt that we gathered enough pinches of tobacco to roll ourselves a cigarette, we agreed to go to our shore gun clubhouse. We met there and entered one of the trenches to escape the wind. We substituted cigarette rolling paper with newspaper because cigarette rolling paper was rare and impossible to get at our age.

We then put these homemade cigarettes into our mouths, struck our matches, lit the outer end, and started to suck smoke into our mouths to get it started. We were all watching and challenging each other to ensure that, rather than sucking smoke into our mouths, we inhaled it into our lungs.

It didn't take too long for the first of us to start coughing; soon after that, it became a cacophonous chorus. I coughed heavily, and I was the first one to throw up. Whatever food I had in my stomach at the time came out freely, but my body pushed me further to dry heave, and I felt an ongoing wave of nausea. I remember Arvid, Ernst, and a few others somehow managed to keep from heaving.

It was late afternoon, and I walked home. As I entered the house, I intended to go upstairs and go to bed because I wasn't feeling very well. This was a big understatement.

My father approached me and immediately smelled that I had been smoking. He pulled out a fresh cigarette from his Raleigh pack and handed it to me as he took out matches. He told me to put it in my mouth so he could light it. At that, I almost threw up again and ran upstairs. My father laughed and shouted after me that he hoped I was sick enough to never want to do this again.

Early August 1945: Liberation
That month, the British 50th (Northumbrian) Infantry Division liberated Norway. After their arrival, they were retitled "HQ British Land Forces Norway."

1945: First Candy
One morning, I left our home in Kviljo, heading for school. I was about halfway there when a truck slowly approached from behind me. After it passed, it stopped. I saw that the rear of the truck was filled with many British soldiers sitting opposite each other. One of them waved his hand, signaling me to come closer. I did, and with that, he gave me a big smile and a piece of candy. I took it, smiling back, and the truck pulled away.

I had never had candy before, so I put it in my mouth. It had a great, refreshing taste that I wanted to last forever. Unfortunately, it melted quickly, and then it was over. I had no idea what that candy was called, but it was a small, round, white life ring with a hole in the middle.

Many years later, when I was in the U.S., somebody gave me another one. The moment it entered my mouth, it was an immediate déjà vu. It had been a white Life Saver.

Wednesday, October 24, 1945: Executions

At Åkershus Festning (the Fortress), where German firing squads had executed Norwegian patriots such as my Uncle Frithjof and his two compatriots, Vidkun Abraham Lauritz Jonssøn Quisling was executed along with seven other Norwegian Nazi sympathizers.

Quisling had been condemned for treason and murder, and his name later became synonymous with the word "traitor."

September, 1946: U.S. Care Package

We received a care package from the United States that included small jars of American food products such as peanut butter. My most precious item was a five-piece packet of Wrigley's Spearmint chewing gum.

A Country's Branding: The Third Reich

Berthold Konrad Hermann Albert Speer* was the German architect who also served as Minister of War Production and Armaments under Hitler in the war. He also did something that had never been done before; he "branded" (a term not used at the time) Germany.

The visual images of the Nazi flag displayed on important buildings, the German military uniforms, and the outside party rally grounds (Reichsparteitagsgelånde) that were enormous in space and had vertical anti-aircraft lights that resembled Roman columns at night when Hitler spoke were all visually arresting.

*In the Nuremberg trials after the war, he was convicted and spent 20 years in prison in England. Born on March 19, 1905, he died on September 1, 1981, at the age of 76 and was buried in Heidelberg, Germany.

LEAVING NORWAY
October 17, 1946: Finally Heading for America

After a very sad goodbye from our grandparents, we got into a car—this was a first for my sister Gloria and me—and headed for Kristiansand to catch the ship that would take us to America.

En route, I got car sick.

Boarding the *SS Stavangerfjord*

Arriving in Kristiansand, we boarded this iconic ship of the Norwegian America Line, built in 1918 in the U.K., for our voyage to America. As we boarded, Mom and Dad were given the cabin number of our assigned stateroom and instructions on how to get there. We took multiple stairs, or companionways, down to a lower deck aft at the back end of the ship.

We entered the stateroom, a tiny cabin with two narrow single bunk beds, one on top of the other on each side. I was given the top berth on the port side, and Frithjof and Gloria had the lower ones underneath me. Dad took the top bunk on the starboard, with Mom on the bottom.

After getting settled, we all climbed the stairs to the deck as the ship began preparing to leave the harbor. We were all excited to finally be heading for America. As the ship pulled away, it was bittersweet and emotional to watch the Norwegian coastline, a country we loved, gradually disappear on the horizon.

Afterward, we returned to the cabin again, and on arriving, we found that we were on top of the propellers. Mom and Dad had us all on a tight budget, and they knew this would not last forever.

The Crossing

It was only a short time until we were at sea in open water, and it was starting to get rough. So, in a relatively short period after being carsick, I also became seasick and let go of what little I had left in my stomach into a bucket. I then went to sleep. After a day or two, I was over it.

B.MARTIN PEDERSEN BIOGRAPHY

It was a rough passage, and I remember us all going to the dining room and hanging onto the table with one hand while eating with the other as the ship tossed in heavy seas. On one steep roll, the plates on our table fell off and onto the deck.

Mom burst out laughing as we all unsuccessfully tried holding onto our dishes; she had a great sense of humor and could sometimes laugh to lighten the moments when things went wrong. Afterward, the poor stewards scrambled to pick them up.

Dad's favorite place in these stormy conditions was standing aft inside an open watertight door, where he could watch the heavy seas crashing astern of the ship while enjoying a cigarette. He loved the sea, and this was his realm.

The SS Stavangerfjord had a speed of about 16 knots that took about eight-and-a-half days to arrive in New York.

Friday, October 25, 1946: America the Beautiful

Dad woke me from my sleep and asked me to leave the cabin with him without waking anyone. I climbed down from my top berth and came out in my underwear, closing the cabin door as Dad handed me my clothes. As I dressed, I became aware that the propellers had stopped, and the ship was stable and not tossing anymore.

After I was dressed, Dad took my hand and walked me up the multiple companionways from steerage to the main deck. It was pre-dawn, and we were at anchor.

When we arrived at the bow, my father stood behind me with his hands on my shoulders. I was arrested by the sight of the Statue of Liberty and the New York skyline, which were magical to me on that pre-dawn morning. This was the first time I had seen buildings that tall. A tear or two of pure joy trickled down my cheek. Fortunately, Dad didn't see them.

For immigrants coming to the U.S. for the first time leaving behind whatever hardships they have suffered in their pasts, they usually fall into thankful silence when seeing this skyline and Lady Liberty for the first time. Overcome with emotion, there is hardly a dry eye amongst them. The memory of that moment is etched into my brain, never to be forgotten.

The United States of America, the land of the free and the home of the brave at the time, was to become a gift for our whole family in the future.

Stepping Onto the United States of America

After arriving at the pier and deboarding, we had to pass health inspections and customs. Finally, we walked outside on the pier and met my father's sister, Tante (Aunt) Frida, and her husband, Tony Tonnesen. They drove us to their home in Brooklyn.

I had my first American meal there, which was very special for Gloria and me. We each got a plate of cornflakes. The only problem for me was the milk was considerably watered down. I had been used to thick, warm milk directly from our farm cows.

EARLY YEARS IN THE U.S.A.

1947: New Home

We settled in the Norwegian section of Bay Ridge, Brooklyn, at 839 58th Street, in a rental on the first floor of a two-story building that Uncle Tony helped us find. Upon arrival, Uncle Tony handed me a dollar and asked me to go to Johnson's Soda and Candy Store on the corner of 8th Avenue and 59th Street. I went there, gave the dollar to the man behind the counter, and pointed out all the candies I wanted. He filled a small paper bag—I'm sure he gave me more than a dollar's worth—and handed it to me with a smile.

I returned to our new home, sat on the stoop, and started eating the candies, each more delicious than the last. After that, I got nauseous and went to the street and threw it all up. I was now cured of candy for the rest of my life.

SCHOOLS

1947: P.S. 105 Brooklyn & Johnny Antonelli's Invitation to Dinner

I attended school but had no comprehension of the English language. One day, a classmate handed me a note, and I took it home. My parents, who had lived in the U.S. before the war, were fluent in English. My mother explained that the note was an invitation to dinner on Saturday at 6:00 PM.

She told me that I should go, and the address was only about five blocks away. I agreed and decided to join the dinner.

On Saturday, I arrived at the house and was greeted by a cheerful Italian mother. She took me into the dining room and introduced me as everyone began sitting at a 10-foot-long dining table. It was a large family gathering that filled the table. I was seated on the corner next to the father, who sat at one end, with the mother at the opposite. Sitting across from me was his oldest son. This was clearly a seat of honor for me.

The mother and a few other ladies began serving the food and filling wine glasses. I was also given a glass with a small portion of wine. As everyone got seated, a toast was made honoring me, and I felt special. The food was so delicious that I couldn't stop eating, and the mother made sure my plate was refilled every time it ran low.

During the dinner, the father got into an argument with the son sitting opposite me. The argument became loud and intense, leading to the two of them getting out of their chairs, grabbing each other, and screaming. They raised their fists for a fight. Another male family member intervened to stop it. Immediately after being separated, the father and son approached each other, crying, hugging, and kissing. I felt silently embarrassed, never having seen men cry and kiss each other.

As the evening ended, I was sent home with a big hug from the mother, who gave me more food to take home. I walked home with warm feelings from my first experience with an Italian family. I liked it, and the next day, my mother wrote a note of thanks in English to the family that I was to give to my new friend, Johnny Antonelli. I came to love this family and the Italians.

1955: Pershing Junior High School & Brooklyn Technical High School

After P.S. 105, I went to Pershing Junior High School. In my final year, I took the test for Brooklyn Technical High School and was accepted.

Engineers and ocean liner captains were highly respected in the Norwegian neighborhood of Bay Ridge. I had a desire to become a civil engineer, dreaming of designing and building bridges in exotic places around the world.

Brooklyn Tech encouraged summer internships for future jobs you had an interest in. In my senior year, I got a job as an intern at an engineering firm. In that two-month experience, I was fortunate to find that this profession no longer interested me.

I went to Pratt Institute to see an entrant professor who said I would easily qualify for their engineering school, but I was now hesitant about enrolling in engineering.

I Finally Found My Passion

After leaving his office and walking the halls, I saw design work on the walls that blew me away. I suddenly felt a powerful desire, knowing that this was what I wanted to do.

I returned to the entrant professor and asked if I could qualify for the design department. He said I would have to take a test, which I took a few weeks later and flunked. I couldn't draw the human body. At Tech, I did exploded view technical drawings that didn't qualify.

I later learned from Milton Glaser that he had also failed the Pratt test. Afterward, he found that Cooper Union, an engineering school at the time, had just started a design school, for which he did qualify. Unfortunately, I wasn't aware of that at the time.

1955: Graduated From Brooklyn Technical High School

In the summer after graduation, I worked in construction for my father's carpenter friends on a site of multiple two-story homes and learned quality lessons. They were immigrant non-union framers, and they could frame one of these homes in two days.

My job was to keep them supplied with timber and clean up after the day was over. I had to meet them pre-dawn in Bay Ridge, and we would drive to the site, arriving at dawn when their work started and then leaving at dusk, making for a 12-hour work day. We had 15 minutes for coffee mid-day, the same in the afternoon, and only a half hour for lunch. This was exhausting, but I learned a lot of valuable lessons. When a frame was completed near the end of the second day, I was asked to clean up all the stray lumber and pile it neatly for garbage pickup. In addition,

B.MARTIN PEDERSEN BIOGRAPHY

I had to clean sweep the sawdust on each of the two floors. While I was doing that, they inspected the whole frame to make sure all the nails were hammered in properly, level with the wood, and not sticking up. When I thought I had finished my job properly, one of the framers asked if I could find a small, square piece of cardboard. I found a piece he approved of, and he handed me a brush.

I asked what this was for, and he said that I had to remove the small beads of sawdust in all the floor corners of the house. They took pride in their profession and did quality work. It was also clear that they loved what they did.

The Americans would take a whole week to frame one of these homes. They would arrive at 9:00 AM and have a half-hour break for coffee mid-morning, then take an hour for lunch and the same half-hour break in the afternoon before leaving at 5:00 PM. That resulted in a six-hour workday. Bless them, because this was the American life that their immigrant grandparents or parents had graced them with.

The State University of New York

After my construction summer, I enrolled in a two-year course in Design and Advertising at the State University of New York in Farmingdale, Long Island. After two years, I was left with a useless portfolio, having been taught by professors who had never been in the profession.

In the two summers between school, I worked at Larchmont Yacht Club, running a launch on weekends while wearing a khaki uniform and hat. During the week, I worked in the boatyard, mainly repairing wooden boats.

On one occasion, a flash storm had damaged a number of small boats in the bay, and they were towed to the yard for repairs. I went to the front desk to inquire if any of these owners worked in advertising, and I was given the name of a man who worked for the advertising agency Benton & Bowles. His name was Gunnar Falk.

I asked my yard foreman, Toby*, if I could repair Mr. Falk's boat under his supervision. Toby agreed, and as I repaired it, Mr. Falk would visit me to see my progress every Friday after work.

After the near completion of the boat, he seemed very satisfied and he then asked me about my plans for after the summer. I said I had just graduated from SUNY and was going to look for a job in Advertising. He then said that he was an Advertising Art Director. I faked complete surprise, and after that, he asked if I had a portfolio. I said I did, and I showed it to him the following Friday.

It became clear to me as he viewed it that he wasn't impressed and was honest enough to tell me. He then said he could get me a low-level job in the agency that would expose me to what goes on and could have some value.

"Would you be okay with that as a start?" he asked.

I immediately accepted his offer and thanked him.

*Torbjorn Vetland, known as Toby, had escaped the German occupation in Norway. After arriving in the United States, he was immediately drafted into the American Ski Troops and fought in Italy. He was wounded a number of times and came back with numerous awards. He earned great respect from the commodores of the Larchmont Yacht Club, and all his employees, myself included, gained valuable lessons from him.

PROFESSIONAL STORIES
First Job in Advertising: At the Bottom

With the summer over, I reported to Mr. Calvin Tompkins, the head of production at Benton & Bowles, an Advertising agency located at 666 5th Avenue and 52nd Street. I was assigned to a small, windowless room with two other guys, where our job was to wrap packages for the wives and girlfriends of art directors and account executives.

After a week, it became clear that they didn't know how to wrap packages properly. A few days later, I decided to visit the Bloomingdale's on 59th Street and 3rd Avenue and check out their gift wrapping department. I asked one of the ladies there if she could show me how it was done and if she could teach me. It didn't take long, and I thanked her by taking her out to lunch.

When I came back, I wrapped them properly, and it didn't take long before everyone only wanted me to wrap their packages. The other two guys just sat around and watched. I went to Mr. Tompkins, who had noticed this and complimented me on it, and offered him a proposal.

346 B. MARTIN PEDERSEN BIOGRAPHY

I asked if I could be promoted to the paste-up department in exchange for teaching the other two guys how to wrap packages properly. He thought it over and agreed.

The next day, I was promoted to the paste-up department. I immediately cleaned up the workspace and was taught how to cut bevel-edged mats to frame the ads that would be shown to clients. The ads were either hand-drawn or painted by talented artists, with the text created by artists using chisel-edged pencils. These hand-drawn and illustrated ads were true works of art. After I framed them, they were presented to the clients.

1955–1958: Ron & Little Jeff

My school friend Ron DaRos immediately qualified a grade higher than me and started paste-up in Grey Advertising, which was a few floors below where I was in the same building. He worked with Jeffrey Metzner, a man two years younger than us, who was intent on attending the School of Visual Arts (SVA) in the fall.

Ron, Jeffrey (or Little Jeff, as Ron called him), and I would reveal our ambitions in our regular brown bag lunch exchanges in Central Park, a short walk from 666 5th Avenue. Jeffrey told us that he was passionate about wanting to become an Advertising Art Director in the future.

Jeffrey Metzner: A Ph.D in Advertising

Jeffrey was street-smart and had made it a habit of being attentive to the Art Directors at Grey. Near the end of each day, he went around to check who required help before the evening ended and who would be burning the midnight oil. He then volunteered to stay late or come in early the following day to paste-up the comps for presentations to the account executives and clients.

This was a lifesaver for many of the art directors, so Jeff quickly gained their favor. Instead of waiting outside in the paste-up room, some art directors invited him to creative meetings with their writers. He listened, learned, gained confidence, and started sharing his ideas.

It was summer, and he was applying to schools, and one of his choices was SVA in New York. As the summer ended, he was admitted to SVA and said he had to leave Grey to start school. All the Art Directors unanimously responded that he should not go to school. They related that, with the passion he showed, they could teach him more than any school at the time could offer. Not only that, they thought that the school was expensive.

Jeff thought about it, and he decided to stay.

He was then invited to join the creative meetings and participated in coming up with ideas. One of the Art Directors hired him as an Assistant Art Director. He ultimately became an Art Director and gradually accumulated a portfolio. In less time than it would have taken him to graduate school, he was hired as a six-figure Art Director at Doyle Dane Bernbach (DDB), the top ad agency internationally. Had he attended SVA, he would have graduated with considerable debt.

Years later, after an extraordinary career, he retired and was invited by Richard Wilde to teach advertising at SVA. He only had a high school education but gained fame with his creative skills. Later in his profession, Jeffrey made history with his students.

Monday, May 9, 1955: Military Duty

I received an A-1 notice to join the military. Having just turned 18, I signed up for the eight-year U.S. Naval Reserve program that President Eisenhower had initiated. Before signing at a naval recruiting station near Times Square, I asked the lieutenant recruiting officer if there was a chance that I could be considered for the U.S. Naval Academy in Annapolis. He then asked me which high school I attended, and I said Brooklyn Tech.

To my surprise, he said yes since Tech was an engineering-based high school like the Academy. He then wrote a letter for me to report to the U.S. Naval Hospital in St. Albans, Queens. He was good for his word, and I was then obligated to sign up for the eight-year U.S. Naval Reserve program from May 9, 1955 to May 9, 1963.

A few days later, I went to the hospital for a physical exam. I was in perfect physical shape since I was into gymnastics. However, my eyes weren't 20/20, which meant I flunked the test*. I then went on active duty for three months of boot camp in Bainbridge, Maryland, and earned the rank of E-2 seaman apprentice.

B.MARTIN PEDERSEN BIOGRAPHY

Afterward, I transitioned to civilian life, although I continued to attend monthly naval meetings in uniform at a Brooklyn armory on 2nd Avenue. In addition, I had to serve two weeks every year on a U.S. naval ship. The good news was that I could now pursue my career.

I still have the letter (page 383).

WHAT'S THE BIG IDEA?

January 1958: Night School at SVA With a DDB Art Director

While at Benton & Bowles, I decided to go to night school at SVA and took an advertising class with Robert M. Fiore, a medal-winning Art Director at Doyle Dane Bernbach. The first class was in January, where he showed some of his extraordinary work and answered questions. At the end of the class, he gave us an assignment.

The following class was on a snowy, wintry night. As we entered the classroom, we all mounted our ads on the wall with masking tape. After we sat down and viewed the wall, we were all proud of what we had done. Mr. Fiore was about ten minutes late. After putting his coat away, he took out a cigar and walked across the room past all the ads. Before walking back, he lit the cigar with a lighter and took a few puffs while he kept the lighter lit. He walked across the room again and lit 90% of the ads on fire. The lighter was then too hot to hold, so he put it away and returned to the few surviving ads. He ripped them down, crumpled them in his hands, and threw them on the floor. We were all shocked, especially given our time crafting the ads.

After a few minutes of silence, he said he had just seen some beautifully rendered work, and some of them would qualify to be hired at his agency in the department that rendered ads for clients.

He said, "If interested, see me after class. However, what I didn't see was great ideas! Great advertising is all about ideas that can sell a product. Next week, the assignment is the same; all I want to see are fast magic marker ideas. From now on, you will spend your time thinking, not drawing or illustrating."

This was when I started to learn about great ideas. Invaluable.

October 1961

During the Berlin Crisis, I was called to active duty in the U.S. Naval Reserve and ordered to join the WWII Fletcher-class destroyer *USS Remey* (DD-688) stationed in Newport, Rhode Island.

At the age of 24, I was now a third-class petty officer in navigation. A few days after my arrival, I was offered a place at the Officer Candidate School (OCS) since I had a college education. I refused since I had only a year and eight months left in reserve duty. If I had signed up, I would have been committed to four additional years of active duty.

April 1963

I accepted a job at Rapeci's Associates, a schlock (Jewish term for low quality) design firm. My portfolio at the time was schlock because of the education I received at SUNY Farmingdale, where I studied Design and Advertising.

Thursday, May 16, 1963

Arna Tompsen Skaarva was crowned Miss Norway of Greater New York at the age of 20. She beat out 19 other beautiful contestants.

January 1964

I met Arna Tompsen Skaarva at a Sons of Norway dance hall in Bay Ridge, Brooklyn. After dating her for six months, I proposed, and she accepted. I told her then that this would be the happiest day of my life for the rest of my life.

I then told her I wanted to become a graphic designer. Although I would probably not make much money doing this craft, I would make a living for us. She asked if I would be happy doing this. I said yes. She then said that was most important; the money was secondary. I didn't know then how much she meant that.

Friday, February 14, 1964: Marriage

I married Arna in a church on 4th Avenue in Bay Ridge, Brooklyn. After the ceremony, we took both families out for dinner at the Hamilton House on Shore Road. That evening, she moved into

my apartment at 525 West End Avenue, between 85th and 86th Street in Manhattan. The next day, we took off for Vermont for a week of skiing at Mount Snow. When we came back, we were $500 in debt. What a way to start.

After our marriage, we struggled through the first few years. The great thing was that money never really mattered to Arna. What she considered essential was that we had enough money for food and our overhead costs.

In our early days, the accountant we had at the time would give us stock tips. Because we didn't have much money, we tried a few $200 investments, but none of them worked. We shared these tips with our friends and told them that they should buy the stock and sell it short.

Some years later, we found a way to make money in real estate. Arna was frugal and careful with it, unlike me. She was the richest person I knew because she didn't need anything. She cared much more for others than herself. What mattered most to her was family, friends, and, of course, our kids when they came. I was included as well.

As we (rather, Arna) raised the family (including me, given my 12 to 18-hour days during annual report season), we realized the only way to make money sensibly was with real estate. This we/she did in our spare time, and it served us well.

I was fortunate to have a loving wife, a great family, and my craft. I told students and others that if you love what you do, you don't go to work.

I felt truly blessed with Arna. She was incredibly beautiful, which she did not want to be complimented on. More importantly, she was 10 times more beautiful on the inside.

March 1964

Fired from Rapeci's Associates, we were both scrambling to find new jobs. It was not entirely unexpected. With the pharmaceutical clients I worked for, I kept trying to improve the work visually, but it kept getting turned down. I had done what was accepted, but the extra time I took to make improvements was not profitable for the firm. We had a respectful ending.

Needing Work Again

We were in a difficult financial situation. Having just returned from our honeymoon with $500 in debt, we both needed a job. We rented a one-bedroom apartment at 525 West End Avenue and were forced to be frugal. We lived on oatmeal and water three times a day and walked downtown for our job interviews. The subway was 15 cents then, more than we could afford.

Ten Days Later, Arna Gets a Job

Arna was hired by American Airlines at 655 3rd Avenue, which saved us. After working there for a week, she expected a check that Friday. However, near the end of the day, it didn't appear. She was told that they paid every two weeks.

She went to her supervisor and asked if it could be remotely possible to get paid for the week she had just completed, relating that we were living on oatmeal. The supervisor was kind enough to arrange for the payment. That evening, we celebrated with a simple yet luxurious feast: spaghetti in clam sauce (canned) and a $3 bottle of white Yago wine.

It was simply delicious, and after just one glass of wine each during the meal, we both fell asleep on the floor. This was the beginning of a chapter in our lives that would unfold into a wonderful, exciting, and loving journey—one we would cherish for years to come.

July 1964: "How much is that Modigliani in the window?"

Arna and I were leisurely walking down Madison Avenue on a Saturday afternoon when I spotted a Modigliani nude painting in a gallery window on the west side of the street, on a block in the 50s or 60s. I told Arna I was curious about what the gallery was selling it for, and she said we couldn't afford it, whatever the price. I agreed; however, I still rang the bell.

A minute later, an elegantly-suited man opened the door. I asked him how much the Modigliani was in the window. Without hesitation, he was graceful and invited us in, even though I was only 27 years old and looked perhaps even a bit younger. He told us the price was $35,000. This was twice the price of the Leisurama summer home we were about to purchase.

B.MARTIN PEDERSEN BIOGRAPHY

I immediately said it was more than we could afford, but would he be open to a proposal?

He responded, "Of course."

I asked, "What if we made a down payment? Could a bank offer a mortgage plan for the painting, with the artwork held in one of their vaults as collateral until it's paid off?"

He thought about it for a minute, then returned with, "I have not heard of this before, but it's a great idea." He gave me his card, asked for my telephone number, and said he would go to his bank with the proposal on Monday and call me. He kept his word and called me back late on Monday, saying that he had spoken to a few banks, but they were not receptive to this unusual deal. He said it was sadly shortsighted of them. He was again gracious and complimented me on my idea. I returned the compliment and thanked him for his kindness.

Thursday, April 22, 1964–Wednesday, April 21, 1965: NY World's Fair

We attended the New York World's Fair at Flushing Meadows Park in Queens, which featured over 110 restaurants and 140 pavilions from 80 nations and 24 U.S. states. It covered 646 acres with a lake, including fountains, pools, and amusement parks. We were awed by what we saw, including a memorable short film by Saul Bass called *Working*. We viewed a Leisurama model home for sale there, built on the circle in Montauk.

A few weeks later, we visited Montauk and saw the home again. We had been invited to stay at the home of George Knoblach, a friend of ours, by his father, and we talked about the house. It was furnished by Macy's, with everything from furniture to dinnerware service for eight. However, it was out of our reach financially. The house was for sale for $18,500 with a down payment of only $500 (normally, this would be 20%, or $3,700). After hearing this, George's father urged us to buy it and immediately offered to lend us the money. We refused at first, but he was insistent. 200 of these homes were built, and they were designed by Andrew Geller, an architect working in the Raymond Loewy office.

Five years later, in 1969, the homes were completed, and we moved in. As all the packages with our furnishings were delivered, we spent the weekend opening and carrying them into the house, giggling joyfully. Two years prior, we had paid Mr. Knoblach back for the loan. This was our first real estate investment.

April/May 1965: Hired at Chenault & Associates

This was at 605 3rd Avenue, a half block away from where Arna worked. It was a Design and Advertising agency whose major client was Trans World Airlines (TWA), which had multiple floors in the same building.

Stacy Mathis owned it, and it was also a sweatshop. He required everyone to arrive at 8:30 AM and work 9-10 hour days. The pay was good, but the hours were long, with many lessons learned.

1966: Hired by American Airlines

I resigned from Chenault & Associates after getting hired as a designer at American Airlines. There, I worked under C.W. Smith, brother of President C.R. Smith, who had been with the airline since 1934. My boss, Juan Homs, had poor taste in design, making it nearly impossible to sell him on tasteful work. He left on vacation sometime in 1968. During that time, a division in the company came to me to design a travel brochure, which I did.

When Juan came back and saw what I had done, he was irate, though it was too late to change since it had already gone to press. When the brochure was distributed, it became a huge success.

Thursday, April 13, 1967: First Son Born

Ford Eric Pedersen was born at 9:43 AM, bringing joy to our new family. Arna and I took him home from the hospital two days later in our VW Karmann Ghia to 525 West End Avenue.

I was also investigating getting a hack, or taxi, license to survive financially.

1968: GEIGY

After two years at American Airlines, I was hired as an Art Director and Designer at GEIGY Pharmaceutical, where I worked in their award-winning Design and Advertising department.

350 B.MARTIN PEDERSEN BIOGRAPHY

This was a reverse commute from New York City to Ardsley, driving about 45 minutes on the West Side Highway in a 356 Porsche convertible. I worked on accounts for Butazolidin and Tandearil (arthritis drugs) and Dulcolax, a stool-softening suppository.

Earlier, after attending the AIGA Awards presentations at their 3rd Avenue walk-up gallery run by Caroline Hightower and Nathan Gluck, I saw that GEIGY had been a consistent award winner and thought it might be a great place to get a job.

Fortunately, I was hired. John DeCeaser and I were the only Americans on the staff. The GEIGY staff were talented, modernist Swiss designers who had been winning the awards. They were one of the significant influences that introduced modernism to the U.S.

This was before computers, and the type shop whose book we used was *The Composing Room*. John and I were given free copies. *The Composing Room* type book was a thick, loose-leaf, spiral-bound book with about 200 pages of just about every typeface out there, each displayed with the entire alphabet in descending type sizes, and extra pages presenting the different text sizes to help specify the type for your job.

After a while, I removed all the pages from the book except for the few with Helvetica. I bundled the rest together and put them into a drawer. While the Swiss thought my approach was a little odd, it saved me valuable time by allowing me to go straight to the Helvetica pages instead of constantly thumbing through the entire book like they did.

They were great designers, and I had great respect for them.

1969

After a year and a half at GEIGY, with corporate advertising and design experience behind me, I decided to resign and finally start my design firm.

MY NEW DESIGN FIRM

1969: Pedersen Design Inc. at 60 Riverside Drive, New York City

I started my design firm myself, without a secretary or assistant designer. I would commute downtown by subway (which I could now afford) to show my portfolio to potential clients.

Months later, Juan Homs, my former boss at American Airlines, surprisingly called me and asked if I would design a magazine for him. I told him I had never designed a magazine before and that if I attempted it, I didn't believe I would get award-winning results, given my past experience with him at American Airlines. He said he needed a quality job; he would stay out of my way and trust my work. He also hired Donald Moffitt* from *The Wall Street Journal* as the editor and wanted me to meet with him. I did, and I liked him and related my past experiences with Juan.

Donald Moffitt had a great reputation as an editor at The Wall Street Journal. One of the epic stories he did was on Sonny Barger and the Hells Angels, which he co-wrote with Hunter S. Thompson.

My First Magazine: *The American Way*

From 1969 to 1973, I designed *The American Way*, the first airline magazine. After a few issues, *The Composing Room* salesman based in New York City, whom I first met at GEIGY and still worked with, set my type for the magazine. Without my knowledge, he submitted several issues to a design competition. Later, I received a letter from the New York Art Directors Club, inviting me to their awards show.

When I arrived that evening, I was seated at a round table near the front of the stage with legends like George Lois and Saul Bass. To my surprise, I won numerous awards at the show for my work on *The American Way*. As a result, I was congratulated by these idols. I was awed and humbled.

Of course, I continued to set my type with *The Composing Room* and continuously thanked the salesman for his gracious gesture.

1970: *Playboy*? A Surprise Call

Still working out of our apartment at 60 Riverside Drive, I received a phone call in my master bedroom office at around 10:00 PM while Arna was serving dinner in our dining room. I had just finished work, and Arna suggested I should go in and take the call since she would take some more time with the food.

B. MARTIN PEDERSEN BIOGRAPHY

I went to the office and picked up the call, and a man claiming to be Hugh Hefner asked for me. Given the late hour and my fatigue after a long day of work, I asked him to tell me who he really was. He asked me to take down a telephone number and to call him back for proof.

To my surprise, it truly was him. I apologized, and he understood. He then offered to pay for me to come to Chicago for 10 days with the intent to hire me. I was surprised, thanked him for this offer, and told him I was extremely busy and could only afford three days at most. He agreed with that, and I flew there a week later.

Off to Chicago

When I arrived in Chicago, *Playboy* had a limousine driver at the airport to pick me up and drive me to the Playboy Mansion. When I arrived, I was greeted by Hugh Hefner's business manager at the time, who thanked me for coming to Chicago and whose office opened up to the ballroom.

He invited me in and said that the small, elegant table outside was being prepared for our lunch. He stated that he was moving in and apologized for what he called a mess. Some of that mess just happened to be a few valuable paintings casually set on the floor leaning against the wall. This was intended to impress me immediately, and of course, it did.

Next, we sat at the table outside in their cavernous party ballroom, which I recognized as being used for their parties. Now, it was just the two of us. After we got seated, a waiter in tails and gloves poured each of us a glass of white wine. Hugh said that the job they wanted me to consider was Executive Art Director for *Playboy International*, with a staff of around 80 people. I was surprised and decided to sit, keep quiet, and just listen. As he continued, we were served multiple small portions of food, each paired with a new bottle of wine. Hugh added that for the rest of the afternoon, I would be meeting a number of the executives for only about 20-25 minutes each due to the short amount of time that I was in Chicago.

The next day, the first meeting was with the most impressive of these executives, A.C. Spectorsky, *Playboy*'s editor. He had been the editor that "Hef," as they called him, had hired to take over the editorial of this girlie magazine.

I was introduced to him and then complimented him on his achievement of giving the magazine sophisticated editorials with top writers. I also told him that this had to have been an enormous challenge with a nude ladies' magazine since he had a reputation as a serious editor.

He said it had been a huge challenge, and Hef had been adamant that he change it by bringing in respectful writers supported by a generous budget to help make it happen. He ultimately did that with great writers and also initiated the Q&As with famous people, which became a hit.

I was impressed and ended up overstaying my time with him by more than an hour. Each time my lovely young escort lady started knocking on the door, he yelled out that we needed more time. I spent the rest of my meetings with a number of executives who were gracious and all said how great it was to work at *Playboy*.

The following morning on the day I was leaving, I asked one of the executives if he could join me for breakfast. After we ordered, I asked him to tell me, in confidence, about working for *Playboy*. He started saying that everything was great, but I cut him off and said, "I already know that."

"What I want to know is what isn't great. If you lie to me and I take the job, I will have seniority over you, and I will have you fired." At that moment, he changed his story immediately.

The day after my return, I called the business manager and explained that moving my entire family to Detroit, leaving friends and our apartment in New York City, as well as a home in Montauk, wasn't possible for me to do. I sincerely thanked him and sent a letter of thanks to Hef. For a few years after, Hef sent us holiday cards.

VISITING MY FIRST SCHOOL TEACHER

1971: Marie Theissen

I had taken a trip to Norway and had stopped by to see my uncle, Torleif Reisvold, my mother's brother, and his wife and daughter. After catching up, I asked about my school teacher, Fru Marie Theissen, and I thought it would be a good idea to go and see her since she had been a great influence in my early life.

Uncle Torleif said, "I'm afraid you may be too late." He had heard that she was in the hospital in Farsund, terminally ill with cancer.

Since it was only about 20 minutes away, Uncle Torleif got me into his car, and we drove there. On arrival, we went to the front desk and asked if we could see Fru Marie Theissen. Fortunately, they gave me a room number, which meant she was alive.

I was 34 years old at the time, with a trimmed beard, and she hadn't seen me since I was 9, when I had left for America. When I came to the room door, I stood quietly for a few minutes before she saw me. What I witnessed was a thin, totally spent scarecrow of a woman sitting up but hunched forward in her bed with her shoulders and head hanging horizontally, barely able to hold herself up and clearly in some pain.

When Fru Marie Theissen became aware of my presence, she turned her head sideways toward the door where I was standing, stared at me for a few seconds, and said, "Bjarne" (my first name in Norwegian). Even with a beard, and after all these years, she recognized me as if it were yesterday.

I walked to her bed, sat beside her, and said in Norwegian, "I am so glad to see you again, and it is now time for me to hold you."

She knew exactly what I meant,* and as we talked for about 10 minutes, I looked up and saw that her daughter, Turid, as well as her husband had been observing this in the corner of the room. I was embarrassed and apologized, and they said they thought my visit and conversation were very special to Marie and them. They couldn't thank me enough for coming.

I talked to them briefly, and after saying goodbye to everyone, I left the room. As I walked away, I had tears running down my cheeks.

Two days later, my first exceptional teacher, Marie Theissen, passed away.

*During the war, when the airfield got bombed, she would get us all into the outside crawl space under the schoolhouse and hold us together.

Purchased a Sailboat: *Saga*

Arna and I purchased a boat in Huntington, Long Island, from a Seafarer factory there. The boat was a Philip Rhodes-designed Seafarer 31 sloop with a tiller for steering. She was 31' on the deck and 22' on the waterline with about a three-foot fixed keel, and she had a beautiful shear line profile similar to the classic Hinckley sailboats out of Southwest Harbor in Maine. We kept her in Keeler's Marina in Montauk. It was the only sailboat in Montauk at the time since the marina was filled with power boats, mostly for sports fishing.

There was one 30-foot inboard motored bass boat in the dock across from us that was owned by the marina loudmouth. We were a disrespected novelty among this whole group of serious, salty fishermen. So it was. Arna and I took the boat out for afternoon sails, and she became comfortable with it. We also brought our son along. On leaving and entering the harbor, we would use the engine. After a few trips, I checked the engine and pulled the oil dipstick out to find that the oil was turning milky white. This meant water was entering the engine.

I called the owner in Huntington, and he said I had to call the engine company in Connecticut, which I did. A mechanic came to check it out and found that the engine had been installed without a vertical elbow on the exhaust pipe. This resulted in my getting a cupful of water every time I turned the engine off. We were then without an engine for a month.

After a few weeks, I told Arna that the large square-rigged ships in the past didn't have engines, so we should be adventurous and see if we could maneuver the boat in and out of our slip using just our sails. We did just that a number of times, and on coming back into the slip, we had a very narrow channel to maneuver in. We did this with our small jib forward, which I walked from port to starboard continuously for each of the short tacks in the channel as Arna controlled the tiller.

On one of these afternoons, the loudmouth had witnessed this. When Arna swung the boat into our slip, he was standing there holding our bowlines for us. He then shouted for all to hear that he had never seen anything like this, and we had his respect after that.

Some weeks later, he was working on his boat and dropped a tool overboard. I was on *Saga* at the time and saw what happened. I opened the deck locker in the cockpit, took out my dive mask and snorkel, and dove down to retrieve the tool for him. After that, we were pier friends for life.

BURNED OUT

Beginning of July 1972

After almost three years in the design business (or rather, service), working 10 to 12-hour days, I found myself exhausted, burned out, and no longer passionate about my work. I told Arna I would like to take a break and sail *Saga* to Bermuda. She wasn't thrilled about this because of the danger, but she knew I needed a break, so she reluctantly allowed me to do it.

BERMUDA TRIP

Sunday, July 9, 1972: Sailing to Bermuda

After dinner at Gosman's Dock by the entrance jetty to the harbor with our wives and family, we boarded the boat (page 381) and departed Keeler's Marina, where I had a slip. The crew included Hugh McElroy from Port Jefferson, George Zuckerman from Smithtown, Alfredo DiNapoli from New York, and John Scarola from Montauk on the neighboring boat, *Andiamo*.

2040/8:40 PM: After leaving the Montauk jetty, we raised the mainsail and genoa and proceeded to sail east to the Montauk lighthouse before setting the course south for Bermuda. I set a single-handed watch schedule for three hours for each of us. If there were a need for additional support, the next person on watch would be called on deck to assist.

After about 10 hours of sailing, we entered the Gulf Stream's cross-currents. This was a continuous front of cloudy and unpleasant weather. In the morning, we became free of it and entered the clear, cerulean blue waters of the tropics. What a dramatic, welcomed change.

This was long before GPS, so I had to navigate there with celestial navigation. During our voyage, we had great days of tropical sailing and were often greeted by small schools of dolphins. They would envelop the boat with their exuberant gymnastics by jumping out of the water with heights halfway up the mast and then reentering the water without a splash. They would also come down deliberately with their entire bodies, soaking us all. We would all scream with joy until we were hoarse. This happened several times on our trip.

We would also encounter whales. During one of my early morning watches on deck, just as dawn started to break, I smelled the equivalent of low tide on our beach in Fort Pond Bay when shellfish and seagrass were exposed. I then saw, upwind of me, a huge sleeping whale.

Its back was covered with small growths of seagrass, and I sailed slowly past it about three to four feet away without disturbing it. Having been given the opportunity of getting so close to this extraordinary mammal was an unexpected gift.

Storms

We also encountered storms in these tropical waters. Before entering them, they appeared dark and ominous, with heavy rainfall and dramatic lightning strikes that seemed straight out of a Walt Disney movie. Once inside, we faced horizontal rain and got completely drenched, but about half an hour later, we would leave the storm behind and dry out in the sunshine again.

Revelations

After about seven days at sea, other crew members and I also experienced this.

Navigating

Bermuda is a speck of a dot in the ocean, and the star and sun fixes had to be accurate on arrival. I took morning, noon, and afternoon sun lines the day before arrival and advanced them, knowing our course and speed. I then got a running fix, which was suitable for latitude.

That same evening, I got three stars for another celestial fix. I used the *Nautical Almanac* and the H.O. 249 reduction table book for that latitude. Later that night, we saw the beam of the lighthouse from Bermuda. Fortunately, my calculated fixes were accurate. After having unsuccessfully attempted this with their fixes, many boats would have to return to the mainland.

Sunday, July 19, 1972: Arrived in Bermuda

0400/4 AM: After 10 days at sea, we arrived outside the Hamilton Harbor entrance and dropped anchor in the five-fathom hole after piloting at night through the north channel to Bermuda.

In the morning, I called the harbor master for approval to enter. They responded immediately and directed us to go to customs for arrival clearance. After that, we motored to the White Horse Tavern restaurant across from customs, tied up to a four-foot concrete bulkhead, climbed off the boat, and entered the restaurant.

The first thing we did before ordering food was to get some British gin and tonics, and we toasted our journey. I brought up my revelation from a few days before at sea when suddenly, in seconds, my mind cleared, and my whole life changed.

It became clear that I didn't hate my work; in fact, I loved it. What I hated was continuously working long hours until I was exhausted. I then changed my work life dramatically. The other guys had similar experiences, making the trip invaluable to each of us.

Monday, July 20, 1972
1430/2:30 PM: The following day, our families arrived, and we motored to another pier that was more convenient for them. Arna, Joyce Zuckerman, Christa, and Sean McElroy, Hugh McElroy's wife and son, joined us, and we all had a great time together.

Thursday, August 17, 1972
Departed with *Saga* from the P&W Marina in Hamilton, Bermuda, for Montauk. The crew aboard consisted of John Scarola from Montauk, Hugh McElroy from Port Jefferson, Howard Mihls from Westchester, and myself.

1645/4:45 PM: We took the departure of the Bermuda Sea buoy to port and set the magnetic course of 340 north with a speed of six knots for Montauk. Howard Mihls was on the first watch.

1740/5:40 PM: The cruise ship *Sea Venture* passed us abeam to starboard heading for Bermuda. We all became seasick.

Saturday, August 19–Sunday, August 20, 1972
We took down the sails as a thunderstorm engulfed us with 35-50 knot winds. We battened down the hatches, went down below, latched ourselves into our bunks, and rode it out.

Sunday, August 20: Unexpected Mid-Ocean Encounter
About two-thirds through our trip sailing back to Montauk, we saw a submarine surfacing about an eighth of a mile away from us on our starboard bow. We decided to head directly for her since, after surfacing, she stopped her forward motion and was seemingly inviting us to come to her.

We approached, and as we did, we saw a red star on her conning tower, which meant she was Russian. When we were about 10 feet off her starboard side, the captain and a few crew members appeared on the conning tower.

He greeted us in broken English and asked us where we were heading. We told him we were sailing for Montauk Point, the east end of Long Island. We then asked him where he was heading, and he smiled without a reply.

We spoke for a few more minutes and then wished each other safe voyages. He went below with his crew, and we waited about five or ten minutes, still dead in the water since we were pointing into the wind. The sub then propelled forward, immediately went into a dive, and disappeared beneath the surface. It was an unforgettable encounter.

Sunday, August 21, 1972
I took a morning sunline, a noon sight, and an afternoon sunline. Knowing our course and speed, I then did a running fix of the three shots to get our position.

1145/11:45 AM-1215/12:15 PM: I took noon sights.

2000/8 PM: I took an evening sextant sight of stars and the planet Jupiter. I then changed our course to 350 magnetic for a correction in our course.

Monday, August 22, 1972
1145/11:45 AM-1215/12:15 PM: I took more noon sights.

2000/8 PM: Again, I took evening sextant sights of the stars and the planet Jupiter.

2200/10 PM: We were sailing at five to six knots when we entered the east-west shipping lanes south of Montauk, New York.

Tuesday, August 23, 1972: Montauk Arrival

0600/6 AM: There was no wind under power; our compass course was 000 degrees north.

1200/12 PM: Wind picked up, and we then sailed again at six knots.

1600/4 PM: We spotted a fishing trawler off our starboard bow, barely visible through the thick smog that hung over the water. It was a sign that we were getting close to land.

1755/5:55 PM: We spotted the Montauk lighthouse through the heavy yellow smog less than a quarter mile ahead. The celestial fixes that I had plotted were accurate.

1942/7:42 PM: When we were about 20 miles away from landfall, the mustard-colored pollution haze ahead of us obscured our vision. Within a half-mile from shore, we finally sighted the Montauk lighthouse on our bow.

Passing the light, we headed west and entered the Montauk jetty with our sails up and the engine off and on standby. We lowered the mainsail passing Gosman's and continued with the jib only into our slip at Keeler's Marina. The engine had not been turned on. What a great ending to an unforgettable round trip, never to be forgotten by any of us! We then each called our families.

BACK TO WORK

A Solution to My Life: Balance of Work and Life

I decided to work three 12+ hour days, Monday through Wednesday. On Thursday, I would work an eight-hour day for a total of 44 hours, leaving that evening after supper for Montauk. I managed three-day weekends without work and had more time for my family and life.

1973–1977: Start of *Nautical Quarterly*, A New Magazine

I love boats, so I wanted to design a new magazine on the subject. At the time, I was disappointed with *Yachting Magazine* and felt I could present the boats in a better way. In my free time, I designed covers and spreads, pasting my ideas onto illustration boards with photos and mock text, using Aachen Bold press type for the headlines. When I finished, I had about 15 boards with transparent paper covering them.

I then found the name of the acquisitions editor at Time Life, called, and the secretary said that I could come and drop them off. The next day, I did that and saw a number of other portfolios there. I was told I would have to wait a week or more before he could respond. Surprisingly, I got a phone call a day later asking me to come and meet with the editor.

I arrived at the Time Life headquarters in Rockefeller Center on 6th Avenue and was called into his office. He complimented me on what he saw and said that it qualified me immediately to get hired by Time Life to design and produce the magazine. I was pleasantly stunned. He then said he would tell me something if I did not repeat it. I agreed, and he related that if I were hired, my designs would have to be shown weekly to a group of directors whose opinions could disrupt my progress. Ultimately, the magazine might not appreciate anything I proposed, and I would probably not want to put my name on it. He said I would probably go to the bathroom frequently to relieve myself of my lunch. In the end, he strongly suggested that I find a wealthy individual who loved boating to invest in it.

I pursued it and, after about a month, was recommended to Don McGraw of the McGraw Hill publishing family, who owned a Hinckley Sou'wester 50 yawl that he kept at his waterfront home in Connecticut. I had already convinced a printer I previously worked with to give me a 16-page press proof of the first issue. If I could get a sponsor, he would do the printing. At lunch, I used these proofs to interest Don McGraw, and he became my investor. The new magazine was called *Nautical Quarterly* (pages 78-91).

I then hired Joe Gribbins as an editor who had worked with Donald Moffitt and me as assistant editor on *The American Way* for American Airlines. I had rented space as Pedersen Design with DeGarmo Advertising on 633 3rd Avenue, and that's where it started.

356 B.MARTIN PEDERSEN BIOGRAPHY

In the December 2012 issue of *Yachting Magazine*, writer Kenny Wooton shared this about *Nautical Quarterly*: "It was an aristocratic boat book in a blue blazer, minus the brass buttons."

1975–1985: The Birth of Jonson Pedersen & Hinrichs Inc.

Kit Hinrichs connected with me for a partnership, but I turned him down three or four times. After leaving his partnership with Tony Russell (Russell & Hinrichs Inc.), Kit wanted to return to San Francisco, where he grew up, and have me take over his accounts. When I asked why he wouldn't hand them to Tony, I couldn't get a clear answer, so I called Tony. He didn't sound happy.

Kit asked if I could take over his accounts and pay him roughly 30% of my design fees to help support him in San Francisco. I told him that it couldn't work since he had a very distinct and brilliant style of design that his clients requested, and I didn't design like that. We were discussing this in my office when Vance Jonson happened to drop by. Vance sat in on our exchange, and we decided to go to lunch at a nearby Japanese restaurant a half block away on Lexington Avenue.

Vance immersed himself into the conversation further and, about 10 minutes later, proposed a possible solution. He suggested we should share each of our portfolios and, most importantly to me, not be financially in each other's pockets. We thought about it for a few minutes, and agreed that it was a great idea.

He then asked if he could include himself as a partner and said we would each own the corporate name in the states we worked in. He said we each had equity in our names and felt they could be used in our corporate name. Vance took out a half-dollar coin and tossed it for the sequence.

He won first, me second, and Kit last. We then formed Jonson, Pedersen & Hinrichs Inc. (JP&H), with Vance owning the name in Connecticut, me in New York, and Kit and Linda Hinrich in California. This kept us financially independent but gave us the advantage of an impressive combined portfolio, which was far superior to the Pentagram partnerships.

In 1976, I hired Neil Shakery, who was leaving Time Life, to join me in my 141 Lexington Avenue office as part of the group with everyone else's approval. We then became Jonson Pedersen Hinrichs & Shakery Inc. (pages 74, 75).

New York Art Directors Club: Awards

In 1978, JPH&S became the first design firm to receive more awards than ad agencies at the New York Art Directors Club awards evening. If you hit the top in the awards games, it's only for a few years, and the next group rises. Fallon McElligott Rice wiped us off the pedestal a few years later.

That evening at the awards ceremony, Kit was pretty deflated, and I told him we were history now. He didn't take it very well, but I cheered him up by telling him we were still in business.

At the end of that evening, I walked over to the Fallon table and congratulated them. They thanked me. As I walked away, they said, "You look familiar. Who are you?" I replied, "I am history."

In the following years, JPH&S still won our fair share of awards. What was important to each of us was our passion for our craft. We worked hard to design and produce great work for clients who were receptive to quality.

1978

I won the Columbia University National Magazine Award (The Calder) for the best-designed magazine in 1977 for *Nautical Quarterly* from the American Society of Magazine Editors.

I was totally surprised.

1980: *U&LC (Upper & Lower Case)* for Herb Lubalin

I designed a few issues of *U&LC Magazine* (pages 100-105) for Herb Lubalin when he was sick. Bob Farber, Herb's assistant, had called me and asked if I could temporarily design the magazine until Herb was well enough to return.

The deadline was tight when I got the assignment, and I had to design it in a rush. Bob told me that Aaron Burns* (the majority shareholder of the magazine) thought I should do it on boats, given his awareness that I had done *Nautical Quarterly*. I said I had done enough with boats and asked if I could do planes, another passion of mine. I got approval and pushed it through, barely

B. MARTIN PEDERSEN BIOGRAPHY

making the deadline. Aaron was away from the office when it went to the printer. When he returned, he was irate at what I had done. He would not have approved it if he had been there at the time.

Herb Lubalin, Ed Rondthaler, and Aaron Burns started the International Typeface Corporation (ITC).

1980: The Muppets?

I received a phone call from Ms. Roberta Jimenez who said that she was an executive at Henson Associates. She said that she had seen my work and very much wanted to work with me on a brochure promoting the Muppets.

I told her that I didn't feel I was appropriate for this job since my work didn't align with the Muppets' style. She immediately disagreed and felt strongly about wanting to work with me. So, I proceeded to design the Muppets' promotion brochure (pages 92-95) for Jim Henson, with Roberta as my main contact. She was an electric, intelligent, and personable client contact who made the job smooth and enjoyable.

Monday, March 30, 1981

Our third son, Christopher Alexander Pedersen, was born.

Sunday, May 24, 1981

Herb Lubalin* sadly died of cancer at the age of 63.

I had helped him purchase his firehouse building from Otto Storch.

January/February 1981: *Sea Cloud*, A Gracious Vessel

For *Nautical Quarterly* issue #14, I decided to do an article about the *Sea Cloud*. I knew of Dina Merrill, the actress whose mother, Marjorie Merriweather Post, had owned the vessel, so I thought Dina might have valuable information about it. Knowing she lived in East Hampton, I gave her a call, and she answered. I explained that I would like to do an article on the *Sea Cloud* in the next issue of *Nautical Quarterly*, a hardcover magazine on boating. She agreed and invited me to visit her in her East Hampton home.

Arna and I visited her house on our way to Montauk on a Friday, and she graciously received us. After introducing ourselves, Dina asked us about our heritage. We related that we were Norwegian, and she emotionally told us a story about a skipper who felt like a father to her on family cruises. When they cruised Europe, her parents had numerous parties in multiple ports. In some instances, there was royalty aboard. One summer, when a nine-year-old Dina was off from school, she joined them. Her parents were continuously busy with the guests, and she told us that the skipper, while in port, would see her crying, and he would take her hand and sit her on his lap, drying her tears and holding her with his big hands. To her, for these summers, he became her father. Many years later, having kept in touch, she flew to Norway for his funeral.

Dina grew up in Palm Beach, Florida, on the Mar-a-Lago estate her mother had built. Her mother, as mentioned, was Marjorie Merriweather Post from the cereal fortune who had married Edward Francis Hutton of Wall Street fame.

E.F. Hutton had built the four-masted, square-rigged vessel *Hussar V* in 1931 and painted her black. Her cabins were luxurious, and she had a crew of 75 when she sailed. At the time, she was the largest private yacht in the world.

Edward Francis had many affairs. Marjorie divorced him four years later, in 1935. As part of her settlement, she received the *Hussar V*. After taking possession of the ship, she repainted it white and renamed it *Sea Cloud*.

Wednesday, June 17, 1981

Britt Pedersen, the daughter of my brother Fred and his wife Gunvor, died in Southampton Hospital from cancer at the tender age of seven.

March 1982: *Nautical Quarterly* is Over for Me

I lost controlling interest in *Nautical Quarterly* after needing more money due to the unexpected recession in 1981-1982 and additional expenses. When the extra money came from McGraw, C.S. Lovelace, whom Don McGraw had hired as the managing director, told me to reduce my fees.

358 B.MARTIN PEDERSEN BIOGRAPHY

I was already losing money with the time my staff and I spent because I loved the work. However, this was not survivable for me, and I resigned.

Years later, I read a biography about the brilliant businessman and pilot Howard Hughes. In his book, he related a similar experience, and he had also asked for too little. As such, he developed a new formula. When he calculated that he needed one million to start a new business, he would ask for three million and spend it as if he had received only half a million. It was a great lesson, but it came too late for me.

1983: An Important Award

I received the first Herb Lubalin Memorial Award from the Society of Publication Designers for lifetime achievement in Editorial Design. This award was among my greatest honors since Herb was my typographic inspirational design hero.

Aaron Burns, who was in the audience, came up to me in tears and congratulated me. After the ceremony, I went to him and related that if he had not controlled or art-directed Herb, he would have had a shelf full of awards for *U&LC*. He then thought about it and became despondent.

February 1984: TED Conference, Monterey, California

Ricky Wurman* invited me to the first two TED conferences he had started. At the first one, he seated me next to a man whom he spoke to and shared something in common with me. Well, that was a conversation starter.

We introduced ourselves, and his name sounded familiar, but I couldn't place it. I told him that I was a graphic designer and publisher for *Graphis*, and he said he was a journalist. We didn't seem to have anything in common, so we discussed hobbies and other interests. He suggested sailing, and then we had it. I asked him about his experience, and he shared that he had sailed solo across the Atlantic from England to the U.S. in a small sailboat. I told him that we had something in common, as I had made two round trip sails from Montauk to Bermuda with a crew. I complimented him on his adventure and asked how he had navigated his crossing, thinking he must have known how to use a sextant. He said he didn't have the skill but knew that if he headed west, he would have to reach the States. He had landed somewhere in New Jersey. Amazing. We had a great time talking boats.

Later, I learned about his reputation and that he was also married to Tina Brown, who had revived *Vanity Fair*. I looked him up again years later and found that Tina had announced that he had passed away peacefully at home at the age of 92 in September 2020. He died of heart failure.

They were married for 39 years, and she called him her soulmate.

Richard Saul Wurman started the TED conference, which was a brilliant concept. Ricky had a curious mind, and what he didn't know, he pursued. With Graphis, I did his Information Architects book. See page 221.

1983–1984: Exploring a Design Magazine

After losing *Nautical Quarterly*, some colleagues encouraged me to start a new design magazine. I thought it over, decided to give it a try, and put some ideas together with a proposal.

I was advised to call Grant Thornton, a company that made acquisitions, and connected with Mr. Kevin R. Batchelor, a partner in the firm. He suggested that, rather than starting a new magazine, I should buy an existing one, which would be easier. He said that an existing magazine would have a proven financial track record. If I purchased it, knowing that I could make improvements to increase revenue, this would help pay off the loan. After some thought, I agreed, and he told me to list three design magazines I would like to consider.

First on my list was *CA Magazine* out of California, run by Richard and Jean Coyne, and the second was *Graphis*. I didn't have a third.

1984: *CA Magazine*

Richard Coyne* and Robert Blanchard started *CA Magazine*, publishing their first issue in August 1959. A letter was sent to the Coynes, inquiring if they would consider selling the company and, if so, for how much. They responded, saying they would seriously consider it and get back to us. Kevin noted that such a decision would take time with a family-run magazine.

B.MARTIN PEDERSEN BIOGRAPHY

He explained their thought process. The first was happiness that they would finally be relieved of full-time work. The second was how much money to ask for the company, and the third was what to do with the payment. This sale would finally allow them to stop working 12-hour days and be able to retire with a grace that had been earned and was well-deserved.

After some time with this potential luxury, the thought came to their son Patrick. They asked him if he would be interested in coming into the business and helping relieve them of the daily workload.

Patrick, then a practicing graphic designer, was not interested in joining his parents at the company. He had started his own graphic design firm and felt he wanted to pursue that on his own without his parents' help.

After six weeks, I received a respectful negative answer. The good news for the Coynes was that Patrick, after thinking it over, ultimately decided to join them in the business.** So, I pursued my second choice: *Graphis*.

*On June 12, 2022, Richard Coyne sadly died of lung cancer at 73.

**Patrick had done a great job with the magazine while his father was still alive, which must have made him proud of his son then. He would be now if he were alive today.

My Other Option: *Graphis*

I remember early in my fledgling career how impressed I was when I saw my first copy of *Graphis* in the 1960s. The magazine was so beautifully produced that it put all the competitors to shame. I subscribed immediately, even though I could barely afford it then. When my first issue arrived, I removed it from its perfectly crafted box, which appeared untouched.

Years later, I was told that the warehouse staff was required to wear white gloves while preparing the magazines for shipping to avoid fingerprints. Of course, I was also awed by the work and wondered if I could ever reach the levels of the talents presented on its pages. I was challenged.

So there I was, about to make an offer on a magazine I had revered for my whole professional life, and I was humbled by it.

Letter to *Graphis*

With further advice and encouragement from Kevin Batchelor, I sent a personal letter to Walter Herdeg at Graphis, Inc., respectfully asking if he would ever consider selling the company. Then, one or two days later, I was surprised to receive a letter from Graphis, Inc., thinking this was unusual Swiss efficiency. The letter was not what I had expected.

Crossed Letters

The letter I received was an invitation from Walter Herdeg at Graphis, Inc. for my colleagues and me at JPH&S to send in our best work for a future presentation in their magazine. I was sincerely taken aback, as were my partners when I informed them of this honor. Of course, I became worried about my seemingly arrogant proposal to buy his company.

So, to his surprise, a letter arrived the following day for Walter with my offer. He sent a letter back to me, which came a few days later with an even greater surprise. Walter told me that the company had just recently been put up for sale and that he would welcome a call from me. He did state, however, that there were several other interested contenders.

Two days later, I flew to Zurich.

1984: Join Pentagram?

At the same time, I received a phone call from Colin Forbes of Pentagram, one of the three founding partners of Fletcher/Forbes/Gill in 1962. The call was about considering me for a partnership with Pentagram in their New York office. I related that I was honored by the invitation and thanked him.

About a month later, I was invited to a partner meeting in New York to get familiar with the firm's operations. After the meeting, I told Colin I would only consider the offer if my other partners were included. They agreed, though Kit hesitated, not due to his talent but because of his West Coast location in San Francisco. They were afraid they might be unable to carry an extra office. However, Kit was ultimately invited to meet with them to ask further questions, and he flew to New York for the meeting.

He first came to my office on 141 Lexington Avenue. After, we walked to Colin's apartment, where we were invited for lunch. En route, I confidentially told Kit that I was negotiating with Walter Herdeg to purchase *Graphis*. He was surprised, and I asked him if he thought I should share this with Colin. He felt that I should.

As always, we arrived at Colin's apartment for lunch, and Pentagram was elegant. Colin had hired a waiter to serve lunch to us while we discussed our potential futures. I revealed my negotiations with Walter for *Graphis*. Colin was equally surprised and shared that Walter was also doing a story on JPH&S. I told him if this were to happen and if I were to bring *Graphis* to Pentagram*, I would like to retain 51% of *Graphis*, which I would pay for. The other 49% would be shared equally amongst the other partners. Colin hesitated for a moment and said that Pentagram had a few bad experiences with past partners who had tried this and failed. He noted that Pentagram partners traditionally shared everything.

Given my publishing experience with *Nautical Quarterly*, I said this could only work if I had primary control over financial decisions, some of which would need to be made immediately.
If I had to wait for all the international partners to meet and talk, the time required could be costly. If this were not accepted, I would have to turn down the invitation if I were to acquire *Graphis*. I said my chances of getting it were slim since I understood there was a lot of competition after it.

**I later found out from Marcel Herdeg, after purchasing Graphis, Inc., that Pentagram was also trying to buy it at the same time. Colin, of course, knew this when Kit and I met with him but never revealed it. So much for him as a partner.*

Monday, June 9, 1985: More Gold
JPH&S took three gold awards from the New York Art Directors Club, as Phil Dougherty reported the next day in *The New York Times* on Monday, June 10, 1985. Kit took one gold, and I got two. It was a surprising evening.

1985
I was elected to the board of directors of the Art Directors Club and decided to decline the offer to join Pentagram as one of the partners.

PURCHASING GRAPHIS
7 AM: Flight to Zurich
Swissair flights would leave JFK at 7:00 PM and fly nonstop to Kloten Airport in Zurich, arriving there at 7:00 AM with everyone jet-lagged. After clearing customs, I took a taxi to a hotel recommended by Walter, which was close to the center of the town. I took a shower to freshen up and slept for about an hour with an alarm clock set because I was due to meet Walter at noon.

Meeting Walter Herdeg: The Deal
I was to meet with Walter secretly away from his office in the middle of the Guisan Quai Bridge on the north side of the lake in mid-Zurich, which made me feel like I was in a Robert Ludlum spy novel. I walked to the bridge and saw an older man waiting at the midpoint, leaning with his elbows on the rail, looking at the traffic on the lake. I headed towards him.

Upon meeting, he welcomed me, and we shook hands. Not wasting time, he immediately told me that the purchase price for *Graphis* was $1,200,000 and checked my reaction. I kept a straight face and quietly nodded, and he then asked if I had the resources to make this happen. My answer was yes, but I would need a little time.

He then asked me to share some of my business experiences with Pedersen Design, JPH&S, and especially as publisher and designer of *Nautical Quarterly*. He knew I had failed with *NQ* and wanted to know why it happened.

I revealed that after four years with some unexpected expenses, I ran out of money and now needed more to keep running the company. When new money came, I lost controlling interest in the company. I also got a big reduction in my design fee, which didn't come anywhere near the time I put in, so I resigned.

He stressed that business management was a necessity in successfully running *Graphis*. I said that I had learned great lessons. He didn't seem concerned about my ability to design since he

B.MARTIN PEDERSEN BIOGRAPHY 361

was working on an article about me. There were no more questions. Afterward, he asked if I could meet with his son, Marcel, the following day. I agreed. As he was about to leave, I asked if he would be speaking with other contenders. He politely replied that it was confidential, and we parted with Wiedersehen ("goodbye"). I had heard rumors before.

Pentagram in Zurich

Arna had booked a room at the Eden au Lac Hotel just a few blocks from Dufourstrasse near the Graphis Inc. offices. The next morning, I went down for breakfast at the Eden. To my surprise, three Pentagram partners were there. We greeted each other, and they invited me to join them.

We all inquired as to what each of us was doing there. We all lied. However, I had a suspicion.

Same Day: Marcel Herdeg Grilling

I met with Marcel Herdeg at the *Graphis* office at 107 Dufourstrasse, a few blocks from my hotel. The approval process involved numerous interrogations with Mr. Herdeg and his son, Marcel Herdeg. I immediately found Marcel to be gracious and charming.

The questions came and were tough but fair. I answered honestly; if I didn't know the answer, I said so. Marcel asked me to share my experiences with Pedersen Design Inc. and later in 1975 with JPH&S. He was now especially interested in my experience as publisher and designer of *Nautical Quarterly*. He also asked me for an explanation as to why I failed with it. I shared the lesson as I had told his father.

After three-and-a-half years, I stated that I required more money after an unexpected recession and unexpected expenses. With the investment amount I received to start the company, I had projected expenses, including everything I could think of plus cushions, which should have been more than enough to sustain the business, especially with a conservative income projection. The income at first turned out better than I had projected, but my expenses were much higher than I had predicted, so in the fourth year, I needed more money. As a result, I lost my controlling interest in the company. However, extra money was required to continue the magazine. New management came in with the money and reduced my design fee, which didn't come anywhere near the time I put in.

I related that a year later, I learned a big lesson after reading an autobiography on Howard Hughes, the multi-millionaire businessman and pilot. He stated that when he wanted to start a new company and needed money early in his career, he asked to be covered for his projections. He later found that he had never asked for enough. So, his new philosophy was to ask for three times his projections and work as if he had only a third of that money, and he was a success after that.

After a few more brief meetings, I had questions about *Graphis*, and he answered. We ultimately came to a close, and then Marcel asked me if I might have any more concerns if I were allowed to take over *Graphis*. I told him I had one big fear, and he asked me what that was. My response was, "What I don't know, I don't know." I then asked if he could supply me with 10 years of *Graphis* profit and loss financials for which I would sign a confidentiality agreement.

He said he would. I received them the next day and took them on my return flight to New York.

Return Flight to New York: *Graphis* Financials

With the financials from Marcel, I started to immerse myself in them during my trip back home. Zurich's overhead costs were in Swiss francs, and about 70% of the sales were in dollars. *Graphis* had reasonably consistent profits every two years, and every third year, there was a very healthy profit spike due to an extra book being produced.

After arriving in New York, I asked Marcel why an extra book wasn't considered each year. He said that producing it exhausted his father and the staff, which made me anxious some years later. I felt satisfied with this and then ran my projections for five years.

The important thing was the unknown exchange rate between the U.S. dollar and the Swiss franc. Despite the profit spike from the extra book, Graphis, Inc. also suffered a loss every third year due to the exchange rate fluctuation. However, the average for all the years resulted in profits. I more than doubled the mean fluctuation for these five years in my projections. I also thought I could add a new book every other year, but I decided to wait two more years.

362 B.MARTIN PEDERSEN BIOGRAPHY

Another important thing was the profit and loss financial performance of Graphis Simaphis (the Swiss name for the company) for the previous 10 years.

I also shared them with Kevin Batchelor after I got back to New York. Again, the average for all years was black and profitable. I felt satisfied.

Publication Solutions Needed

At first, there were too many people for six magazines and one to two books yearly. Another problem was the additional work of publishing three languages in each book and magazine.

Walter also dealt with three different printers for the film to be used in the print production. Each supplier would provide bids for every publication, and the lowest price would prevail. This was a full-time job for one of the employees.

In addition, to save more money, all the publications were printed four over one, meaning every other spread was in four-color while the others were in black and white. This required Walter and the design staff to decide which of the mostly four-color works from the talents he presented would be printed in black and white instead.

My Edge in the Competition

My advantageous experiences included running a design firm under my name and later with partners at JPH&S. Although we were primarily designers, we were compelled to navigate the business aspects, ensuring the survival of our firms. My role as a publisher of *Nautical Quarterly* also held significant value for the Herdegs. Despite the loss of *NQ*, I hoped my experience with it would still have some merit.

Crucial for the Herdegs was the assurance that I could successfully manage the business, preserving Walter's established tradition while maintaining design quality. Finally, their confidence in my ability to finance the deal, if accepted, played a pivotal role.

After several meetings, the Herdegs reached a decision.

Massimo & Lella

Back in the States, I remember one cold winter evening when Arna and I had gone to the theater on the west side, and we bumped into Massimo and Lella Vignelli. As always, Massimo hugged me, and he whispered in my ear that he knew I was negotiating for *Graphis*.

Surprised, I asked him how he learned this, and he said he couldn't reveal it.* He did relate to me that other people were after it, and he strongly felt I should have it. I thanked him for the information and for his confidence in me.

Massimo, as always, was an uplifting and supportive spirit in the design community. He was one of the rare few who had the confidence to go out of his way to compliment others in the profession. He and Lella, who was an architect, were an extraordinarily talented team.

After we all hugged each other again, Arna and I departed for home that chilly evening. When we were home, we discussed their grace and what we would need if *Graphis* came through.

*It must have come from Colin Forbes at Pentagram, as Massimo Vignelli, Alan Fletcher, and Takenobu Igarashi were contenders for Graphis, Inc., alongside Pentagram. Igarashi also had the Suntory whiskey company to back it financially.

Anxiety: The Waiting

At the time, while I was still waiting for a decision from Herdeg, I desperately needed money to help finance it if it came in my favor. I wasn't exactly in a good comfort zone.

Great News!

Finally, the Herdegs had decided and sent me the unexpectedly great news: they had chosen me. I called to thank them for their confidence in me to carry on Graphis, Inc. After hanging up, I felt a mix of sheer joy and fear. I then called Arna at home from the office. She was thrilled for me— and for us. Little did she know the financial sacrifices that lay ahead.

The old adage, "Be careful what you wish for because it may come true," held true. I was both humbled and thankful, but I was also feeling a bit scared.

The Deal

BMP/ATP personal money: $200K from credit line loans on our real estate

Bank loan(s): $600K

Investors: Doug Bittenbender and Tom Lewis: $400K

The cost to purchase Graphis, Inc. totaled $1,200,000.

Money, Partners, & Legal Help Needed

I was delighted, of course, but I had a lot of anxiety about the terms. I was given only one month to come up with the money. I had made arrangements in advance with two interested investors: Doug Bittenbender, who had been a former print salesman at S.D. Scott and who worked with Crafton Printing Co. (both in New York), and Tom Lewis, a graphic designer in San Diego. I had my investment in addition to Doug's and Tom's.

Now, what I desperately needed was a substantial bank loan. Kevin Batchelor of Grant Thornton, who had helped me first with *CA Magazine*, came to help on multiple levels. When I called him, he was pleased to help. We got started immediately, and he planned our needs.

Attorneys

Firstly, I needed attorneys with impressive experience in this game. After some research, Kevin recommended Rita Hauser, a partner in Stroock & Stroock & Lavan, a big downtown law firm. We met with her within a few days.

After hearing of the deal and its urgency, Rita recommended Dr. Lehner in Zurich for the Swiss support we needed. After I answered several of her questions, Rita provided a low-high estimate for her firm's costs for closing the deal. Shortly after, I also received Dr. Lehner's cost estimates. I discussed them all with Kevin, who said it all seemed fair for this kind of deal, and I accepted.

Investors: New Partnerships Formed

I shared the *Graphis* 10-year financials with Doug Bittenbender and Tom Lewis. We discussed the future potentials, and they each took some time to reflect on them.

Tuesday, March 18, 1986: Legal

Rita Hauser and her assistant, David Kauffman, prepared a five-page investment escrow agreement for Doug Bittenbender, Tom Lewis, and me to sign. We each got a copy.

Citibank: $600K Loan Needed

Arna and I went to Citibank, where we had a good relationship for over 20 years. They said they could do this for me if we would put up 50% in cash, or $300,000, for our end of the deal. I was also told that I had to wait a few days for an answer since this deal, which involved a foreign company, was unusual.

While waiting, I went to a few other U.S. banks and, in two days, realized this was all clearly looking like a dead end. Citibank took more than a few days, which we didn't have, and they turned me down. It would not have been a problem had I purchased a U.S. company. Less than a few weeks before our due date for closing, we were in a critical situation.

TIME RUNS OUT: FLYING BACK TO ZURICH WITH EMPTY POCKETS

Help From My Swiss Attorney

I called my Swiss attorney, Dr. Lehner, and related the circumstances. We both felt that I needed to head to Switzerland immediately to meet with Mr. Herdeg and his attorneys with just a few days left of our deadline and tell the truth.

I landed in the morning in Zurich and went to Dr. Lehner's office to discuss how we would present the bad news. We both agreed with immediacy. However, Dr. Lehner would come to my defense to say that getting a loan in the U.S. in one month was virtually impossible.

After arriving at Graphis, Inc., we were invited in and took a seat. They expected we had the money and could make a date to close the deal. However, I admitted that I had not received the financing needed. Immediately, the mood became somber.

Dr. Lehner took over and said that had I been a Swiss citizen, this would have been easy, provided I had a credible relationship with a Swiss bank. However, this was impossible in the U.S. since the banks would take at least two to three months, especially for foreign transactions. He emphasized that I had already secured 50% of the needed funds, meaning that I was serious and it should be a feasible transaction to complete with additional time.

Initially, the board was dismissive, but as Dr. Lehner spoke, they began to raise attention. When he finished, they asked a few questions, and then we were told to wait outside the boardroom. We sat in silence for what seemed like forever until we were finally asked to come back in. To our relief, they gave me more time. However, it was just one additional month. I had to fast-track it back and make it work with the time constraint.

Back to New York
It took a while with Kevin, but he finally managed to get a loan with little time to spare.

The Loan
Kevin had found the bank and brokered the deal. It was with Trefoil/Fidelity Bank on 7th Avenue in New York City with its president, Jerry Blum. However, it was at four points above prime, with no ceiling. This meant if the prime rate went up, I would have to pay 4% above that, no matter how high it went. I went to the bank and signed piles of legal papers, each putting Graphis, Inc. and me into a deep debt that had to be paid for with hopefully increased profits.

They knew I had no choice but to accept. I had to sign even more legal papers to make it happen. At the time, the prime rate was 8.5%. So, I would pay interest with the four points above prime for 12.5%. Our loan with the bank was $600,000. This, multiplied by 12.5%, totaled $75,000, or $6,250 a month. I had to hustle to make up for this with Graphis, Inc.

Arna still cared little about money. Since we had gained some financial padding, she supported what we needed to do. She believed in me; I was a fortunate guy with that lady. We had come far from eating oatmeal three times a day when we were first married, which wasn't a problem with her. Now, we had kids, but we had also gained financial comfort with real estate investments, which she dealt with brilliantly.

Wednesday, April 9, 1986: To Zurich for the Closing With the Bank
We called in advance to make an appointment again with Walter's attorneys for the closing. Kevin and I were in business class on the Swissair flight to Zurich. The president of Trefoil/Fidelity Bank and his two associates were on another Swissair flight, and they all flew first class on my bill. All of us were now relieved and excited, heading to close the deal.

We arrived at 7.00 AM and took a cab to the hotel. We stayed at the Eden au Lac again, an elegant and expensive hotel on the east side of the lake in Zurich. This was just a few blocks from the Graphis Inc. offices on Dufourstrasse. All this was on me and Arna's dime. Dr. Lehner joined us in Zurich for the closing meeting at the Herdeg attorney's office the following afternoon.

Thursday, April 10, 1986: A Setback the Night Before the Closing
The night before the closing in Zurich, one of the Trefoil/Fidelity Bank guys knocked on my hotel room door, asking if I could meet with them in the lounge for a short time. I came down about 10 minutes later, where they were all seated. They then smugly told me they were adding another $75K to the deal. I sat in silence for a few minutes to let it sink in.

I couldn't believe what I was hearing and said, "Absolutely not. We had a deal, and this is over if you don't hold up your end." They asked, "Are you really willing to lose the deal over just an additional $75,000?" I said yes and walked out.

It was now clear to me that they had deliberately pre-planned this bull****, so I walked away angrily. They immediately called me back. Without turning around, I gave them the finger and continued toward my room. As night fell, I refused to respond to their phone calls or knocks on my door. They knew I had given them $50K; I would lose it if the deal didn't go through. I was now angry enough to do that. They called the room, and I knew it must have been them, but I didn't answer. They later knocked on my door again, and I told them to leave.

B. MARTIN PEDERSEN BIOGRAPHY

Later, I got another knock on the door. It was Kevin Batchelor, who was sent to calm me down. He was concerned—if this didn't close, he'd lose the broker deal for Grant Thornton. He asked me to be reasonable. My response was to tell them to be reasonable. I reminded him that we had an agreement, and this was a very nasty break in the deal, especially the night before the closing. He agreed. I told him to go and tell them again that this was over.

Kevin left, and now he was also upset. I knew they had invested significant time in the deal.

I went to bed, anxiety keeping me awake for a while. But then it hit me: if the deal fell through, they would lose not just time but also the money they'd spent on travel, hotels, and, most importantly, the substantial loan. With that thought, I let go of my worries and slept well.

Friday, April 11, 1986: Morning of No Closing

I woke up cheerful that morning, realizing I was walking away from a formidable responsibility. Frankly, I was feeling relieved. I even had a smile on my face as I sat down for breakfast.

Then they all appeared again and rudely sat down at my table. I asked them to please leave. Instead, they said that if they didn't close the deal, I would lose the $50K I had given the Trefoil/ Fidelity Bank. I responded, "I don't give a s**t, so please leave my table."

They left and returned 15 minutes later to tell me that they were returning to the original deal. I told them I didn't trust them anymore and was uninterested. They kept on insisting. I said the original deal was off because they broke it, and I reiterated that I didn't trust them anymore. If I were to consider anything again, I would want a new deal. They asked what it would be. I said I wanted a few hours to think about it.

We met a third time, and I related the new deal: "If this is going to happen, you will now pay all of your expenses, including the hotel, food, airfare, and the ski trip that was planned after the closing. I'm no longer paying you for any of this. If you don't accept this, you also lose the loan."

After telling them this, I left.

They called me an hour later and accepted.

Friday, April 11, 1986: Graphis, Inc. Purchase

Against stiff competition, I purchased Graphis, Inc. from Walter and Marcel Herdeg in Zurich. Kevin Batchelor of Grant Thornton helped to broker the deal. That afternoon, we closed the deal at Walter and Marcel's attorneys' offices with Dr. Lehner, who represented us. We then all signed an endless amount of legal papers.

In the later years, there was also an issue with their accountant, who Marcel had caught taking money from the company. He had a few years left on his employment contract, and he had to be purchased out. We ended up splitting the money he was owed.

After some hours, everything was completed. Following a handshake, we all left, each carrying our respective stacks of documents. It was finally done. I now owned Graphis, Inc. but had an enormous debt to deal with. My anxiety had risen again, but at the same time, I was also thrilled.

Arna was legally clear of any liability in the future since she didn't sign anything and, therefore, was not an officer in the company. However, she felt the burden on my shoulders. If I went bust and had to go to jail, I knew Arna would come and visit me.

Closing Costs

Graphis, Inc. purchase price: $1,200,000

Partner shares and contributions:

60% - B. Martin Pedersen: $200,000

20% - Doug Bittenbender: $200,000

20% - Tom Lewis: $200,000

Total: $600,000

Bank loan: $600,000

Total required for the deal: $1,200,000

In addition to the $200,000, BMP/ATP paid $111,553 for closing costs. This totaled $311,553.

Saturday, April 12, 1986

The following day, we all left the hotel for a celebratory ski trip. The ski slope was located just over an hour's drive from Zurich. We rented ski equipment, got fitted correctly, and took the gondola to the top of the mountain for our first run.

After we got to the top, President Blum, the banker, took off first. After a few turns, he lost control and skied off the edge of the mountain trail. He tumbled down the cliff and almost entombed himself in the snow after he stopped falling. He didn't move. I managed to sidestep down to him on my skis and then checked him for injuries. Fortunately, he was okay but in shock.

I patiently waited until he regained some composure, then assisted him in putting his skis back on. I then called and asked if one of the groups on top could get the ski patrol. After that, I slowly traversed the slope with him horizontally until we reached the trail further down. Two Swiss ski patrolmen arrived, checked him out, strapped him on their sled, and took him down the mountain to first aid for further observation. Blum spent the rest of the day recuperating in the ski lodge at the bottom of the mountain. We went skiing again after knowing he would be okay.

After another ride up the mountain, we all gathered at the top. Blum's associates asked me why I hadn't left him down there on the cliff after what he had pulled on me the night before. It was, of course, a joke, and we all laughed. After a day of skiing, we drove back to the Eden au Lac and enjoyed a celebratory dinner that evening. The next morning, they headed back to New York.

Sunday, April 13, 1986

The next day, Walter and Marcel Herdeg gratefully invited me for dinner at an exquisite French restaurant to celebrate our deal. After sitting down, the sommelier opened a wine bottle. Once our glasses were filled, we toasted and celebrated each other. Setting my wine glass down and briefly pausing, I asked them the big question: Who else was in the running for wanting to purchase *Graphis*? Marcel looked at me and answered.

My Competitors

It had been Pentagram, of course. In addition, there was a triumvirate comprised of Alan Fletcher from Pentagram U.K., Takenobu Igarashi from Japan, and Massimo Vignelli from the U.S. This was a formidable group of extraordinary talents at the top of their game. To top it off, Takenobu was even financially backed by Suntory, a Japanese whiskey company. With his respected reputation in Japan, Takenobu managed to make this happen. Money was not an issue for them.

Also, a few publishing houses were also in the running. As they were relating this, I froze and sipped wine. I then asked why they chose me over these formidably talented designers. They explained that firstly, the publishing houses were not seriously considered for Graphis, Inc. Secondly, none of the others had any publishing or credible business experience. My response to that was that they could have hired professional people. They agreed but then related that Pentagram had multiple partners, each with equal shares. Who would be taking charge, especially when they were all equal? Because of this, they had also failed in some previous business ventures with a few past partners.

The Herdegs and I knew that in many instances when vital decisions had to be made, especially if they were financial, phone calls and meetings to get every partner's approval from the U.K. and U.S. would take time, which could be costly, especially with any disagreements that could take place. This was why I had also turned down Pentagram as a partner if I were to take over Graphis, Inc. I would have accepted only if I had owned 51% of Graphis, Inc. and the other partners were to share the other 49% equally. So then, Pentagram was out.

What about Takenobu Igarashi, Massimo Vignelli, and Alan Fletcher? Generally, it was for the same reasons as Pentagram, with the additional problem of the vast geographic distances between them and who among them would be in charge. In addition to their lack of publishing experience, communication would be very complex, and they would face other issues. However, the best part for these three was that Takenobu had the backing of Suntory to pay for the whole deal. This must have been deeply tempting. With the money from Suntory, they could hire business people with publishing experience. But there were other issues, and the Herdegs were uncomfortable with it.

B.MARTIN PEDERSEN BIOGRAPHY

I then asked again, why me? Marcel told me that my business experiences, first with Pedersen Design and then the JPH&S partnership, had value. Most important were my *NQ* experience in publishing, my open admission of failure, as well as the valuable lessons I had learned from it. Additionally, it was my answer to Marcel after he had completed his extensive interviews with me. He asked me whether I would have any future concerns if I were to take over *Graphis*. I had then told him of my fear of that which I didn't know. I also asked him if he would be available for future support if I needed answers, and he agreed. All these showed them I was very serious about taking this on.

After Dinner

As we left the restaurant, I again expressed my gratitude to Walter and Marcel. On my return to my hotel that evening, I was half drunk with joy and fear, knowing now that I was about to venture into unknown territory. This held, and then some. Little did I know what I would be experiencing in the future.

On the Swissair flight back to New York, after having a glass of wine, I reflected on the gift and trust the Herdegs had bestowed upon me. Now, it was my responsibility to honor that trust and live up to their expectations.

About Marcel Herdeg

Some years earlier, Walter had begged Marcel to join him after graduating from law school. Walter was on edge economically with Graphis, Inc. Marcel felt he had a promising future ahead of him as an attorney and had to think hard about his future. However, being a kind and compassionate person, Marcel ultimately agreed to help his father. Walter also said he would make it worthwhile for his son. Marcel immediately became an invaluable asset in helping his father survive the business. He spent five years learning publishing by spending time in each division learning about the financial situation, distribution, sales, design and production, printing, and warehousing.

As Marcel's knowledge grew, the time spent in each part of the company's divisions lessened until he had gained command of them. Eventually, he rose to qualify as the publisher. Marcel streamlined operations in each department, reducing the staff team from 46 to 20. This, amongst other changes, brought Graphis, Inc. into profitability.

With his age advancing, Walter became tired, so he told Marcel that he wanted to retire and end Graphis, Inc. After all of his hard work and with his legal background, Marcel thought about it and came up with an idea. He convinced his father that Graphis, Inc. had great value and that they could sell the company. He explored this, found appropriate buyers, and achieved a successful sale. Marcel gave his unexpecting father a great retirement gift. After the sale, Marcel continued supporting me, giving his time and advice freely.

Introduction to the Zurich Staff

The next morning, Walter and Marcel introduced me to the staff in Walter's boardroom. The staff was comprised of about 20 people at the time. Most of them came in and looked at me, wondering who I was and what I was doing there. Walter then gracefully introduced me and related that I was the company's new owner and that he would be retiring. There was a stunned silence. The Herdegs had successfully kept the sale a secret.

After answering more questions from the staff, Walter and Marcel left the room, and I felt slightly stunned. I asked each employee to share their name and their job function. Marcel had given me the names of the staff in advance, which was very helpful. I then assured them that with their help and support, which I would desperately need, I/we could continue as before. I also said that my door would always be open for them to visit me.

A few days later, when I returned to New York, I left Heinke Jenssen Walters, a trusted assistant, in charge for many years. The biggest shock to the staff and the European design community was that Graphis, Inc. had been sold to an American.

After the sale, Marcel established a successful law firm in the Dufourstrasse building that had housed Graphis, Inc., which Walter owned. In the meantime, he continued to support me when problems arose. I will forever be indebted to both Walter and Marcel for favoring me in the purchase over staggering competition.

AFTER PURCHASING GRAPHIS

Back to New York & Meeting Colin Forbes

When I returned to New York, I got another Pentagram dinner invitation from Colin Forbes.
We went out the following evening, and I let him have it. I was furious and asked him why he had
not been candid with me after I had stated that I was working on purchasing Graphis, Inc.

"Why did you not tell me that Pentagram was also pursuing *Graphis*?"

Colin Forbes denied remembering this and said that if that had been the case, he wouldn't have
been able to sleep at night. My response was that the next day, I would mail him a thank you
note for dinner accompanied by a small tin of Bayer aspirins. I thought the better of it and called
him instead to thank him for the previous evening. Colin was the Machiavellian manager of
Pentagram, brilliant at keeping everyone focused at their annual meetings.

Jonson Pedersen Hinrichs & Shakery, Inc.: 1975–1986

Back in New York, I called my partners to explain my new ownership of Graphis, Inc. and how
I had to devote all my time to dealing with it. Neil Shakery, based at the 141 Lexington Avenue
office, was the first to be informed, followed by Vance Jonson in Connecticut and then Kit and
Linda Hinrich in San Francisco. After 11 years of great success, they knew that I had to deal with
Graphis, Inc. and that they now had other opportunities with Pentagram.

Ultimately, we all decided to end JPH&S. Pentagram was then available to each of them. Kit,
Linda, and Neil decided to join. Vance decided against it, wanting to keep his independence.
I wished them all luck, as they did for me.

Jonson Pedersen Hinrich & Shakery Inc. was now history. I was on my own again.

1985: The Longest Name in Design

With my announcement of taking over Graphis, Inc., Dick Hess called and congratulated me.
Afterward, he asked if he, with a few designer friends, could use a part of my office at 142
Lexington Avenue and take over the JPH&S telephone number to get my past clients. I told him
no and that I thought it was a bad idea.

One of these partners, whom I didn't know then, was Lyle Metzdorf, who, with Dick, became
quite persistent. They produced a short-run promotion poster, which won a few awards, to solidify
their intent. It was called The Longest Name in Design, formed with the names of Dick Hess,
Woody Pirtle, John Alcorn, Vance Jonson, and Lyle Metzdorf. It didn't last.

Legal Bills

I worked with two attorneys on the deal: Rita Hauser of Stroock & Stroock & Lavan in the U.S.
and Dr. Lehner in Switzerland. Rita provided a low-high estimate for the deal, but when the bills
came in, they exceeded the high end of the forecast.

Upon receiving the bill, I protested, and she arrogantly asserted that I had never done a deal
like this before. I acknowledged that and pointed out the estimate seemed to be a wild guess,
emphasizing that I was never informed about surpassing the forecast during the proceedings,
which I found highly unprofessional. I requested proof of her and her assistant's time with tasks
worked on and billable hours for each phase.

A few days later, I received a pile of computer printouts of time spent without clarifications
for specific tasks. In response, I told her I would love to get away with something like this with
my clients. I also shared that Dr. Lehner did more work on this deal than he had anticipated.
His hours were meticulously accounted for by stating what he performed on the job with a price
for each. In addition, he saved the deal, which was not part of his original estimate. Even with
this extra work, his charges were still below his high estimate. Rita then became tough since this
was a minimal fee (though significant to me), given her status as a partner.

I said, "If you continue to insist on this sum, with hourly computer files and no record of what was
spent on each of these files, I will go to a newspaper reporter with the story."

She then backed off, and I paid her just within the high end of her estimate. As a gesture of goodwill,
I also gifted her a signed silkscreen series of Quanah Parker, the disappearing Comanche warrior,
and we parted as friends.

B.MARTIN PEDERSEN BIOGRAPHY 369

Earlier, I had also paid Dr. Lehner's bills and expressed gratitude for his crucial role. I told him there would not have been a deal without him. Sometime later, I asked if he would consider joining the Graphis, Inc. Board of Directors, and he fortunately agreed.

1985: Walter Herdeg Awarded

Walter Herdeg was honored with the Lifetime Achievement Award and Medal from the American Institute of Graphic Arts (AIGA) in New York. Having dedicated 42 years to publishing *Graphis* and producing 246 issues of the magazine, along with numerous influential books, he was truly deserving of this award from the U.S.

1985: Reconnected With Pentagram Partners

Months after the purchase, during a visit to Switzerland, I received an invitation from the Pentagram partners in the London office to join them for dinner on my return to New York. I agreed, joined them in an elegant restaurant they had selected, and found them all sitting at a big circular table. The wine was poured, and I was toasted for purchasing Graphis, Inc.

Suddenly, Alan Fletcher,* sitting directly opposite me, asked with a loud outburst, "Why the f*** you?" Everyone fell silent.

After a brief pause, I responded, "Because I'm smarter than all of you."

A moment of silence followed as they realized I had known about their negotiations for Graphis, Inc. Alan broke the tension with a hearty laugh and toasted me again.

I greatly liked Alan Fletcher since he was a straight shooter with enormous talent. As a partner in Pentagram, he was more focused on his craft than on financial gain. When he got Phaidon as a client, he delivered brilliance for them and was paid properly.

1986: Back to Zurich

At an AGI meeting, Stuart Ash of the Gottschalk+Ash office in Canada recommended that I connect with Fritz Gottschalk when I return to Switzerland again. I ultimately did it and called the Gottschalk+Ash office in Zurich, only to find that Fritz was out of town.

Therefore, I left a message about when I would return to Zurich and suggested we could get together. We made a date for my return, and Fritz was to meet me outside the Graphis, Inc. office on Dufourstrasse at 5:00 PM.

When I came out to meet him, I saw Fritz across the street next to his car, wearing a sunny smile. As I walked toward him, he rushed over, grabbed me, and hugged me—a surprisingly un-Swiss gesture. We enjoyed a great dinner, discussing the surprise that we had worked just around the block from each other when Fritz was in New York. Although my office was on 141 Lexington Avenue, between 29th and 30th Street, while the Gottschalk+Ash office was on 30th Street between Lexington and 3rd Avenue, we hadn't ever connected. After that, we formed a friendship for life.

Board of Directors Needed

Dr. Lehner and Dr. Remo Schuermann of UBS Bank both shared the need to assemble a responsible board of directors to help guide the company, Graphis, Inc.

About the Board of Directors in Switzerland

It is a serious commitment to agree to serve on a board of directors in Switzerland. If you agree, you are financially responsible for the business. For example, if the company goes bankrupt, the board members and the owner are equally responsible for any debt that may have occurred.

This is different from in the U.S., where board members face no financial risks. In many instances, they are paid handsomely for their time and advice, especially if they support an annual raise for the CEO. This required me to be interviewed about how I would deal with the company in the future, which gave each member the confidence that I would be transparent when communicating with them, especially with any major decisions that could alter the company's profitability.

Chosen Board Members

The board members who embraced the uncertain future with me included Fritz Gottschalk of Gottschalk+Ash, Dr. Lehner, and Dr. Remo Schuermann from UBS Bank, all hailing from Zurich.

Additionally, Doug Bittenbender from the U.S. had invested in the company. Dr. Schuermann from UBS played a crucial role as the bank managed *Graphis'* revolving annual credit line of CHF 500,000, established by the Herdegs. This credit line served as an annual advance used to settle printing bills for Swiss printers, given the delayed income from book and magazine sales, which arrived months after delivery to distributors.

The bank's support was essential, and I had qualified for it in advance by signing numerous documents and contracts; without it, purchasing Graphis, Inc. would not have been possible.

Steep U.S. Loan

The board quickly learned that Graphis, Inc. had a $600,000 Trefoil/Fidelity Bank loan in New York City with four points above prime and no cap. Dr. Schuermann managed to transfer this loan to his bank successfully, and I signed additional legal papers at UBS to secure it.

At the next board meeting, everyone was relieved to hear that Dr. Schuermann had taken over the Trefoil/Fidelity loan with no cap. The UBS commercial loan, now at 7%, presented significant savings compared to the 17-18% I had been paying. With Dr. Schuermann on the board, UBS Bank felt comfortable due to his internal access to the business operations.

Quarterly Meetings

As we started meeting quarterly, the board's initial mandate was for me to hire a responsible manager to oversee the business operations, particularly considering my dual offices in Switzerland and the U.S., which led to my occasional absences.

Manager for Graphis, Inc.

We saw several candidates and asked a few back for additional interviews. We returned to one, gave him the last five years of our financials, and asked him to look them over and come back with suggestions for what he could do for us.

When he returned, he promised a 20% annual increase in the business with a written plan, which impressed us. We decided to hire Woody Wade, a Harvard business graduate living in Zurich. He was an American fluent in German and French, married to a Swiss-French lady, and he came with impressive business references. Despite the seemingly too-good-to-be-true qualifications, we chose to bring him on board with a substantial salary and fulfilling his request for a new BMW.

First Quarter Board Meeting

The first quarter meeting took place with Woody in the Graphis, Inc. board room. He appeared in an elegant suit, cuff-linked white shirt, and tie, taking the head of the table. He handed everyone copies of the financials to look at, pulled out a broad nibbed ink pen from the inside pocket of his suit, and then hung his jacket on the back of his chair. We all felt he was appropriately dressed, which gave everyone some security.

Despite the financial figures not meeting his promises, they were not too deep in the red. He came up with seemingly appropriate answers to the tough questions from the board and also related that being new to the job, he would require a bit more time for the turnaround. The meeting ended with him promising us that he would still have a 20% increase in income by the end of the year.

August–October 1986: Running for My Health

Under the escalating pressure, I took to daily running in Zurich and New York to alleviate anxiety and maintain both physical and mental well-being. I knew this kind of pressure could kill you if you let it get to you internally.

I committed to running the eight-mile loop in Central Park every other day. During one spring evening run, I encountered Derek Ungless, then the art director of *Rolling Stone*, heading in the opposite direction on the park's loop. One of us turned around, and I discovered that Derek was training for the New York City Marathon, about three months away. He had applied and was accepted. After hearing what I was going through, he recommended that I do it to keep myself focused. I agreed and asked him if he could share his running schedule with me since I had a lot of catching up to do. He did this, and I immediately applied to the race and was fortunately accepted.

October 1986: The New York City Marathon

I participated in the New York City Marathon. On the morning of the marathon, I took a bus to Staten Island and settled into a crowd of runners intent on doing a 3:30 finish. Though I wasn't sure I could manage this, it was my goal. Little did I know what awaited me by the end of the race.

The race started, and we ran across the Verrazzano Bridge, where some runners stopped to pee off the edge. We came to 69th Street and 4th Avenue in Brooklyn, where I stopped to hug my mother, who had been waiting for me. Continuing through the boroughs and over the Manhattan Bridge, I observed runners ahead of me passing a man in a wheelchair. Each runner patted him on the back, causing breaks in their pace.

As I looked ahead at the bridge's steel grids, I wanted to be careful. I didn't see what could cause this break in their gait until it happened to me. As I came up to the man and was about to pass, I saw a very intense look on his face. He sat in a totally sweat-soaked t-shirt, making a monumental effort to keep his feet moving on the ground beneath him as fast as his wheelchair was being pushed. After patting him on his back, tears of emotion came into my eyes, and I, too, stumbled a bit.

Third Avenue

Descending from the bridge onto 3rd Avenue in New York City, the crowd's roar for each runner was almost deafening. This was the first time an amateur runner could experience what it was like for the professional athletes who won races. This enthusiastic support provided a super lift, momentarily overshadowing any pain.

As the race continued, I was still feeling good and charged. When I reached the 18-mile mark, timing devices predicted my finish time. Delighted to find myself at a 3:20 marathon pace, I was 10 minutes ahead of my goal.

Hit the Wall

At the 19th mile, I began feeling joint pain and considered slowing down. However, when I reached the midpoint of the Willis Avenue Bridge, my body collapsed. I immediately turned to jelly and fell flat on my face. This was depressing and humbling.

Soon, I was taken into a tent and laid down on a cot where my legs were massaged. The attending nurses suggested that I should not continue. One warned that if I did, I would run off muscle tissue. Despite the suggestion, I had no choice but to continue.

In the Bronx, with my family waiting with a hero's welcome in Central Park, my vanity drove me to get up and walk. I felt like my body was filled with water, making me sluggish and heavy. Starting with a slow walk, I gradually urged myself to a slow run, eventually adopting a gangly, slightly out-of-control gait typical of runners who've hit the wall.

When I reached the lower end of Central Park with about a mile to go, I ran past my wife and sons, who were screaming my name. I didn't hear a word since I had tunnel vision and was focused on driving my dysfunctional body forward.

I finally finished in 3 hours, 44 minutes, and 57 seconds. I was 49 and a half years old at the time, so I had nothing to be ashamed of. I gangly walked to our friends Bill and Carole Lewis' apartment on Central Park South. After Arna and my kids hugged me, I asked if I could use their tub for a warm bath. About a half hour later, I was in recovery and joined the party.

Despite its physical demands, the marathon was easier than the challenges I faced at Graphis, Inc. I believe running helped prevent cancer and other diseases while serving as an endurance test to propel Graphis, Inc. into solvency.

On Monday, I called Derek to check on his race performance, learning that he had gotten sick and watched the marathon from his hospital bed. Thankfully, he recovered.

November 1986: Back to Switzerland & Lunch With Walter

Before my second or third trip back to Switzerland, even with my hands full, I called Heinke Jenssen, formerly Walter Herdeg's secretary and now mine. I asked her to arrange a lunch with Walter at his favorite restaurant by the lake in Meilen below where he lived. Walter accepted my invitation, and a few days after my arrival, I took a short rail ride to Meilen.

Traveling by tram or train in Switzerland is a joy. It was a short but pleasant experience with a view of the lake that always seemed quiet and peaceful. In the summer, elegant old passenger ferries and sailboats abound, especially in the early evenings. Sailing, in particular, provides a peaceful escape from daily tensions, accompanied by the soothing sounds of a simple one-cylinder motorboat. Of course, the same is true for small motorboats, but then there's the engine's noise (unless it's a simple one-cylinder put-putter that is pleasant to the ear).

Overall, this short ride was peaceful and pleasant in anticipation of seeing Walter again after the pressure we had both faced in completing the sale. After walking from the tram stop, I met him at the restaurant. I entered, and Walter waved me to his table. After seating myself, he expressed pleasant surprise at my call. I asked him why. He then related that this sort of thing was not traditionally done in Switzerland after I had taken over his business. He said the former owners usually became history.

Editorial Advice: On Writers
At lunch, I asked about the stories written about the talents he presented in the issues. He said most were by their friends, so the articles were, for the most part, highly complimentary, rarely touching on the difficult times that these individuals may have had on their path to success. I asked him if I should consider investing in some decent authors for the articles. He answered that I shouldn't waste my money.

He had done this on occasion and never received any letters from the editor or any other responses from the design community. He tested a few times after they had complimented him on a particular designer in an issue and asked them if they had read the person's story. Their answers made it clear to him that they had not. He then became aware that most of the design community didn't read. Their interests were visual only. So, Walter asked that the talents he presented in the magazine ask a friend to write articles on them. Most of these stories were saccharine.

He finally shared that he missed *Graphis* but was settling down, spending more time with his then-wife, and enjoying the lake view from his hilltop house. The lunch was enjoyable, and I asked him several questions about the business, which he willingly answered. I paid for the lunch and told him we must do this again before leaving. He appreciated this, especially since I was now the only designer to take him to lunch.

Lake Lunch Again With Walter in Meilen
A few months later, I asked Mrs. Jenssen to arrange another lunch appointment for me and Walter. I took the tram again to the restaurant. To my surprise, Walter had a gift for me—a painting by Dick Hess titled "The Commuter," which had appeared on the cover of issue #178 of *Graphis Magazine*. Knowing my friendship with Dick, Walter gifted me this painting, and I was deeply moved and thankful. I then said that I would be buying more lunches in the future if this keeps up. We both laughed, and I asked again how he was now enjoying his life of leisure.

I said, "I'm now working long hours as you used to, and I'm a bit jealous of all your free time."

He became very quiet, and I sensed a bit of sadness. I asked if everything was alright. He reflected for a moment and then said that no one ever called him anymore.

I asked, "What do you mean?"

He related that when he owned Graphis, Inc., he received numerous phone calls from designers around the world whom he considered his friends. In a number of these instances, these friends asked if they could take him out for lunch or dinner when they came to Zurich. Now, he was experiencing complete silence.

I was shocked. I asked whether at least some designers that he considered close friends, especially from AGI, had called to congratulate him on the sale of the company and for the tremendous support he had given the design community over the years. He replied no, not even one!

I expressed my disappointment in them to him. Later, I learned that Walter's Swiss and German friends in AGI were angry that he had sold Graphis, Inc. to an American.

I also thanked him for the generous Dick Hess gift and promised myself to call him in the future. I then knew what I would be looking forward to and told him so.

B.MARTIN PEDERSEN BIOGRAPHY 373

Walter had devoted 42 years to Graphis, Inc.—it had been his whole life. A year later, in 1995, he passed away in Meilen at the age of 87.

PROBLEMS TO SOLVE

Financial Corrections in Zurich

Exchange rates on each invoice were corrected, making year-end financials precise. However, this process involved excessive office work, often costing more in postage and time than the amounts owed. Corrections were mailed to customers, requesting fractional reimbursements to the nearest Swiss pfenning (pennies).

I stopped it despite Marcel's objections. My solution for the year-end financials was an additional line that posted the exchange rate profit and loss as a plus or minus. This saved a lot of office time, all for the need for absolute Swiss accuracy, which was important to them. This approach also significantly reduced customer confusion. I also trimmed more costs and moved our printing from Switzerland to Japan.

U.S./Swiss Staff Friction

Two of my New York employees—my financial officer and my Advertising sales lady—convinced me to fly them over and pay for a hotel so they could smooth out some rough edges between the two offices. Our offices shared the best and sometimes the worst of each other's cultures.

After they returned, it became clear they partied more than they worked. Zurich employees reported that the meetings with them had been brief and didn't lead to any meaningful resolutions. It was a vacation for the two and a waste of my money. They didn't last in the company.

1985–1986: I Now Un-Swiss the Design

The Books: Months after the purchase, I started looking at many existing books and decided to redefine the *Graphis* Annuals during my round trip plane journeys between New York and Zurich.

I primarily worked on this twice-monthly task upon my return to New York. The westbound trips were more manageable in terms of jet lag when crossing the six time zones between Zurich and New York. On the other hand, constant travel between the U.S. and Switzerland and persistent jet lag from eastward trips to Zurich left me exhausted.

The Magazine: I decided to transform the magazine to be presented solely in English to avoid the need to translate for French and German, which was editorially intensive work. Also, I had to revisit Walter's decision to save money by printing four over one. This meant making difficult decisions about whose work would be in color and whose would be in black and white. I realized I could not continue this since many talents would not be happy.

With that, I started to design my version of *Graphis Magazine* and screwed it up. I was on numerous trips to the Zurich office with a 24-person staff while also managing contracts and the U.S. staff, and merging two cultures sometimes made for some inter-staff friction.

When the newer issues started to reach the subscribers, many weren't pleased, especially the Swiss and Germans, since I had left modernism behind me. Even Massimo, whom I loved, was very gracious with a letter to me relating that I could do better.

November 1990

As the business began losing money, both of my investors, Tom Lewis and Doug Bittenbender, expressed their desire to be bought out. I held discussions with them and their attorneys, ultimately reaching a financial settlement that was agreeable to both parties.

1994: James Nachtwey, War Photographer

I decided to do a story for our next magazine issue on James Nachtwey*, the famous Magnum war photographer. We invited him into our office on Lexington Avenue and had Rita D. Jacobs, a great writer, interview him. In person, he was very humble and quiet. As Rita wrote, he was Gary Cooper handsome. He had survived the stuff of action-adventure movies. When he showed some of his camera coverage of the brutality of man's inhumanity, I was so moved emotionally. He had deservedly received the Robert Capa Gold Medal for exceptional courage. In his article, he related that political leaders tell us one thing, but still photography tells the truth.

374 B.MARTIN PEDERSEN BIOGRAPHY

I later asked him how he recovered after weeks or months in these horrible conditions. He said that he has good friends and goes fly-fishing in Montana until he recovers.

His story is in the Nov/Dec. 1994 issue of Graphis Magazine.

HISTORIC ARCHITECT

1996: Philip Johnson, Architect (*Graphis Magazine* Issue #305)

My *Graphis Magazine* editor at the time, Jack Crager, and I received an invitation from Philip Johnson for lunch at the Four Seasons Hotel. This was because we did a cover story in *Graphis* on this legend. This occurred not too many months after Philip had survived a stroke, a period when many doubted he would pull through.

We met him at the restaurant's interior entrance. He had just come down the elevator from work, which he did twice a week at the time. He asked if we could each hold him by his upper arm on each side since he was cautious after the stroke. As we walked in with this recognizable icon of architecture, the conversations went silent. We were watched by just about everyone in the restaurant, with everyone probably wondering who these two guys were.

After sitting down, a number of the regulars came by to greet Philip. One of the big real estate tycoons told him that he thought he was a goner and was expecting to get Philip's special table. Philip retorted that he would easily outlive him, so he could forget ever getting the table.

The waiter came by and asked Philip if he would like to have his usual, and with that, asked if we would join him in having a martini. We hesitated at first, but Philip coaxed us to agree. When the drinks came, we toasted him on his success and stature in the profession, which he appreciated. He, in turn, congratulated us on his buildings' editorial and visual presentation.

We had just featured him in a cover story in *Graphis Magazine* issue #305, and he complimented us on the presentation. He said he was delighted with it, which was why he invited us for lunch. We said that when the secretary stated his name, we thought it was a joke; however, we also related that we were honored to be here with him. After a few sips of the martini, I dared ask him what his requirements would be if I asked him to build a private home for me. He outlined the necessity of a site with either a great view or a property of at least 10 acres. Then I asked what I could expect to pay for this. He said probably around two to three million (back in 1996).

He thought it over for a few seconds more and said, "Well, you can't expect to get much for that low of a sum, can you?"

Having heard of my experience with architects in the past from a friend of mine who was a builder, he said, "You can usually easily double or triple that amount, but with the right architect, you will end up with a priceless gem worth every penny you spend."

As he looked through the crowd, he recognized several wealthy real estate developers and shared stories about a few of them. Philip then pointed out a guy he recognized and said he had come to him after completing a design to ask if he could suggest some changes. Philip asked him what kind of changes he was considering. He came back with suggestions to change the specifications for some bathroom and kitchen appliances. If Philip agreed, he could save a lot of money. Philip's immediate retort was that he could do that, but he would also remove his name as the architect of the building. The guy retracted his requests and apologized.

After our one martini lunch, we had dessert, then walked Philip back to the elevators. He was heading up to his office to do what he loved: designing homes and buildings.

1997: Honored

I was elected into the Art Directors Club Hall of Fame as a Designer alongside Allan Beaver in Advertising and Sheila Metzner in Photography.

Sunday, June 9, 1997

Departed Montauk with *Concinnity*, my Hinckley Bermuda 40 yawl to Bermuda. The crew and I all needed to leave work and clear our heads at sea.

Saturday, June 14, 1997

1310/1:10 PM: After five days at sea, we arrived at the customs dock in Bermuda.

B.MARTIN PEDERSEN BIOGRAPHY

Thursday, June 19, 1997
We departed St. George for Montauk.

Tuesday, June 24, 1997
1650/4:50 PM: Entered the Montauk jetty and proceeded to the landing in my slip.

2000: Death of a Friend
Dick Hoppe, a brilliant print salesman at S.D. Scott, sadly died on Friday, April 28, 2000.

He was born in 1946 and served in Vietnam. I'm convinced that he had died from exposure to Agent Orange.

His friend, Dagfinn Olsen*, who served in Vietnam alongside him, died a few years later, most likely from the same exposure.

*I met Dagfinn at a party that Dick and Karen Hoppe hosted. When I was introduced, it was clear we were of the same nationality. We sat next to each other, and it turned out he was the son of the owners of Olsen's Bakery, a half block away from my home at 839 58th Street in Brooklyn when I first came to the U.S. An amazing coincidence!

2004: New Talent Annual Introduced*
When the first New Talent Annual for student work came out, the School of Visual Arts (SVA), under the guidance of Richard Wilde, won 35% of the awards in the book. When I received the printed copies, I sent a book to Richard and congratulated him. He took it to his boss, Silas Rhodes, the founder and president of SVA. When Silas thumbed through it, he was thrilled and asked Richard, "Do you know what this means for us?"

Richard did, and Silas immediately gave Richard a raise, saying he should order copies of the book for all the seniors.

This accomplishment held significant meaning for Silas and Richard, who had navigated years of political challenges to achieve accreditation for the school. They finally got approved when they sent copies of the book to the accreditation board. The school saw increased revenue as more parents wanted their children to attend because of the awards.

A few years later, Richard felt it was important to get the book for the juniors so they could see what was expected of them in their senior year. The support for the annual under Richard helped the book make profits for Graphis, Inc. early. The abundant awards the school received were publicity, admissions, and profits.

*This book is available in our store as a digital copy.

Graphis New Talent Student Annual: Jeffrey Metzner
It didn't take Jeffrey long to get award-winning work from the students he taught, provided they could qualify and survive his course. At the time, he submitted work to the *Graphis* New Talent Student Annual, and much of it was Platinum and Gold-winning work.

After a few years of this, I became curious about Jeff and called Richard, the creative chair at the school, to inquire about him. I told Richard that I may have known Jeffrey Metzner from my past. I described what I visually remembered, including his distinctive smile. Richard agreed with my description and felt it must be him. He gave me his telephone number.

I called, congratulated him on his many Graphis Awards, and asked if he would meet me at my office after he finished teaching for the day. He agreed because my office was at 141 Lexington Avenue, not too far from SVA.

When he arrived, Rita, our front desk receptionist, typist, and all-around dynamo, called me upstairs and said Jeffrey had just entered. I told her to have him take a seat in our reception room on the ground floor.

I came down a few minutes later and sat across from him. I recognized him immediately. I sat there smiling at him for a few minutes as memories came flooding back. He looked back at me, smiling, and said he thought I looked familiar, but he couldn't quite place it.

I asked, "You're Little Jeff, right?" With that, the recognition was immediate, and we both laughed. This still very young man sitting across from me was a multi-medaled Advertising genius, Jeffrey Metzner, who was already in the Art Directors Hall of Fame. He had also married the multi-award-

376 B.MARTIN PEDERSEN BIOGRAPHY

winning Photographer Sheila Metzner*. We had a precious reunion and exchanged multiple stories from over the years.

On one occasion, he said that a campaign he directed the students on had won multiple awards. It was an ad campaign for an outdoor camping company, and the ads were brilliant. One was an overhead shot looking down on a polar bear comfortably tucked into a sleeping bag, facing up and asleep with only his head and paws lying outside the bag on the top.

This ad and several others from this campaign were so effective that they attracted the outdoor camping company, who called SVA asking to talk to Jeffrey. The client was awestruck by the work and wanted to hire Jeffrey and his award-winning students with very comfortable salaries.

Jeffrey graciously turned it down because it would mean relocating and wouldn't be a practical change for his life. He and Sheila had eight kids, so uprooting the family wasn't realistic.
Sheila Metzner and I each received the AIGA Lifetime Achievement Award in 1997.

2008: Unexpected Bad News

Glenn Heffernan, who had been my sales contact at Watson-Guptill for many years, walked unexpectedly into my office one morning and asked if he could sit down. He then asked for a glass of water. I said of course and asked him what was wrong because he looked pale.

He explained that when he had come to work that morning, he tried unlocking his door as usual, but the key didn't work. He tried it again and checked to see if he had the right key. As he did so, looking down, he saw several boxes stacked up outside his office. He opened the lid on one of them to find it filled with items from his office. It was only then that he realized he had been rather crudely fired without any forewarning.

Next, he looked to his right and left to see everyone else in the same situation. This unsettling scenario extended to numerous colleagues who had also been let go without warning. I then asked whether this meant that our *Graphis* book sales in the U.S. were over with. He said yes. I was glad I had been sitting down when I heard this.

The cause of this upheaval was the dominance of bookstore chains like Borders and Barnes & Noble, which had gradually eliminated most of the small and not-so-small mom-and-pop bookstores that Watson-Guptill relied on. The loss of these stores had continuously eroded Watson-Guptill's sales until it was over. The company then sold what was left to Random House in 2008. As a result, Marta Schooler at HarperCollins, our international distributor, was also affected by Watson-Guptill folding. HarperCollins increased their discounts on our books until it no longer made any sense.

I called her and said this was unacceptable. She understood and apologized. Graphis, Inc. now had to sell directly to the rest of the world.

Zero Book & Magazine Sales for Graphis, Inc.

Starting with zero sales on our books and magazines, we incurred losses totaling close to $800,000 in the subsequent years until sales gradually began to repay us. Arna and I are still owed around $200,000. Since 2008, neither Arna nor I have received a salary.

2008: Other Consequences

The Art Directors Club and the American Institute of Graphic Arts (AIGA) were also affected—each ended their annuals immediately.

2009: Unforgettable Lunch With Helmut Krone, Advertising Legend

The University of Delaware invited me to speak. Later in the year, students were asked to pick their favorite speakers. In the field of Advertising, they chose Helmut Krone, renowned for his work at Doyle Dane Bernbach, especially the award-winning Volkswagen ads*. As for Design, they selected me. The school decided to host a lunch for Helmut and me, along with the top five students in Advertising and Design. We were to answer students' questions about our careers.

At noon, we all came from separate places, gathered at the restaurant, and got seated. Helmut and I sat opposite each other, with five students on either side. The waiter came and asked for our orders. Drinks were served first. Helmut ordered a martini while I chose a glass of red wine. The students had a variety of liquor and soft drinks.

After we toasted the 10 students for their achievements, a brave Advertising student asked Helmut about his views on the latest styles in the field.

Helmut, sipping his martini, responded after a dramatic pause. "Style isn't important to me."

A bit intimidated, the student then asked, "What is important to you?"

Helmut paused again, took another sip, and with a measured tone, responded, "Ideas. I get paid a lot of money for great ideas."

His delivery was theatrical, and the room absorbed the wisdom. More questions followed, and we all learned from each other. I made clear my admiration for Helmut's legendary career, making it an unforgettable lunch.

Helmut Krone is a Graphis Advertising Master, and his work can be accessed on our site.

2011: Borders Closes

Borders went out of business, but along with Barnes & Noble and Amazon, it was responsible for putting most independent design and architecture bookstores out of business.

Friday, November 11, 2016

My youngest son, Christopher Alexander Pedersen, with Rebecka Anna Maria Johansson from Jönköping, Sweden, gave us our first grandson, Viggo Alexander Pedersen, who was born in New York. The joy of welcoming the next generation into our family was indescribable.

Tuesday, April 7, 2018

Christopher married Rebecka in the Swedish church at 5 East 48th Street in Manhattan.

2019: Investing Since 2008

Arna and I had invested $800,000 since 2008 to save *Graphis'* books, and we were now slowly being paid back on this loan. During this entire period, neither Arna nor I received a salary.

Monday, July 12, 2019

My second grandson, Axel Christopher Pedersen, was born in Jönköping, Sweden.

August 2019: Bad News

In early August, after a trip to Norway and Sweden to visit family, Arna experienced stomach pains and lost 16 pounds. On her return, she weighed only 92 pounds. Her weight her whole life had been 112 pounds.

It turned out to be a stage three cancer stomach ulcer.

Thursday, December 12, 2019

I received an email from Kevin Swanepoel, CEO of the One Club, stating that starting the following year, they would no longer publish the One Club 600-page annual. He cited the high costs and storage issues associated with the print edition, as well as the fact that 84% of their entries were predominantly digital, including video and audio content online.

This left only the Type Directors Club (TDC), the Society of Publication Designers (SPD), and the Illustrators Club still producing physical annuals—four including Graphis, Inc.

Saturday, August 29, 2020: Death in the Family

On this day at 8:30 PM, Arna passed away in my arms from stomach cancer after battling the disease for more than a year.

Our youngest son, Christopher, had flown from Sweden, where he lived, and had held Arna's other hand when she left us. She was now in a better place, at peace, and without pain.

During our 56-and-a-half blissful years of marriage, she had been my wife, lover, best friend, and business partner. I was blessed with her presence for all of these wonderful years.

How do I live without you?
Oh my love I do not.

You are with me from the moment I open my eyes until they close.
And even after that,
on the plane of dreams where mortals and souls meet, you are with me still.

"I have not yet learned to live without you,
and perhaps I never will,
the truth of the matter is,
you are always with me still."

You walked such a blazing pathway, when your feet were on this earth, that your imprint lingers
on and I place my own feet in your steps, one by one.

How do I live without you?
It's really very simple.
I do not.

"I have yet to live without you
perhaps I never will,
perhaps the key to grief is,
you are always with me still."

By **Donna Ashworth**, *Poet*

Arna is buried in the Fort Hill Cemetery in Montauk, New York.

2022: *Graphis Journal* #374

I placed a portrait of Arna on the cover of *Graphis Journal* #374. In that issue's publisher's letter, I related why. The portrait was done by Mark Hess, the son of Dick Hess, who grew to be equal to his talented father in painting.

Mark had met Arna in 2020 at our office, and when he heard about her death, he told me he wanted to paint her. I told him I would be honored and that I would pay him for the portrait.
He told me he didn't want my money.

When he delivered the painting, I was deeply moved by how well he had captured Arna's essence.

Tuesday, February 14, 2023: Valentine's Day Present

Graphis Inc.'s design director, Heera Kim, called me and said, "I am sending someone very special to meet you; her name is Claire Yuan Zhuang."

This happy, smiling young lady arrived at my office and sat down across from me before handing me her resume. She had graduated from SVA and was doing a two-year master's degree at Parsons School of Design. I asked what that was about.

She gave me a big smile and said she had worked on a project with two other ladies, Mengxi Li and Savvy Rajan, where they totally refreshed Graphis Inc.'s website for the future. I was completely surprised by this and said that after she completed her master's at Parsons, I would hire her full-time. She has since become an invaluable gift to the Graphis, Inc. team.

May 14, 2023: *Graphis'* Future

I have always felt a deep responsibility to this extraordinary creative community. I have always told my staff that we should present the work as if it were our own. Graphis, Inc. has continued to evolve the legacy established by Walter Herdeg in 1944 by presenting award-winning work from all five creative professions: Advertising, Design, Art/Illustration, Photography, and Education. The digital library and the website are now more accessible than ever before.

Looking forward, I have no doubt that Graphis, Inc. will continue to discover and promote the emerging talents of the future.

B.MARTIN PEDERSEN BIOGRAPHY

THE ODDS ARE AGAINST YOU.
BUT DESIGNERS STILL WANT
SOMETHING THAT WILL ALLOW
THEM TO LOVE DESIGN.
GRAPHIS IS LOVE.

Steven Heller, *Art Director, Author, Journalist, Critic, & Co-chair, MFA Design, School of Visual Arts*

380 B.MARTIN PEDERSEN BIOGRAPHY

I must go down to the sea again, to the lonely sea and the sky,
And all I ask is a tall ship and a star to steer her by,
And the wheel's kick and the wind's song and the white
　　sail's shaking,
And a grey mist on the sea's face and a grey dawn breaking.

I must down to the seas again, for the call of the running tide
Is a wild call and a clear call that may not be denied;
And all I ask is a windy day with the white clouds flying,
And the flung spray and the blown spume, and the
　　seagulls crying.

I must down to the seas again, to the vagrant gypsy life,
To the gull's way and the whale's way where the wind's
　　like a whetted knife;
And all I ask is a mérry yarn from a laughing fellow-rover,
And quiet sleep and a sweet dream when the long trick's over.

"Sea-Fever" by John Masefield

Ships that pass in the night, and speak each other in
　　passing;
Only a signal shown and a distant voice in the darkness;
So on the ocean of life we pass and speak one another,
Only a look and a voice; then darkness again and
　　a silence.

"The Theologian's Tale" by Henry Wadsworth Longfellow

Photo on right: Sloop Seafarer 31 en route to Bermuda with crew of four (see BMP Bio, page 353).

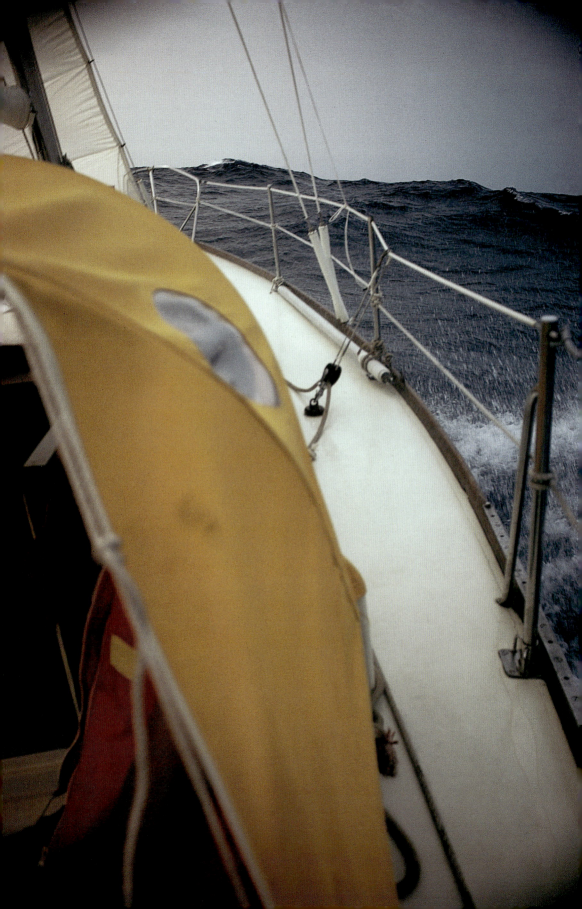

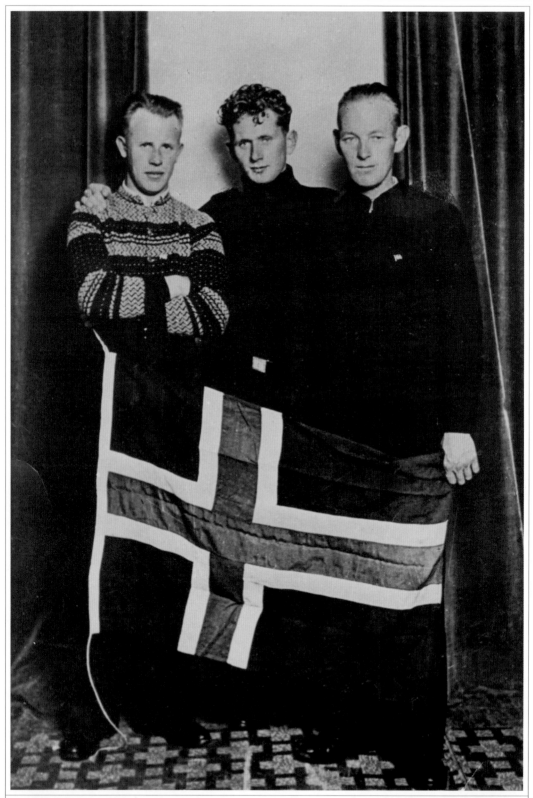

Photo: Frithjof Pedersen (Left), Odd Kjell Starheim (Middle), & Alf Lindeberg (Right), 1941 | Pg. 335: Bio

DEPARTMENT OF THE NAVY
BUREAU OF NAVAL PERSONNEL
WASHINGTON 35, D. C.

IN REPLY REFER TO
Pers-C1214-lm
Ser: C121/1126

6 January 1956

From: Chief of Naval Personnel
To: Martin (n) PEDERSEN, 465 38 25, SR, USNR

Via: Commanding Officer
Naval Reserve Surface Division 3-52(M)
U. S. Naval and Marine Corps Reserve Training Center
52nd Street and 1st Avenue
Brooklyn, New York

Subj: Application to compete under the Reserve quota for an appointment to the United States Naval Academy by the Secretary of the Navy

Ref: (a) BuPers Reserve Instruction 1111.1A
(b) BuPers Reserve Instruction 1111.5

1. Receipt of subject application is acknowledged.

2. You have been nominated to participate in the entrance examination commencing on 28 March 1956 to compete under the Reserve quota for an appointment to the United States Naval Academy by the Secretary of the Navy.

3. A report of your preliminary physical examination has been reviewed in the Bureau of Medicine and Surgery and it has been found that you are not considered physically qualified by reason of **defective visual acuity, each eye 20/100, correctible to 20/20; albuminuria.**

4. This physical examination is only preliminary and does not disqualify you from taking the mental examination for the United States Naval Academy. Your final physical fitness for the United States Naval Academy will be determined when you are authorized by the Chief of Naval Personnel to report for a formal physical examination by a Board of Medical Examiners. However, this letter is to inform you that unless the above condition is corrected, you may be rejected for appointment to the United States Naval Academy for reasons set forth in paragraph 3.

5. Your attention is invited to the fact that you must complete the military requirements as set forth in references (a) and (b) prior to 28 March 1956. As soon as possible after the above date, your Commanding Officer must submit a report of your drills and active duty for training on Form NAVPERS 2489.

J. B. NELSON
By direction

Photo: Test Result Letter from the U.S. Naval Personnel, 1956 | Pg. 347: Bio

384 B. MARTIN PEDERSEN PORTRAITS & PHOTOS

Top Left: Arna Tompsen Skaarva, when I first met her | **Top Right:** Arna, later in life
Bottom: I was on the bridge while fueling from the carrier *USS Essex* (CV-9) at the start of Hurricane Emma off the western coast of Ireland on the Fletcher-class destroyer *USS Remey* (DD-688), 1961 | **Pg. 347:** Bio

B. MARTIN PEDERSEN PORTRAITS & PHOTOS

Photo: Arna Tompsen Skaarva is crowned Miss Norway of Greater New York, 1962 | **Pg. 347:** Bio

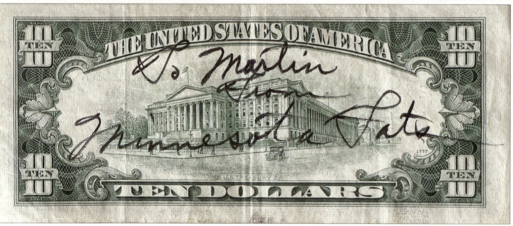

Photos: Minnesota Fats: John Caldwell, B. Martin Pedersen, George Plimpton, Peter Duchin, 1970

Top: Adrian Pulfer (Left), Molly Epstein (Middle), B. Martin Pedersen (Right)
Bottom: Advertising legend George Lois (Left) & B. Martin Pedersen (Right) at an Art Directors Club Awards dinner

Top: 50 Ton Coast Guard Marine Officer Certificate for Sail and Power Vessels, 1987
Bottom: Hinckley Bermuda 40 *Concinnity*, 1971 | Pg. 374: Bio

Photo by Fritz Gottschalk

390 TESTIMONIALS

In addition to being a great designer, Martin was the creative director who gave me my first national exposure years ago with assignments for The American Way and Nautical Quarterly.

Bart Forbes, *Illustrator & Painter, Bart Forbes Commercial Illustration & Fine Art*

Martin's sense of design—and his fervent belief in its ability to change our world —has been a beacon for young designers for decades and will continue to be.

Jeff Goodby, *Co-chairman, Founder, & Partner, Goodby, Silverstein & Partners*

A legendary and iconoclastic man on a quest for perfection and a paradigm of excellence and elegance, Martin has relentlessly elevated the standards for design, typography, art direction, illustration, and photography through his extraordinary and iconic publications for many years. Thank you for all the invaluable inspiration and, above all, your valuable friendship... You "deserve" the highest award of excellence!

Parish Kohanim, *Photographer, Parish Kohanim Fine Art LLC*

Martin reached out to me shortly after I arrived in NYC around 1996; since then, we have become friends. He is as passionate about the craft as someone can be. Martin has all my respect as an old-world gentleman and is a wonderful designer and publisher.

Henry Leutwyler, *Photographer, Henry Leutwyler Photography*

With Graphis, Marty has inspired photographers, illustrators, and designers for nearly four decades, presenting unparalleled excellence in the visual arts. Marty's profound knowledge and appreciation for photography, illustration, and design are truly remarkable.

John Madere, *Photographer & Director, John Madere Photography LLC*

Bjarne and I share some regionally related fellowships. We both bear drops of Viking blood in our veins; Bjarne is a passionate and tireless design warrior.

Finn Nygaard, *Graphic Designer, Finn Nygaard Design*

Elegant is the first word I think of when I think of B. Martin Pedersen. He is adventurous in life and design, determined to make magic happen (which he has for decades), and so kind.

Rosanne Olson, *Photographer, Rosanne Olson Photography*

The legacy Martin has created through his work with Graphis, along with his unwavering dedication to the creative arts, has profoundly shaped who I am as a designer and artist. Martin Pedersen is a rare example of what occurs at the intersection of design, creative excellence, strong character, and deep compassion for the future of our industry. Martin is a person I greatly respect and admire.

Michael Pantuso, *Founder, Principal Creative Director, & Designer, STUDIA*

Martin has led a stellar career of his own but, of even greater note, has recognized the potential of countless aspiring creatives and given them a chance to shine.

Daniel Pelavin, *Illustrator & Typographic Designer, Daniel Pelavin Studio*

TESTIMONIALS

Martin has spent most of his career developing, redeveloping, and refining Graphis, the most popular international publication of Design, including related disciplines and profiles of the artists who created featured published works.

Woody Pirtle, *Creative Director & Owner, Pirtle Design*

He is a legend in his time. The principles I learned from him when we were partners in JPH&S I used in the classroom for over 30 years and continue to use in my own work today. Thank you, dear friend.

Adrian Pulfer, *Designer & Professor, Brigham Young University*

He is a person of amazing dedication and passion in the world of publishing, graphic design, photography, and illustration. He is also an outstanding designer, immersed and engaged in the well-being of our society and planet Earth.

François Robert, *Photographer, François Robert Photography*

Not many people are alive today with a legitimate claim to have changed the course of design for the better; Martin surely stands on top of the very few.

Stefan Sagmeister, *Graphic Designer & Typographer, Sagmeister Inc.*

I know no one as talented, skilled, creative, joyously generous, or kind as Martin Pedersen. He has elevated my life and career to places I had never thought attainable, as he has with everyone he touches.

Howard Schatz, *Photographer, Howard Schatz Photography*

Webster defines "class act" as "something or someone regarded as outstanding or elegant in quality or performance." I can't think of any better way to describe B. Martin Pedersen.

Rich Silverstein, *Co-chairman, Founder, & Partner, Goodby, Silverstein & Partners*

Martin's design and creative prowess were inspiring. Early on in my studies, after seeing his extraordinary work at a college lecture, my career had a true North Star—and it still does.

Ron Taft, *Founder & Chief Creative Officer, Ron Taft Brand Innovation & Media Arts*

I've known Marty since the 1970s. He is an exceptional designer and has also accomplished the incredible feat of continuing the legacy of the legendary Graphis, cementing his place in design history as a designer, editor, and aesthete. He has single-handedly set the bar for excellence in graphic design for decades.

Michael Vanderbyl, *Designer & Principal, Vanderbyl Design*

Take perfection, add a dash of elegance and grace, and you have the essence of B. Martin Pedersen as both a person and a master of design.

Allan Weitz, *Photographer, Allan Weitz Design*

B. Martin Pedersen is an extraordinary human being whose pursuit of excellence is evident, especially as a publisher. He has established a level of excellence representing the gold standard for college and university students worldwide. His impact on the world of visual communications is immeasurable.

Richard Wilde, *Former Chair of BFA Advertising & BFA Design, School of Visual Arts*

392 B. MARTIN PEDERSEN PORTRAITS & PHOTOS

Photo by Howard Schatz